before

William John
Leech

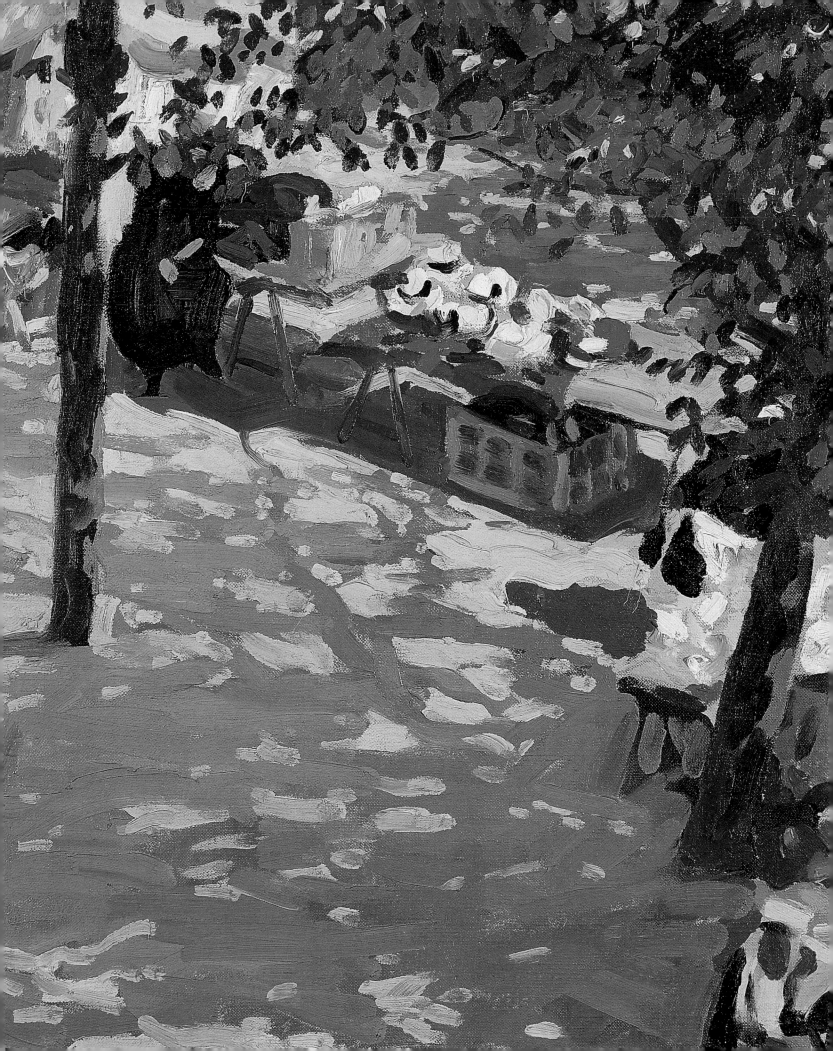

William John Leech

An Irish Painter Abroad

DENISE FERRAN

NATIONAL GALLERY OF IRELAND

in association with

MERRELL HOLBERTON
PUBLISHERS LONDON

This book accompanies the exhibition
William John Leech: An Irish Painter Abroad

at the National Gallery of Ireland, Dublin
23 October 1996 – 15 December 1996

Musée des Beaux Arts, Quimper
10 January – 10 March 1997

The Ulster Museum, Belfast
28 March – 22 June 1997

First published in 1996, in association with the National Gallery of Ireland,
by Merrell Holberton Publishers Ltd
Axe and Bottle Court, 70 Newcomen Street, London SE1 1YT

Hardback ISBN 1 85894 034 6
Paperback ISBN 0903 162 733

Produced by Merrell Holberton Publishers
Designed by Roger Davies
Printed and bound in Italy

Jacket/cover illustration: *A convent garden, Brittany* (cat. 36; detail)

Frontispiece: *The hat stall* (cat. 9; detail)

Illustration p. 6: *'Twas brillig* (cat. 22; detail)

Contents

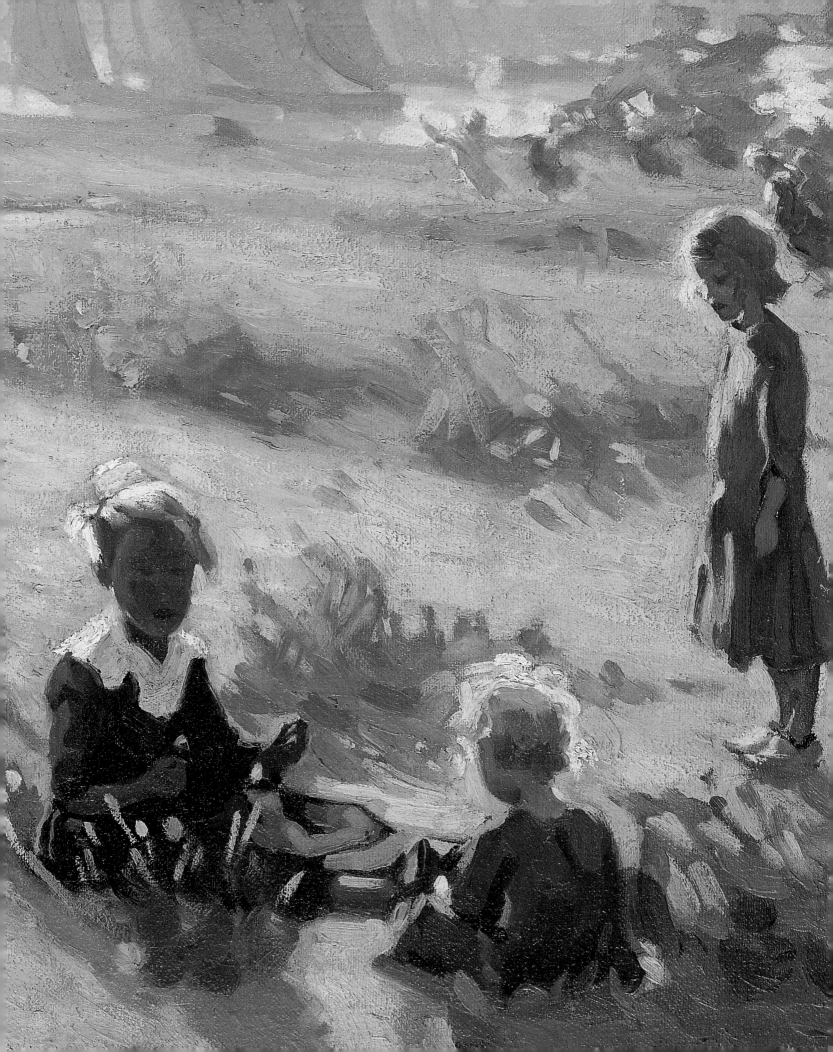

Foreword

The paintings of William J. Leech which form part of the permanent display at the National Gallery of Ireland are among its most popular exhibits. Given this interest, and the fact that the last exhibition dedicated to the artist was at the Dawson Gallery in Dublin in 1951, it is evident that a comprehensive presentation of the artist's work is long overdue. Since the early 1980s the National Gallery has hosted a series of shows dedicated to many of the artist's contemporaries and it is with great pleasure that we welcome this opportunity to reassess and enjoy the contribution of William Leech to the development of Irish art in this century.

This exhibition would not have been possible without the generosity of all the lenders – relatives of William Leech, many private collectors, museums and corporations – to whom we extend our deepest appreciation for agreeing to be parted from their treasured possessions for the duration of this event. The selection of the paintings and the compilation of the catalogue have been the responsibility of Denise Ferran, to whom we are greatly indebted for sharing with us her unique knowledge of the artist. Her text was skilfully edited by Paul Holberton. Photography for the catalogue was carried out by Roy Hewson. A very special note of thanks is due to Fionnuala Croke, who, in the course of what has already been a very busy year at the National Gallery, worked selflessly to ensure that this exhibition would stand as a valid testament to the achievement of one of Ireland's most admired artists. Susan O'Connor provided very welcome support with the administration of all the essential details.

Following its presentation in Dublin, the exhibition will travel to the Musée des Beaux-Arts, Quimper, Brittany, and then on to the Ulster Museum, Belfast. To the directors and staff of the Musée des Beaux-Arts and the Ulster Museum we extend our warmest appreciation for their co-operation in bringing the work of William John Leech to the widest possible audience.

RAYMOND KEAVENEY
Director, National Gallery of Ireland

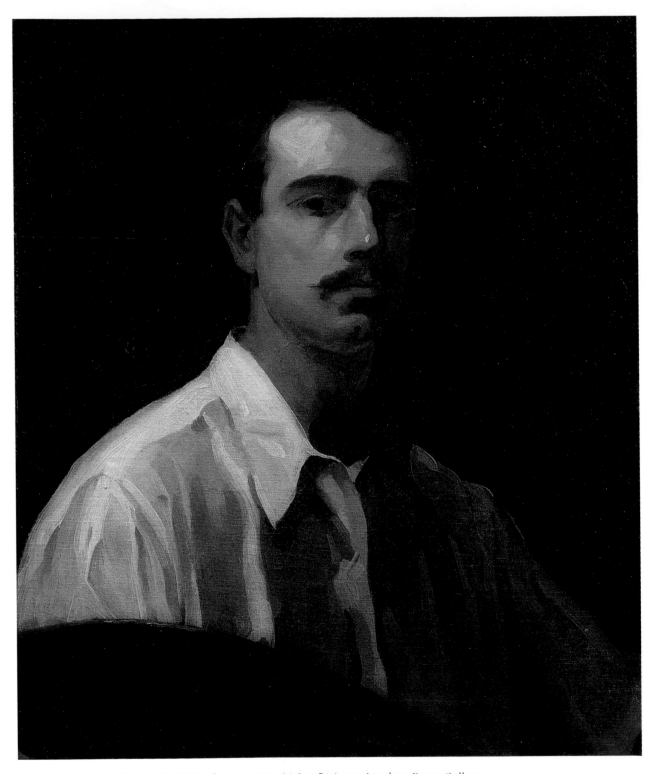

William John Leech, *Self-portrait*, 1908, oil on canvas, 64.3 × 54.6 cm, London, Pyms Gallery

1

The Leech Family, their Background and the Family Years in Dublin

The future painter William John Leech was born on 10 April 1881 at no. 49 Rutland Square, Dublin, the third son in a family of eventually six children, five of whom were boys. His father, Henry Brougham Leech, was an authority on international law and jurisprudence who had been elected to lecture at Trinity College, Dublin, in 1878. The Leech family had been long established in Ireland: in 1667, George Leech from Mayo is recorded, and to his descendant the Reverend John Leech of Cloonconra, Chaplain of Kingston College, Mitchelstown, County Cork, Henry Brougham was born on 15 November 1843.[1] Brougham married William John's mother, Annie Louise Garbois, the daughter of William Garbois, of French Huguenot stock, a teacher of dance in Dublin, on 1 June 1875.

The profession of law was a family tradition. One of the Reverend John's brothers and his brother-in-law were barristers with practices in Dublin, and these uncles may have influenced Brougham Leech to become a barrister, subsequent to his 1865 graduation in Classics and Philosophy at Trinity College, Dublin.[2] Afterwards he proceeded to read law at Caius College, Cambridge, where he became a fellow; he was called to the Irish Bar in 1871. Brougham lectured at Trinity College from 1878 until 1889. Thereafter he became Registrar of Deeds, the head of a considerable government department then housed in Charlemont House in Rutland Square (now the Hugh Lane Municipal Gallery in Parnell Square);[3] he was also soon elected Regius Professor at Trinity.

Brougham Leech (photograph, fig. 1) was a prominent figure in the College, giving opinions on many matters of current controversy. He was a vigorous and active Unionist and wrote a long letter to the editor of *The Times* in June 1886, entitled 'Is Ireland Worth Keeping?' In it he argued the case against Gladstone's Home Rule Bill, enunciating the many gains Ireland enjoyed from the union with England and denouncing the Home Rule movement and its supporters.[4] The following year he

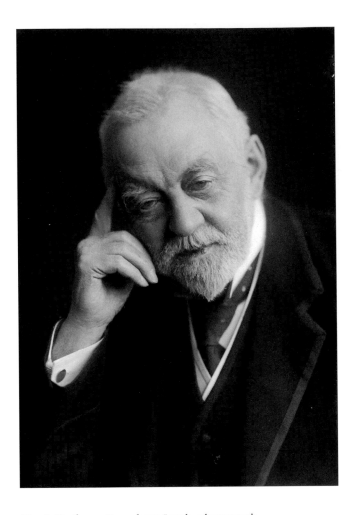

Fig. 1 *Professor Brougham Leech*, photograph

published a pamphlet entitled *The Continuity of the Irish Revolutionary Movement*, which attempted "to prove to the British public, in as simple and concise a manner as the complicated nature of the subject permitted, that the various movements which had taken place in Ireland during the previous forty years had, while differing in their methods of operation, all been directed to the attainment of one great object – the separation of Ireland from Great Britain.[5] He spoke out against Charles Stuart Parnell's addresses in America and against William Smith O'Brien, MP, an equally active advocate of Home Rule seeking "an independent Irish nation". Having grown up in this environment William John Leech would later, ironically, be commissioned to

paint a posthumous portrait of O'Brien (National Gallery of Ireland).[6]

Professor Leech was an affluent professional man, whose academic salary alone exceeded the then considerable sum of £500 annually. Brougham held his Regius Professorship until he retired in 1908, at the age of sixty-five;[7] though Trinity did not at that time provide pensions for its staff he was able to draw a pension from his government post as Registrar of Deeds, from which he had retired three years earlier.

The mother of William John (known in the family as Billie, and otherwise as Bill),[8] placed great emphasis on courtesy and gentility. A coloured aquatint of Annie Louise Garbois at the age of eighteen shows her as a slim, aristocratic-looking young woman in a fine embroidered dress with her hair fashionably *coiffured* in ringlets which frame her face on either side.[9] Later photographs show her, even in old age, as an elegant, beautiful woman.[10] All her sons were born at Rutland Square, where the couple moved in 1877: Arthur in the same year, Henry Brougham in 1879, William John in 1881, Cecil in 1882 and Frederick in 1884. Their sister Kathleen was born in 1889, the year after they had moved to Yew Park, Castle Avenue, Clontarf – a move made apparently in the interests of the growing Leech family. At Clontarf they continued to live for twenty years, until 1908.

Clontarf, where Bill grew to adolescence and adulthood, was described in those days as a "maritime parish ... three miles E.N.E. from the General Post Office, Dublin".[11] Although for his work Brougham Leech was more conveniently located at no. 49 Rutland Square, Clontarf was highly desirable as a residential area. It was close to the sea: "The High Road [renamed Clontarf Road] skirts the strand, and off it branch many important roads and avenues, which are lined with villas and houses. Castle-avenue occupies the centre of the township, and runs from the High road to the gate of the castle ... It is much frequented in summer for sea-

bathing and is well provided for as regards recreation, as the Royal Golf Club Links are at Dollymount and there are also good cricket and tennis clubs and a yacht club."[12] Like other middle-class Protestant families at that time and place, the Leech family played lawn tennis and held summer parties at their home.[13] They also owned a yacht, *The Lady Nicotine*, which they used to sail around the coast of Ireland and which Leech painted, exhibiting it as *The white boat* at the Royal Hibernian Academy in 1911, price £36. 15s. (fig. 2). (He exhibited it again at the Cooling Gallery in London in 1927, and it was regarded by the reviewer of *The Times* as "excellent").[14] All in all, Bill Leech had a privileged and pleasant upbringing in a very happy, cultured home environment at Clontarf. His father, what is more, owned a significant collection of Flemish, Dutch, French and Irish paintings, among them works attributed to Jacob Jordaens, Albert Cuyp, Meindert Hobbema and James Arthur O'Connor.[15] Bill Leech's artistic ability was nurtured and continued to be fostered by his close-knit family throughout their lives.

In 1892 Arthur and Henry went to school at St Columba's College, Rathfarnham. St Columba's, founded in 1843, was a classical collegiate school, in the tradition of an English public school.[16] The boys boarded at the school, in a dormitory and house system, and although Dublin lay in the valley below, there would have been visits home only at the end of term.[17] The Leech family played an important rôle in the development of St Columba's in those years: Professor Leech became one of the Fellows of the College and his eldest son Arthur became one of the two secretaries to the school magazine, *The Columban*, secretary of the Games Committee and captain of the First XI cricket team.[18]

Following in the tradition of their father,[19] three sons attended Trinity College, where, thanks to their father's position, they received free tuition. Arthur went up to Trinity in 1895, and after taking his BA studied law.[20] However, he never practised and

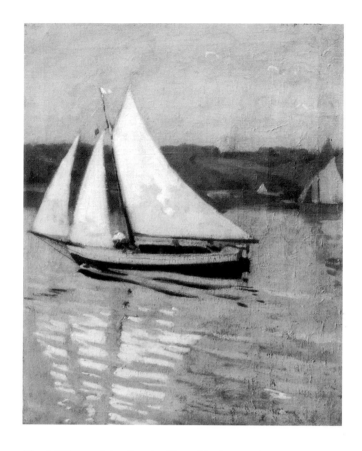

Fig. 2 William John Leech, *The white boat*, oil on canvas, private collection

instead obtained a commission in the Royal Horse Artillery and became a career soldier (photograph, fig. 3).[21] The second son, Henry, or Harry as he was known to the family,[22] had a noticeable limp owed to an attack of polio as a child. He went up to Trinity College for a BA in 1896 and then studied medicine.[23] He practised for seventeen years at Hattons Psychiatric Hospital in Winchester, England, and then, on retirement, bought a house in Kent with Arthur. Cecil had also gone to St Columba's, and then obtained a commission in the Royal Field Artillery.[24]

Bill Leech, like his brothers, had gone to St Columba's at the age of twelve, in 1893, winning a prize for English in the midsummer examinations that year. The following year he won a prize for French and a creditable mention for Classics and

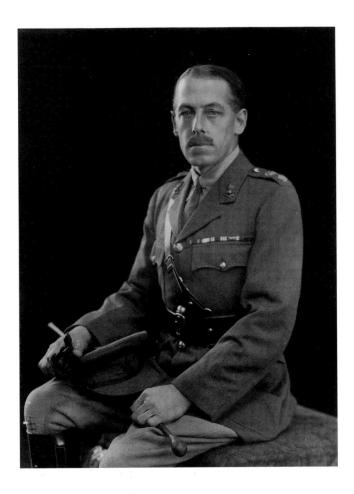

Fig. 3 *Arthur Leech*, photograph

1896 may have precipitated his decision to leave, and to study French in Switzerland – a usual choice, rather than Catholic France, for a Protestant family. His time there seems to have instilled in him a lifetime love of the French language, culture and people. This he was able to share with his sister Kathleen, the only girl and the youngest in the family (photograph, fig. 4), who was at first educated privately at home and then, in 1907, aged eighteen, also went to Switzerland, to Lausanne, to 'finish' and to become fluent in French herself.[27]

In 1899, then eighteen years old, Bill Leech entered the Metropolitan School of Art in Dublin. It would have been more in keeping with the family tradition to have gone to Trinity, but his parents, considering his love of art and his early demonstration of ability at St Columba's, supported him in his choice of an artistic career. In addition to the Earl of Erne prizes for drawing and painting which he had won at St Columba's, the fact that he had a painting (*Lake Brienz before a storm*, present whereabouts unknown) accepted by the Royal Hibernian Academy in March 1899, just before his eighteenth birthday, must also have been a significant factor in his parents' support.

Frederick, or Freddie as he was known, the fifth and youngest son, also went to St Columba's and then studied law at Trinity. In 1906, he was awarded a Gold Medal for his studies: he "won first place in the Examination for Classical Moderatorship after a distinguished University career".[28] His father envisaged that this son would follow him in an illustrious career in law. Unfortunately he died of peritonitis on 8 December 1906, when he was only twenty-one. Just three months later Brougham Leech's health broke down.[29] The tragedy would haunt the Leech parents until their own deaths in 1922;[30] indeed Freddie's death had long-lasting repercussions on the whole, close-knit family, and Freddie, his favourite brother, had been particularly close to Bill. Even though Freddie was still at school when Bill began going to the Académie Julian in

Divinity, and continued to win prizes for French and for his term's work. From 1895 he repeatedly won the Earl of Erne's prize for drawing and painting at the school. The ambiance of St Columba's College was evidently congenial to Bill. Not only was art on the curriculum, taught by a Mr Allen,[25] but in addition he was taught photography and carpentry in the carpenter's shop. Throughout his long life Leech often made the frames for his pictures. He enjoyed making pieces of furniture and a model boat he built still exists.[26]

Bill remained at St Columba's until the end of Easter Term 1897, when he turned sixteen. The difficulties experienced by the school in coping with the aftermath of a very serious fire on 7 December

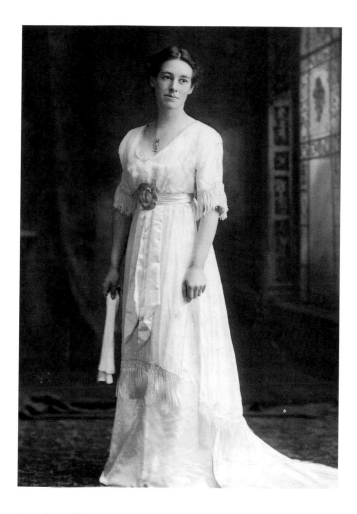

Fig. 4 *Kathleen Leech, later Mrs Charles Cox*, photograph

medicine, and the stability provided by his brothers helped to accommodate his more precarious choice of career. Now twenty-five years of age, he was just beginning to exhibit in Dublin in mixed exhibitions and to attract attention from the critics. Freddie's death shattered this harmonious pattern.

Brougham Leech retired from Trinity College in 1908, and auctioned off all the family's furniture and possessions at Yew Park, Clontarf, that August.[33] He may already have been planning to leave Dublin, or simply wished to move to a smaller house now that his family had grown up. In any event, Professor and Mrs Leech moved temporarily to Victoria Villas, Morehampton Road, and then to Wilmar, Dartry Road, before leaving to live at no. 45, Westbourne Park, Fulham, London.[34] According to Alan Denson,[35] Bill Leech remembered that this move was a direct result of his younger brother Freddie's death in 1906 and the great sense of loss it caused his parents. However, another factor may have been the changing politics in Dublin, and the resurgence of nationalism in the prospect of the Third Home Rule Bill.[36] Brougham Leech was not alone among the mainly Protestant professionals who moved out of Dublin and set up home in London around this time.[37] His sons Arthur and Cecil were in the British Army, and Harry was a doctor in England. Bill, still living with his parents when he was not in France painting, moved with them, and so did Kathleen, but in 1912 she married the Reverend Charles Cox, and moved to live at Tettenhall Vicarage near Wolverhampton. Though past thirty, and even after his marriage to Saurin Elizabeth Kerlin in 1912,[38] Bill continued to live with his parents when he was not painting in France.

The family was an important influence on the artist Bill Leech (photograph, fig. 5), and his parents' moral and financial support continued until just before his father's tragic death on 2 March 1921, which precipitated his mother's death a few months later.[39] In the ensuing years, other members of the

Paris in 1901, each summer when Bill returned to visit his family in Clontarf, Freddie met him at the boat and always saw him off again. "Freddie always met the boat when I returned home from France, he always saw me off at Kingston Harbour. I can still see him, waving as he always did. He used to say at home, 'Our family name will be remembered because of Billie's pictures.'"[31]

In the autumn of 1906 Bill had just returned to Dublin from France and for just over a month had been settling into a happy existence of living at home in Clontarf and working at a studio in Dublin.[32] Arthur and Cecil were pursuing their careers in the British Army, as was Harry in

family, especially his brother Cecil and Kathleen, maintained this important financial and moral support to the still struggling artist. Throughout his life, even after two marriages, first to Elizabeth and then to May Botterell in 1953,[40] Bill remained on close terms with his brothers and sister and their own families.

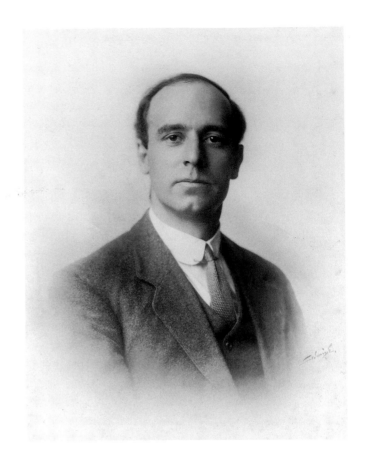

Fig. 5 *William John Leech*, photograph

2

Student Years

1899–1903

The Metropolitan School of Art, Dublin

"I must have had something about me which persuaded my father to let me go to the Metropolitan School in Dublin", Leech later remarked.[1] As far as can be ascertained from family records and verbal accounts, there is no evidence of anyone in the family having been an artist earlier. However, his mother's cultural background, his father's studies in classics and philosophy and literary talent, and the whole family's appreciation of the visual arts as an essential enrichment of their lives – apparent from their collection of important paintings[2] – would have been conducive to their son's artistic bent.

The choice of the Metropolitan School,[3] instead of the Royal Hibernian Academy Schools, showed a practical approach on the part of Leech's parents, for the Metropolitan's main purpose was the training of teachers for secondary schools throughout the country. The prospect of their son's being an art teacher as well as an artist seemed to provide a more secure future. The Metropolitan, however, was the best art school in Ireland, it was efficiently run, and it received funding of £4000 annually, enabling it to employ good teachers and allocate scholarships to talented students.[4] Its curriculum was closely related to that of the English art education system, being based on that of the South Kensington School of Design in London,[5] so that it could provide a foundation for later study at the Slade School in the capital. Emphasis was on the repetition of mechanical exercises in drawing, and students began by copying from prints and drawings. They then proceeded from two dimensions to three, drawing from plaster casts and antique sculptures, and they were trained in anatomical and geometrical drawing. They needed to be competent in drawing before proceeding to painting. Though the Metropolitan primarily trained teachers, not a few of its students, including Roderic O'Conor, John Hughes, Sarah Purser and William Orpen, went on to become established artists.[6]

During 1899–1900, when Leech went to the

Metropolitan, the total number of students enrolled was 483, an increase of twenty-eight over the preceding year – but these figures include part-time students as well as full-time.[7] Leech made friends with painters Lilian Davidson and Estella Solomons and the very talented and beautiful Beatrice Elvery (later Lady Glenavy), who was not only taught sculpting by John Hughes but modelled for him and was sculpted by him. She was also the subject of a painting by Orpen.[8] In 1902, she, Estella Solomons and Leech exhibited among the 'Young Irish Artists' in Dublin,[9] and at the Leinster Lecture Hall in Dublin in 1910 "she exhibited twenty one small paintings in a figurative group show with Leech, A.E. [George Russell] and others".[10]

Both Lilian Davidson and Beatrice Elvery had been students at the Metropolitan School with Orpen: Davidson for four years from 1895 and Elvery for Orpen's last year, before he left for the Slade in London. Orpen had gone to the Metropolitan in 1891 "within six weeks of his thirteenth birthday",[11] and Beatrice Elvery had gone at age thirteen in 1896,[12] whereas Leech, as we have seen, was eighteen years old with a much more broadly based education.[13] The thirteen-year-old Orpen had a long tiring day by train from Blackrock to Westland Row and then to the school in Kildare Street;[14] Leech, by contrast, came by tram-car from Clontarf to the terminus in Sackville Street (now O'Connell Street), a very good service: "A tram car starts from Sackville-street every five minutes."[15]

Leech was included in the school's prize giving in 1900, achieving First Class in Perspective and a prize for the session's work. Evidently he had benefitted from his art lessons at St Columba's and from further classes in Switzerland.[16] The fact that the painting he had accepted at the RHA in 1899 was a Swiss landscape suggests that he had continued to paint while in Switzerland. His shading of the model and his advanced shading from the cast were accepted for the Art Class Teacher's Certificate,[17] the award of which brought free admission to the school for a year. Leech, however, left to enrol at the Royal Hibernian Academy Schools in Abbey Street, thus making a positive decision not to complete the Art Class Teacher's Certificate.

Beside him at the Metropolitan Beatrice Elvery's talent was recognized in 1900 by the award of the Queen's Prize for tenth place in the kingdom in drawing from life. Neither Leech nor any other student matched Orpen's virtuosity, however: at the end of his second year he had already won one of the twenty £20 scholarships awarded throughout the British Isles which further entitled him to free tuition,[18] and at the end of his six years at the Metropolitan in 1897 he had won the Gold Medal for drawing from life against competition from all the schools of art in Britain and Ireland. It was understandable therefore that Orpen became an example for Leech to follow and to emulate. In later years he told Leo Smith of the Dawson Gallery, Dublin, that when he went to the Metropolitan, "Orpen had just left for the Slade, everyone was talking about him and old Brenan used to call me a second Orpen."[19] This was praise indeed from James Brenan, the headmaster, also a painter, whose pride in the Metropolitan's outstanding student is exemplified in a letter he wrote at the time: "All who knew him here will bear me witness when I say that he was a model student, eminently teachable. He had a rare natural gift, joined to great industry; such combination is not too common and we may, I think, hope to hear of his success in the World of Art in the not too distant future."[20]

Leech not only knew of Orpen's reputation but could examine his life drawings at first hand since they still hung on the walls in the life class (they were still there when Orpen's protégé Seán Keating arrived in the Metropolitan School in 1907).[21] Leech was less than three years younger than Orpen, and it is reasonable to surmise that the two artists already knew each other or at least of each other, especially since both came from Protestant professional families whose fathers

were leading figures in the law in Dublin. Orpen's older brothers had attended St Columba's College, Rathfarnham, and then proceeded to Trinity College, Dublin, as Leech's brothers had done. Orpen, born in November 1878, was of an age with Leech's brothers Arthur and Harry, born in 1877 and 1879 respectively.[22] Indeed the decision to send Leech to the Metropolitan may have been prompted in the first place by Orpen's example. Orpen, however, in spite of all his successes, later criticized the Metropolitan's academic system, in particular the continuous tedious practice of drawing eyes, ears and noses before being allowed to proceed to the Antique Room to draw from plaster casts.[23] Leech, too, later recalled that "the teaching there wasn't very good at that time. After a year or so I transferred to the Royal Academy Schools."[24]

The RHA Schools and Walter Osborne

An additional factor in Leech's decision to change from the Metropolitan to the Royal Hibernian Academy Schools may have been that in September 1900 the Metropolitan was changing its status, from an institution of the Department of Science and Art to one attached to the Department of Agricultural and Technical Institution. However, it had been quite usual for art students to begin elementary art studies at the Metropolitan and then transfer to the Academy Schools to study life drawing and painting.[25] The much smaller RHA Schools, which were based on the Royal Academy Schools in London, were for students who wished to become professional painters. They were equipped with a life studio and painting was taught there, whereas these facilities were not available at the Metropolitan.[26]

When Leech went to the RHA Schools in 1900, student numbers were very low and had been declining since the 1890s. In 1893 women students had been admitted to the schools, not only in order to increase numbers but also to accommodate demand, but the number of male students fell. By 1905 there were only sixteen students, and there can

hardly have been more than twenty in 1900.[27] The Academy Schools received an annual grant of only £300, which had long remained unchanged. The money was allocated yearly from the Department of Science and Art in London mainly for the maintenance of the life studio. Students who went to the RHA Schools needed more family backing but in compensation they had greater academic freedom, allowing them to concentrate on fine art and to draw and paint under the guidance of visiting teachers who were themselves established painters, for example Nathaniel Hone, Professor of Painting at the RHA. As at the Metropolitan, prizes and awards were geared towards the English South Kensington system and an inspector came each year from London to assess the standard of student work.[28]

One of the visiting teachers at the RHA Schools was Walter Osborne, and when, in later years, in a letter to Leo Smith, Leech dismissed his short stay at the Metropolitan, he specifically mentioned Osborne, "I doubt if I was there a year and then went to the RHA school. Walter Osborne was a visiting master, he had enthusiasm and could teach."[29] In fact Osborne's reputation as a teacher was probably paramount among the factors determining Leech's move from the Metropolitan. He is quoted in later life, recalling these years at the RHA Schools, "Walter Osborne taught there, he taught me all I needed to know about painting."[30] Denis Gwynn wrote in his obituary of Leech that the artist had told him "that he had learned more from Osborne than from any of the celebrated teachers of that time, either in London or in Julian's Studio in Paris."[31] It is significant that Leech emphasized the fact that Osborne taught him to paint, since at that time teaching in art schools, whether in Dublin, London or Paris, focussed primarily on drawing. Osborne's own student training at the Antwerp Academy under Charles Verlat had taught him to combine drawing and painting,[32] and had accustomed him to painting from life in the studio; then his year of *plein air* painting in Brittany followed

by his years in England had developed his style to the accomplished maturity he possessed when he became Leech's teacher. He had by then moved from the 'square-brush' approach of Bastien Lepage to a looser brushwork and a more painterly approach with a heightened palette.[33]

The importance of Osborne to the young Leech at this time is unmeasurable, since so little of Leech's student work remains; however, his influence only manifests itself fully later on, in Leech's Brittany paintings. When one compares a picture such as Osborne's *In the garden, Castlewood Avenue* (fig. 6), of 1901,[34] to Leech's rather later, more sunlit work a debt to Osborne seems apparent in the bold use of impasto to give solidity to the form and in the way this is combined with the flicker of light and shade over the composition. Like Osborne, Leech would draw directly in paint on to the canvas, blocking in broad areas of the composition with only the simplest of outlines. Few drawings by

Leech are extant, but in *Haystack and window, evening* (fig. 86, see cat. 105) he notates in the manner used by Osborne for sketches in the catalogues of exhibitions he attended, mostly for information on line and form.

Further, a close affinity in subject-matter can often be found between Osborne's and Leech's *plein air* painting, for example Osborne's *A market stall*, 1882, and *Near St Patrick's Close, an old Dublin street*, 1893 (fig. 8),[35] and Leech's early Brittany paintings *The market, Concarneau* (fig. 7) and *The fair, Concarneau* (cat. 8). In particular the subject-matter and the paint handling of the lilies in Osborne's *A cottage garden*, 1888 (fig. 73),[36] anticipate the lilies in Leech's *Secret garden, ca. 1910–12* (cat. 36), which is a study of the garden for his important work *A convent garden, Brittany, ca.* 1910–12 (cat. 37).

Osborne's increased use of watercolour in the last years of his life may have influenced Leech,

who used this medium freely and with confidence throughout his career to record directly from nature. Practice in this medium gradually brought into Leech's work freedom of brushstroke, luminosity in the use of paint and boldness in the use of space and form. Osborne's paintings *At a child's bedside*, 1898, of his niece Violet Stockley, and of *Master Aubrey Gwynn* (fig. 10), 1896, demonstrate his confidence in using watercolour and his ability to paint figures freely in the medium.[37] Leech demonstrates similar dexterity and sensitive paint handling in his portrait of his wife Elizabeth (cat. 39), painted *ca.* 1910–12, or in his watercolour of his niece, *Sylvia as a baby* (cat. 63), painted in 1913 – though this is a simple study compared to Osborne's *Master Aubrey Gwynn* or his complicated group set in an interior in *At a child's bedside*.

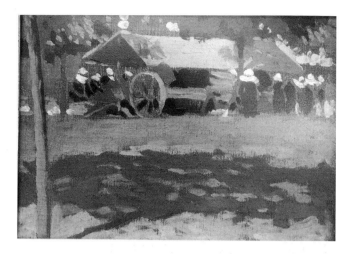

Fig. 7 William John Leech, *The market, Concarneau*, oil on canvas, 16.5 × 22 cm, Clonmel Museum and Library

The Art Loan Exhibition, Dublin, 1899

Dublin was an exciting place to be at the end of the nineteenth century and the beginning of the twentieth century, for politics as well as for the literary revival and the renaissance in the Irish visual arts.[38] Leech recalled in later years to Leo Smith: "It was about then that I first saw French painting, the Impressionists etc. what a sudden revelation! Doors and windows thrown open and the darkness invaded by light and air, it was the beginning for me."[39] It was not only Osborne's teaching that inspired Leech, but Osborne's knowledge and appreciation of French painting and his desire to see Impressionist painting in Dublin, which resulted in his significant role in organizing a loan exhibition in 1899.[40] The exhibition included work by so many contemporary avantgarde painters who were changing previously established artistic practices that it must have made a lasting impact on the young Leech. It was comprised of eighty-eight paintings, including works by Degas, Manet, Monet, Wilson Steer and Whistler. It was the first time that these prominent Impressionist artists had been shown in Dublin. The exhibition surely

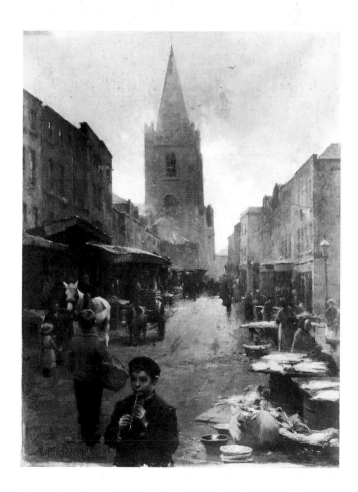

Fig. 8 Walter Osborne, *Near St Patrick's Close, an old Dublin street*, 1893, oil on canvas, 69 × 51 cm, National Gallery of Ireland

Fig. 9 Walter Osborne, *Master Aubrey Gwynne*, watercolour, 33.5 × 25 cm, National Gallery of Ireland

influenced Leech's approach to his own art. For example, Degas's two pastels *Two ballet dancers in the dressing room, ca.* 1880, and *Two harlequins* (fig. 63), *ca.* 1885,[41] would have instilled in Leech an awareness of placing figures in interiors, as in his important oil-painting *Interior of a café* (cat. 4), specifically the figure at the bar. The compelling simplicity of Monet's landscape *Argenteuil basin with a single sail-boat* (fig. 10),[42] bathed in light, with a village in the distance, a clump of trees on the right bank, boats on the water, may have strengthened Leech's desire to become a landscape painter. This landscape by Monet contains many of the motifs which Leech continued to paint throughout his life. Denis Gwynn wrote that Leech "was deeply influenced by the French Impressionists, and his landscapes show the influence of Monet and Sisley and Pissarro".[43]

At eighteen, Leech had now experienced the work of "Corot, Millet, and Daubigny, representing the French landscapists; Courbet and Clausen for Realism; Leighton, Millais, Orchardson and Watts for the Pre-Raphaelites; and Degas, Manet, Monet, Wilson Steer and Whistler for Impressionism."[44] The next year Osborne's teaching could only have reinforced the influence of the Loan Exhibition, and he had had the inspiration and encouragement of Osborne to achieve his goal in becoming an artist. After two years of Osborne's teaching and perhaps with Osborne's advice, based on his personal knowledge of the art centres Antwerp, London and Paris, Leech set out to Paris in 1901.[45] It is worth pointing out, though, that even Osborne, though he first gone abroad to study, in Antwerp, in 1881, had come only very recently to the Impressionists. Thomas McGreevy has commented that if Osborne had gone to study in Paris instead of Antwerp, "he would doubtless have come to Impressionism earlier".[46] At any rate, as Anne Crookshank points out, it is not at all clear that Osborne had seen French Impressionist pictures even as late as his visit to the Luxembourg Museum in Paris in 1895, since he makes no reference to them, mentioning only Manet in a letter to Sarah Purser.[47] According to Jeanne Sheehy, Osborne "was conservative in his work and in his tastes and his admiration for modernity did not extend much beyond Manet and Whistler".[48] By 1899, however, the list of artists he included in the Loan Exhibition shows that he had by then accepted that Paris was the centre for modern art and the most influential art capital.

Osborne died suddenly of pneumonia in 1903, at the age of forty-three when he was at the height of his career. He bequeathed a significant legacy to Irish painting both in his own art and in his teaching and his endeavours to introduce to Dublin "influences from European and British *plein air* painting".[49] His death was a great blow to the

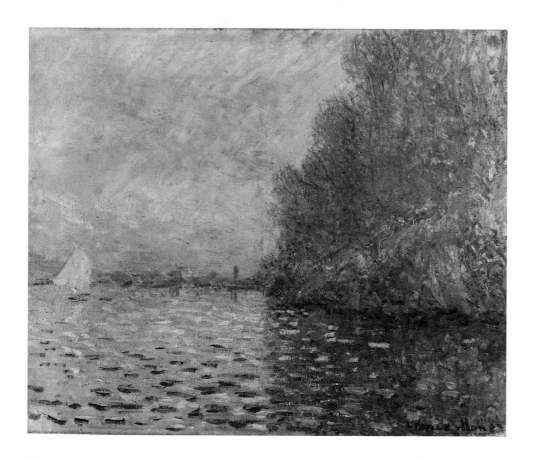

Fig. 10 Claude Monet, *Argenteuil basin with a single sail-boat*, oil on canvas, 55 × 65 cm, National Gallery of Ireland

Dublin art scene and especially to Osborne's students (one of these, Beatrice Elvery's sister, "travelled on top of a tram in the rain so that she, 'like Osborne, might catch pneumonia and die'").[50]

A less well documented influence on the developing Leech was the great Irish landscape painter Nathaniel Hone, Professor of Painting at the RHA from 1894 until 1917 and a former St Columba's pupil of 1861.[51] Hone had assimilated the best of French teaching from his days in Adolphe Yvon's and Thomas Couture's ateliers in Paris, copying in the Louvre and drawing from the model.[52] One of Couture's emphases in his teaching was "the practice of making painted sketches, and the emphasis on the underpainting, or ébauche, in the execution of each picture".[53] Leech used this method of first painting sketches, usually *en plein air*, which he developed later into larger studio works. He used an *ébauche* method, as practised in the Académie Julian, of laying in broad tonal masses.[54]

More important for Leech were Hone's periods at Fontainebleau and Barbizon when he began painting *en plein air* and became familiar with the landscape painters Corot and Millet, and friendly with Harpignies. The seventeen years Hone spent in France and his knowledge of some of the embryonic Impressionists developed his own free painting style featuring transitory light effects across meadows or water (see fig. 11).[55] As a committed landscape painter of light and shadow he served as a rôle model for Leech, a rôle which can only have been reinforced after Sarah Purser's organization of an exhibition of paintings by Nathaniel Hone and John Butler Yeats, held in Dublin in 1901. The twenty-eight landscapes by Hone and forty-four works, mainly portraits, by Yeats were, on the whole, acclaimed by the critics, and the exhibition marks the origin of Hugh Lane's wish to establish a gallery of modern art in Dublin.[56] Although Leech had by this time begun his studies in Paris, he may

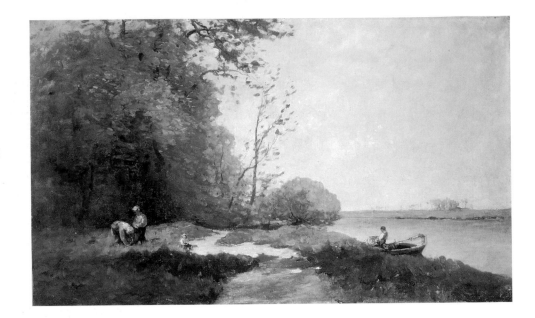

Fig. 11 Nathaniel Hone, *On the banks of The Seine,* oil on canvas, 62 × 100 cm, National Gallery of Ireland

well have been aware of the reviews and accompanying publicity.

Although Hone was then seventy years old and had virtually stopped painting,[57] these landscapes, imbued with a *plein air* approach and a fluid handling of paint which emphasized important structures and eliminated unnecessary detail, were a significant example for Leech. Ten years later, the critic of *The Irish Times,* mentioning Leech's work in his review of the RHA exhibition in 1911, wrote, "Mr. W.J. Leech achieves something of the Hone manner in his 'Rocks and Seaweed'."[58] This work, painted *ca.* 1910, may have been a study for the painting *Seaweed* (cat. 34), which, with its writhing textural forms and heavy impasto, also indicates an awareness of Van Gogh and Roderic O'Conor.[59]

Hone himself had in 1909 bought Leech's landscape *A sunny afternoon, Concarneau* (cat. 13), exhibited at the RHA in that year.[60] In Leech's career this was a seminal work, showing the development of his landscape painting from his earlier, restrained, tonal style to a freely painted, large-scale naturalism with hints of reflections, light and colour – elements Leech would further develop until colour and textured form erupted in *Seaweed.* Hone bestowed a tremendous accolade on his former student by buying this work, a gesture that was valued by Leech to such an extent that he remembered it over fifty years later. However, Leech was not content, once he had achieved the effects in *A sunny afternoon, Concarneau,* to continue painting in this Impressionistic manner, but strove on in search of greater colour and bolder composition, with scant regard for the commercial success his earlier painting may have acquired for him.

The Art Loan Exhibition of 1899 had included not only French artists but a significant number of English, or English-speaking, ones. Among them James McNeill Whistler (see fig. 12), in particular, was to become an overriding influence on Leech's evolving art practices and stylistic approach. Leech was not unique in this admiration – in fact Whistler had such a popular following among younger painters that he opened the Académie Carmen in Paris, although, owing to his ill health, he was rarely there and it finally closed in April 1901. His name was synonymous with 'avantgardism' in England, and through his 'Ten O'Clock Lectures' on art, which he delivered in London in 1885, his influence increased.[61] His early interest in French Realism gave way to an 'aesthetic' approach, with an emphasis on pictorial form over content: he

declared in 1878 that "my combination of grey and gold is the basis of the picture ... the picture should have its own merit, and not depend upon dramatic, or legendary, or local interest".[62] Leech consistently eschewed narrative in his work, and, whether in his portraits or in his landscapes, composed in 'Whistlerian' fashion by constructing his picture in a play of balanced tones and colours. Whistler's influence is particularly apparent in Leech's work up to 1910, in his early, dark toned, Brittany work (see cats. 1–9), before his *plein air* activity becomes apparent in the brighter colours and stronger light in his pictures, and in his Swiss snow studies of 1910–11 (cats. 16–22). In 1907 Leech exhibited a *Nocturne* at the RHA, inevitably recalling Whistler's *Nocturnes*, appearing from 1872 onwards. After Whistler's death in 1905, the International Society of Sculptors, Painters and Gravers mounted an exhibition of 750 of Whistler's works in London and 440 of them in Paris and it is possible Leech saw both.[63] At any rate Whistler's brand of Impressionism had a profound effect on Leech's early work, in the way he 'studied' tonal harmonies in his figure painting and landscapes.

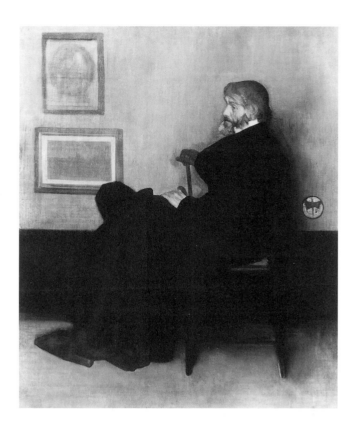

Fig. 12 James McNeill Whistler, *Arrangement in grey and black, no. 2: Thomas Carlyle*, 1872–73, oil on canvas, 171.1 × 143.5 cm, Glasgow Museums (Art Gallery and Museum, Kelvingrove)

Paris and the Académie Julian, 1901–1903

In addition to Walter Osborne, perhaps also Nathaniel Hone, who "was the first [Irish] artist of significance to go to Paris to study",[64] nearly half a century earlier in 1853, may have had some influence on Leech's decision to go to Paris. But there had been many others: Aloysius O'Kelly who went to the Ecole des Beaux-Arts around 1875, Sarah Purser who went to the Académie Julian in 1878–79 and Henry Thaddeus Jones who also went to Julian's around 1880.[65] Even as early as 1881, the year Osborne went to Antwerp, John Lavery had decided after a year's study at Heatherley's in London that "only in Paris would I get the grounding that I needed", and enrolled at Julian's.[66] An article on 'Student Life in the Quartier Latin, Paris' confirms Lavery's opinion and expresses the attraction Paris held for young artists: "It is to Paris – wonderful Seine-side Paris – with its treasures of art, its freedom for the exercise of instincts in pursuance of the painter's craft and for the untrammelled development of talents, that the true student turns with longing. A year or two at Julian's ... is worth a cycle of South Kensington, with all its 'corrections' and plaster casts."[67]

Leech also knew Dermod O'Brien, who had returned to Ireland in 1901, having studied at Julian's for two years and earlier in Antwerp.[68] Leech may have met O'Brien through Osborne, since Osborne had visited O'Brien when he was a student in Antwerp in 1891 and they were close friends. Although O'Brien was to prove an influential and life-long promoter of Leech as a painter, his own style made little impact on Leech,

because, as Lennox Robinson assessed, it was too rigid and "a touch of the French School might have done him all the good in the world ... but he reached Paris too late, he was too set in his method."[69]

Rodolphe Julian had founded his *académie* in 1868 along informal lines, where "students paid a small fee to use a studio in the Passage de Panoramas, just south of the Boulevard Montmartre, working from a model hired by Julian and enjoying each others' criticism".[70] As a former art student, Julian knew of the frustration created by the long preliminary studies required from students who wished to gain entrance to the Ecole des Beaux-Arts. Many English-speaking students could not pass the entrance examination, with its questions in French on history and other academic subjects in addition to its requirement of a certain level of technical proficiency.[71] Initially, his Academy was "founded to serve the Ecole des Beaux-Arts *concours des places*", but it soon grew in importance to rival the government school,[72] mainly thanks to the demands of American students who flocked to Paris. When the numbers began to grow, the school moved to larger premises and Julian forsook his art practices to run the Academy. In 1877 he had opened a second studio and the fees were raised from 2 francs to 30; by contrast the Ecole was free, except for foreign students, who had to pay an admission fee. However, foreigners were admitted to Julian's without an entrance examination and without the requirement of being conversant in French.

When Leech arrived at the Académie Julian there would have been several hundred students, all accepted on the payment of fees. An earlier visitor to Julian's, William Rothenstein, recounted the far from idyllic surroundings that prevailed there: "The Académie Julian was a congeries of studios crowded with students, the walls thick with palette scrapings, hot, airless and extremely noisy ... Students from all over the world crowded the studios. Besides the Frenchmen, there were Russians, Turks, Egyptians, Serbs, Roumanians, Finns, Swedes, Germans, Englishmen and Scotchmen, and many Americans."[73] In addition the crowded students smoked so much that the air became almost too thick to see the model.

Among the foreign students in Leech's time, there were two New Zealanders, Charles Bickerton and Sydney Lough Thompson, with whom he became very good friends. In fact Leech and Thompson (whom Leech called "Tomy") remained life-long friends.[74] Both Thompson and Bickerton, after leaving New Zealand, had begun at Heatherley's in London before moving to Paris. They had planned initially to study at Whistler's academy in Paris but, when they discovered that Whistler was rarely there, they had enrolled at Julian's instead.[75] Thompson recalled the trend among artists at the time to go to Paris: "All the world went to Paris in those days to study art".[76] The reasons were the worldwide recognition of French art, the consequent position Paris held as the art capital of the world and the reputation its Salons had acquired over the decades. Paris-trained art students had credibility on their return home, especially if they had achieved success at any of the Salons.[77] There was a "direct route ... from the Ecole and other teaching ateliers to the Salons and on to critical acclaim and patronage".[78]

Leech is registered in Julian's fees book in 1901 as a student in the atelier of Bouguereau and Ferrier.[79] William-Adolphe Bouguereau, Commander of the Legion of Honour and Member of the Academy, was by then seventy-seven years old; he had been the teacher of John Lavery and other Irish artists at Julian's already twenty years earlier.[80] He was holder of the Salon Medal of Honour – the highest honour[81] – and his students were given greater consideration when they exhibited at the Salon, run by the Société des Artistes Français, of which he was an influential member.[82] The routine at Julian's was the usual one of students working from models and instructors criticizing their work

in progress in their twice-weekly visits. Robert Henri, writing about Julian's in 1888, recalled that at the beginning he had "made charcoal drawings from the model, which Bouguereau criticized severely at first, finding fault with the modeling and values ...".[83]

When Walter Osborne visited the Luxembourg Museum in Paris in 1895, his condemnation of Bouguereau was scathing: "Could anything be much worse than ... Bouguereau? ... I really think we have no cause to run down English art".[84] It is understandable that Osborne would find Bouguereau's studio paintings of sentimental scenes, executed in an even, unnatural light, unacceptable. However, in spite of this reaction, Osborne would have valued the teaching and the milieu provided at Julian's and encouraged Leech to go there. Bouguereau seems to have been a sympathetic teacher and he admired "in others the very opposite qualities which distinguish his own work. 'Faire large et simple' ... anything like imitation of his own style finds but little sympathy from him."[85] Nevertheless both Bouguereau and Ferrier emphasized academic practice, upholding qualities of 'finish', restrained brushwork, firmly drawn contours and the gradual registration of light and dark through subtle tonal gradations. "Drawing rather than colour was emphasised at Julian's, and Lavery worked in charcoal",[86] a medium Leech also used, for example in a study he made of his sister's husband, the Revd Charles Cox (fig. 46, p. 73). In a letter of advice to his friend Helena Wright,[87] Leech would advise her to overcome an impasse in her painting by observation through drawing, which suggests this may have been his own practice, although few drawings by him survive.

It was rather from Gabriel Ferrier, who was more than twenty years younger than Bouguereau, that Leech and his fellow students sought guidance,[88] and Leech was also taught painting by the head of the studio, the history painter Jean-Paul Laurens. Considering the finish Laurens strove for in his own paintings, it is not surprising that he "criticized a student for using an 'impressionistic palette'".[89] Laurens strove for richness in colour and therefore became angry "if we tone our canvases; the other, Benjamin Constant, if we do not ...". Accordingly the students responded to each instructor's individual preferences alternately, but on one occasion "Jean-Paul turned up in his [Constant's] place and he had the shock of his life and said he would only criticize the drawings that month as the painters preferred the old way of working."[90] Leech was, however, fortunate to have Laurens as a teacher because he gave individual attention to his students, sympathetically allowing personal development. Laurens considered his own art modern and, like many of his fellow exhibitors at the Salon, regarded the Impressionists as a destructive force, overthrowing excellence and the classical tradition.

The variety of approaches at Julian's, even among the visiting artists, was possibly beneficial to the students, providing a latitude which allowed for some personal development and critical awareness. Nonetheless students were only encouraged to study traditional art and an essential part of their training was at the Louvre, where they studied Italian and French 'primitives' and paintings from the Italian Renaissance as well as the work of Velázquez, Rembrandt and Hals. The most modern painters they looked at were Millet, the Barbizon School and Bastien-Lepage.[91]

Student life in Montparnasse

Leech's father had found him in Paris "a comfortable Pension, kept by an Irish woman",[92] but the two New Zealanders he had met, Thompson and Bickerton, "persuaded me to share their studio".[93] Initially, this probably was to cut costs, although food, accommodation and studios were much cheaper than in London. "[Stanhope] Forbes only had to pay about eighty francs a month for a studio with a bedroom," which in the 1880s was a quarter of the cost of living in London.[94] Before

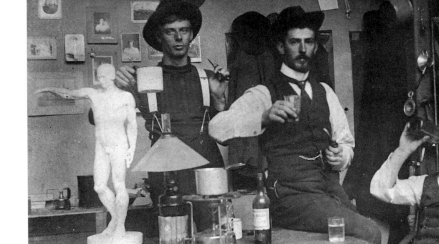

Fig. 13 *Charles Bickerton,
Sydney Lough Thompson and
William John Leech in their
Paris studio*, photograph

Thompson and Bickerton found their studio adjacent to Julian's, they had to be up before seven and "they caught the paddle steamer from Meudon to arrive at the studios in the Rue du Dragon on the left bank, ready to commence work at eight".[95] At the Académie they worked hard and their accomodation, typifying the life led by the artistic society of Left-Bank Paris, "was a small studio in the rue Belloni, away up behind the Gare Montparnasse and very bleak, no curtains, the bleak north light and skylight stretching right across it. Furniture? – a deal table, two or three kitchen chairs, a gallery to sleep in, no beds, just a mattress on the floor."[96] Leech forsook a more comfortable pension to share a studio with the two New Zealanders, but a studio was important to complete assignments in composition which were usually set as weekend projects. They ate breakfast and their evening meal there, but they had lunch in a little restaurant near place St-Germain, where they paid one franc for their meal.[97]

A photograph (fig. 13) survives of Charles Bickerton (left), Sydney Thompson and Bill Leech in their Paris studio. Their smart dress and the tidiness of their surroundings indicate that the

Bohemian image, Thompson and Bickerton with their glasses raised and Leech holding a wine bottle to his mouth, is posed.[98] In fact during his student days Leech maintained a level of fastidiousness and order which amused his flatmates: "That fellow Leech must be very dirty to require all that washing." Leech remembered that they worked very hard at the school from 8 am till noon, then from 1 pm to 4 pm – "Of course one learned a lot, drawing and painting the nude".[99] When C.R.W. Nevinson attended Julian's a few years later, he also arose early: "At six o'clock in the morning I used to go round to Julian's in the rue du Dragon."[100] Lavery reported that when he was at Julian's in 1881 the afternoon session lasted until 5 pm.[101] This was one of the advantages Julian's had over the Ecole, which only operated lessons in the morning. It was, furthermore, a six-day week. When Sarah Purser went to the Académie Julian, in 1878, it was "the hardest six months of her life".[102]

"'Learn to draw' was the great cry by the masters. Male and female models stood all day, for the study of the live model was regarded as indispensable to those who desired draughtmanship".[103] A new model, usually male, was posed each

Monday and students worked all week from the same pose. George Moore, recalling his art training at the Ecole, wrote that "the studio model was the truth, the truth in essence; if we could draw the nude, we could draw anything".[104] Although little of Leech's student work is known to have survived, an exception is his painting after a male model, executed in Laurens's studio at the Académie Julian in 1901 (fig. 14).[105] A comparison between this work and the *Standing male nude* (fig. 15) Orpen completed when he was at the Slade two years earlier, in 1899 (and was awarded first prize for figure drawing),[106] shows the different approach not only of the artists but of their schools. C.R.W. Nevinson, comparing art schools he had known, commented that at Julian's (and elsewhere) "the draughtsmanship was essentially a painter's method of drawing, and often colour and tone were used rather than the pure lineal draughtmanship associated with the old masters such as Leonardo and Raphael."[107] Julian's was evidently more suited to Leech's kind of draughtmanship and his aims as a painter, by contrast to Orpen who excelled at the Slade thanks to his exceptional ability in pure drawing.

Both students painted these works when aged twenty-one. Orpen had completed eight years as an art student while Leech was in his fourth year. Each has painted an academic male model, posed in a bold upright position, one of the weekly poses both students drew and painted daily for four hours. Orpen captures the soft texture of the skin in a gentle suffused light and has captured the life and vitality in the strident pose. The figure seems to have just paused, looking to the right, with his right arm raised against the wall and his left hand resting on his torso. The strength of the model's legs carries through into his proud bearing and his erect head. On the other hand, Leech's figure is cadaverously thin, standing looking to the left, holding a staff with his raised right arm, with his exposed ribs accentuating his thinness. A strong light from the left emphasizes his high cheekbones and aquiline nose creating a dramatic *chiaroscuro* effect which evokes a kind of religiosity, emphasized by the El Greco-like elongation of the figure. (Coincidentally, in O'Conor's studio in Paris in 1904, his large collection of books and photographs were "mostly of works by El Greco and Cézanne".)[108] Leech's thicker brushstrokes, applied in broad strokes and having a creamy consistency, convey expressionism instead of realism. Details in the background reflecting the corner of the studio are included, whereas Orpen's work focusses on the pose in a traditional manner.[109]

In later years, when Leech recalled to Leo Smith his decision to go to Paris, he emphasized the fact that he had won the *concours* and that his draughtsmanship was acclaimed: "I went to Paris to the Academy Julian in the autumn of 1901, and soon won first mention in the monthly 'Concours' for drawing and found myself accepted by the French students."[110] His friend Thompson was placed fourth in the portrait *concours* for his painting *A French girl*.[111] Wilson Steer emphasized the importance of the *concours* at the Académie Julian: "I shall spend Christmas in a rather novel way this year by rushing off as usual to the atelier and working all day, this no doubt sounds very heathen but the reason is that they are going to do the studios for the 'Concours' which means a prize of 100 francs for the first and the others simply get marked."[112] Additionally, by winning the monthly *concours*, the successful student was able to choose a prime position in front of the model, an important factor in the overcrowded studios.

Thompson recalled that he learnt more at Julian's from other students, but he and Leech remained among friends who spoke the same language and did not make friends with French artists. As Lavery had remarked of his own experience," We foreigners kept together so much by going to the same cafés and rarely meeting any of our French atelier friends at exhibition."[113]

The Irish artist Roderic O'Conor was exceptional

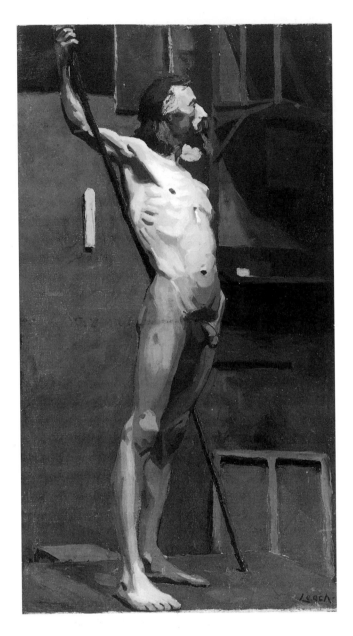

Fig. 14 William John Leech, *Standing male nude*, oil on canvas, 90 × 60 cm, private collection

sionism and the power of Post-Impressionism. Leech in later years, however, regaled his nieces and nephews with tales of his life in Paris and evenings spent with other artists, drinking wine and discussing art in Parisian cafés and bars.[115] He was a softly spoken, naturally retiring man,[116] but besides Thompson and Bickerton he would have met other artists in the Chat Blanc restaurant, one of the more popular haunts for artists, in the rue d'Odessa.[117] Among them may possibly have been John Hughes who settled in Paris in 1903 and kept in contact with his former pupils at the Metropolitan, including Beatrice Elvery and Estella

Fig. 15 William Orpen, *Figure study of a man standing*, 1899, oil on canvas, 91.4 × 61 cm, London, University College, College Art Collections

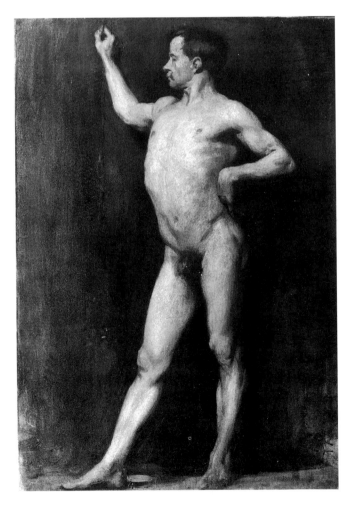

in that he made friends among French artists and remained in France all his life. With his fluency in French, Leech enjoyed acting as interpreter for Thompson and Bickerton when they were in class at Julian's,[114] but there is no record in Leech's later writings of deep conversations exchanged in the street-side cafés about the new approaches to visual problems, about the passing movements of Impres-

Solomons; it is probable therefore that Leech knew Hughes. There is also every likelihood that Leech met Hughes's and Osborne's contemporary O'Conor, who had a studio from 1904 in the rue du Cherche-Midi, also in Montparnasse. Certainly Thompson knew O'Conor, also the Scottish painter Barnes and the English painter Joseph Milner Kite, with whom we later find Leech, too.[118]

According to an unpublished memoir written by Sydney Thompson's wife, the students visited the museums in the afternoon, but it was the Impressionist painters which enthused them most. Leech and his friends Thompson and Bickerton were able to visit the Durand-Ruel Galleries, and after buying a postcard of a work by one of the Impressionists were free to view the rest of the collection.[119] Leech had some awareness of the French Impressionists from the 1899 Loan Exhibition in Dublin, but hitherto Thompson's "understanding of Impressionism was that of British painters, Impressionism meant either the tonal atmospherics of Whistler or the dashing brushwork of Sargent".[120] Even in France the work of the Impressionists which Leech had seen in Dublin was still often unappreciated,[121] and even among the French students in the late 1880s there had been little awareness of Impressionism, as Maurice Denis, a student at Julian's at that time, noted: "Among the young artists, who, about 1888, were studying at the Académie Julian, even the most daring were in almost total ignorance of the great movement, which, under the name of Impressionism, had recently revolutionized the art of painting ... They had not progressed beyond Roll and Dagnan; they admired Bastien-Lepage, they spoke of Puvis with respectful indifference, honestly suspecting that he did not know how to draw...."[122]

Thompson had to leave Julian's in the summer of 1902 because of the heat and the fumes from the oil paint scrapings on the walls,[123] referred to above. However, he may have had enough of Julian's anyway, because "a little of Julian's goes a long way, and a year spent in his studio will probably teach all that can be learnt with profit there".[124] He was persuaded by an old English doctor, who was also an art student, to accompany him to Grez-sur-Loing in the Forest of Fontainebleau. At the end of the summer, Thompson went on to Concarneau in Brittany and rented a studio from M. Le Rose. According to his wife's unpublished memoir, Leech and another acquaintance, C.J. Webb,[125] left Paris that same summer of 1902. Leech, however, recalled in later life to Leo Smith that "I spent about two years in Paris, except in the Summers I came home to Clontarf. I then followed Thompson to Concarneau, he had been there some time."[126] This would seem to imply that Leech went in 1903, after two years at Julian's.

In going to Brittany Leech was following in the tradition of Hone, Osborne, O'Conor and several other Irish painters. Dublin-born Aloysius O'Kelly had painted in Concarneau in the 1870s and 1880s[127] and when Leech and Thompson went to Concarneau to paint O'Kelly – or Oakelly as he called himself – had returned. He, too, rented one of the studios from M. Le Rose[128] and his friendship was a significant influence on Leech over the next six or seven years, until he left for New York in December 1909.[129] For Leech, as for Thompson, "it was the time spent painting in Concarneau and his contact with the Colony's underlying ideals which proved to be influential, and which had a decisive effect on his life and art".[130] His studies in Paris, judging from his *Male nude* (fig. 14), had resulted in a more academic approach with a darker colour range than would have been nurtured by Osborne's teaching, and it was only to be some time afterwards that continued painting *en plein air* in Concarneau brought light, colour and a spontaneity of brushwork flooding into his canvases, and that he assimilated the freedom of the Impressionists which he had first experienced in Dublin in 1899.

3

Concarneau, Brittany

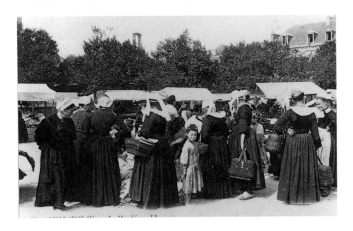

Fig. 16 *Market at Concarneau*, early postcard

Leech's departure from Paris to Brittany in 1903 was the usual practice for students from the Académie Julian or the Ecole des Beaux-Arts. When the Parisian studios closed down for the summer months, artists left the city, looking for somewhere congenial and cheap to continue their painting. Each year, they went with their friends and fellow students to their favourite locations, staying in hotels or boarding houses, which were cheap and hospitable and often provided studios for artists. Gauguin wrote to his wife in 1885 that "it is still in Brittany that one lives the cheapest".[1] It was also a route followed by Irish artists before Leech, like Nathaniel Hone and Walter Osborne, while Helen Mabel Trevor, Aloysius O'Kelly, Henry Thaddeus Jones and John Lavery specifically choose Concarneau (figs. 16, 17).[2] All these factors may have had some bearing on Leech's initial decision to go to Concarneau, although the overriding motivation seems to have been his friendship with Sydney Thompson.

When Thompson visited Concarneau with Charles Bickerton, he may have intended to return to the Académie Julian in the autumn of 1902. However, he remained there painting, preparing works for submission to the Paris Salon.[3] By the turn of the century, French painters such as Bouguereau, Bastien-Lepage, Dagnan-Bouveret, Alfred Guillou and Charles Cottet, to name but a few, had made Breton subject-matter fashionable at the Salon.[4] They painted its landscape and harbours, its peasants and fishermen and their families, at work and at prayer, dwelling on the naturalistic detail. Since the Revolution Brittany had provided a source of inspiration for artists, because of its unique, dramatic landscape, its colourful and distinctive traditions, its language and culture, its interwoven Celtic and Christian rituals.[5] "Brittany is essentially the land of the painter. It would be strange indeed if a country sprinkled with white caps, and set thickly in summer with the brightest blossoms of the fields, should not attract artists in

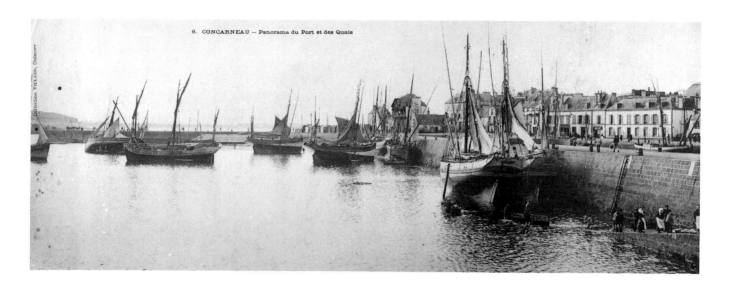

Fig. 17 *The harbour, Concarneau*, early postcard

scarch of picturesque costume and scenes of pastoral life."[6]

More especially, from the 1840s painters began to visit Brittany seeking unexploited and unspoilt areas in a region "largely untouched by the Industrial Revolution".[7] Ironically, though, it was the expansion of the railway network which led to the establishment of artists' colonies in Brittany, initially in the 1860s at Pont-Aven and in the 1880s at Concarneau.[8] "For many years the artists had the impression of discovering uncharted territory."[9] However, in the second half of the century, "the region had in fact become much less backward and remote than it had been in the first half of the century".[10]

Pont-Aven was the most famous artist colony in Brittany, started mainly by an American, Robert Wylie, who settled there in 1865.[11] But it was the arrival of Paul Gauguin and Emile Bernard and the formation of the Nabis which brought the area its international fame and created a school of painting identifiable with the region. Although Gauguin painted in Pont-Aven and Le Pouldu, he visited Concarneau in 1894, with his fifteen-year-old Javanese model Anna, the artist Armand Seguin and his wife.[12] Roderic O'Conor was in the party as

well,[13] but their visit was terminated abruptly by a brawl, caused by their unusual appearance.[14]

Concarneau was ten miles further west than Pont-Aven and with its harbour and its fishing industry it was an attractive town with suitable subjects for painting. Although it became an important artistic colony, it never developed a defined school of painting like that of Pont-Aven. A sympathetic environment, rather, was created by the company of other artists, the availability of a range of models, and the poverty of the peasants owing to the precariousness of the fishing industry. Henry Thaddeus Jones found, when he painted in Concarneau in 1881, that five or six families were often crowded into one house, without sanitation and with polluted water.[15] Willing to pose for a modest fee, the local people brought along their peasant outfits, the women with their *coiffes* and collars, the fishermen in their Breton fishing gear.[16]

The situation had changed little when Thompson arrived in 1902. He became acutely aware of the poverty of the Concarnois when a little girl who had been posing as his model died suddenly from a disease.[17] On his return to New Zealand in 1905, he described the area as full of "quaint fisherfolk,

31

with their picturesque boats, and in the other villages characteristic types particularly valuable to figure painters".[18] Thompson was one of the first New Zealand artists to join the group of Americans, British, Scandinavians, Slavs and Irish who comprised the foreign artists who came in their hundreds and formed a strong and active colony.[19] As we have seen, Leech apparently continued as a student at Julian's for another year before he joined Thompson in Concarneau. He remained there painting full-time from 1903 until 1906, with probably summer and Christmas visits home to Dublin to see his family. From his Dublin base he continued to return to Concarneau for long periods between 1906 and 1910.[20] From 1910 onwards he returned to stay with his parents at their London home, but continued to paint in Concarneau, off and on, until 1917,[21] and he also spent periods in Paris from 1911 onwards[22] and during the First World War. Gweltaz Durand claims that among all the Irish artists, "Brittany was the right land for Leech whose gift to pick up the typical and the original could only have bloomed in the very exotic country that Brittany then was."[23]

When Thaddeus came to Concarneau, he stayed at the Hôtel des Voyageurs, which he found "crammed with a crowd of cosmopolitan painters similar to that at Pont-Aven".[24] It was the most popular hotel, modern and luxurious, and "though cheap by normal French standards was much more expensive than Gloanecs [in Pont-Aven]".[25] The hotel provided studios at the top for artists,[26] and its location overlooking the harbour and the local market was ideal. There were other studios in converted lofts in the new town but the only studio in the *ville close* was in an old chapel which Thaddeus used during his stay.[27] Studios were also provided "in one of the town's numerous sardine factories"[28] and the artists lived in some of them during the summer months. Thompson rented a studio from M. Le Rose, as did Aloysius O'Kelly[29] and possibly Leech. It is likely that Leech and Thompson initially

shared a studio, or that Leech rented one close by with their artist friends Webb and Bickerton. These studios were along the quayside and Leech became close friends with several of the permanently residing artists and some important visiting artists to the town. He knew John Lavery and Aloysius O'Kelly, and his work during this time shows the influence of both men, especially O'Kelly (see cats. 5, 12, 36).

When Leech arrived, the population of Concarneau had risen to 8000 from 2200 in 1850 and the port and the town had been transformed, mainly through the development of the tuna fishing industry. Leech stayed in the Hôtel de France when he arrived, and lodged there, off and on, until 1906.[30] Since that time the hotel has been renovated, but then it was a three-storey, creeper-clad, picturesque building with shutters, where many young painters met to eat and to sit together on the terrace.[31] It is situated a little way up the avenue de la Gare but within a short walk of the harbour and the market. The proprietor and his wife, M. and Mme L. Bris, provided excellent lodgings and food at a very reasonable price, and allowed credit when necessary.[32] Leech probably painted his two watercolours, *My bedroom, Concarneau*, 1903 (cats. 1 and 2) in the Hôtel de France. From 1907 to 1910, Leech stayed in the Hôtel des Voyageurs, where Thaddeus had been before him. Concarneau had two other hotels: the Grand was the finest establishment, at the corner of the main square, the haunt of visiting Americans. It was situated across from the *ville close* with a dominating view of the harbour. The Hôtel Atlantique was close to Leech's and Thompson's studio, at the beach end of the town, along the Peneroff basin. Leech made a painting of it (fig. 18); this is possibly the work he exhibited at the Goupil Gallery in 1924 as *Rain, Atlantic Hotel Concarneau*.[33] The combination of soft tones and the fluid handling of paint retain the influence of Whistler and Lavery (see fig. 19). Although the hotel has been renovated, the basic architectural

forms of today relate closely to Leech's painting. All four hotels still operate as hotels today.

Breton subject-matter

One of the dominant influences on the colony at Concarneau had been the *plein air* painting of Jules Bastien-Lepage, "whose images of peasants in fields had an enormous international influence in the early 1880's".[34] After his early death in 1884 his influence waned, but there were still some painters, such as the American Alexander Harrison, who continued to paint in his manner. Harrison had been awarded the Gold Medal and the Légion d'honneur in 1900 and his painting *The wave* (Philadelphia, Pennsylvania Academy of Fine Arts) was acclaimed in 1904 by Wynford Dewhurst as "the most successful Impressionist work of the last fifteen years".[35] *Marine*, 1893 (Quimper, Musée des Beaux-Arts), a typical seascape, depicts the sun at evening, spreading a pinkish glow over the waves, as they ebb and flow over the wet sandy shore. Lavery came to visit him in Concarneau in 1903,[36] and Leech and Thompson probably knew Lavery during the year he spent there. They were already befriended by the rich American artist Haushalst and his wife, who stayed at the Hôtel de France and whose studio was next door to Harrison's.[37] Lavery had been influenced by Lepage's work when he first saw it in Paris,[38] and this is evident in the foreground of Lavery's *Under the cherry tree* of 1884 (Ulster Museum, Belfast). Osborne, too, had been influenced by Bastien-Lepage during the time he was at Concarneau, as is evident in *Apple gathering, Quimperlé*, 1883 (fig. 67, see cat. 35),[39] but by the time he taught Leech he had moved on. Lavery, too, must have realized after meeting up again with Harrison in 1903 that his own work had developed from "the rustic naturalism" of the 1880s into work which related to the "mainstream Impressionism of the era".[40]

Lavery's painting would have had a significant influence on both Leech and Thompson, because

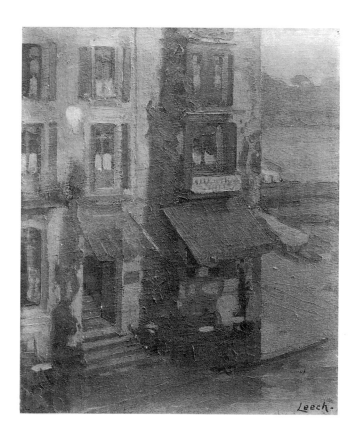

Fig. 18 William John Leech, *The Atlantic Hotel, Concarneau*, oil on canvas, 59.7 × 51 cm, private collection

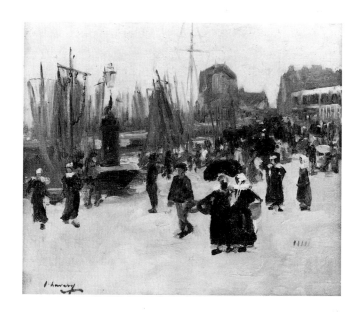

Fig. 19 John Lavery, *A wet day, Concarneau*, 1904, oil on canvas (courtesy of Christie's Images)

33

of Lavery's absorption of the aims of Impressionism, his respect for Whistler, his knowledge of contemporary trends in painting and his success as a portrait painter.[41] Lavery returned with his friend Milner Kite to paint at Beg-Meil, just outside Concarneau, in 1904,[42] and it is likely that the friendship made between Lavery, Leech and Thompson in 1903 would have continued. Few of Lavery's Concarneau paintings remain, but a small canvas entitled *A wet day, Concarneau* (fig. 19), painted in 1904, retains the harmonies of Whistler in the greyness of the wet day and encapsulates the fluid brushwork absorbed from Impressionism.[43] The empty foreground accentuates the high horizon-band created by the concentration of quayside figures against the masts of the boats.

When Leech arrived in Concarneau, Whistler was already an important influence on his work,[44] and meeting Lavery, who knew Whistler and was a pallbearer at Whistler's funeral the next year, 1904, can only have reinforced this. After Whistler's memorial exhibitions in Paris and London in 1905, Whistler's influence on Leech possibly increased further.

During this early stay in Concarneau, Leech and Thompson made visits to London and Dublin in 1904 and at the exhibitions they visited saw the work of John Singer Sargent, Augustus John, William Orpen and Walter Sickert.[45] It is also possible that they saw Lavery's exhibition of forty-nine works in London in November 1904, since Thompson spent several weeks in London before he left Southampton on 22 December 1904.[46]

Lavery, although celebrated as a portrait painter, was criticized for posing his favourite model in 'fancy' pictures, and for concentrating on figure-painting instead of straightforward portraits.[47] This approach in Lavery's work can be seen repeated in some of Leech's subsequent portraits, particularly of his first wife, Elizabeth, in *The cigarette* (cat. 45) and *The tinsel scarf* (cat. 46). In fact Leech's meeting Elizabeth in Concarneau in 1903 is echoed in

Lavery's meeting of his future wife Hazel Martyn in Concarneau in 1904.[48] Lavery and Leech both married beautiful, cultured American women who had come to Brittany to study painting and became their husbands' inspiration and favourite models. Lavery married Hazel Martyn in Brompton Oratory in 1910,[49] and Leech married Saurin Elizabeth Kerlin (née Lane) on 5 June 1912 at Fulham Register Office, London. She was thirty-three years old and the former wife of Fentress Gordon Kerlin.[50]

Concarneau's colony also thrived in its pursuit of academic painting inspired by Bouguereau. He had forsaken his former grand, classical subject-matter and '*pompier*' manner to paint, naturalistically, images taken directly from life,[51] but still rendered in a finished manner. Emile-Victor-Augustin Delobbe, one of his students and his friend, was also popular at the Salon for his meticulously finished Breton genre paintings. He befriended Leech and Thompson and this friendship continued as late as 1911 when they visited him in Paris.[52] Another student of Bouguereau who painted in his manner was the Russian artist Emile Benedithoff Hirschfeld, who first came to Brittany in 1891. Hirschfeld became friends with Thompson and Leech, and painted a portrait of Leech reclining in the open air in Concarneau (fig. 20).[53] In 1905 Hirschfeld married the Austrian artist Emma Leuze, who had come to Concarneau, by chance, the previous year;[54] Thompson would paint her portrait in 1914 (Concarneau, Collection municipale), a picture which shows his awareness of Renoir in framing her dark locks by her blue bonnet.[55] Impressionist influence is manifest in her white dress and parasol and in the sunlight reflected in the colours of the shadows. It was at this time that Thompson painted his first major Impressionist-influenced works,[56] some years after Leech, and unlike Leech he continued to paint in an Impressionistic manner for the rest of his long painting career.

Hirschfeld initially came to Concarneau to seek

out interesting subject-matter for paintings but he stayed there all his life. His work changed from his earlier social melodramas to painting the fishing boats in sunlight or stranded by the outgoing tide, as they remained, lit by moonlight, in the mud of the Peneroff basin.[57] *Tunny-boats at anchor, ca. 1910* (Concarneau, Galerie Henry Depoid), shows an introduction of colour and light into the painting of sails and reflections[58] and echoes closely the subject-matter and treatment of Leech's *Coloured sails, Concarneau* (cat. 18) of the same period. Both artists were working together but it may have been Leech, with his intuitive appreciation of colour, who influenced the other artist, nearly twenty years his senior. In Hirschfeld's painting of a religious *Procession de Notre-Dame-des-Flots*, the group of women, dressed in traditional Breton wedding dresses and *coiffes*, anticipate the pose and dress of Elizabeth in Leech's painting *A convent garden, Brittany* (cat. 37).

The artist who painted the Breton way of life most dramatically was Alfred Guillou. His *Unloading tunny at Concarneau* (St-Brieuc, Musée d'histoire)[59] may have relied on the photographic images of contemporary postcards.[60] The detail of the women in their lacy white gowns in Guillou's two paintings *Sunday procession,* 1893 (Morlaix, Musée des Jacobins), and *The arrival at Concarneau of the pardon for St Anne of Fouesnant* (fig. 74) again anticipate those in Leech's *A convent garden Brittany* (cat. 37). Thompson similarly collected postcards, which were useful in providing details for studio compositions,[61] although Thompson and Leech relied mostly on sketches made in front of the motif.

The paintings of Théophile-Louis Deyrolle do not have the same activity and dramatic effect as Guillou's but they capture the essence of the fishing port and its inhabitants. His *Low tide in the harbour at Concarneau,* 1882 (Concarneau, Hôtel de Ville),[62] shows the outer harbour in Concarneau with the tunny boats docked at the Peneroff quay. The

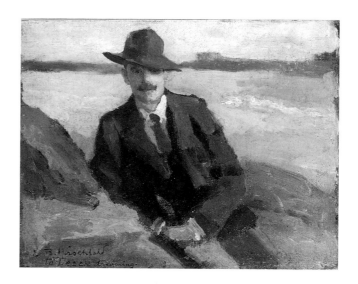

Fig. 20 Emile Benedithoff Hirschfeld, *Portrait of William John Leech*, oil on board, 18 × 13.8 cm, London, Pyms Gallery

scale of the figures and the brown tones in the smooth surface of the canvas suggest earlier Dutch paintings which were then fashionable at the Paris Salon. Initially, Leech and Thompson, too, concentrated on figure studies of peasants and retained a dark tonality in their paintings imbued with a Dutch realism, in the style then becoming typical of paintings exhibited annually at the Salon.[63] Thompson, in his 1904 painting *At the pardon* (fig. 21), may have used bitumen to darken the background.[64]

The first painting Leech exhibited at the Paris Salon was the Breton genre painting *Interior of a café*, assumed to be the 1908 painting of this title (cat. 4). This detailed interior of figures is painted in a style reminiscent of an early Orpen and is an important example of Leech's still academic approach after five years in Concarneau. Though relieved by glimmers of warm-toned grey highlights, the work shows little influence of modern French painting or of the light created by the Impressionist palette. However, there is a reference to Degas in the green of the walls and in the emptiness of the foreground composition and in the grouping of figures. The interiors of the Irish painter

Fig. 21 Sydney Lough Thompson, *At the pardon*, oil on canvas, 73 × 51 cm, Christchurch (NZ), Robert McDougall Art Gallery

Norman Garstin, who is reported to have met Degas in Paris,[65] also have this same characteristic green, broken with floods of light. It is likely that Leech had met Garstin and knew his work, because Frances Hodgkins, from Dunedin, New Zealand, who knew Thompson and through Thompson had met Leech,[66] had joined Norman Garstin's annual summer sketching classes in Caudebec-en-Caux in Normandy in 1901 and frequently attended these classes for the next few years – at Dinan in Brittany in 1902 and also at Penzance, where Garstin was one of the Newlyn School. She remained his close working associate until 1922.[67] Hodgkins also spent

eighteen months in Concarneau from 1910 and was certainly in Paris in 1911 at the same time as Leech and Thompson.[68] Leech owned a watercolour by Hodgkins of a baby asleep (fig. 61, p. 96), which he donated to the Hugh Lane Municipal Gallery in Dublin in 1966. Hodgkins's watercolour has a similar subject to Leech's *Sylvia, ca.* 1913 (cat. 63). In a letter to the then curator of the Municipal Gallery, Miss Waldron, Leech wrote that Hodgkins's picture "was painted a long time ago, about 1911 or 12 in Brittany, we exchanged pictures, her idea, but I rather think I came off best in the bargain."[69]

It is curious that Leech waited six years before exhibiting *Interior of a café* at the Paris Salon, if it was, in fact, the 1908 picture he exhibited. Perhaps Leech did not submit work to the Paris Salon in the preceding years, or alternatively he made two or more paintings on the same theme. In any case there exists a second *Interior of a café*, establishing a pattern in Leech's work of painting a smaller study in front of the motif. In a letter to Leo Smith Leech recalled that he exhibited an *Interior of a café* at the Paris Salon in 1914 and was awarded a Bronze Medal, and that the painting was "bought by an American Gallery, Philadelphia".[70] Previously he had exhibited an *Interior of a café* at the Royal Institute of Painters in Oil in October 1908,[71] and presumably the same painting again at the RHA the next year, where it was bought by the Hon. Lawrence Waldron and has remained in Ireland. He exhibited a painting entitled *Interior of a café* once again at the Goupil Gallery, April–May in 1912,[72] which was then transported for exhibition in Reading in the same year by the firm of Bourlet.[73] It is probable that Leech made several paintings on this theme, and less likely that he was always showing the same work between 1908 and 1914.

In his review of the RHA in *The Freeman's Journal* in 1909 Thomas Bodkin mentions Leech favourably and at length but though he refers to other paintings, mainly landscapes and portraits, he makes no mention of *Interior of a café*.[74] However,

the review in *Sinn Fein* of the Aonach Art Exhibition in December 1909 recognizes that "'W.J. Leech A.R.H.A. is one of our foremost painters. His work is characterised by a thorough mastery over his material. The picture of the 'Interior of a Cafe' shows him to be a skilled draughtsman, possessing masterly technique...."[75] He may have included this painting in the exhibition at the Leinster Lecture Hall in Dublin in 1909,[76] since the reviewer, obviously a different one, condemns the "monotonous ... tone" and suggests, "Many of Mr. Leech's pictures might have been painted from reflections in a black glass. They are low in tone, and so thin and shadowy as to make the observer fear that if scrutinized too closely they would melt into darkness and disappear altogether...."[77] In this last review, Leech's use of dark tones of browns and greens in an academic style, following a Dutch tradition, is denounced because the critic is searching for evidence of colour and light.

Like Leech's, Thompson's subjects were peasants – more of these "innumerable peasant studies which find their way to Paris, to sell well and adorn the walls of luxurious houses, where peasants are myths".[78] But, though similar in its dark tonalities to Thompson's *At the pardon*, Leech's study of a peasant, sitting relaxing in the café after work, differs from Thompson's in its lack of religiosity or piety. Although Leech painted *St Anne and the poppies, ca.* 1916 (private collection) and *Petunias and St Anne, ca.* 1919 (private collection), these are treated as still-life paintings rather than as altarpieces. Again, Leech's *Portrait of a man with a bottle* (cat. 3), which is slightly smaller than Thompson's *The crucifix* (Wellington (NZ), National Art Gallery), which Thompson was able to sell in 1906, in New Zealand, for £15. 15s. 0d,[79] does not conform to the 'myth' of the peasant or to the degree of 'finish' then demanded for Salon paintings. In Thompson's painting a Breton girl sits serenely in profile on a chair fingering her rosary beads, and barely discernible on the wall behind

is the dim shape of a crucifix. A bright light is thrown on the face and hands of the praying girl and the gentleness of the picture echoes more the conventional, acclaimed style of Bouguereau than that of Millet or Courbet.

Leech depicts his Breton peasants in *Portrait of a man with a bottle* and *Interior of a café* without sentimentality, closer in spirit to the realism of Helen Mabel Trevor's *Interior of a Breton cottage* of 1892, which Leech could have seen in the collection of the National Gallery of Ireland when it was bequeathed in 1900.[80] Although Leech's composition indicates knowledge of Degas, his palette is still unaffected by the work of the Impressionists. It was to be a few years more before he assimilated the bright colour and textured paint surfaces attained in Van Gogh and O'Conor's later work. Roderic O'Conor, although twenty years Leech's senior, had also painted Breton peasants in a dark, traditional manner while he was still under the influence of his teacher Carolus-Duran.[81] However, by the time O'Conor painted *Head of an old man* (private collection) and *The cider drinker* (South Brisbane, Queensland Art Gallery), both *ca.* 1891, his work began to change "with the partial introduction of bold, directional brushstrokes",[82] until his portraits *Head of a Breton boy with cap* (private collection) and *Breton peasant woman knitting* (private collection), of 1893, were painted in rhythmic lines of pure colour which spread across the background into the faces of the sitters.

Leech may have seen O'Conor's work as part of an exhibition put on by Hugh Lane in Dublin in November 1904. Included also were works by Emile Blanche, Boudin, Corot, Courbet, Daubigny, Daumier, Degas, Fantin-Latour, Nathaniel Hone, Augustus John, Lavery, Mancini, Manet, Monet, Monticelli, Dermod O'Brien, William Orpen, Walter Osborne, Pissarro, Puvis de Chavannes, Renoir, Sisley, Steer, Whistler and John B. Yeats.[83] It must have had a profound effect on Leech, to find that artists as young as William Orpen and Augustus

John were already included and hung with the great moderns of France.

In Concarneau the barber's shop was, like the café, a meeting place in the village for Leech and Thompson and other artists. They were able to observe local people and discuss the latest works and news from Paris. In *Interior of a barber's shop* (cat. 6), painted the year after *Interior of a café*, Leech continued to paint in dark tones of greens and browns with strong contrasts. The back of the barber with the figure of another man is shown in the mirror in front. This may be Leech caught capturing the scene. It is an early display of his interest in the use of mirrors in his work, an interest shared by Orpen who admired Velázquez's *Las meninas* (Museo del Prado, Madrid) and *Venus at her mirror* (the Rokeby *Venus*) which Leech could have seen in the National Gallery, London. Lavery, too, after completing *The studio of the painter* in 1910, re-examined Velázquez's *Las meninas* and

"He was fascinated by the technical problems of using mirrors, both to reflect his work to the sitter, and to create an instant, yet animated picture plane".[84]

The greater fluidity of brushwork which Leech developed in the *Barber's shop* was developed further in pictures of exteriors such as *The market, Concarneau* (cat. 7) or *A caravan at Concarneau* (cat. 8), and other Concarneau market pictures (cats. 9, 10, 11). In these works the laden brush is drawn with assurance to depict the subject with great vividness. Splashes of white, Naples yellow and alizarin crimson contrast with the greys and earth colours of the surrounds. Leech's technique recalls Sickert in his series of shop exteriors, or again, still, Whistler (see fig. 78, cat. 43), from whom Sickert had assimilated the tones and compositional approach.[85] These *plein air* studies form a bridge between Leech's earlier, more academic painting and his later, more freely painted, Impressionist work.

4

Exhibitions and Critical Acclaim in Dublin, 1903–1910

The Royal Hibernian Academy

Although the first work Leech exhibited in 1899 was a Swiss landscape, in 1900 he exhibited a portrait of his sister, *Miss Kathleen Leech*, painted when she was about ten years old (whereabouts unknown). While a student in Paris, he stopped showing at the RHA and it was not until 1903, at the end of his second year at the Académie Julian, that he again sent paintings there. In that year he showed two paintings, entitled *Alone* and *A glimpse of Notre Dame* (both unlocated), giving his Paris studio address, no. 7, rue Belloni. The next year, when he sent *Portrait of Miss R.K. Leech*, probably a painting of his aunt Roddice,[1] he gave his parents' Dublin address at Yew Park, Clontarf. Leech sent his RHA invitations to his aunt in Dublin after his departure for London in 1910 and she faithfully went to see his exhibited work. She is reported to have declared her dismay on seeing nudes on exhibition – which may have been the work of other artists since Leech did not show a *Nude* at the RHA until 1932.[2]

The next year, 1904, he again submitted a portrait, *Miss Dorothy Bradshaw* (whereabouts unknown).[3] Despite his interest in landscape and genre subjects, he had exhibited portraits in three out of the first five years he exhibited at the RHA. He may have had an initial desire to become established as a portrait painter, following in the tradition of Sarah Purser and William Orpen and his teacher Osborne. Sarah Purser had become a very successful portrait painter on her return to Dublin from the Académie Julian in 1879 and earned £30,000 in commissioned fees during her working life.[4] Orpen, almost his contemporary, had earned £473 from portraits alone in 1904.[5] This desire to advance himself as a portrait painter may have been mainly financially motivated, although his training in Paris had concentrated on figure drawing and painting and he later told Denis Gwynn that "he regarded Osborne's unfinished self-portrait, which is now in the Irish National Gallery, as his

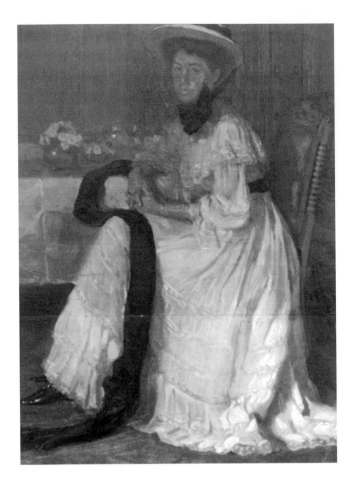

Fig. 22 William John Leech, *The black scarf*, oil on canvas, private collection

ample proof of the powers already developed by this rising artist."[8]

Dermod O'Brien wrote to his wife Mabel in January 1910 relating how during his visit to an art student's show, possibly at the Metropolitan School, "W. Leech and a soldier brother then came in and I helped to carry round some of his work to the studio and saw what Leech was at".[9] The brother most likely was Cecil, close in age to Bill, who helped support him throughout his life and who, with his sister Kathleen, was devoted to him.[10] Leech's portrait subjects were chosen from his immediate family or circle of friends. One or other of the two early portraits of Kathleen, *The black scarf* (fig. 22) or *Study of a woman* (fig. 24), could have been the painting exhibited at the RHA in 1907 as *Portrait of Miss Kathleen Leech*. Both

Fig. 23 William Orpen, *The mirror*, 1900, oil on canvas, 50 × 40 cm, London, Tate Gallery

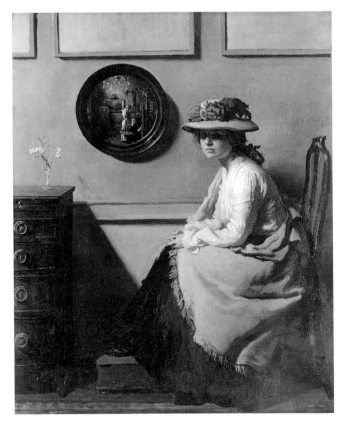

most brilliant work, showing how much he would have developed in strength and simplicity if he had lived".[6]

In 1905, his father commissioned Leech to paint portraits of his sons Arthur and Cecil, who had become officers in the Royal Horse Artillery and the Royal Field Artillery.[7] Leech painted both brothers in their army uniforms and exhibited the portraits at the RHA in 1909, entitled respectively *Major A.G. Leech, R.A.* (present whereabouts unknown) and *Captain C.J.F. Leech, R.F.A.* (cat. 12). The unsigned review of the exhibition (possibly by Thomas Bodkin) in *The Freeman's Journal* stated, "Nos. 17 and 31, the full size portraits of Artillery Officers, by W.J. Leech, furnish

portraits show a great debt to Whistler and to Orpen in their formal arrangement and painterly techniques. Like so many of his contemporary portrait painters, including William Rothenstein and John Lavery, Orpen had been influenced by Whistler's compositional arrangements, as is clearly apparent in *The mirror* (fig. 23). In Leech's *Black scarf*, more so than in *Study of a woman*, there is a debt, not just to Orpen's *The mirror* but to Whistler's *Arrangement in grey and black, no. 2: Thomas Carlyle* (fig. 12, p. 23). Although Whistler's portraits are distinguished by their side profiles and both the Orpen and the Leech female portraits incline their faces to the viewer and gaze out of the canvas, a Whistlerian compositional grid and simplification of form exist in both the Orpen and the Leech. These portraits coincided with Leech's early Brittany period when he was influenced by Whistler in his landscapes as well, for example in *Still evening, Concarneau* (cat. 14) or *Waving things, Concarneau* (cat. 21).

By the time Orpen exhibited *The mirror* at the winter exhibition of the New English Art Club in 1900, Leech had left Dublin and had been some months in Paris. He may have seen the work, however, in the large exhibition of Irish art which Hugh Lane organized in May 1904 at the Guildhall in London, and which included not only the work of Orpen, but also that of Lavery, Osborne, Hone and both John Yeats and his son Jack. Although these artists were included with other less well known Irish artists, they each exhibited such a large body of work that they dominated. Other artists Lane included were Corot, Watts, Whistler and Sargent. Leech was in London with Thompson at that time and they saw "work by Whistler, as well as by John Singer Sargent, Augustus John, William Orpen and Walter Sickert".[11]

In the *Black scarf* the pose of Orpen's Emily Schoebel in *The mirror* is echoed in the arrangement of the seated figure of Kathleen as she stiffly sits in an upright chair. The dado-rail in Orpen's

painting becomes the straight edge of the white tablecloth in Leech's work. Kathleen's hat rests off her face as she looks directly and cautiously out to the viewer, unlike the cocky angle of Emily Schoebel's hat, which throws a mysterious shadow over her confident and more sensuously painted face. The predominant tones of the full-length white lacy dress and the fine tablecloth echo those of Orpen and contrast in both colour and form with the curving flow of the encircling black scarf. Kathleen, as model, is Elizabeth Leech's precursor, and in just five years Leech will have painted Elizabeth in a white Breton lace dress in his masterful *Convent garden* (cat. 37). Kathleen's white dress, black sash and black neck-band typify the Edwardian dress which society portrait painters liked to portray lavishly — for instance Lavery in his portrait of Mrs Arthur Franklin, *The black poodle*, 1905 (present whereabouts unknown) or Osborne in *A portrait of a lady* (fig. 25).[12] Leech's portrait lacks the coquettishness and the brio of older artists like Lavery and Osborne, although when Leech exhibited the *Black scarf* at the Leinster Lecture Hall, Dublin, in 1907, the reviewer in *The Irish Times* (perhaps Thomas Bodkin) wrote, "'The Black Scarf' is remarkable for the brilliant and dexterous painting of the lady's white dress".[13]

But although Kathleen is painted in her débutante finery, her shy, introverted personality permeates this portrait and later works as well. The contrived composition adds to the awkwardness of the sixteen-year-old sitter — possibly heightened by the number of sittings in which Leech worked and overworked the pose. In *A study of a woman* (fig. 24), which, judging from the handling of paint and the more relaxed pose adopted, is a later work, a greater informality has been achieved in Kathleen's pose, with her left arm draped over the back of the chair and her head resting on her right hand, a pose which was to become characteristic of Leech's later work. The round mirror in the background on the wall behind the head of the model

Fig. 24 William John Leech, *A study of a woman*, oil on canvas, 51 × 41 cm, Kilkenny, Butler Art Gallery

Leech, now approaching thirty, had demonstrated his ability as a portrait painter in the tradition of Sargent, Lavery or Orpen but, unlike them, he failed to become a society portrait painter. He seems to have decided finally in the early 1920s that a career as a society portrait painter was not his vocation, and he concentrated on painting subjects which he enjoyed, most especially an unusual view from a window, the corner of a garden or studio, a bowl of fruit or flowers on a window-sill, a railway track, cornfields, orchards, beaches full of light, but not necessarily of people. He still painted portraits but they were those of his friends, his family and their children and of both his wives, Elizabeth and May – the subject of many of his best works. This path

Fig. 25 Walter Osborne, *Portrait of a lady*, oil on canvas, 138 × 84 cm, National Gallery of Ireland

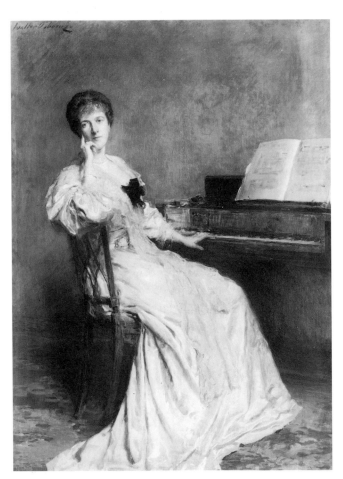

has echoes still of Orpen's *The mirror*. Leech has confidently created space and volume around Kathleen in the Edwardian affluence of, possibly, their Clontarf sitting room. He uses the strong light coming from the left to focus attention on her happy face, framed under her large hat.

In a later portrait of Kathleen (private collection),[14] to judge again from stylistic qualities and the self-confidence she exudes as she sits, with her right hand resting on the back of a chair, confronting the viewer, Leech's sister gazes directly and appealingly out of the canvas. All background detail has been excluded to focus attention on her face, especially on her sad, appealing eyes. The simplicity of the composition, the control of lighting and the freedom of handling demonstrate the confidence Leech was continuing to gain. The work was possibly painted *ca.* 1911, four years later than *The black scarf*.[15]

gave him the freedom to experiment with colour, light and pattern in painting his immediate environment. His decision may have been influenced by seeing with distaste how Osborne had turned more and more to portraiture as a source of income,[16] but was also probably due to a lack of success in selling his work, including his portraits, and his own retiring manner in coping with commissions from strangers; not least, to the time he took to paint such portraits. Accordingly he developed his painting style and his painting objectives more slowly and with less urgency and less burning ambition than Orpen. Leech was misguided, however, in believing that success would come solely from the quality of his works, which, he stated, "being what they are, honest and sincere works of art, will probably, should in years to come, turn out to be really good investments as well".[17] Orpen, on the other hand, knew that he had to become known in social circles and create a demand for his work. Although Leech's portraits are beautiful, sensitive studies which accurately and with ease capture the physical likeness of the sitter, and although they attracted some critical acclaim, they achieved little financial reward for him. One commission Leech accepted did not end well. It was from a Miss Sinclair to paint a portrait of her mother, Lady Pentland.[18] He depicted his sitter so honestly that it caused offense and was denounced as *"Quelle cruelle"* by the sitter and her daughter.[19] Although Leech would have been aware of the financial and social success society portrait painters like Orpen and Lavery enjoyed, he knew it involved compromise. He had the freedom to pursue his painting in his own way thanks to the moral and financial support of his immediate family, his extended family and especially both his wives. Furthermore, unlike many of the artists of his generation, Leech never taught. Not only did this deprive him of a source of income but it also reduced the influence he would have exercised on a younger generation of painters.

Though portraiture never became the main focus of his work, the strong skills of draughtsmanship and structure which Leech had developed in portraiture were to be useful in his expanding interest in capturing light-filled landscapes. After his arrival in Concarneau Leech had also been painting landscapes, which he showed mainly at the RHA and other mixed shows.[20] One of the early landscapes he showed (at the Royal Institute of Oil Painters in 1907) was *Malahide* (private collection), and at the RHA in 1906 he included a landscape *Near Malahide* (private collection), both works showing an area which Hone had immortalized in paintings such as *Pastures at Malahide* (National Gallery of Ireland) and which Osborne also painted in the later years of his life.[21] Leech probably painted these works on visits home from Paris or Brittany, and *Malahide*, $7^{1}/_{2}"\times 9^{1}/_{2}"$ (19 × 24 cm) is a small study, showing that he was adapting his Concarneau method of *plein air* small-scale painting. He may have painted these works in 1904 when both he and Thompson were recovering in Dublin from typhoid fever, and also visited and painted in Connemara and Killarney. Thompson exhibited a dozen of these Killarney landscapes in 1905, when he returned to New Zealand.[22] Few of Leech's landscapes from this period have, as yet, been located, if indeed he completed many, since he was an artist who was slow in adjusting to new locations.

Two other paintings in the 1906 RHA exhibition had French titles, *Les Stores* and *Le Mendicant*, and one of the other paintings, *The village patriarch*, could possibly be the Breton character who is the subject of *Portrait of a man with a bottle* (cat. 3). This last is a study in tones of brown, and Robert Elliott's mention in *The Nationalist* of "Mr. Leech's 'brown studies'" gives the overall impression of Leech's works at that time.[23] Another painting included in the exhibition was *A lesson on the violin* (whereabouts unknown), which had won a £50 Taylor Scholarship for Leech the year before and which could have been painted in either Ireland

or France. The judges were Nathaniel Hone, Sir Walter Armstrong and James Brenan, Leech's former headmaster at the Metropolitan. At the same exhibition *The Studio* praised his works because they remained "in one's mind as very personal and sincere expressions of the *chose vue*".[24] Leech won the £50 Taylor Scholarship again the next year for his painting *The toilet* (whereabouts unknown). Two of the judges were Nathaniel Hone and Sir Walter Armstrong.

Having won the Taylor Prize like Osborne, Orpen and Beatrice Elvery before him, and having studied for two years at the Académie Julian and having painted for three years in Brittany, Leech seemed poised to become an established artist. At the end of 1906, he returned to Dublin. Possibly, after a year without his friend Thompson, who had left for New Zealand, Concarneau may have proved too lonely and unproductive. Or he may have decided to return to his parents' home in Dublin in order to exhibit more and to achieve a success similar to Thompson's in New Zealand.[25] In any event, 'Studio Talk – Dublin' reported in the autumn of 1906 that "Mr. Leech has just returned from Brittany, where he has been working for the past couple of years, and will in future make his home in his native city of Dublin".[26] It was fortunate that Leech had made Dublin his base just before his younger brother Freddie tragically died (see chapter 1).

The six paintings Leech sent into the RHA in 1907 were a combination of French and Irish landscapes and French figure-painting. Titles like *The North Bull – evening* and *The Bailey Lighthouse, Howth* are very positively Irish landscapes, which he probably painted on his return from Brittany. The subject-matter of three of the other paintings was French: *La Bigouden*, a large oil (84" × 60"; 213 × 152 cm) of a Breton peasant woman, priced at £100, *Nocturne* (both whereabouts unknown) and *La Toilette*, presumably the painting *The toilet* which won the Taylor Prize in 1906. He had earlier exhibited *La Bigouden* at the Munster-Connacht exhi-

bition in Limerick in 1906,[27] and the catalogue had contained an explanatory description of the Breton woman from the region of Pont-l'Abbé which gave this genre painting its title.[28] 'Imaal' (F. Sheehy Skeffington), the reviewer of the RHA exhibition in *The Leader* in March 1907, was far from complimentary, however. "Mr. W.J. Leech's 'La Bigouden' (a blockish Breton woman) is a quite unnecessary production."[29] 'Imaal' seems to be faulting Leech's choice of subject and his method of portraying it, preferring the beauty of the women in Orpen's *Little Spanish dancer* and regarding Lavery's *A lady in pink* as "one of the most charming things in the whole exhibition", mentioning specifically the "delightful colour" of the pink dress.[30] Interestingly, Thompson exhibited a painting entitled *Bigouden* in New Zealand in 1905,[31] suggesting that he and Leech may have painted this subject together in 1904. Leech's large painting of a Breton woman was probably painted in a style similar to the *Portrait of a man with a bottle* (cat. 3) or the figures in *Interior of a café* (cat. 4).

Leech seemed undeterred by this criticism because he exhibited *La Bigouden, La Toilette* and *Nocturne*, together with *The North Bull: evening* and *Still life* (both unlocated) in the Irish International Exhibition that summer, at Herbert Park, Dublin. Walter Armstrong was the chairman, with S. Catterson Smith (who had recently painted portraits of Leech's father, mother and brother Cecil), Oliver Sheppard and Walter Strickland as committee members. Leech was included with Rose Barton, Frederic Burton, Andrew Nicholl, Walter Osborne, Nathaniel Hone, Norman Garstin, William Orpen, John Lavery, Dermod O'Brien, Count Dunin Markiewicz and Percy F. Gethin in the Irish Fine Art Section. As well as Beardsley illustrations and works by "Rossetti and some of the continental Symbolists" four galleries displayed British and Continental Art.[32] Leech was not only included but well represented in such a major exhibition. A month later he exhibited with Dermod O'Brien,

Count Dunin Markievicz and Percy F. Gethin at the Leinster Hall in Dublin (see further below).

At the RHA in 1908, all three Leech paintings had Breton subjects; one, entitled *The fair, Concarneau,* was probably cat. 8.[33] That year, at the age of twenty-six, Leech had been proposed by Dermod O'Brien and elected an Associate Member of the Royal Hibernian Academy. Only two years later Leech became a full Academician. Leo Smith later claimed that "his [Leech's] work received the highest possible approval in his native country and he was made a member of the R.H.A."[34] His election to Academician did show the esteem in which he was held by other Academicians. It brought the privilege of having his work automatically accepted for exhibition, without selection.

The eight paintings Leech sent to the RHA in 1909 from his parents' home at no. 6, Victoria Villas, Morehampton Road, Dublin, included *Interior of a café* (discussed above), priced at £63,[35] *A sunny afternoon – Concarneau* (cat. 13) and *Le Sable blanc, Concarneau* (present whereabouts unknown). He also exhibited the portraits of his brothers Arthur and Cecil and of his sister Kathleen already discussed and, in addition, two landscapes of the Howth area. This group of paintings created such an impression that the unsigned review in *The Irish Times* stated: "Mr. Leech's work will be, to many people, the greatest surprise of the exhibition. His earlier painting showed, undoubtedly, great promise but that promise has been fulfilled more rapidly and more completely than even his greatest admirers could have dared to hope. He showed portraits, landscapes, and interiors, and in all there is the sureness of touch, the strength and the sincerity which characterises the man who has attained an assured command over his art. His interiors of French cafés are distinguished by a brilliance of execution, a realistic treatment, and a mastery of composition, which make them singularly attractive, while his two full-length portraits are no less remarkable for their technical skill and

breadth of conception."[36] Indeed the impact he made at the RHA exhibition must have hastened Leech's election to the status of full Academician in 1910.

Possibly the same reviewer in *The Irish Times* wrote about Leech's work at the RHA exhibition in March 1912 with a tinge of disappointment, "Other landscapes and seascapes worthy of particular notice are – 'The End of the Land,' by Mr. J.W. [*sic*] Leech, who has not yet fulfilled the promise he showed at the Academy Exhibition of 1909."[37] These early paintings still retained a dark, restrained palette with a refined brushwork and detailing.

The Leinster Lecture Hall Exhibitions, 1907–1910

On his return to Dublin Leech was soon embraced into the artistic circle of George Russell (A.E.), Constance Gore-Booth and her husband Casimir Dunin Markievicz, and he exhibited with them in a group exhibition at the Leinster Lecture Hall in Molesworth Street, Dublin, in August 1907. Markievicz and Gore-Booth had met at the Académie Julian where Gore-Booth studied under Laurens in 1897, and they and A.E. had exhibited together at the Leinster Lecture Hall from 1904. They were joined in 1905 by Percy Gethin, in 1907 by Leech, in 1908 by Dermod O'Brien and Mrs Frances Baker, and in 1910 by Beatrice Elvery.[38]

The exhibition of 1907 received a very full and comprehensive review in *The Irish Times*, which may have been written by Thomas Bodkin,[39] who, as a student at University College Dublin, wrote most of the art reviews for *The Freeman's Journal* and *The Irish Times* during the years 1906–09. Bodkin had spent 1906 in Paris and his acceptance of Impressionist principles is implicit in his admiration for the *plein air* qualities of Leech's work, especially the "small sketches".[40] Even after he was called to the Bar at King's Inn in 1911, he continued to write laudatory reviews of Leech's work. The approbation was important for Leech, especially after Bodkin became Director of the National

Gallery of Ireland, 1927–35, and afterwards Professor of Fine Arts and first Director of the Barber Institute in the University of Birmingham until 1952. He owned one of Leech's paintings, *The blue shop, Quimper* (cat. 43), exhibited at the RHA in 1918.[41]

Leech was twenty-six in 1907, and Bodkin had just turned twenty when he gave favourable mention to Leech's work. "This year Mr. W.J. Leech has joined the group, and a new and most attractive personality has been added to the little society. On entering the room one is struck with a certain harmony of purpose, underlying the work of all these artists ... A few pictures exhibited by Mr. Leech at the R.H.A. and elsewhere, during the past two or three years have revealed him as a painter with a rare feeling for beauty, a technique delightful in its simplicity and directness, and a delicate sense of tone."[42] Leech had shown "nearly seventy pictures" at the Leinster Lecture Hall,[43] compared to the six works eligible at the RHA. The review in *The Irish Times* comments on this fact, too, recognizing, "This is the first time that a collected exhibition of Mr. Leech's work has been shown in Dublin, and lovers of pictures will feel grateful to Count Markievicz for giving them the opportunity of studying in greater detail this revelation of a very charming personality."[44] However, many of these paintings were on a small scale and Seamus O'Congaile comments in *Sinn Fein* on "his inordinate fondness for working on small sizes".[45] The size of these works, usually $7\frac{1}{2}" \times 9\frac{1}{2}"$ (19 × 24 cm) on board, resulted from Leech's painting them *en plein air* (see further cat. 7).

The review in *The Irish Times* also noted, "With the exception of a few more important works, the majority of Mr. Leech's pictures are small sketches done direct from nature 'en plein air'. They are composed in a key of low tones of colour, treated with absolute directness, and laid on in a series of blots, the relative value having been carefully considered by the artist before beginning the picture. The tones have, as it were, been reduced to a common denominator, and each touch seems to have brought the whole effect into complete harmony with the keynote. Mr. Leech's subtlety of perception, his sensitiveness, his poetical gift, his fine sense of proportion, invest his work with a singular charm."[46] Seamus O'Congaile singled out "No. 87 ('Malahide') a picture full of repose and quiet colour ... and No. 66 ('The Black Scarf') [fig. 22] a piece of fine and delicate craftsmanship, and No. 67 ('A Grey Morning') with its beautiful scaling of definition in the trees, the barges, and the blurred background."[47]

The Irish Times also focusses attention on these last two paintings: "One of the most delightful is No. 67, 'A Grey Morning – Concarneau', a suggestive study of boats on a river seen through a frame of trees, while the interior No. 66, 'The Black Scarf' [fig. 22] is remarkable for the brilliant and dexterous painting of the lady's white dress."[48] *A Grey morning*, from the descriptions given, was similar to cat. 14. These two reviews on the exhibition of Leech's work in the Leinster Lecture Hall counteracted the much less favourable one by 'Imaal' in *The Leader* that March for his work in the RHA.[49] Seamus O'Congaile concludes his review in *Sinn Fein*, "There is undoubted individuality and distinction in Mr. Leech's work. He is sure to do great things one day."[50] *The Irish Times* continued the summation of the exhibition at the Leinster Lecture Hall with praise for A.E.'s paintings and concluded by advising anyone who was "interested in pictures, and in the development of the modern Irish School of Painting, to visit the exhibition".[51]

Leech was mentioned favourably again in August 1908, when he showed with this group during Horse Show week in the Leinster Lecture Hall. The unsigned review in *The Irish Times* could have been written by Bodkin. "Leech, however, exhibits no less than 63 works. They all show the careful handling and genuine taste for which his pictures are noted, and several of them have already found purchasers; the 'Glass Globe' and 'The Cloud' are amongst the finest of his efforts, but in all the

others, his many admirers will find much to charm the eye."[52] Dermod O'Brien exhibited "16 pictures, including the presentation portrait of 'Major F. Wise'" but sixty-three works by Leech almost amounted to a one-man show.[53] It is interesting to note that the reviewer also commented on Leech's sales, considering that Leech recalled in later life, to Leo Smith, that *A sunny afternoon, Concarneau* (cat. 13) from the RHA in 1909 was one of the first paintings he sold.[54] Perhaps he was referring specifically to the sale of more important, larger works or to sales from the RHA alone.

The unsigned review in *The Irish Times* of this 1909 group show was titled 'Five Irish Artists'. Leech received a long but qualified mention: "We could not expect Mr. Leech to have another big display ready for us so soon after his very brilliant exhibition in the last Hibernian Academy." It seems that Leech submitted his larger, studio work to the RHA and only exhibited his smaller, experimental 'sketches' in the context of a larger body of his work. The changes Leech was initiating in his landscapes, painted in a freer, impressionistic manner, were not accepted by this reviewer as 'finished' work and were regarded solely as a means to an end. "He once more sends a large number of those little direct atmospheric impressions of nature, broadly treated, and very harmonious in colour, which are the preliminary practice for the important, thoroughly worked-out pictures we all so confidently look forward to seeing before long from this young artist. Sometimes, remembering the long line of masters whose work began by being 'tight' and full of detail, and who developed breadth and freedom of handling as they went on, we wonder whether these younger men will reverse the process. Anyway, there is no lack of serious effort in many of these notes."[55]

Leech had progressed from detailed smooth painting in an academic brown, monochromatic palette to Whistler-style, simplified tonal landscapes. He saw these works as finished and not, as this reviewer regarded them, as "preliminary practice"

and a means to an end. This critic differs from Thomas Bodkin's earlier view in 1907, which had welcomed his "small sketches done direct from nature" for what they were.[56] The difference in attitudes illustrates the difficulty for a young artist seeking to implement change. A.E. (George Russell) wrote to Stephen Gwynn in 1902 of his intention to exhibit "pictures of the Sidhe", saying he was prepared "for the usual row which follows a new innovation here".[57] The Leinster Lecture Hall exhibitions, in the absence of a commercial gallery, allowed the participating artists to show unselected work, ungoverned by RHA values, since "the business of academies is not to be innovative".[58] Each artist paid for his own "share of the wall space", which in 1910 was about £2. 7s. 6d., after the receipts at the door and the sale of catalogues, which amounted to £16. 16s. 3d., had been discounted.[59] Although Leech had been accepted yearly at the RHA, his output of work and his desire to be accepted as an established practising artist made him strive to show his work in as many venues as possible.

'Young Irish Artists'

With Beatrice and Dorothy Elvery, Mary Swanzy, Eva Hamilton and Estella Solomons Leech had also shown in the Society of Young Irish Artists at the Leinster Lecture Hall from the spring of 1902.[60] In his review in *The Leader* of 1 May 1909, Thomas MacDonagh accepted that the aim was to "found a new Irish School of Painting and Sculpture", although he questioned whether theirs was a unanimity of style as well as nationality. Still he applauded the quality of the exhibition, which "will do Ireland honour, school or no school ... Mr. Leech shows the greatest number of canvases, I think, and the best technique – work delicate and sincere."[61] Leech's work included two, *La Toilette* and *Nocturne*, which he had exhibited at the RHA and the Irish International Exhibition in Dublin in 1907. MacDonagh praised the work of Beatrice Elvery:

"Her exhibits are not merely original and gracious, they have, perhaps, the greatest distinction of all in the room."[62] In 1907 and 1909 Leech also received favourable reviews in *Sinn Fein*, Seamus O'Congaile commenting on the "numerous 'Sketches' and 'Studies'", titles which he regarded as modest understatement. Some of the work, he noted, was dominated by the "flavour of the schools; a suggestion of the Salon Julian with monthly medals and things in the background."[63] Leech's choice of subject-matter is accepted as that of someone who "paints with affectionate gladness the beauty he sees about him".[64] He selects three of Leech's paintings for specific mention, "'Old age', 'The Bull (Dollymount)', the 'Velvet Strand' and a little study in greys, are good".[65]

Leech also exhibited in the first 'Aonach' art exhibition in December 1909, which was part of the Irish Festival organized by Sinn Fein at the Rotunda. The contributing artists included Jack Yeats, Albert Power, Eva Hamilton, William Orpen, Lily Williams, A.E., Constance Gore-Booth and Dermod O'Brien. This was an effort to awaken an "interest in Irish Art" and a definite step taken to stem the tide of emigration of "our young and most prominent artists".[66] This aim was unsuccessful as far as Leech was concerned, since he left Ireland the next year. It is interesting that Leech participated, considering his Unionist background, with no empathy with Sinn Fein's aims or objectives. This demonstrates a bond among the artists which superseded political affiliation. Before he left Ireland, Leech was singled out as "one of our foremost painters. His work is characterised by a thorough mastery over his material."[67] Yet Leech returned to Dublin and Ireland for one short visit only, which questions whether he regarded Ireland as his native country.[68] However, in a letter to Leo Smith in 1967, in reference to the imposition of importation tax on his pictures to Dublin, he sought "permission to send my pictures home free of tax".[69] Whistler, although often intending

to return to America, never achieved it, yet still regarded himself as an American.[70] Ireland was closer to England but Leech probably harboured analogous feelings, especially in later life.

These works of Leech seem still to have been painted in low tones because the critic in *Sinn Fein* states, "The beauty of the picture", in the painting *Old age* (whereabouts unknown), "is in its exquisite calm; autumnal, as of something passing".[71] Seamus O'Congaile commented, "it is a pity Mr. Leech is so fond of working on sizes, some of them little larger than a post-card", which recalls Leech's *Hell Fire Club*, painted on a postcard in 1914 (cat. 42).[72] Leech's Irish landscapes, however, received attention and praise. O'Congaile concluded by reiterating the philosophy of both Ruskin and George Moore "that no artist can properly express the life of any country but his own". Yet Leech, like Roderic O'Conor, proved this premiss false, since the majority of Leech's subsequent landscapes were painted in England or in France.

Hugh Lane, in his attempts to create a Gallery of Modern Irish Art, organized an exhibition of 'Irish Art' at the Guildhall in London in 1904, and wrote in the preface to the catalogue that his aim was to create "A gallery of Irish and Modern art in Dublin" which would show the ability of Irish artists in the context of other non-Irish artists. This, he hoped, "would create a standard of taste, and a feeling of the relative importance of painters. This would encourage the purchase of pictures, for people will not purchase where they do not know."[73]

Leech would have seen the Hugh Lane exhibition either in London or in Dublin in 1904 and would have been aware of the growing self-consciousness and desire to identify with an Irish school of painting, to echo the Irish literary movement.[74] This striving towards a new Irish awareness and cultural identity was spearheaded mainly by the Anglo-Irish, who had the necessary education, wealth and confidence to foster such a rebirth.[75] Leech supported Hugh Lane's efforts to found a

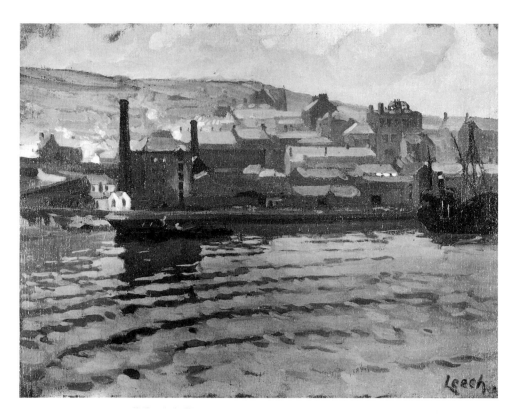

Fig. 26 William John Leech, *Wicklow*, oil on canvas, 35.6 × 45.7 cm (courtesy of Milmo-Penny Fine Art, Dublin)

Municipal Gallery of Modern Art, with its nucleus of a collection of Irish art, and in the tradition of Hone and others donated a major work, *Un matin* (cat. 50), one of his *Aloes* series painted in France *ca.* 1920.[76]

Unlike Orpen, in such works as *The western wedding* (whereabouts unknown),[77] Leech did not attempt to paint Irish genre or legends or display sentimental pictures of his country. He did, however, enjoy painting the landscape around Dublin, for example *Killiney Hill under snow* (cat. 23), the Leech family yacht *Lady Nicotine* (as *The white boat*; fig. 2) and *Wicklow* (fig. 26). In Dublin during a return visit around 1928, or possibly in 1934, Leech painted different views of Rutland Square, now renamed Parnell Square, where he had lived as a child and where his father had worked (cats. 85 and 86). We have seen that he also painted in Killarney and Connemara,[78] and he probably painted with Dermod O'Brien at his home at Cahirmoyle, Limerick, and in Kerry.[79] As an artist, Leech was interested in the composition of the landscape,

whether it was Brittany, Ireland or Wales, and he endeavoured to resolve on canvas diverse elements in nature.

Despite his recognition as an artist, there is little evidence to suggest that Leech socialized very much. Indeed, even in his late twenties, he displayed a tendency towards being a rather withdrawn and private person. Beatrice Elvery narrated later in life to Maurice MacGonigal how shy Leech was when she had asked him to go with her for a cycle ride and had refused, saying he had to ask his mother.[80] This is confirmed by Dermod O'Brien when he wrote to his wife Mabel in May 1909, complaining how the girls in his company "hardly addressed a word to Leech though he is a friend of the Gwynns and was at St. Columba's with Jack and Charley Monsell", but he concluded that it was really Leech's fault: "I don't say that he is very forthcoming, being shy and silent."[81]

A 1909 visit to London

O'Brien was writing from London where he had

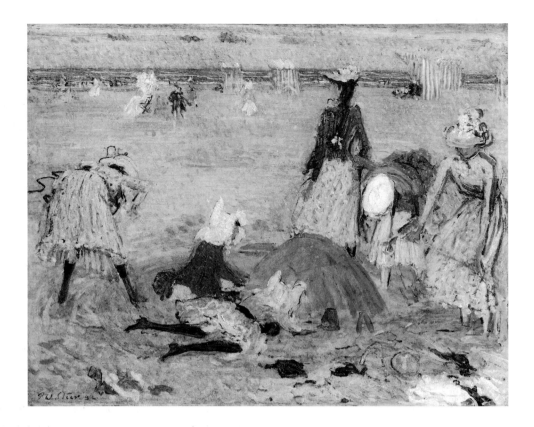

Fig. 27 Philip Wilson Steer, *Boulogne sands*, 1888–91, oil on canvas, 61 × 76.5 cm, London, Tate Gallery

accompanied Leech, a trip that may have been a direct consequence of the fact that "Leech said he got notice this morning of the rejection of two of his sendings to the R.A.".[82] It is interesting to know that Leech was sending paintings to the Royal Academy in London from his Dublin address, but only achieved having his first pictures exhibited there in 1910 (see below). Another reason why Dermod O'Brien may have gone to London with Leech in 1909 might have been to see the exhibition of Wilson Steer's paintings at the Goupil Gallery in May,[83] since O'Brien and Steer were friends. O'Brien took Leech to visit "Steer and others, then on to see a small show of Arnesby Brown's work ... good competent work, but just a little bit common-place and wanting in individuality of vision, which one felt all the more coming from the Steer."[84] (Arnesby Brown painted idyllic rural scenes such as *Full summer* which at the Royal Academy in 1902 was received as "one of the pictures of the year".)[85] They also visited the National Gallery "to see some new Van Dycks that were on loan ... and looked at other things".[86]

It is somewhat surprising, given the conservative nature of O'Brien's work, that he admired Steer's painting. It is understandable, though, that Leech should have been influenced by Steer, particularly by his beach scenes (fig. 27). Steer here exhibited landscapes painted at Corfe, and two of these works, *The lime-kiln (Corfe)* and *Corfe Castle and the Isle of Purbeck*, were both bought by Hugh Lane for the Johannesburg Art Gallery and reproduced in *The Studio* in 1909.[87] The wide expanses of these Corfe paintings, with their sweeping foregrounds merging into distant dramatic skies, painted with free, paint-laden brushstrokes, can only have reinforced Leech's development as a landscape painter, though Leech would already have seen Steer's work in the International Loan Exhibition in Dublin in 1899, in particular the painting *Sunshine and shadow, Hawes*, which he donated for inclusion in the 'Exhibition of Pictures presented to the City of

Dublin to form the nucleus of a Gallery of Modern Art' in November 1904.[88] Hugh Lane's friendship with Steer and Orpen is immortalized in Orpen's portrait of both men in his painting *Homage to Manet*, 1909 (Manchester City Art Galleries).[89] Bodkin in his records states that "Hugh Lane bought two paintings, *Ironbridge, Salop* and *The Bend of the Severn*, from Steer for Dublin Municipal Gallery in 1911" and that the large Severn painting "combines sunlight on the river with rain clouds overhead".[90]

The interest, admiration and respect which Dermod O'Brien held for his English contemporaries, especially Steer, whose painting *Richmond Castle* (1904) O'Brien owned,[91] may well have instilled a similar regard in the younger painter Leech, a regard that developed more fully after he had moved to London (see below). O'Brien's dislike of Orpen and his personal taste in painting are revealed in the statement he is reported to have made in 1909: "Rothenstein is doing more interesting work than Orpen or Kelly and always will and to me he is the most interesting artist after Steer. I should like to possess several of his pictures."[92]

The year 1909 had been a productive and successful year for Leech in Dublin and he seemed poised to rise to greater achievements. By 1910, at the age of twenty-nine, Leech had become an established painter but he was still dependent on his parents for support since he was only just beginning to sell his work. His decision to move to London in this year was perhaps prompted more by his parents' decision to move there than by his own desire to make his mark there as a modern painter. However, his visit with Dermod O'Brien the year before had perhaps led him to see the attractions of London. Indeed his parents' move to London in 1910, though made primarily for political and personal reasons (see chapter 1), may also have been intended to facilitate Leech's access to the superior art market in London. In Dublin there were fewer patrons and paintings fetched lower prices. Lavery and Orpen had achieved their reputations and financial success through society portraits in London. As it turned out, Leech would not make much of a mark there, and although he submitted work to the RHA nearly every year until his death in 1968, the fact that Dublin was not again to see a large exhibition of his work until 1945 contributed to his comparative obscurity in later life. We can only surmise what his direction might have been had he stayed in Dublin and continued to exhibit with the other Irish painters and to attract the attention of the critics.

5

Exhibitions in London 1910–1914

After Leech's parents moved to London, their home became Leech's London studio and his London address. Even after his marriage in London in June 1912 to Saurin Elizabeth Kerlin, née Lane,[1] he resided with his wife at his parents' home.[2] However, he returned to France, especially to Brittany, for long painting trips. Here, although he continued to paint the Breton landscape, he painted what were in essence portraits of Elizabeth Kerlin, who he had probably met in 1903.[3] He appears to have returned to Dublin for only one brief visit in the late 1920s.[4] Since his immediate family had left Dublin to reside in different areas in England, he had no family ties in Ireland and no base to return to.

Leech continued nonetheless to send his paintings to the RHA almost every spring until his death in 1968. This was remarkable, considering his almost permanent self-imposed exile, but possibly reflects both his happy boyhood and his loyalty and respect for his former artist friends and associates. More importantly, his work was generally favourably received by the Dublin critics and public, even though sales of his pictures were infrequent. Between 1899 and 1968, there were only nine years in which Leech did not exhibit at the RHA, and for most of these years there were understandable reasons: in 1901 and 1902, for instance, he was a student in Paris; in 1941 and 1943, his studio was damaged by a bomb; in 1965 and 1966, he had been nursing his second wife May through an illness.[5] He did not exhibit, either, in 1924 or 1927, when he spent time with May Botterell in the South of France, nor in 1951, when he had a solo exhibition with Leo Smith at the Dawson Gallery in Dublin. Outside of these years, the RHA was the main outlet for Leech's paintings in Ireland from 1910 until he had his first one-man show with Leo Smith at the Dawson Gallery in 1945. Usually he showed his most recent work at the RHA and then showed the same work in exhibitions in England and at the Société des Artistes Français in Paris, on the few occasions that he exhibited there.

Leech's move from Dublin to London coincided with Roger Fry's first exhibition, 'Manet and the Post-Impressionists', at the Grafton Galleries in 1910, the year from which "modern art in Britain is often said to date".[6] Possibly Fry expected that the exhibition would cause controversy, consternation and be condemned as testifying to "the existence of a widespread plot to destroy the whole fabric of European painting".[7] His second "Post-Impressionist" exhibition, in 1912, did nothing to calm the turmoil among public and critics alike. The first show had focussed on the work of Gauguin, Van Gogh and Cézanne, but the second exhibition was dominated by the paintings of Cézanne, Picasso, Braque and Matisse. It was a crucial period in English art. However, it is not known that Leech visited either of Fry's exhibitions, and it is not easy to see any immediate reaction in his own work.

The Royal Academy

As Leech exhibited yearly at the RHA in Dublin it would seem highly likely that he would submit work to the Royal Academy in London. However, he did not exhibit until 1910 and then infrequently afterwards, although Thompson had exhibited in 1904 when Leech and he were painting together in Concarneau.[8] He may have been submitting his work, without success, for some years, perhaps as early as 1904.[9] It could be deduced that Leech was not producing Academy exhibition material. George Clausen was the president in 1904 and, although other painterly influences prevailed, Clausen's admiration for Bastien-Lepage had been paramount.[10] However, since Leech exhibited only six times at the RA during his lifetime, between 1910 and 1940,[11] it seems likely that he was not striving to make his name there. Perhaps he did not identify with its conservativism; the fact, too, that, on those occasions when he did submit work, it was badly hung and he failed to receive any critical acclaim may have been significant.

As we have seen, Leech exhibited *Portrait of C.J.F. Leech* (cat. 20) at the Royal Academy in 1910, and with it another painting, entitled *Ireland* (present whereabouts unknown), which may have been a landscape or an allegorical painting or even a portrait, if Leech was emulating Orpen's 1908 painting *Young Ireland*, a "portrait of his republican student, Grace Gifford" in which he tried to capture and personify the emerging pride of nationalist Ireland.[12] Four years later, Leech exhibited *Portrait of a lady* (whereabouts unknown),[13] and it was then another seven years before he exhibited *Lilies* in 1921, which was almost certainly the painting better known as *A convent garden, Brittany* (cat. 37).[14] Considering that Leech showed so infrequently at the RA it is significant that he was included in 1921, the year that so many established painters who had continuously exhibited for decades were rejected.[15] The reason Frank Salisbury gave for this pruning by the selection committee, which was "composed of men mostly of the new school", was "to give a 'flip up' to modern British art, and set a higher standard".[16] The attempt met with great furore.[17] The art critic of *The Times*, however, though supporting the new selection, failed to see signs of "the new school", and found that "most of them belong to a pre-, not a post-, impressionist age".[18] Artists like Sargent, Orpen and Lavery, established painters who Leech admired, were included in the exhibition. Indeed the same critic found it to be "Sir William Orpen's year. He has six [portraits], all painted with his unfailing if rather standardized vivacity."[19] It would appear from Leech's inclusion that he wished to be identified with this move to radicalize and to revamp the Royal Academy, perhaps in conjunction with O'Brien, who exhibited that year, too, with a landscape *Harvesting the laid corn*.[20] But the attempt to change the Royal Academy into an avantgarde arena failed.

The next year Leech exhibited two paintings, *A sermon on a mount* and *Aloes near Grasse*.[21] It was

then another thirteen years before he exhibited *La Cimetière de St-Jeannet* in 1934 (cat. 66).[22] A discouraging factor may have been that *A convent garden*, one of his most important paintings, exhibited in 1921, which he had previously exhibited also at the Société des Artistes Français in Paris,[23] received no mention in the various reviews in *The Times* and failed to sell.[24] During the War, in 1940, Leech exhibited the somewhat slick and sentimental *Christmas tree* (private collection), but when he saw how it had been skied he determined never to submit work again.[25] In 1969, the year after Leech's death, two of his paintings, *The lake* (possibly cat. 87) and *The lace tablecloth* (fig. 82), were exhibited by Alan Denson in the category reserved for recently deceased former exhibitors.[26]

The Royal Institute of Painters in Oil

The Royal Institute of Painters in Oil (ROI) had opened in 1884 as an offshoot of the Royal Institute of Painters in Watercolours to attract younger, less experienced exhibitors.[27] Leech began exhibiting there in 1907 with *Malahide* (private collection),[28] a small study, and two years later, the same year he unsuccessfully submitted to the RA, he exhibited four works, from his address at the Hôtel des Voyageurs, Concarneau. One of the works included was an Irish landscape, *Cliffs at Howth*, but paintings with Irish subject-matter and titles became infrequent and then ceased. In the following October, when he again exhibited four more paintings, he gave his parents' address at no. 45, Westbourne Park, London W. Early in 1911 Leech visited Switzerland and also Italy, and in October of that year exhibited four works reflecting this trip. Leech then stopped exhibiting until 1936, perhaps because he preferred other more forward-looking venues such as the New English Art Club, the Baillie Gallery, the Goupil Gallery and the National Portrait Society.[29]

The Baillie Gallery

In 1911 Leech showed forty-three paintings in a two-man show at the Baillie Gallery in Bruton Street, London, a gallery run by John Baillie and W.D. Gardiner to exhibit modern paintings and etchings. Its galleries were "available for 'Special' and 'One-Man' Exhibitions. Terms on Application."[30] Robert Bevan, who showed with the Allied Artists Association (AAA), the Fitzroy Street group and the New English Art Club (NEAC), and had worked with Gauguin at Pont-Aven and was friendly with Sickert, Gore and Gilman,[31] exhibited at this gallery in 1905 and 1908.[32] Another member of the AAA, the Scottish colourist J.D. Fergusson, had an exhibition there in 1905 and was included in a group show in 1908 with Conder,[33] Gilman, Hornel,[34] Sickert and Lucien Pissarro; there were also works by the nineteenth-century Italian painter Monticelli,[35] who influenced English artists, especially Steer, in his use of a palette knife and impasto. These were artists who became the core of the Camden Town Group, initiated mainly through the efforts of Walter Sickert, in 1911, artists who were united by their common interest in the exploration and use of colour as practised by Seurat, Van Gogh, Gauguin and Matisse and in Cézanne's restructuring of pictorial form, artists who Roger Fry for convenience called the Post-Impressionists. With his exhibition at the Baillie, Leech was endeavouring to become part of the contemporary metropolitan artistic fraternity.

The artist with whom he shared the show, William A. Wildman, a contemporary, had also exhibited at the RHA. Born in Manchester in 1882,[36] he was a painter and etcher of figures and landscapes. His exhibition of thirty-one watercolours was in an adjacent room. The critic of *The Times* wrote favourably about Leech's paintings at this exhibition: "There are some good oil pictures, landscapes and portraits by Mr. W. J. Leech, an artist of much promise".[37] The exhibition represented the early work Leech had produced, together with landscapes painted in Ireland such as *"Dublin Bay, evening"*.[38] Leech also included the portraits of his

brother Cecil (cat. 20) and *The black scarf* (fig. 22), priced at £20. It did not sell, and he eventually gave it to his sister and her family as a gift for their annual hospitality to him at Tettenhall Wood, outside Wolverhampton.[39] He also included a self-portrait (possibly one extant in a private collection) a motif which was to preoccupy Leech, at intervals, for the rest of his life.

Seven paintings had Concarneau in their title, representing some of the work he had completed in the old harbour town from 1903 onwards. The exhibition plotted his artistic progress and the development of his style from one of his early, intimate, dark interiors, *Interior of a barber's shop* (cat. 6), to the confident handling of close tones in the Concarneau harbour scene entitled *Waving things, Concarneau* (cat. 21), probably painted *ca.* 1910.[40]

The Goupil Gallery

Leech had surely seen Steer's paintings on exhibition at the Goupil Gallery in April–May 1909,[41] when in London with O'Brien. Steer was an influential teacher at the Slade School, and Leech's move to London brought him into closer contact with artists associated with the Slade, including Orpen and Orpen's close friend Augustus John, with whom Leech became friends. The Goupil Gallery was a favoured venue for such painters, and at the forefront of 'English Post-Impressionism' in 1910–12.[42] Leech exhibited there in mixed exhibitions from 1911 until 1928 and also had a joint show in which he exhibited forty-one paintings in 1912.[43]

Leech first exhibited at the Goupil in November–December 1911, with William Orpen and John Lavery, among others, in the sixth of the Goupil Gallery Salon series.[44] One of the two watercolours he exhibited was *A portrait* (possibly cat. 39) at £21, £10 less than Orpen's watercolour *The woman in white*. Orpen, then, was an Associate of the Royal Academy, while Leech – up until the year before – had been unsuccessful in being selected for exhibition. (However, Leech was a Royal Hibernian

Academician, whereas Orpen was still only an Associate of the Royal Hibernian Academy.)

Leech failed to sell any of these four paintings at the Goupil exhibition and this result was repeated in 1912 when he exhibited two oils – *Afternoon* and *Children playing*, possibly a work similar to *'Twas brillig* (cat. 22).[45] This group show was described as an exhibition "which featured the British Post-Impressionism of Alfred Wolmark, S.J. Peploe and Augustus John". The exhibition received a mixed reception: the critic of *Outlook* thought that Wolmark's *Decorative panel* drew attention to itself "simply by its over emphasis of crude, noisy colour", while Peploe's *Tulips* "has certain unrestful decorative qualities which quite fail to charm".[46] The inclusion of Leech in the Goupil Salon paved the way for his joint exhibition in April–May 1912 in the same gallery with Alfred Wolmark. Leech wrote about this to Leo Smith years later, recalling that he "was given a one-man show by Mr. Marchant, at the Goupil Gallery 1911 or 1912 in London, a beautiful Gallery it was. Vincent van Gogh used to be employed there as a salesman before he started to paint!"[47]

Leech was being associated with other artists who had had exhibitions at the Goupil, such as Steer, April–May 1909, William Rothenstein, May 1910,[48] and Orpen, March 1912. In just two years Leech was exhibiting among the foremost English artists but still without much financial success. Bourlet records show that Leech sold few of these paintings,[49] and the bulk of his work, mainly landscapes, was not favourably reviewed.[50]

Leech's visit to Switzerland and Venice in 1911 was the subject-matter of his exhibition in April and May 1912, entitled "Visions of Switzerland, Venice, etc. by W.J. Leech, R.H.A".[51] Two of these works, *A mirrored sky* and *The end of the lake*, were also shown at the RHA in 1911 and 1912 respectively, and seven were shipped to the 1913 RHA exhibition where they were exhibited under the same titles and at the same prices. One painting, *The grey*

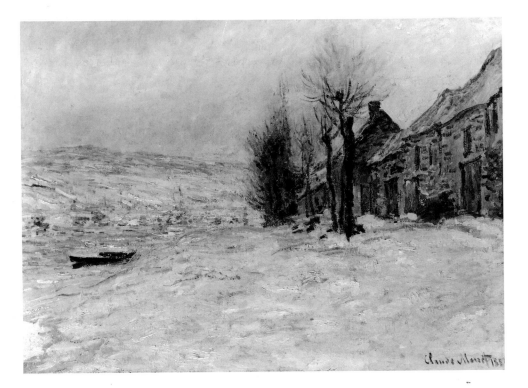

Fig. 28 Claude Monet, *Lavacourt under snow*, oil on canvas, 59.7 × 80.6 cm, London, National Gallery

bridge (possibly cat. 37), went to Worthing and Leech later mentioned he had shown at the Towner Gallery in Worthing.[52] *Interior of a café* (possibly cat. 5, judging from the price of £12) went to Reading in December for an exhibition.

The review in *The Times* of 20 April 1912 was long and comprehensive, covering first the work of Wolmark and then that of Leech. "Mr. W.J. Leech, who exhibits in the same gallery a number of 'Visions of Switzerland and Venice', is an artist who aims at vivid illusion by means of that process of elimination which was practised by Whistler. His subjects, however, are very different from those of Whistler, and he is not a mere copyist. Where the illusion fails, his pictures are quite empty; but it is strong enough in several of his snow scenes and in his sea-piece, 'Monaco', to compensate for their slightness; indeed the slightness makes the illusion more agreeable, because it seems to be so easily obtained." The review highlights Leech's new confidence in painting directly from nature, emphasizing the important elements and eliminating extraneous details. Leech was refining the painterly

technique he had developed in Concarneau from 1903 onwards, aware of Whistler's harmonies and the fluidity and directness of Lavery's landscapes. The review continues: "Mr. Leech has a hit or miss method dangerous to any one who is not a great master; and when he applies it to human beings the result is as unsatisfactory as the decorative method of Mr. Wolmark."[53]

The hanging of Leech and Wolmark together was perhaps arbitrary. Alfred Aaran Wolmark was a Polish painter and designer, who had studied at the Royal Academy Schools and showed at mixed exhibitions with Leech, including the Goupil Gallery and the RHA.[54] His reputation as a Post-Impressionist had been acclaimed the previous November at the Goupil, and he is included in the index of J.B. Bullen's *Post-Impressionists in England*, unlike Leech. Leech's numerous initial studies completed *en plein air* in Switzerland of the same river running along beside snowy fields with trees, snowladen, on the river banks and views down over Lake Constance feature instead spontaneity. A review of Leech's work at the Cooling

Galleries in 1927 recalls: "One seems to remember in pre-war exhibitions paintings by him of snow in sunlight, owing their appeal to the refinement of the relation of colour in shadow."[55] The area Leech had chosen to paint, in the winter of 1910–11, was around Lake Constance on the border with Germany, where Turner had painted in 1841. To put Leech's work in context, in 1841 Turner's Swiss watercolours were valued at 80 guineas each, Leech's at 15 guineas seventy years later and still not selling.[56] But revisiting Switzerland allowed Leech to concentrate on simplified compositions and to render in watercolour his sensations in front of the snowy scenes, particularly *Trees in the snow* (cat. 28), *A snow-covered field* (cat. 30) and *A mountain town* (cat. 29). There is perhaps an awareness of Turner's own paintings of the same region, but more significantly the series of twenty snowscapes on canvas owe a debt to Monet, particularly in his series of fourteen paintings *Morning on the Seine*, painted in 1897, and in the tonal qualities of Monet's earlier view of the Seine, *Lavacourt under snow*, painted in 1881 (fig. 28).[57] His handling of paint, however, is different: instead, his simplified handling of large tonal areas suggest Whistler or Lavery, who had more direct influence over him.

Lake Geneva (fig. 29) maps Leech's route into or out of Switzerland, through the Aosta Valley from Venice. The painting is typical of his Swiss landscapes, portraying the lake down in the valley from the white expanse of the nearside hill, a viewpoint which throws into stark contrast the soft blues and greys of the middle distance. *Lake Constance* (private collection) depicts the soft blues of the lake nestling in the snowy valley below, from a high vantage point of a sweeping driveway bordered with bare trees, silhouetted against soft greys and blues. *Crystal morning* (fig. 30) portrays the early sun which lights up a snowy river bank, contrasted against the grey swollen river. In *Swiss landscape* (private collection) a solitary bush breaks the thick

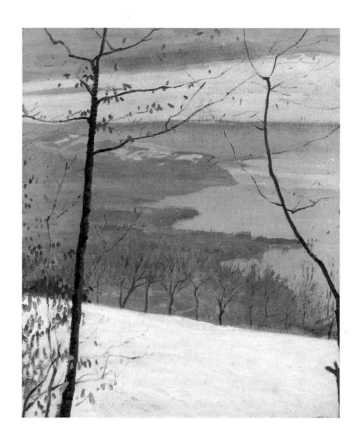

Fig. 29 William John Leech, *Lake Geneva*, 1911, oil on canvas, 63.5 × 53.3 cm, private collection

covering of snow which is reflected in the icy water of a swollen, grey wintry river. The composition is characteristically Leech: a top border formed by snow encloses the scene and the dramatic diagonal, formed by the snowy bank on the left, leads the viewer into the simplified landscape. The shapes are solid and clear-cut as a Japanese woodcut, an influence which could have come via Whistler, who "had assimilated the fundamental Japanese principles of simplicity of design and economy of expression into his art".[58]

In the fluidly painted, impressionistic landscape of *A thaw, Lanenen* (fig. 31), the river is a shimmering surface of silvery movement and soft-toned, blue shadows. Leech's fluid and free brushstrokes create movement and depth in the expanse of river of *The vanishing of the blue shades* (fig. 32). Here sunlight floods into the scene and highlights an area

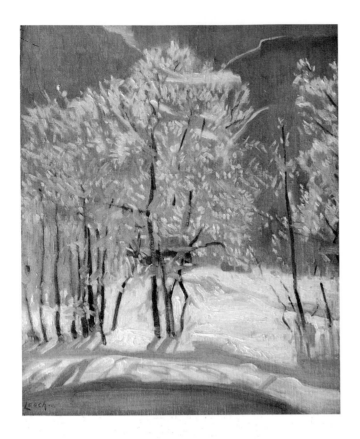

Fig. 30 William John Leech, *A crystal morning*, 1911, oil on canvas, 40.6 × 53.3 cm, Dublin, John de Vere White

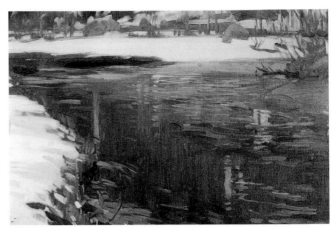

Fig. 31 William John Leech, *A thaw, Lanenen*, 1911, oil on canvas, 45.8 × 55.9 cm, private collection

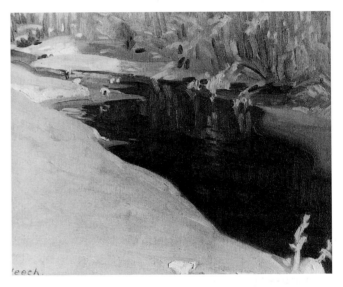

Fig. 32 William John Leech, *The vanishing of the blue shades*, oil on canvas, 49.5 × 60.5 cm, Dublin, Cynthia O'Connor Gallery

of the snowy banks, but in *Sunlight on snow-covered landscape* (private collection) confident brushstrokes and a low-toned palette give an over-all golden glow to the painting. *The rocks at Naye* (fig. 33), which Leech painted at Montreux during this trip to Switzerland, captures the scale of the mountainside covered in snow. The volume of the mountain, its simplicity of form and its vibrancy are echoed in Lavery's painting *The summit of the Jungfrau*, 1913 (fig. 34).[59]

Although Leech only seems to have sold two paintings, he had further established himself as a painter and had a quantity of work available for exhibition in mixed shows. However, having pro-duced so many accomplished snowscapes, he never again subjected himself to this tonal discipline and limited palette and never returned to Switzer-land to paint similar scenes but instead became fas-

cinated by capturing colour.

In the same year, November–December 1912, he exhibited two paintings at the Goupil Gallery Salon: *Afternoon* and *Children playing* (both whereabouts unknown). These were quite different paintings, and indeed different subject-matter. Neither sold, but, undeterred, Leech showed three paintings at the Goupil Salon of 1913, this time exhibiting a small picture of a market-stall and two landscapes

– one of which was *The rocks at Naye* (fig. 33) which he had included in his 1912 exhibition, and which he also sent to the RHA in 1914. He never sold the painting but gave it to his sister Kathleen as a wedding present when she married the Revd Charles Cox.[60]

The Goupil Salon shows were interrupted because of the outbreak of war in 1914 but a special autumn exhibition was held under the heading 'Business as Usual'. Leech contributed a Welsh land-scape entitled *Llanbedr, N. Wales* (private collection), a painting he again exhibited at the RHA in 1914 at the same price of 16 guineas. Leech had painted this scene in Wales when he had accompanied his father on a political tour, as he recalled to Alan Denson in later life: "I know he was very much interested in Tariff Reform, and was to tour in North Wales on that platform. I was home before he was due to leave, so I went with him. That's when I made the painting of Harlech Castle and other scenes in the area which you know."[61] This particular Welsh landscape is uncharacteristically heavy in its handling and Leech came to dis-like it so much that he intended to destroy it.[62] The brevity of his Welsh visit prevented him acquiring the necessary familiarity with his subject-matter to enable him to handle the paint freely. The passing reference to his father intertwines his painting pre-occupations with his close-knit family.

Leech continued to show frequently at the Goupil Autumn Salon shows of November to December each year, in the company of artists such as Orpen and Lavery. He does not seem to have exhibited in the Goupil Summer Shows, which in 1912 featured Clausen, Conder, Augustus John, Le Sidaner, Nicholson, Orpen and Steer.[63] The expla-nation for this could simply be that Leech went to France in the spring of each year, staying on into the summer to paint, the results of which he showed at the Goupil Autumn Show. Additionally, in the summer of 1910 he began to show with the New English Art Club.

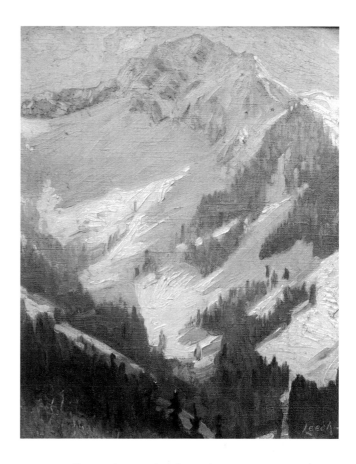

Fig. 33 William John Leech, *The rocks at Naye*, 1911, oil on canvas, 46 × 56 cm, private collection

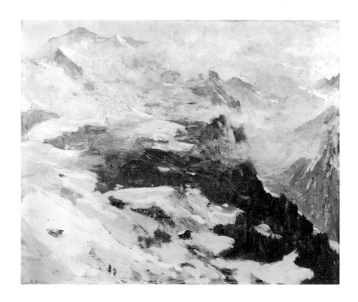

Fig. 34 John Lavery, *The summit of the Jungfrau*, 1913, oil on canvas, 38 × 63.5 cm, private collection (courtesy of Christie's Images)

The New English Art Club

Leech's meeting with Wilson Steer in the company of Dermod O'Brien in 1909 may have occasioned his exhibiting at the New English Art Club from 1910, for Steer had been one of the founder members in 1886 "in an attempt to challenge the monopoly held by the Royal Academy".[64] Indeed Steer and Osborne knew each other and Osborne had shown at the NEAC. Osborne painted *An October morning* in 1885 at Walberswick with Steer:[65] "Steer was interested in the struggles of his friend and fellow Walberswickian, Walter Osborne, who in 1887 showed *October by the Sea* at the New English."[66]

"During the 'nineties, the N.E.A.C. became a focal point for all that was most adventurous in English painting".[67] Sickert showed with this group from 1899 until 1917, William Rothenstein was a member from 1894 and Orpen first showed in 1899 and became a member in 1900. "By 1900 it had become more or less the Slade's unofficial shop window to the world."[68] The influence of painters living and working in England was becoming more apparent in Leech's work; after the influence of Orpen and then of Lavery on his portraits and landscapes, the influence of Steer (see fig. 27) can be seen on Leech's painting *Plage des Dames* (fig. 35). The figures of the children along the high shoreline, their clothes flowing in the wind, are painted with heavy impasto in bright blues and reds against the blue sea.

In 1915 Leech again exhibited one painting at the NEAC, the committee being Augustus John, Ambrose McEvoy, Orpen and Steer. Other exhibitors were C.R.W. Nevinson, Stanley Spencer, Walter Sickert, Lucien Pissarro, Harold Gilman, Mark Fisher and Paul and John Nash. Leech's work was a new portrait of his father, *Portrait of Professor H. Brougham Leech*, probably the same portrait that Leech exhibited at the RHA in 1916 and which received favourable mention in *The Irish Times* review: "Mr. W.J. Leech has not hitherto been known as a portrait painter, but his 'Professor Leech'

is an excellent piece."[69] This painting was destroyed with all the other exhibits and records during the Easter Rising of 1916. Leech showed another oil portrait of his father at the National Portrait Society in 1917, which used to hang in the offices of the Registrar of Deeds for Ireland.[70] Yet another portrait of Professor Leech, now the property of Trinity College, Dublin, depicts Brougham Leech not as a learned professor but as a French peasant, wearing a black beret and resembling Aloysius O'Kelly's *Breton fisherman* (private collection).[71]

In 1916 Leech gave his parents' address at no. 39, Gunterstone Road, West Kensington when he exhibited three paintings at the NEAC, *The lady and the trees*, *Poppies* and *Lilacs*. Orpen was not on the committee that year because he was serving as a War Artist. The first two paintings' whereabouts are at present unknown, but perhaps they are listed now under different titles. In the catalogue, *Lilacs* is described as representing a girl under a lilac and yellow parasol, which seems to have been similar to *The sunshade* (cat. 38).[72]

The final painting Leech exhibited at the NEAC was *A cactus hedge, Tunisie* (whereabouts unknown), one of his *Aloes* series (see chapter 7), which he exhibited in 1920–21. Leech exhibited there on just four occasions with a total of six paintings. It may not have been the sympathetic company Leech expected. In fact a review of the Retrospective Exhibition of the NEAC in 1925 stated, "There is nothing rebellious on the walls, no sign of Post-Impressionistic contagion."[73] Even though it praised Orpen's "brilliant group 'Homage to Manet'", it continued: "It seems almost incredible that the original members of the N.E.A.C. could have been regarded as artistic rebels."[74] The NEAC was already twenty-four years in existence in 1910 when Leech joined, and by the 1920s many changes had happened on the English art scene to make the ideals of the NEAC *passé*. In fact many of the Club's artists now showed at the Royal Academy.

Other Venues and Exhibitions

In the autumn exhibition of the International Society of Sculptors, Painters and Gravers, in 1916, Leech exhibited one painting, *L'Actrice* (cat. 46). The International, initiated by Whistler in 1898, attracted the younger generation of painters, Charles Shannon, William Rothenstein, William Nicholson, who showed their work in the company of Monet, Rodin, Lautrec and Toorop. It is difficult to surmise why Leech exhibited only twice at the International, in 1915 and 1916. When Orpen became president of the Society in 1920 it might have been expected that Leech would exhibit there again but there is no evidence of this having happened. Perhaps he sent work in without success. However, in the same year, November–December 1916, he exhibited at the Goupil Gallery with two paintings, *The blue shop, Quimper* (cat. 43) and *The cigarette* (cat. 40), as part of 'A Small Collection of Works by Modern Artists including Augustus John, Wilson Steer, Charles Ginner, William Nicholson'.

In March 1913 Leech exhibited three works at the Public Art Gallery and Museum in Belfast: *Above the mists*, *Lieutenant C.J.F. Leech, R.F.A.* (cat. 20) and *The grey bridge* (possibly cat. 31).[75] This exhibition closed in April 1913, and Leech's work was then included in the loan exhibition of Irish art at the Whitechapel Art Gallery. The fact that Dermod O'Brien served on the committee to organize this summer exhibition, to run from 21 May until 29 June 1913, may have been responsible for Leech's good representation.[76] The committee also included Sir Hugh Lane, continuing his effort to promote Irish art. Leech showed seven paintings, which demonstrated the range of his subject-matter.[77] He included a Venetian landscape, *A circle, Venice* (whereabouts unknown), a portrait of his eldest brother, *Lieutenant A.G. Leech* (present whereabouts unknown), one from his series of expressionistic paintings *Rocks and seaweed* (see below), and one of the landscapes he painted in Switzerland in 1911, *Where the snow spirits live* (whereabouts unknown). These five paintings Leech lent from his studio. The other two were *Sea-pieces* were lent by the Hon. Mary Massey, and had been sold following their exhibition either in the Baillie Gallery of 1911 or the Goupil Gallery of 1912 (whereabouts now unknown). A review of the 1913 RHA exhibition in *The Irish Times* remarked, "He [Leech] used to specialise in ripples, and his old mannerism in the painting of water is exemplified, with all relevance, in his Venetian picture."[78] The painting referred to was *A circle, Venice*, which, as *A little bridge – Venice*, Leech exhibited at the RHA in 1913, and which he had exhibited the year before at the Goupil Gallery. Leech's joy and skill in painting water continued in his Regent Park series (see below) and remained unchanged throughout his painting life, including paintings of the River Wey, in Surrey, in the late 1950s.

Leech exhibited three or four portraits nearly every year at the National Portrait Society from 1915 until 1921, in the company of Lavery, Rothenstein and Kelly. Leech sent *Portrait of C.J.F. Leech, R.F.A.* (cat. 20) in 1915, *The cigarette* (cat. 40) in 1918, *Portrait of Mrs May Botterell* (cat. 45) and *Portrait of Suzanne* (cat. 47) in 1921. He stopped exhibiting in 1921. This was the year both his parents died and by then, too, his relationship with May Botterell was well established. From this time on his exhibiting venues in London reduced significantly, suggesting a desire to shun any publicity, even as an artist. From his arrival in London in 1910 until 1914, when war broke out, he had exhibited extensively in London and at the RHA in Ireland. But although he managed to evade conscription, the Great War changed his life irrevocably. During the War, which he spent mostly in England, his opportunity to exhibit was limited. After the War and after his meeting with May Botterell, he never again was to have a one-man show in London, or indeed any part of England, throughout the remaining fifty-four years of his life, much to the detriment of his painting career.[79]

6

"Trying to evolve sunlight and reflections"

Dermod O'Brien wrote to his wife in February 1910 that Leech was "in his studio since luncheon trying to evolve sunlight and reflections".[1] Significantly it is from this date onwards that canvases of a more impressionistic manner evolve. Gradually, his confidence increases with painting out of doors, and he incorporates the competent draughtsmanship of his early studio figures and first portrait paintings into paint. Leech, like Lavery and Whistler, used a small *pochade* box to carry '*en plein air* boards' which were later worked up into studio canvases (see cats. 7, 60).

Around 1908, in *A sunny afternoon, Concarneau* (cat. 13) he used soft tones of blues and greys to depict a panoramic view of the gentle harbour scene with a tunny boat coming into the Peneroff basin. He is combining the careful depiction and the dark tonalities of *Portrait of a man with bottle* (cat. 3) and *Interior of a café* (cat. 4) with the colour of the harbour scene. He uses veins of subtle but rich colouring in the water, the boats, the fishermen and the sunny quayside. By around 1910, however, when he painted *Concarneau in the breeze, ca.* 1910 (cat. 17), he was exploring the use of bright colour in strong sunlight although the combination of light and colour renders this more an impressionistic painting than a Fauve one. He may have been aware of Signac's painting with a similar title, *Brise à Concarneau* (Breeze at Concarneau; private collection) and perhaps of Signac's book *De Delacroix au néo-impressionisme* of 1899. However, although Leech in such works as *Beach scene* (cat. 55) and in some of his sandy seascapes appears to be informed by the pointillists' paintings, he uses colour for representational purposes rather than allowing colour theories to change his motif beyond recognition.

During 1910, together with Saurin Elizabeth Kerlin, Leech rented a large house which overlooked the sea at Plage des Dames, a curved bay of silvery shingled sand on the outskirts of Concarneau.[2] Touches of Fauve iridescent colours

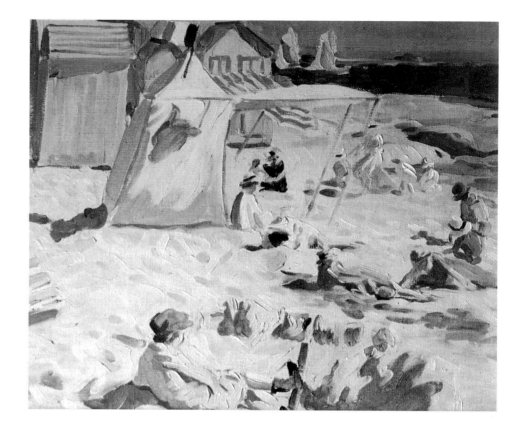

Fig. 35 William John Leech, *Plage des Dames*, 1910, oil on canvas, 38 × 45.7 cm, private collection

appear in his painting *Plage des Dames* (fig. 35). Strokes of vermilion-red edge the beach huts, the windows and the striped parasol and recur in the French flag and a child's sweater and contrast with the strident blue of the distant sea, the white yachts and the foreground of sand.[3] This use of contrasting primary colours would suggest the influence of the Fauves on Leech's developing technique, especially Matisse who he admired.[4] In contrast to Matisse's *The roofs of Collioure*, 1905 (St Petersburg, Hermitage Museum) or similar Collioure paintings of that period, Leech's *Plage des Dames* is restrained, but Leech's admiration for the work of Matisse is evident not only in his landscapes but also in the pattern and colour of some of his interiors, views through windows and still lifes which he painted later in London. Even in works where the influence of Post-Impressionism is apparent, Leech assimilates these new theories in a restrained way, always allowing his own philosophies and painterly qualities to mould his works, which he,

above all, regarded as "honest and sincere".[5]

Leech's absorption of new influences from Matisse and later Cézanne is assimilated and underpinned by earlier influences in his life, such as Osborne. In *Plage des Dames* the foreground space which curves into the middle distance to the blue sea beyond is reminiscent of Osborne's *On the beach, ca.* 1900 (private collection). This painting was probably exhibited in the Osborne Memorial Exhibition at the RHA in 1903–04,[6] which Leech would likely have seen. Osborne's figures are freely painted with drawn brushstrokes in a fluid, confident manner and merge with the sandy background. Leech's beach huts introduce a more discordant note to the left of the composition, replacing the gentler sand-dunes in the Osborne work.

Colour now dominates Leech's work. He also experimented with surface texture and brushstrokes, which he developed mainly in his beach scenes. This exercise of painting bright sunlight on colour-speckled beaches was, for Leech, the final

liberation from his brown academic paintings into his mature, light and colour-filled works. A continuous examination of the play of light on the scene in front of him enabled him to heighten the *chiaroscuro* effect, and to give equal importance to form and shadow in the overall synthesis of his painting. From this period onwards these factors are particularly evident in his landscape paintings and become his primary concern. He uses colour but it is primarily local colour, heightened and exaggerated under strong sunlight. In *Plage des Dames* his brushwork has attained the fluidity of handling frequent in his work from 1910 onwards – a kind of brushwork which was not only characteristic of the Impressionists but also of painters who were influenced by them, such as Sargent, Whistler and Lavery.

Sydney Lough Thompson painted La Digue at Concarneau frequently, since his home and studio looked out over the quayside. After returning from New Zealand in 1911,[7] Thompson spent six months in Paris, then went to live in Concarneau with his New Zealand wife, Ethel Coe, while Leech lived close by with Saurin Elizabeth Kerlin, who became his wife in 1912. Although she had been in Concarneau in 1903, she had returned to the USA and had attended the School of Fine Art in Boston from October 1906 until May 1909 when she received her diploma.[8] She had progressed from drawing after the antique to life classes and anatomy, basically following a programme similar to the one followed by Leech. She won a scholarship to Europe to study,[9] arriving in Concarneau possibly in 1909 or in 1910. Her landscape paintings have been regarded as faint echoes of her husband's (for instance by Alan Denson) but an examination of her work proves her to be a painter of pattern with a good sense of colour harmonies. It is possible that she decorated some of the frames on Leech's canvases, for instance *Un matin* (cat. 50) and, ironically, *Portrait of Mrs May Botterell* (cat. 57). Two small signed oils on board, *Spring (Printemps no. 2)* (fig. 36) and *Woodland scene*

(fig. 37), in a similar size to Leech's studies made *en plein air*, suggesting that she followed this practice as well. *Spring* depicts a flowering fruit-tree covered in pinkish-white blossoms, painted in staccato strokes. The background is enclosed by a garden wall above which appear the heads of neighbouring trees against a blue sky. The high horizon-line, created by the wall and the diagonal sweep of the green border, suggests influences from Leech, but the paint is applied with a small brush and lacks the underlying confidence and draughtsmanship of Leech. He also painted a work entitled *Spring* (present whereabouts unknown), and exhibited it at the RHA in 1911; during this period Elizabeth and he were painting together and it is possible that it was a similar subject. *Woodland scene* focusses on two thin-trunked trees with a sprinkling of fine leaves against the background of a high garden wall. The trees are similar to those Leech painted in his similarly sized work *Still evening, Concarneau* (cat. 14). The fact that Leech, for more than fifty years and through all his studio moves, had kept these early works by Elizabeth, from a happier time when they painted together, indicates that they were important to him.

Until 1919 Elizabeth played an indelible rôle in Leech's life, as companion and model. Her beauty and presence shine out from many canvases, including *Portrait of Elizabeth* (cat. 39), *The sunshade* (cat. 38), *A convent garden, Brittany* (cat. 37), *The cigarette* (cat. 40) and *L'Actrice (The tinsel scarf)* (cat. 41).

Thompson's friendship was an important one for Leech because Thompson was a very gregarious man, sociable and outgoing.[10] Although they painted together, initially influencing one another, Thompson embraced Impressionism and remained, essentially, an Impressionist painter until his death in Concarneau in 1973.[11] The group of New Zealand painters living in Paris were a further stimulus to Thompson in appraising the new developments in painting. He maintained a very

Fig. 36 Saurin Elizabeth Leech, *Spring (Printemps no. 2)*, oil on board, 26 × 21.1 cm, London, Pyms Gallery

from Manet, and used a semi-naturalistic style with a "fairly light and rich palette".[14] Simon freely integrated figures into landscape and this became a characteristic feature of Thompson's work from then on.

Leech did not follow this path. In fact, Leech's landscapes had increasingly become devoid of people. The freedom Leech gained from painting *en plein air* around the harbour soon evolved into his bolder confident beach studies of strident colour. The earlier detailed figures of *Interior of a café* (cat. 4) became freely painted blobs of bright hues, absorbed in colour with reflected and refracted light. The successful amalgamation of all the influences to which Leech was subjected resulted in colour, light and form merging harmoniously and effortlessly in major works such as *A convent garden, Brittany* (cat. 35).

Fig. 37 Saurin Elizabeth Leech, *A woodland scene*, oil on board, 30.5 × 20.5 cm, London, Pyms Gallery

close friendship with Frances Hodgkins, who had been living in Paris since 1908, and with other New Zealand artists, including Cora Wilding, who recalled how Hodgkins had made her aware of the work of Picasso, Cézanne, Gauguin and other Post-Impressionists.[12] Leech remained close friends with these New Zealand painters whom Thompson knew, notably Frances Hodgkins.

On his return to Paris, Thompson enrolled at the Académie de la Grande Chaumière for painting lessons with Lucien Simon, possibly because of Frances Hodgkins's high regard for Simon. Hodgkins saw Simon as "an artist who played a mediating role against competing artistic directions in Paris during the early twentieth century".[13] Well known for his Breton subjects, he employed broad brushwork, which he is reputed to have adopted

7

The Great War and a New Love

A return to portraiture

With the outbreak of the First World War in 1914, Leech's lifestyle and therefore his painting changed. That year, when he sent five works to the RHA, giving his parents' London address at no. 16, Eardley Crescent, Earls Court, his wife, Elizabeth, who exhibited three works at the RHA for the first time,[1] gave the same address, so we can surmise that they lived with Leech's parents.[2] However, they were both in Concarneau in the spring of 1915,[3] and Leech spent the winter of that year painting with Thompson in Les Martiques, close to Marseilles in the South of France.[4] In the spring of 1918, the four years of the Great War were coming to an end and so, ironically, was Leech's freedom from military service. He was eventually called up in the spring of 1918, after his trip to Les Martiques with Thompson, who also received call-up papers but was past the required age.[5] Leech spent the last six months of the war in a training camp but acknowledged, when writing to Thompson after the outbreak of the Second World War, that he had fared well.[6] Elizabeth had possibly stayed in Concarneau with her close friend Mme Adornay when Leech went painting with Thompson in Les Martiques.

The cigarette (cat. 40) is a portrait of Elizabeth which probably dates from the War period and which was first exhibited in 1916. It is a small-scale work painted on coarse-grained canvas, with thin glazes to represent the satin dress, the patterned rug and the cover of the chair. The light that shines in through the window and catches the unpatterned wall behind is not the sunlight of *A convent garden* (cat. 37) or of *The sunshade* (cat. 38) but perhaps that of artificial lighting, which gives a dramatic *chiaroscuro* effect to Elizabeth's emotionless face and raised hand holding a cigarette. There is tenseness in the pose of Elizabeth, who has moved from being the novice in the garden of the convent to this fashionable lady, whose eyes stare relentlessly out. There is a departure from the textured brushstrokes of *A convent garden* in favour

of smooth glazes to achieve a rich shiny texture in the long elegant satin dress. The War brought changes in women's fashion and attitudes, and food rationing, so that slim women soon replaced the hourglass figures of the old Gaiety girls. Stiff corsets were replaced by camisole bras and rubber girdles, and 'the flapper' had arrived. Women worked long hours in the munitions factories, rode pillion on motorcycles and smoked cigarettes publicly. Elizabeth Leech, however, in her elegant dress represents the fashionable Edwardian figure from *Vogue*, which in 1921 regretted this new woman and yearned for past times: "One cannot help wishing for a less independent, less hard, more feminine product than the average 20th century girl."[7]

The reason for this marked change in style may have been a response to the demand at that time for fashionable portraits of Edwardian affluence and style. *The cigarette* (cat. 40) and *The tinsel scarf* (cat. 41) show the influence of the portrait painters of the National Portrait Society, with whom Leech exhibited from 1915 until 1921. One of the main exhibitors was William Rothenstein, who returned to the work of Velázquez to achieve the 'finish' of his portrait *Girl with tattered glove*, 1909 (National Portrait Society, London). R.A.M. Stevenson's book on Velázquez's painting had been widely influential when it was published in 1895.[8]

After an absence of four years from the RA, during which time he may possibly have been sending work in without success, *Portrait of a lady* (present whereabouts unknown) was accepted in 1914. A work of the same title was exhibited at the RHA the next year, and judging from the price of £89. 5s. 0d., Leech considered it either a major work or did not want to sell it, since it was the second highest price he had allocated to a painting. *'Twas brillig* (cat. 22), the third most expensive work he had shown up to then – *La Bigouden* was the most expensive, at the RHA in 1907 – was priced at £84 in 1910. Leech had already exhibited *Portrait of a lady* in his exhibition at the Baillie Gallery, London, in 1911, marked n. f. s. (not for sale), which is an indication that the painting was significant to him personally. When it was exhibited at the National Portrait Society in 1917, a review in *The Studio* referred to "his beautiful portrait of a lady in rose and grey which was shown at last year's Royal Academy, as well as several landscapes in which his sense of finely modulated tonal harmonies is expressed with a delicate precision".[9] This is possibly one of the first portraits Leech painted of Elizabeth.

Although Leech had begun to attract critical acclaim in London as well as Dublin, it brought little in the way of financial success. *The tinsel scarf* (*L'Actrice*) (cat. 41), which was favourably reviewed by the critics and reproduced in *The Studio* in 1917,[10] and in *The Irish Times* in 1947, never sold during Leech's lifetime. It was purchased from the Dawson Gallery by the Hugh Lane Municipal Gallery in 1976, eight years after Leech's death.

Elizabeth was an exciting model for Leech, a beautiful chameleon in her various rôles. Being a well-to-do American from Boston, she had an independent spirit and natural style. Her own efforts to become a painter pale into insignificance against her rôle as wife and model. A more successful work than her landscapes *Spring (Printemps No. 2)* (fig. 36) and *Woodland scene* (fig. 37) is a decorative panel which she painted for her mother-in-law, Mrs Annie Leech, and which consists of five exotic eastern dancers in an Erté style (fig. 38). *Five dancers* was to fit in with the décor of Mrs Brougham Leech's drawing room in her new home at Porchester Square.[11] Since Professor Leech and his wife lived at this address from 1918 until 1921, it is probable that Elizabeth Leech painted this panel when she returned from France after the War and visited them until both their deaths in 1921. These dates would tie in with the suggestion that Elizabeth painted some of Leech's most decorative frames, which contain many of the elements of her long panel, possibly influenced by Bakst's designs for the Ballets Russes, first seen in

Fig. 38 Saurin Elizabeth Leech, *Five dancers*, poster paint on paper, 56 × 81 cm, private collection

Paris in 1908. Paul Poiret, the dress-designer, was greatly influenced by Bakst's work and he introduced, as a result of this influence, clashing pinks, scarlets and apple-green to replace the half shades of mauve and blue then fashionable. Elizabeth Leech was possibly informed by illustrations in *Vogue* magazine of Poiret's flowing, exotic evening dresses and stiffened over-skirt, inspired by Bakst's designs for the ballet *Scheherazade*. It is easy to see the similarities between Poiret's design and those of the head-dresses and the flowing lines of the dresses used by Elizabeth Leech in her panel. The principal colours of purple and cyclamen, against a stylized background, were chosen to pick up the colour of the silk cushions in the room.[12] The smooth handling of the poster paint effectively captures the pattern created by the dancers' head-dresses and the women's sinuous forms. The trees' viridian-green foliage recurs in the dancers' legs, forming a pattern against the ochre barks of the silhouetted trees which, in turn, are contrasted with their blue background.

If Elizabeth's work shows her awareness of contemporary fashion and her familiarity with *Vogue*

magazine, this interest is also evident in Leech's portrait of his wife in *La Dame aux irises* (fig. 39), probably painted in France, *ca.* 1914, perhaps at the beginning of the War when *Vogue* was full of fashion news from Paris with headlines such as "Paris makes a brave show in spite of guns".[13] Additionally, the first record of this painting is its inclusion in a group of eight paintings, together with *A convent garden Brittany* (cat. 37) and *The sunshade* (cat. 38), which were transported from France on 11 September 1919,[14] suggesting that it was painted in France – but since it is stylistically different, probably at a later date than these two works of *ca.* 1912. Elizabeth poses, hand on hip, behind a vase of irises, and Leech paints one of these to become a flower in the side of her hair. The rich cerises and purples of the petals and their complementary blue shadows bring colour to Elizabeth's black, V-necked dress and black cloche hat. The position of the flowers to the extreme right of the picture plane is a daring compositional arrangement, and is reminiscent of the figure of Elizabeth as the novice moving out to the right of *A convent garden* (cat. 37). The brushwork in the

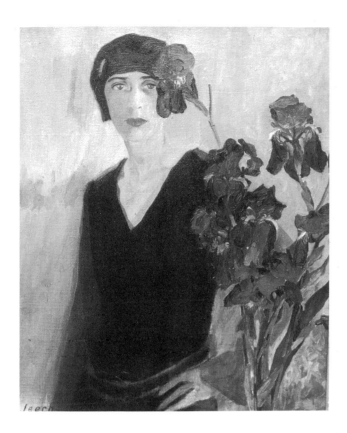

Fig. 39 William John Leech, *La Dame aux irises*, oil on canvas, 66 × 86.5 cm, private collection

painting of the flowers is confident and fluid, applied with a creamy consistency that heralds the painting technique of future Leech work.

When Leech was free to return to his parents' home in London after the War, Elizabeth may still have been in France.[15] The couple had become separated by the War, which must have added further strain and contributed to the failure of their seven-year marriage. The subject of his next and last theatrically posed portrait, *Portrait of Mrs May Botterell* (cat. 45), became Leech's inspiration and companion from their first meeting in 1919 until her death in 1965. Not only did *Portrait of Mrs May Botterell* record the end of his society portraits, it heralded the beginning of a new relationship which shaped his subject-matter and his approach to his work. The portrait was commissioned by her husband, Percy Botterell, and exhibited by Leech at the

Paris Salon in 1922. Although Leech's family initially disapproved of his liaison with May Botterell, out of regard for Elizabeth and concern for May's husband and three children, they nevertheless continued to support him in his struggle to exist as an artist since, now past forty, he had sold little. In 1920, for instance, he sent eight paintings to the RHA, including *The Secret Garden* (cat. 36), and all eight were returned.[16] This pattern became a depressing repetition at each of his exhibiting venues. Through the perspicacity of the RHA who generously paid for the transportation of works from London to encourage a broader dimension to the annual Academy exhibition,[17] Leech was able to continue to send his work. However, lack of financial success, which brings an approbation in itself, is morally destructive for most artists but especially demoralizing for Leech when he was without a personal income, of the kind that Hone, O'Brien and O'Conor possessed.

The Botterell family

Leech had met the Botterell family after their return to London from Holland in 1919 through his brother Cecil.[18] Percy Botterell, an eminent London lawyer, had been a commercial attaché to The Hague during the War, and he now commissioned Leech to paint a portrait of his wife May, another of himself and a portrait of each of his three children. Percy Botterell's patronage was intended to renew Leech's artistic energies and to re-establish him as an artist, but instead resulted in the break-up of Botterell's marriage and the disruption of his family life.

Leech painted a dramatic portrait of May, entitled *Dame en noir* (Lady in black; present whereabouts unknown), which was exhibited at the Exposition d'Art Irlandais in Brussels in 1930.[19] This strongly contrasted black and white portrait of May in a fur coat and pill-box hat starkly highlights her pale face in a way reminiscent of Lavery's portraits of Hazel, as in *The gold turban* (private collection).[20] The

background is in a stylized pattern and Leech uses an oriental-style signature similar to the one he employed in a second portrait of her (cat. 45), also shown in the Brussels exhibition. Leech's *Portrait of Percy Botterell, CBE* (fig. 40) depicts the lawyer in his dark suit, stiff, wing-collared shirt and tie, leaning back in a chair, in a masterful pose with a hint of a leer on his face, eyes slightly closed in an inscrutable gaze. He is portrayed as a saturnine man, his dark hair touched at the sides and temple with grey, whereas the *Portrait of Mrs May Botterell* (cat. 45) gives the impression of coquettishness and gaiety. A contemporary photograph of Percy, together with his wife, Leech and Suzanne, shows Percy slightly removed from the group (fig. 41), a handsome man with dark looks, who remained generous to his wife to the end.[21]

Leech also painted the Botterell's eldest son Jim (fig. 42) *ca.* 1923, when he was seventeen years of age and a boarder at Winchester.[22] This painting was exhibited at the RHA in 1926. A contemporary photograph, taken at no. 24, Hamilton Terrace, London – his mother's address independent from the family home at Coombe-Edge, Hampstead, while Leech had a studio nearby in Hamilton Mews[23] – shows Jim as a tall, handsome young man.[24] The portrait of Guy, painted the same year (fig. 44), depicts him as a gentle, vulnerable fifteen-year-old, and a photograph of Jim and Guy in a boat on the lake in Colne Park, the Essex estate owned by their maternal grandfather, shows them enjoying the freedom and amenities of this very extensive estate where their father, Percy Botterell, had grown up as a boy.[25]

Leech's own family

Brougham Leech ended his own life at his London home, no. 19, Porchester Square, on 2 March 1921 at the age of seventy-eight.[26] A photograph (fig. 45) shows Professor Brougham Leech the summer before he died with his two sons Bill and Cecil, his

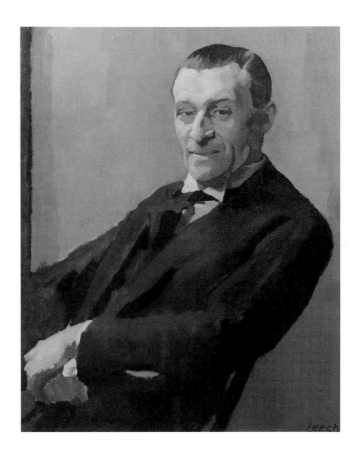

Fig. 40 William John Leech, *Portrait of Percy Botterell (CBE)*, oil on canvas, 76.2 × 63.5 cm, London, Pyms Gallery

Fig. 41 *May, Percy and their daughter Suzanne Botterell, with Bill Leech*, photograph

daughter Kathleen Cox, and her two children Sylvia and Cecil. After Brougham Leech's death, his wife Annie Louise came to Wolverhampton to be cared for by her daughter, but died a few months later in the October of the same year. Bill Leech inherited only personal effects, as detailed in the will drafted on 11 June 1918:[27] "I leave to my third son William J. Leech the gold medal awarded in 1906 to the dear boy who had gone before and any books on subjects connected with art which he may wish to have. I leave to him also all my pictures and picture frames...." The bequest indicates the closeness Bill shared with his younger brother Freddie, and highlights the loss he must have experienced after his brother's tragically young death. The frames bequeathed to Leech were possibly used for his own work, and the paintings he inherited may have been sold. His Hamilton Mews studio, acquired the previous year, was now his base in London. With the exception of his stays in Paris, Switzerland and Brittany, Bill had lived at his parents' home for forty years.[28] Brougham Leech's original will had included Elizabeth Leech as a beneficiary but he added a codicil, the day before he died, to take into consideration his altered financial status and Bill's estrangement from Elizabeth.[29] In fact the estate was encumbered with debts, which Cecil cleared, and also took over the task of supporting his brother Bill until his own death in 1952.

After the death of his parents, Bill spent long visits with his only sister, Kathleen, and her husband Revd Charles Cox at Tettenhall Wood Vicarage, and became intricately connected with Kathleen and her family. Their children, Sylvia and Cecil, have happy memories of him, as a charming uncle, who played with them and delighted them with tales of his student days in Paris.[30] Bill Leech himself, approaching eighty, nostalgically recalled these days when he wrote to Sylvia, "I often remember the gay times we used to have at Tettenhall Wood".[31] Even though the Cox family

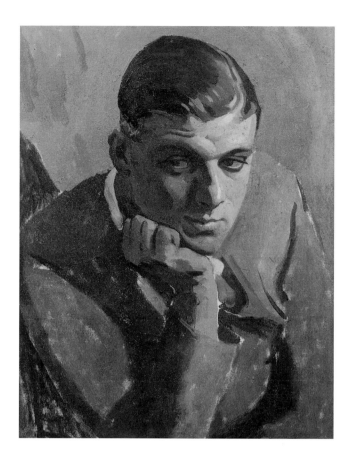

Fig. 42 William John Leech, *Portrait of Jim Botterell*, oil on canvas, 69.2 × 50.8 cm, London, Pyms Gallery

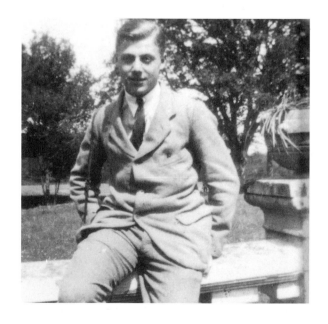

Fig. 43 *Jim Botterell*, photograph

Fig. 44 William John Leech, *Portrait of Guy Botterell*, oil on canvas, 73 × 57.2 cm, London, Pyms Gallery

lived on a vicar's income, Leech found a haven at his sister's house,[32] spending at least a month each year there, painting works which he left in lieu of hospitality.[33] During these visits he painted his niece and nephew several times, as well as his sister Kathleen and her husband the Revd Charles Cox, whom he drew in charcoal (fig. 46) and then painted in oil by gas-light.[34] This portrait (private collection) shows a striking likeness to photographs of the Revd Charles Cox, demonstrating not only Leech's method of using charcoal as the basis of his preliminary work, but also his natural facility to capture a good likeness. Painting portraits by artificial light was a practice he continued in London, as in his *Portrait of Sydney Lough Thompson* (fig. 47) and *Hanni Davey* (cat. 93).

Bill and May

Leech's relationship with May Botterell brought him new personal happiness but neither was free to marry because of their existing spouses and her young family. Although May effectively left Percy to live on her own close by to Leech, the Botterells maintained a close family relationship, with May spending time at the family home with her children. May relied on her own allowance of £600 per annum from her father, Isaac Pearson,[35] and refused her husband's offer of further assistance. Percy Botterell, however, was generous with gifts of champagne, wine, and invitations to Sunday lunch in London restaurants, and even provided her with an Austin Seven car, but, much as he hoped otherwise, his wife never tired of Leech.[36]

After falling in love in 1919,[37] Bill and May were as inseparable as circumstances allowed, and it is evident from family photographs that Leech was accepted by the Botterell family. This relationship had a profound effect not only on both their lives and on their families' lives, but also on Leech's painting. His subject-matter became more preoccupied with portraits of the Botterell family and especially with May and her friends as portrait subjects. The relationship brought personal stability and a degree of financial security to Leech, which provided him with the opportunity to remain selective about his subject-matter and with the time for experimentation, trial and error.

Bill's ten-year relationship and marriage to Elizabeth Leech was ended and, inevitably, Elizabeth ceased to be his model, superseded by May Botterell also as confidante. The style of his paintings of May began to move away from society portraits, to become less formal in their poses and more *intimiste* in mood. Leech had inevitably become more influenced by English painters such as Augustus John, and later the Bloomsbury Group and the work of Duncan Grant in his decorative still lives and flower pieces. His life became more settled and revolved around May and her circle of friends. He

Fig. 45 *Professor Brougham Leech* (centre), *with his sons Cecil* (left) *and Bill* (far right) *and daughter Kathleen Cox, and her children Sylvia and Cecil*, photograph

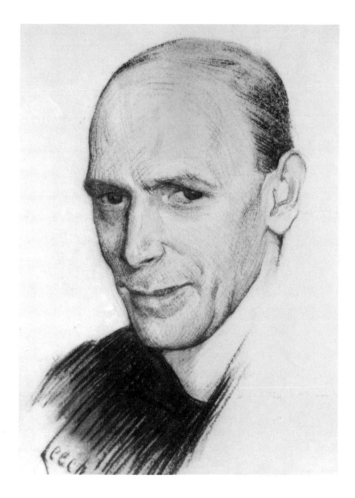

Fig. 46 William John Leech, *The Revd Charles Cox*, charcoal on paper, 76.2 × 67 cm, private collection

painted in his London studio, or, on his annual trips to France each spring, painted May as she walked on the beach, as she lay reading on a bed or, in later years, in front of the fire or darning close to the window. He tried to capture these moments in paint as arrested movement rather than as formal studio poses. His dramatic society portraits, which he had exhibited at the Society of Portrait Painters with Steer, Lavery, John and Rothenstein, were not repeated and Leech stopped exhibiting with the Society in 1921, after showing *Portrait of Mrs May Botterell* (cat. 45). His friendship with May, and his continued friendship with Sydney Thompson and his family, resulted in frequent visits to the South of France and only occasional visits to Concarneau, which by then had ceased to be an important stimulus for his landscape paintings.

In 1921 Leech stopped exhibiting at the NEAC, also at the Walker Art Gallery, Liverpool, where he had sent pictures from 1919. He continued to paint full time, to maintain a studio, to send works to the RHA; also to exhibit at the Goupil Salon in London until 1928, and at the autumn exhibition of Modern Paintings in Oils and Watercolours at the Museum and Art Gallery, Derby, from 1921 until 1933, but after his meeting with May Botterell he maintained a much lower profile, which was not conducive to his promotion as an artist.[38] However, in 1927 he had an exhibition at the Cooling Gallery in New Bond Street, London, to critical acclaim which seemed to indicate that he had re-established himself on the London artistic scene at the age of forty-six and that he would progress further in the future. No catalogue of the exhibition has been located but the review in *The Times* is comprehensive and laudatory.[39] However, this was to be Leech's last major exhibition in London and his last one-person exhibition anywhere until Leo Smith presented his work at the Dawson Gallery in Dublin in 1945, nearly twenty years later. Perhaps the favourable review in *The Times* in 1927,[40] asking for Leech "to be better known in London", signalled to him in

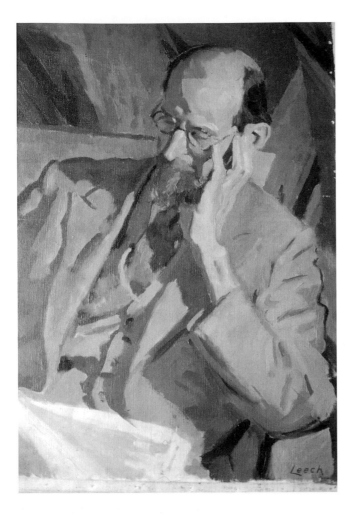

Fig. 47 William John Leech, *Sydney Lough Thompson*, oil on canvas, Pont-Aven, Musée de Pont-Aven

an alarming way the potential publicity such success would bring him, with the fear of exposure of his personal life.[41] His love for May meant that though he continued to paint he effectively sacrificed the London arena of public acclaim or critical assessment which he needed as an artist to keep on striving towards new horizons in his painting.

New locations and the Aloes series

Every springtime Leech and May Botterell went to France for two or three months.[42] There is much evidence to show that May and he shared this love of France, its climate, its culture and its language, and if circumstances had not dictated otherwise,

then they would have spent even more time in France, as he had done before the outbreak of the First World War.

The first pictorial evidence that Leech had moved to the South of France in search of subject-matter is a small painting *A farm house – Grasse*, exhibited at the RHA in 1916, which was possibly a watercolour judging by its price of £5. 5s. 0d.[43] Leech began to use watercolour more frequently to capture contrasting light and shade on the unfamiliar landscapes of the South of France. It was also a more convenient medium for him to use as he travelled about in search of suitable subjects. During his stay in Concarneau, where he had a permanent studio, his use of watercolour was rare. When he travelled through France and Italy, in 1911, he had used watercolour frequently to paint the landscape. Responding to intense sunlight with fluid brushwork, Leech now achieved an intensity of colour and a strength of composition which were unique to him. The more academic portrait painting of the War years was superseded by these brighter, freer paintings which developed the colour used in his Brittany paintings of 1910 onwards.

While the Great War was still running its course, in the winter of 1917, Leech had gone with Sydney Thompson to Les Martiques, a small fishing village near Marseilles, where he began a new series of paintings of aloes (see cats. 49, 50, 51). Augustus John, Leech's contemporary and acquaintance,[44] had painted in Les Martiques in 1910, and the results of this visit, about fifty paintings, were possibly seen by Leech when they were exhibited at the Chenil Gallery.[45] John's *The blue pool*, 1911 (Aberdeen Art Gallery), demonstrates how he has assimilated the colour, pattern and form of the Post-Impressionists: Cézanne in the far headland and Matisse in the touches of orange against the cobalt blue of the water. These works would have had an effect on Leech, coming immediately after the Roger Fry exhibition of 1910, which was the period when strong colour entered Leech's painting.

Leech approaches his aloes with a heightened awareness of colour and pattern. He transforms the jagged cactus leaves, bathed in intense heat and sunlight, into decorative, writhing forms. The aloes grow as part of a panoramic landscape in nature but Leech selected and enlarged, on canvas, areas of cactus growing against the undergrowth, freeing the image from mere representation and imbuing the cactus leaves with vitality and a personality of their own. Decorative pattern and a heightened palette are characteristic of this small series. Of the powerful impact they have on the viewer, Kenneth McConkey has written: "the sheer exuberance of these works, their bright synthetic colours, create an almost hypnotic effect".[46]

Some of the *Aloes* which he painted in Les Martiques were exhibited at the Cooling Galleries, London, in 1927, and the reviewer in *The Times*, who remembered Leech's "pre-war exhibitions, paintings by him of snow in sunlight, owing their appeal to the refinement of the relation of colour in shadow", now referred to this later work as "more robust, but colour in shadow is still the prevailing motive"; he also observed that we should "relate Mr. Leech to the Impressionists, but his technique is unbroken, and his feeling for decorative pattern brings him into line with later developments". Two of the paintings noted as "excellent" were of his *Aloes* series: *Aloes and a sunny field* (possibly cat. 49) and *A cactus hedge, Tunisie* (whereabouts unknown).

Leech exhibited some of the *Aloes* painted on his trip to Tunis in 1920 (see below) at the RHA exhibition in 1921, and he included *Hammamet, Tunisie* the next year at the Royal Academy in London. Most of these paintings, or at least paintings with the same title, he exhibited at the RHA in 1923.[47] The aloes theme was continued when he was working, at this period, near Grasse in the South of France. *Aloes near Grasse* and *Aloes and poplars* were exhibited at the RHA in 1923, and he exhibited *Aloes and poplars* again at the Goupil

Gallery Salon, November–December 1920. In this Goupil Gallery Salon he also exhibited *A dying aloe. Aloes near Grasse*, exhibited at the 1921 RHA, was also exhibited at the 1922 Royal Academy exhibition.

By 1920, however, Leech seems to have ended his series of aloe paintings. They are magnificent, exuberant paintings, on a much larger scale than Leech's other work. Possibly the freedom from representational restrictions allowed him the freedom to paint a motif ungoverned by scale.

Tunisia, winter 1919 and spring 1920

Perhaps following in the footsteps of John Lavery, or like him and others who went in quest of more exotic subject-matter, Thompson, Leech and May Botterell went on a painting trip from December 1919 until April 1920.[48] Unlike Lavery, however, Leech did not paint Hammamet's Moorish architecture in the intense heat and light of the North African sun,[49] but aloes, olive trees and colourful beach scenes of May walking on the sands. A series of four paintings of May walking on the beach in a long white robe (see fig. 48) vibrate with colour and begin a new series of beach paintings which exude happiness. This figure of May becomes the focus of many of Leech's paintings of this period, in *The opal* (private collection), and in *Pink parasol* (cat. 58) or *Paper parasols* (cat. 57). *Beach parasols, Concarneau* (fig. 49) combines this figure of May with figures of children on the beach in Concarneau, showing how Leech put together different elements from his initial sketches. In 1922, Leech exhibited six paintings at the RHA, of which three were *Paper parasols* (cat. 57), *A blue parasol* (whereabouts unknown) and *The opal*, which were studies of May Botterell on the beach, carrying a parasol as protection against the intense heat of the South of France sun.[50] He had already exhibited one of this series, *Children on a beach* (present whereabouts unknown), at the Goupil Gallery Salon in 1921 and again at the RHA in 1923. The review in

The Times in 1927 likens Leech to the Post-Impressionists:[51] "'Children and Shadows' of trees painted against the sun, is a little like Van Gogh." This last painting was exhibited at the RHA in 1920 as *Les Enfants et les ombres* (present whereabouts unknown),[52] and Mrs Cecil Leech, herself a capable artist, remembered it as one of his most beautiful paintings. The review in *The Times* continued to praise Leech, stating that irrespective of "whatever he derives from Mr. Leech is a very accomplished painter, following out the relations of colour produced by sunlight with breadth and simplicity, a nice feeling for pictorial balance and a pleasing

Fig. 48 William John Leech, *May Botterell on the beach*, oil on canvas, private collection

surface quality".[53] Leech first included children in a landscape in *'Twas brillig*, 1910 (cat. 23).

St-Jeannet and Cassis

Leech's paintings at this time concentrated on his location, and his personal happiness is now evident in his works, in the colour, light and freedom of execution. He chooses to depict what would appear to be an uneventful aspect of a garden or a house in a landscape, examining in paint whatever subject was close by and imbuing it with his artistic interpretation.

The following winter after Tunisia, Leech rented a house high up in the rocky hillside town of St-Jeannet, a house which looked down over the valley to the sea at Nice.[54] Leech sent *St-Jeannet, near Nice* (present whereabouts unknown) to the RHA exhibition in 1926, and the review in the *Irish Statesman* by Y.O. (A.E. or George Russell) commented: "Mr. Leech sends us a mountain, St. Jeannet, this year, instead of the monstrous sunlit vegetation he was absorbed in for so many years. It is a welcome change...."[55] He certainly did not like Leech's *Aloes*. If A.E., with his intellectual and artistic ability as painter and writer, regarded Leech's *Aloes* with such disdain, then he had little hope of convincing the general public. A.E. discusses *St-Jeannet* at length, concluding that "the composition and colour please in this picture".

Leech's house was adjacent to the St-Jeannet cemetery, and *La Cimetière de St-Jeannet* (cat. 66) includes the panoramic view of the valley that Leech enjoyed from his house, a view which has changed little even today. At St-Jeannet, Bill and May lived quietly in privacy away from the coast for a few months each year until 1926. The Thompson family were frequent visitors, travelling from their house nearby at Cros de Cagnes where they stayed each winter until they returned to New Zealand in 1933.[56]

Leech kept the house at St-Jeannet for about seven years, although even after he had given it up

Fig. 49 William John Leech, *Beach parasols, Concarneau*, oil on canvas, 56 × 68.5 cm, private collection

he continued to go to the South of France with May Botterell in the spring of each year. They stayed in hotels for three months at a time: at Cagnes-sur-Mer, at the Hôtel Para Palace in Grasse, at the Grand Hôtel on the route Magagnosc in Grasse, and at Robins Hotel, La Verrarie, outside Cassis. They were often in the company of Dr Helena Wright and her family on these spring visits, which continued until the Second World War broke out.[57]

Cassis is a town close to Marseilles, around the bay from Les Martiques where Leech had first visited in 1917, resulting in his first paintings of aloes. Several Cassis landscapes now emerge at exhibition. In one such (private collection) his characteristically high horizon-line, which is created by trees and a farm building, frames the top of the work, and the fields in-between are awash with lavender and blues. Frances Hodgkins visited Cassis in the winter of 1920 and described the place in a letter of 21 December:[58] "This place is off the beaten track, not far from Marseilles, on the coast, much fre-

quented by artists on account of the landscape." The sunlight and landscape of the South of France released a new freedom and enjoyment in Leech's work and his return in the spring of each year was a rebirth and an awakening after the English winter. In December 1950, Leech expressed nostalgic feelings in a letter to Leo Smith: "The winter is a trying time now that I cannot go to the South of France, I work so much better and more easily from nature."[59]

Nice and Grasse

During his stays in the house he had rented at St-Jeannet, Leech painted the area in and around the nearby seaside town of Nice. In *The Château gardens – Nice* (private collection) Leech used the paths and luxuriant growth to create a watercolour of decorative shapes in a Douanier Rousseau manner, much more exotic than his *Regent's Park* series of just over ten years later. The harbour at Nice also provided him with one of his recurring motifs, boats

and water (cats. 70 and 71), and he produced a series of brightly coloured oil-paintings of the harbour in which the Whistlerian tonality of his Concarneau harbour scenes has been replaced by a full palette. Warm ochres and Indian reds contrast against the bands of blues and greens of the harbour water. Leech once again uses the palette of *Caves at Concarneau* (cat. 33) or *Seaweed* (cat. 34) but with a smoother brushstroke and without the writhing texture of his earlier work.

Leech continued to paint the Grasse area and the soft tones of the houses in the Provençal town (cats. 72, 73, 74). In *Steps to the cours* (fig. 50), in which the glow of the early-morning winter sunshine adds a deeper tone to the siennas and ochres of the winding steps, the balustrade and the houses, harmonizing with the soft greys and blues of the buildings and of the sky behind, Leech creates a pattern of shapes which nears abstraction in the painting of the shadows and of a faded poster on the wall. The tonality of this landscape would be repeated in St Paul's (cat. 101) over ten years later. His painting style becomes closer to that of British painters, such as Paul Nash (for example, *Pillar and avenue*, 1943, London, Tate Gallery), as colour is reduced to tonal harmony applied in smooth, thicker brushstrokes.[60] *Steps to the cours* was taken to New Zealand by Mrs E. Murray Fuller, a Wellington art dealer, and exhibited at the Canterbury Society of Arts in May 1936. Sydney Thompson was back from France, and as president of the Canterbury Society of Arts opened the exhibition.

Fig. 50 William John Leech, *Steps to the cours*, oil on canvas, 73 × 60 cm, Christchurch (NZ), Robert McDougall Art Gallery

8

Middle Age in the Inter-War Years; the Second World War

Steele's Studios, London

It was about the time of his exhibition at the Cooling Galleries in 1927 that Leech rented no. 4, Steele's Studios, and he gave this address at the RHA for the first time in March 1928. He was then forty-seven years old.[1] These purpose-built artist's studios in Hampstead were owned by Eton College and still exist today (figs. 51, 52) in more or less their original state: a single row of four mews-lane studios with high clerestory windows letting in clear northern light into a large room with a galleried bedroom above, and with a small kitchen and model's changing room. Outside the front door is a gravelled laneway with climbing roses and absolute tranquillity, broken only by birdsong, belying the fact that the main thoroughfares and bus-lanes of London are just yards away. No. 4 was the end studio, much larger than the others, detached in its own garden and entered through a gate at the end of a wall, as if entering 'A Secret Garden'. Leech's studio area was large and elegant, and much brighter than the other studios since he had the advantage of having windows on either side. In the 1930s Miss E. Aitken lived next door in no. 3,[2] and in no. 2 the artist Edmond Kapp, almost a contemporary of Leech's, lived and worked. His widow still lives there[3] and she remembers Bill and May as a quiet couple who drove past the back entrances in their Austin Seven, sending the gravel flying as they drove out to the country for outings, no doubt for Bill to paint and May to read, as was their practice.[4]

C.R.W. Nevinson ARA occupied Studio 1a and 1b, the end studio nearest the gate and entrance, from the 1930s until his death in 1942, and his wife continued to live there for approximately three years after his death.[5] The original front doors of the studios opened on to the back gardens and pedestrian access was through the back gardens, including Nevinson's. Leech disagreed with Nevinson's having planted a hedge, obstructing the right of way for himself and other neighbours, and when he

Fig. 51 *No. 4, Steele's Studios, Hampstead: garden view,* photograph

Fig. 52 *No. 4, Steele's Studios, Hampstead: interior,* photograph

refused to remove it, Leech cut it down in the middle of the night.[6] Although Leech and Nevinson shared neighbouring studios from 1928 until 1942, they never became friends, and their differing concepts and attitudes to contemporary painting did little to help. Nevinson had also studied in Paris at Julian's Académie, in 1912–13, ten years later than Leech.[7] His work derived from Cubism and Futurism, and his paintings of the 1914–18 War with their sense of relentless and dehumanized movement are products of this enthusiasm.[8] Apart from their personal differences Leech's appreciation for modern art stopped at Matisse and early Picasso. He had no appreciation nor sympathy with abstract work. "I would believe in 'Modern Art' if the pictures were

not so like each other. I do believe in, and like very much those that show sincerity and personal vision such as Braque, Bonnard, and some of Picasso and others, but the horde of so called artists that simply follow these men without conviction of their own must be found out in time for the cheats they are."[9] His attitude to modern art is further illustrated in his letter to his niece Sylvia in 1966 about the art classes she was going to: "Those classes you go to seem to be fun, I suppose it is all the ultra modern stuff. It ought not to be difficult!"[10]

Braque and Picasso were Leech's contemporaries, Picasso an exact contemporary, Braque a year younger. Leech, although familiar with their work and their revolutionizing pictorial boundaries,

was not prepared to stray too far from the naturalistic path he had chosen. He appreciated Picasso's early work, probably his 'pink' and 'blue' periods and perhaps his Cubist work when he collaborated with Braque,[11] but Leech disliked the Picasso show at the Victoria and Albert Museum, London, in December 1945, which he denounced as "exhibitionism".[12]

In 1928, Leech's life centred around Steele's Studios and May Botterell's flat close by, at no. 20, Abbey Road, St John's Wood. This pattern remained constant from 1928 until the outbreak of the Second World War; he had ceased using this address by 1941,[13] possibly because of bomb damage during the Blitz. From this period, the address he gave when exhibiting was no. 20, Abbey Road. He appears to have sold his lease on the studio in 1948.[14] After his marriage to May in 1953, following the death of her former husband Percy Botterell, the couple began to look for a house outside London.

During the 1930s Leech exhibited at the RHA fewer and fewer pictures painted in France. He began a series of paintings of Regent's Park, executed when the weather was fine (see cats. 87 and 88); otherwise he painted a series of still lifes, portraits and self-portraits in his studio. May's daughter-in-law Eileen recalled, "All his painting during that time was done either in his studio or outdoors in the Regents Park – mostly during the thirties".[15] His work became more introspective, with a limited range of everyday motifs — tulips, bird baths, flowers on window ledges, still lifes reflected in mirrors. The vivacity and luminosity which he had captured in his Tunisian and French landscapes were channelled into still lifes, interiors and flowers on sunlit window-sills and on tables bathed in light. The lack of sunlight to some extent curtailed the strength of his colour, although the colour and the decorative elements of his *Aloes* series of the 1920s were carried on in his many later flower-paintings. These continued to be, for Leech, a challenging study. In later life, Leech wrote to his friend Sydney

Thompson: "I am painting very simple things – Still lifes, mostly without flowers, so that I only have the changing light to compete with, quite enough, and I learn what I can."[16] In a letter to his close friend and unofficial 'pupil' of the 1930s, Dr Helena Wright, he reinforced this approach when he advised her, "Choose simple things, they are the most interesting."[17]

This change of subject-matter was possibly influenced, too, by his English contemporaries. Augustus John's *Cyclamen* was reproduced in 1937 in *The Studio*, in an article entitled 'How to Look at Flower Paintings' by Nadia Benois. When referring to Matthew Smith's *Tulips*, Benois stated: "His main interest is composition in colour."[18]

"The closest search for beauty"

In Steele's Studios, *ca.* 1938, Leech began a series of studies of a South American model, at about the same time as, in Brittany, Sydney Thompson was painting *Josepha*, 1938 (Hocken Library, Dunedin), a model from Martinique.[19] The painting of a black model, at this period, seemed to be fashionable. Of the seven paintings Augustus John had reproduced in *The Studio* in 1938, two were *Two Jamaican girls* and *Hazel*, a little black girl with pig-tails. Maxwell Armfield remarked in his article, "And why all these negresses? Where did he paint them, and why?"[20] Leech was therefore aware of current trends but it is difficult to know whether Thompson influenced Leech on this occasion or whether Leech influenced Thompson from England because of his friendship with Augustus John. Leech's 'glass studio'[21] at no. 4, Steele's Studios made painting from the nude possible in England, something which was much more easily achieved in France with its warmer climate.[22]

His series with a "black" model (see cats. 89 and 90) is the last nude series in Leech's œuvre. He nevertheless regarded the study of the nude figure highly, as he explained to Dr Helena Wright: he saw it as "the closest search for beauty".[23] "In our search for beauty, I sometimes think, we have a better

chance of getting near it, with the figure than in any other way, who knows."[24] Perhaps his ending of painting the nude was determined more by the availability of models than by any other factor. There was a greater availability of models in Paris; Sydney Thompson's model Josepha had come from Paris to Pont-Croix, where Thompson was painting, and William Scott negotiated the hiring of models from Paris when he was teaching and painting at Pont-Aven. Though models were obtainable in London, too, the task became increasingly difficult. Living in Surrey in the 1960s, Leech asked *Chloe Abbott* (fig. 59) when he was painting her portrait to pose in the nude for him, but she was unwilling.[25]

London and the country

When Leech was unable to go to the South of France, he found the English weather depressing. The light, colour and pattern of aloes bathed in strong sunlight and views of Grasse, Nice and St-Jeannet were never surpassed once Leech moved away from this source of inspiration. He and May had been invigorated by their trips back to Grasse each spring after the grey English winters. The Thompsons, too, returned to New Zealand at the end of 1938, although May and Bill continued a correspondence with them. Leech constantly referred to the weather in these letters and wrote: "Here we are swimming about in fog so that everything, including one's mind, is dim, while you are in glorious light painting like mad. I suppose in your country you can see even in the Winter. How right the English are to call their country 'Blighty'."[26] Interestingly, in this last sentence, he obviously does not regard himself as English, but as an Irishman living in England.

Leech turned to locations close at hand for landscape subjects. Regent's Park was a short walk downhill from his studio and it provided a range of subject-matter, such as cats. 87 and 88 and *Queen Mary's Gardens* (private collection), *York*

Fig. 53 William John Leech, *A rowing boat in Regent's Park*, oil on canvas, 24.1 × 19 cm, Dublin, Hugh Lane Municipal Gallery of Modern Art

Bridge (private collection) and *The lake, Regent's Park* (private collection). Each season brought different tonal values to Leech's depiction of the weeping willows, the grey of York Bridge or the varying reflections on the grey water under the bridge. He used his travelling box to paint on small panels *en plein air*, as had been his custom in France. Several of these panels were of a small rowing boat, as in *A rowing boat in Regent's Park* (fig. 53), which is seen from above as it rounds the bend on the river. The boat is framed by the far sunlit bank, in soft greens and yellows, and the boys' figures in the boat are freely captured in bold brushstrokes of colour, blue, pink and white. These are the most colourful of Leech's Regent Park series. He achieves depth and recession, and yet maintains the surface of the water as a solid expanse while

Fig. 54 William John Leech, *In Regent's Park*, oil on canvas, private collection

retaining its inherent fluidity. The paintings are full of the sunshine and laziness of summer but Leech painted in Regent's Park throughout the year, even in the winter months. His Regent's Park series is possibly Leech's longest, comprising over twenty known works. There is a small study for the larger painting *In Regent's Park* (fig. 54), indicating that Leech used these little panels to paint *en plein air* in Regent's Park and then develop the work, on a larger scale, in his studio. This was a practice Leech began in Concarneau and continued until he stopped painting landscapes in the early 1960s. He wrote to Leo Smith in January 1953 telling him that he was still painting in Regent's Park at that time.

Having his studio in London, Leech's work became less rural and more restricted; his trips, in May's Austin Seven car, to paint countryside scenes became fewer and fewer. However, both during the 1920s and in the 1930s frequent and extended visits to Leech's family, especially to his brothers Cecil and Arthur and to his sister Kathleen, afforded him the opportunity to paint out of London. On leaving the Royal Artillery, Cecil bought a farm at Wiltsham, Ham Green, in Kent in 1924, and Bill painted

the surrounding landscape, some farmyard scenes, possibly May's daughter Suzanne (cat. 99) and the plum orchard, which became the subject of his painting *Back of Wiltsham at Ham Green* (private collection). This freely painted landscape captures, in an orchard of plum trees, the quintessence of an English summer's day: the bright colours of his French landscapes have been replaced by a green lushness.[27] Leech painted other landscapes of the area; one of these, *Hop field, Kent* (private collection), exhibited at the RHA in 1928, may possibly have been a watercolour, considering the price of £7. 7s. He also painted freely executed studies of the *House near Ham Green* and three other studies of his farm with sheep grazing.

Leech's older brother Arthur moved to Saxmunden in Kent in the early 1920s to share a house with Harry, his brother, who retired from being a doctor in Hatton Hospital. Saxmunden did not have a farm but merely some fields to keep Arthur's horses since he had become a partner in a riding-school.[28] Bill and May sometimes rented a modest cottage close by at Saxmunden for the summer months, and Leech painted in the area. One of these works, *The pig-stys* [*sic*] *Saxmunden* (private collection), *ca.* 1933-34, is a pleasant grouping of farm buildings in the corner of a field.

Following his marriage in 1929 to Ellen Mabel (Babs) Stevens, Cecil moved to a house he built in Devon in the midst of fields planted as apple orchards. Leech's journeys to Devon extended to a trip to Looe in Cornwall, recorded in a watercolour which he showed at the RHA in 1931. 'Babs' was an accomplished artist and draftswoman; she posed for Leech during an extended visit in 1941, although Cecil disliked the result. One fine work he painted there was *The gate* (fig. 55), depicting the view through the gate at the edge of the apple orchard out to the distant hills of the Devon countryside. Sunlight created by the warm ochres and siennas once again floods into Leech's work, and the light and colour of his Brittany paintings is again recognizable.

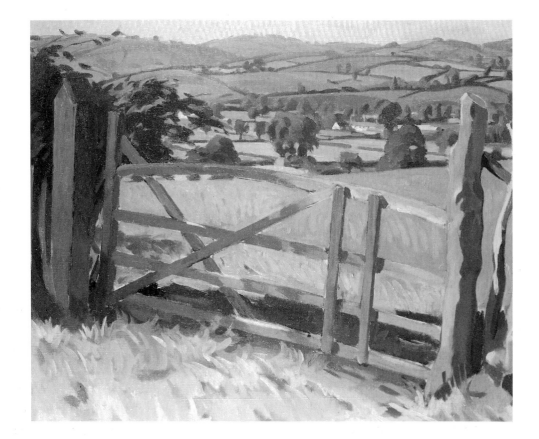

Fig. 55 William John Leech,
The gate, oil on canvas,
54 × 65 cm, private collection

May's flat in no. 20, Abbey Road, St John's Wood, became the meeting place for many of May and Bill's close friends. These were an interesting group of intellectuals who were companions and associates of the main Bloomsbury set. Dr Helena Wright, a liberal, influential medical doctor who campaigned for sexual freedom and contraception for women, and was author of *The Sex Factor in Marriage*, became their lifelong friend. Not only was Helena Wright an eminently famous pioneer of family-planning clinics and a renowned gynaecologist, but she was an accomplished amateur painter who was determined to learn from painters such as Leech. From 1934 until the outbreak of war in 1939, the Wrights holidayed in Provence twice a year, and they usually travelled to the same location as May and Bill when they went for their three months in the spring. Helena Wright's son Beric remembers "Leech teaching his mother to paint in blobs with Fauvist colours and with simplification

of forms".[29] Leech shared intellectual discussions with Helena Wright about painting, and in a letter written to Helena in the early 1930s he clearly sets out his own approach to composition and the craft of his picture-making:

"I am writing to you to try to answer questions that you have asked me. The questions you ask are the kind that one cannot answer at the moment because they set one thinking.

"You said you had come to a place in your work as a painter and stuck. One has to come to several of these sticking places, its a good sign I think. Now I think you would get over this place if you did as follows. Get a drawing board good size, charcoal (not pencil) and good sized sheets of paper tinted or not, tinted would be less trying to the eyes. Then start to draw landscape instead of painting it. Now I don't mean by drawing what is generally meant by drawing. I am going to take this advice too. I want you to draw not merely to represent what you

see, but to draw in order to teach yourself to see. This puts me in mind of a definition of a genius – one who sees what others look at. I dare say you have come across it too. You must not be in a hurry, and you must not draw or paint everything or anything. You must search till you find some arrangement of lines that speak to you, then sit and contemplate it for a long time. ... Goodnight Helena. I hope this helps you a bit. By the way my sensation that I had my back to the direction in which I was going was perfectly right now I come to think of it, I had my back towards the East. I hope you ... are doing good work. Choose simple things, they are the most interesting."[30]

Helena and another close friend, Bruce McFarlane, a history don at Oxford, owned many of Leech's paintings, which Helena kept at her country home near Aylesbury and in the family house in Randolph Crescent, London.[31] Leech was commissioned by Helena's husband Peter, who was also a doctor, to paint his portrait, which Leech exhibited at the RHA in 1947. It is a gentle study of the man, captured in soft light and in a subdued palette. Yet it is painted freely and is consistent with Leech's London portraits of the 1930s and 1940s – further emphasizing that although Leech was a proficient portrait painter he was only happy when painting his friends. He also continued to paint watercolours and it is interesting to note, "There was a watercolour of a stallion by her friend 'Billy' Leech whose paintings also adorned her rooms in London, and the nude which Eric Gill had given her."[32] More specifically, "Above [Wright's] examination couch hung a Gill drawing, for demonstration purposes, showing the penis from the lateral view."[33] Eric Gill was a contemporary of Leech's and a friend of William Rothenstein, who painted a portrait of Gill and his wife, and he was also friendly with Augustus John. Gill, too, helped Helena with her painting,[34] and it would be reasonable to surmise that Gill knew Leech, and May Botterell.

May Botterell was highly influenced by the Bloomsbury Group and wished to be part of it and its aims.[35] She shared the Bloomsbury group ideal of the pursuit of beauty.[36] That Helena Wright knew Vanessa Bell, too, and her sister, Virginia Woolf, increased the Bloomsbury influence on Leech, and it seems probable that he would have met Duncan Grant. Iris Tree was a frequent visitor to Augustus John's home at Alderney and she was also a visitor at Charleston, the home of Vanessa Bell, Duncan Grant and their friends, and had been painted by both Vanessa Bell and Duncan Grant.[37] Grant's *Portrait of Iris Tree*, 1915 (Reading Art Gallery), in its freedom of paint handling and its use of colour and simplified forms, is echoed in Leech's paintings of May in informal poses. There is a suggestion, too, of Leech in Augustus John's portrait of *Miss Iris Tree* (Dublin, Hugh Lane Municipal Gallery of Modern Art) in the diagonal pose of the figure and the bold simplification of form and colour against the background. Leech's subject-matter from the 1930s onwards became similar to the subject-matter of the 'Bloomsbury' painters, Duncan Grant, Vanessa Bell and Roger Fry. Their focus was more with private than public concerns, and by their example they may have influenced Leech to paint purely for 'art's sake'. In retreating from confrontation, and from convention, in dwelling on their own ideal form of beauty and civilization, the Bloomsbury group ignored social, political and economic realities.[38] Their views on marriage and acceptance of the freedom to have lovers revolutionized conventional views on marriage. This was an attitude shared and practised by Helena Wright.[39] It was an *ambiance* that embraced the relationship of May Botterell and Leech. They ascribed to the thinking of this loosely homogeneous group and enjoyed a culturally rich lifestyle but not such an extravagant one as Charleston exuded.

Living in London gave Leech the opportunity to visit galleries and to see exhibitions, and he continued this practice until late in his life. He remained particularly interested in the development of

French art. When Thompson arrived from New Zealand in December 1937, *en route* to France, he stopped in London with Leech, and both went to the Tate Gallery to see work by Van Gogh, Cézanne, Degas, Manet, Bonnard and Vuillard.[40] The following October, on his return journey to New Zealand, Thompson stayed in London with Leech, after a year spent painting in Concarneau, Paris and Nice. Since Thompson and he had enjoyed painting harbour-scenes together around Concarneau and since Thompson had been told by Trafford Klotz in Brittany[41] that the docks at Billingsgate provided interesting subject-matter, they spent afternoons painting there.

Views of Billingsgate and the War

After Thompson left again 1939, Leech would have continued painting in Billingsgate, but was prevented by the outbreak of war. Most of his Billingsgate pictures seem to have been painted in October 1938, with Sydney Thompson. With the oncoming of the Blitz, which caused damage to Steele's Studios, May and he moved to no. 104, Windermere Road, Reading, a house rented for them by Sydney's son Jan, who had been educated in England and now lived there. Leech wrote to Thompson in February 1942 describing the effects of the Blitz, and wishing that they could meet up again to paint along the Thames: "I hope we may again, in the not too distant future, paint on the banks of the Thames. That would be rather glorious, though our Lyons Restaurant is no more, still its shell is there and who knows, it may be built up again."[42]

It was not until November 1945 that Leech returned to paint at Billingsgate, and these expeditions were soon ended by the Dock Strike. In a further letter Leech described the destruction brought to the dockland that they had painted, "Not long ago I went to our haunts in the city but could not get down to the water, the Fish Market is still there, but the warehouses next door are gone. And of course the landscape between there and St.

Paul's really is landscape."[43] Leech could see beyond the devastation, beyond the flattened buildings, to see a landscape that had been wrenched back, by bombing, from the cityscape. In a letter to Ethel Thompson, Boxing Day 1945, May, too, described the situation: "Billy went down to Billingsgate during November and painted a bit around the bombed parts by St. Pauls – but the Dock Strike rather ended all that [.] the river was crammed with stationary barges and of course no Ships, so he is doing a study of the garden at the Studio."[44] Each time that Leech had difficulty in finding a painting location he reverted to whatever scene was literally in his own back yard. This painting could possibly be *Back gardens* (private collection), because on the back is a fragment of a label relating to the War effort.

The letters between the two families continue through this period, giving an idea of the domestic situation in London during and after the War. Late the following year, on 14 October 1946, May wrote with thanks for a parcel "with all sorts of lovely things in it including Honey and dripping" and mentioned that Bill had been down to Billingsgate again to paint but that the area was too devastated as a result of the Blitz, and that he was unable to further any of his previous work: "He has been down to Billingsgate since then (September) but it is all so altered and so much devastated by bombing that he can't finish anything that was begun before – I think you would admire the new Waterloo Bridge, it is so graceful and beautifully proportioned."[45]

Paradoxically enough, the War was the occasion for Leech to exhibit more than he might have done. As he wrote to Thompson in 1942, "It is ages since I have written to you, and to do so is like wakening up to normal life again after a particularly bad nightmare. But I am afraid the nightmare is spreading in your direction now. I found the beginning of the war particularly trying everyone was rushing to arms and it was difficult to keep ones head

and reason clear of the emotional wave that seemed likely to swamp us all, a wave whipped up by the BBC. But I, with many other people, have always regarded the creative arts as great forces on the side of good and it would be a sad denial of this Faith to drop our creative weapons and pick up those of destruction, there are very few that can use the former and millions that can use the latter. So I decided to remain free to do my own job and to help in other ways in my spare time. Of course if I was a younger man I would have to put this case before a tribunal but the importance of the Arts is recognized to a greater extent here than was the case during the last war, though I personally was quite well treated even then. There are a number of Exhibitions in aid of various war funds being organized, I am showing in two or three of these, I am very glad this has been done, one does not feel so isolated and also it makes immediate use of the artist without interfering with him. I have not painted a great deal though, to begin with my studio was twice damaged, and life has become so very complicated owing to Ration books *etca.* that all ones time seems to be taken up with the mere business of living."[46]

Leech had just contributed two paintings to a United Artists' Exhibition held in the Royal Academy, Burlington House, in aid of HRH the Duke of Gloucester's Red Cross and St John Fund. Leech exhibited with Stanhope Forbes, Dorothea Sharp, Dame Laura Knight, Augustus John and John Lavery, showing two paintings, *Flowers in a mirror* (cat. 82), and *Portrait of a painter*, one of his self-portraits. Two years earlier, in 1940, he had donated two paintings (one of them the same *Flowers in a mirror*, which evidently had failed to sell at £80) to a similar exhibition at the Royal Academy in aid of the Lord Mayor's Red Cross and St John's Ambulance Fund.[47] Among the many artists represented, of all styles and schools, Dermod O'Brien was also included with a landscape, *The salmon leap, Leixlip*.[48] The second painting in the 1942 exhibition was *Christmas tree*,

£45; again neither sold. The War needs to be taken into consideration as a mitigating reason for Leech having painted, in a somewhat slick manner, this sentimental work (private collection). He visited the Royal Academy from Sussex,[49] but when he saw how his painting had been skied he determined never to submit work again to the Royal Academy.[50]

Leech had continued to exhibit his work at the RHA in Dublin until 1941; that year, his studio was bombed twice. The painting *The cliffs, Sidmouth*, which was exhibited in 1942, was possibly submitted by Leo Smith from his gallery, since this work had been previously exhibited at the RHA in 1940. In 1943 Leech did not exhibit either, but in 1944 he exhibited five works, including *Haystack* (possibly cat. 105) giving May Botterell's address at no. 20, Abbey Road. In 1945, the six paintings exhibited by Leo Smith on behalf of Leech included *Olive trees in winter near Les Martiques* (possibly *The old orchard* (cat. 52)), *Aloes near Les Martiques* (cat. 51) and *Wet seaweed* (possibly *Seaweed* (cat. 34)). In 1943 Leech exhibited two paintings, *A nursery still life*, £57. 15s. 0d. (private collection), and *Under the cork trees, Provence*, £40 (present whereabouts unknown), in the third United Artists Exhibition at The Royal Academy.[51] His neighbour at Steele's Studios, C.R.W. Nevinson, exhibited *Hope* at £105 and Jack Yeats exhibited *The avenger* at £250.[52] Leech's prices had fallen well behind those of his contemporaries and yet he still failed to sell.

The damage to his work and disruption of his life resulting from the bombing of his studio was devastating for Leech. However, he had May's unswerving support, and May's fifth-floor flat at no. 20, Abbey Road, which she had rented since 1938, became both his home and his studio.[53] Fortunately, her flat had managed to escape without much damage, as Leech informed Thompson: "her flat has escaped so far with nothing but a broken window, and we hope, and indeed I think, that this indiscriminate bombing is over, it is difficult to see how Hitler could afford to indulge himself in this way

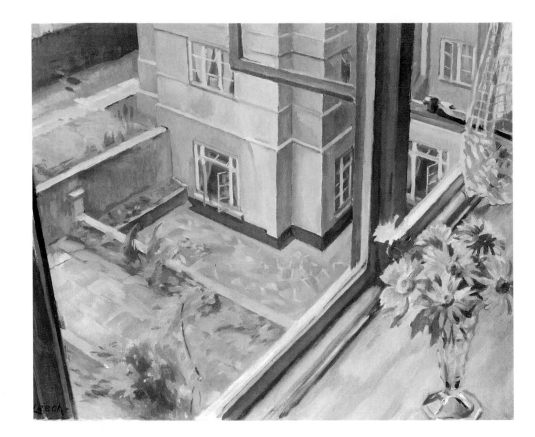

Fig. 56 William John Leech, *Through this window*, oil on canvas, private collection

any longer".[54] *Through this window* (fig. 56) is a view from no. 20, Abbey Road, and shows the 1930s-style architecture of the block of flats. Leech paints the window-sill at a dramatic diagonal angle with recession through to the walled gardens below, while the glass vase of chrysanthemums creates a detail in the immediate foreground. The soft pink tones of the chrysanthemum petals add colour and offset the angularity of the building, while the open mesh pattern of the lace curtain is repeated in *The kitchen, No. 4, Steele's Studios* (cat. 76), suggesting May bought similar curtains for both homes.

The aftermath of the War

Even after the end of the War a letter from May to the Thompsons in 1946 reports on the state of repairs at Steele's Studios and how these have been hampered by the scarcity of materials. "We have got most of the Studio patched up but still no gutters down one side, they are apparently unobtainable,

like many things at the moment and one must make do."[55] The 'Britain Can Make It' exhibition at the Victoria and Albert Museum only accentuated the shortage of materials with the display of goods made in Britain for export.[56] These unobtainable items included the gutters Leech needed for Steele's Studios. But, although rationing was still bad and there were strikes which made the queues even longer, London life was returning to normal: there was a Picasso show at the Victoria and Albert Museum, which was "like a football match ... people just herd along staring at them solemnly having been told that this is the last word in High Art – one would rather see them laugh at it or demonstrate loudly as they did in Paris or show some individual reaction – I suppose were all become rather subdued & sheeplike since the war & almost involuntarily form in queues & take what is given without comment."[57] The fact that Bill and May went in the first days to avoid this rush

confirms that Leech continued to go to exhibitions. In 1947, the Old Masters had been brought back out from the slate mines in Wales, where they had been safely and secretly hidden during the War years, and cleaned at the National Gallery. He went immediately to see them out on show again.[58]

Leech's interest in painting was wide ranging and informed and he seemed to miss no opportunity in going to exhibitions, irrespective of the period of the works. He praised Botticelli's *Pietà,* which he saw in a loan exhibition from Munich, as "the greatest picture ever painted. I will never forget the effect it had on the people, when it was on loan from Munich, not to speak of myself. We could not move away. Could anything be more wonderfully composed."[59] This work is composed of sweeping diagonals which appealed to Leech. He had the knowledge to link the art of past centuries with the art of the Post-Impressionists, and combined the qualities of both in the art he created in the twentieth century, which was personal to him, though informed by the art of others.

The twenty-five years spent at Steele's Studios were formative years for Leech, consolidating what he had learned while living in Paris, Brittany and Provence, but adjusting and absorbing into his work the influences of British painters, like Augustus John's portraits and flower studies and the decorative qualities of Duncan Grant's still lifes. His world became more private and he retreated into a quiet domesticity with May Botterell, surrounded by close friends and family. With no exhibitions of his work in London, the reputation he had begun to forge for himself with his London shows of 1910, 1912 and 1927 soon faded. Nonetheless he remained in contact with artistic circles, and he continued to exhibit, if not very frequently and with little success in terms of selling.

Leo Smith of the Dawson Gallery

When his studio was bombed Leech was not able to send, as usual, his paintings to the RHA, and Leo Smith of the Dawson Gallery, no. 2, Dawson Street, Dublin, arranged to borrow paintings and submitted six for exhibition in 1944. This began an interesting relationship between dealer and artist, and Leech and Dawson communicated by letter regularly. In spite of their letters becoming friendly and even personal, they always maintained a formal mode of address – it was always Mr Leech and Mr Smith – and when May was mentioned she was always referred to as Mrs Botterell.

Leo Smith of the Dawson Gallery, Dublin, became W.J. Leech's sole agent and encouraged him to present a one-person show with him in Dublin the next year. The exhibition, which opened on 8 June 1945, displayed thirty-five paintings, both oils and watercolours. Although in ill health and destined to die later in the same year, Dermod O'Brien opened the exhibition; O'Brien had been Leech's supporter, too, when President of the RHA. Because of his relationship with May Botterell and his desire for personal anonymity, Leech did not come over to Dublin for the exhibition. This did little to help Leo Smith's efforts to establish him as one of the most important painters he showed in his gallery. In the exhibition, his prices ranged from a mere £10 for a watercolour (*The gate,* 14" × 18"; 35.6 × 45.7 cm), up to £145 for the large oil entitled *Aloes* (cat. 51). It is interesting to see how Leo Smith raised some prices and lowered others.[60] Most of the paintings, judging from the titles, were works executed in France, though *Haystack* (private collection), which he had painted in Yorkshire the previous year, was also included. Their date ranged from the Steele's Studios period to his pre-War Concarneau period; one included was *The tinsel scarf* (cat. 47). Leo Smith organized another one-man exhibition at the Dawson Gallery in June 1947. This followed on the success of Leech's show of two years earlier; it included two of the nude paintings of his black model, *The negress (model)* (cat. 89) and *Refugee* (cat. 90). This more recent exhibition was opened by Lennox Robinson and

was reviewed in *The Irish Times*, 21 May 1947, and in the edition of 30 May photographs of no. 5, *The tinsel scarf*, and no. 15, *St Mary Le Bow, 1945*, were reproduced.[61] Leech exhibited twenty-five paintings; once again the exhibition included paintings he had painted in Concarneau, including *Beach parasols, Concarneau* (fig. 49). Paintings executed in Grasse were also included: *Maison Cabris, Grasse*; *Villa Jeannette, Grasse* and yet again *The tinsel scarf* (cat. 47) (it had evidently failed to sell at the previous exhibition). Although Leech did not attend, he was pleased that Lennox Robinson was opening his exhibition. "I am glad Lennox Robinson will open the show, I feel sure he will be interesting on the subject of art and his approach to it is likely to be both wide and unusual. You, no doubt, will be sending invitations to Dr. Best and the Gwynns and the O'Briens."[62] Dr R.I. Best was a significant collector of Leech's work, who later bequeathed such works as *St Pauls – 1945* (cat. 101) to public institutions. Denis Gwynn had earlier been an active patron (see cats. 85, 86).

Leech was still anxious not to draw any attention to his personal life and relied on Leo Smith to look after his interests in Ireland. Leech wrote to Leo Smith on 28 May 1949, from no. 20, Abbey Road: "I am sending you the enclosed from Cork in case you think it would be a good thing to send these, though, if there is the slightest chance of the hanging committee turning down my stuff it would be better not to, I think you are the best judge of my interests in Ireland so I leave the matter entirely to you...."[63]

In 1951, Leech had his final one-person show at the Dawson Gallery (1–12 May), and it was to be opened by Seán Keating, which met with Leech's approval: "So glad to hear that Keating will open the show".[64] He was again receiving approbation from one of his fellow Irish artists. He showed thirty-three works, eighteen of which he had sent over to Dublin the previous August.[65] Another fourteen Leech paintings were sent over to Ireland in

October 1950.[66] At this time he wrote to Leo Smith: "I do hope you will like them, I think they are rather a good lot myself I hope you will let me know how you like the pictures, and that they will arrive quickly and safely."[67]

Leech had been an established Academician of the Royal Hibernian Academy for forty years from October 1910. The RHA had played a significant rôle in establishing young artists, like Leech, who became an Academician in 1910, still in his twenties.[68] In the climate of 1942, however, Louis Le Brocquy's painting *The Spanish shawl* (private collection) was rejected by the Royal Hibernian Academy. As a consequence the artist's mother was instrumental in creating a new independent group which would be more receptive to contemporary art. This group was united, not by a single unifying philosophy, but by their shared reaction to conventional Irish art. When Leech wrote to Leo Smith in 1967, he mentioned Le Brocquy's work, praising his earlier, more representational pictures, but he had no appreciation of his head-paintings of Yeats, Joyce and other writers: "I liked Le Brocquy's tapestry designs so much and some of his other things – but those heads! Well I suppose they are meant to shock. I am so sorry but this lack of discrimination gets me down."[69] It is apparent in these sentiments of Leech that he was not in sympathy with the artists who exhibited in the Irish Exhibition of Living Art. However, Leo Smith exhibited there three paintings of Leech's in 1945.[70] Also, he showed two paintings at the Oireachtas exhibition in 1945: *Fuinneog tí feirme* (Farm-house window) and *Iumgeas i gcill manntain* (A plant in Wicklow). The next year he exhibited one painting, *Buvet vert* (The green glass); and in 1947 two paintings, *Hopfields Kent* and *Bean ag Léamh* (Woman reading). Again it was Leo Smith who was responsible for exhibiting these paintings in order to give Leech additional exposure.

Another artist who exhibited at the Exhibition of Living Art was Norah McGuinness, who painted landscape in a freely patterned manner rather like

Dufy – replacing his colour range with local colour. Leech thought highly of Norah McGuinness and he expressed this when he wrote to Leo Smith in May 1967 expressing concern and irritation about a letter about him to *The Irish Times*: "Also thank-you for sending me Denson's letter to the Irish Times. That was rather a pity. I do wish he would not exaggerate so. And I do apologise to really fine artists like Norah McGuinness, indeed to all my fellow artists, not to speak of critics."[71] Leech was therefore aware of the artistic scene in Ireland, even though he never visited. A further exhibition of Leech's work was being planned at the Dawson Gallery in the 1960s, but Leech found it very difficult to prepare this exhibition and found the stress too great, so he kept delaying it. However, he left all his paintings to Leo Smith and the names of his executors so that Smith could have a retrospective exhibition after his death.

9

Last Years

Leech seemed to regain his energy for painting even before moving out of London to live in the country, and in his letter from Steele's Studios to Leo Smith on 4 July 1953 he wrote, "In great haste as I am painting like mad at the moment".[1]

The year 1953 was an important one for Leech. His marriage to May Botterell in Marylebone Registry Office on 23 April that year seemed to contribute to his new phase of painting. After thirty-four years, May, his inspiration and guiding strength, had now become his wife, and many difficulties, including financial, had been resolved. Their main objective was to find a home in the country suitable for a retiring couple in the later years of their lives. This was finally achieved when May's niece, Margaret Wallace, found them Candy Cottage, West Clandon, where they moved in 1958. Margaret had come to live in the area after her husband's death in north Borneo, as her brother-in-law, Caleb Wallace, and his wife, Lucy Piggott, lived and worked locally as doctors. Lucy Piggott, otherwise an eye specialist, was also a very competent and skilful watercolourist and on occasion painted with Leech, who changed her traditional perspectival composition to strong diagonal intersecting forms.[2] Margaret Wallace, née Pearson, was the daughter of the Reverend Tom Pearson, May's closest brother and a good friend of Percy Botterell from their Oxford student days, who had been responsible for May and Percy's meeting. His support for May continued after her meeting Leech in 1919.[3]

Candy Cottage, Off the Street, West Clandon, was an ideal home for Leech and his wife to retire to in their seventies, since they were already acquainted with the area and had the friendship of the Wallace family. It was an idyllic Tudor-style cottage with diamond-paned mullioned windows with climbing roses over the trelliswork, and the bird bath, from Steele's Studios, was given pride of place in the garden.[4] Leech spent his days either outside in the garden or inside in a new studio he had built on to a corner of the house, a photograph of which

(fig.57) he sent *ca.* 1958 to his niece Sylvia who he had painted so frequently (cats. 63, 64, 65). On the back he wrote, "Here is your old, old uncle in his New, New, Studio wishing you all the best wishes for Christmas and the New Year"[5]

May and Bill lived a genteel lifestyle, pertaining to a French *ambiance* in their home at Clandon. They often conversed with each other in French, which they spoke fluently, even though they had stopped going abroad for some time now.[6] May no longer drove her Austin Seven but used a local taxi to go shopping in Guildford, and, if the light was good, Leech was ferried by Margaret Wallace to suitable painting locations along the River Wey. She would leave him to paint and return some time later to collect him.[7] Even in his late seventies, the intensity of light and vibrancy of colour attained in his canvases, as in *The studio garden* (cat. 104), *Etude Clandon Station* (cat. 117) and *Steps to the studio* (private collection), testify to his undiminished ability as an artist. He paints with the assurance and knowledge acquired from over fifty years of painting. His move from London to the Surrey countryside, his marriage finally to May, and the freedom and security which this had brought to him in his later years seemed to suit his retiring personality and his painting. Leech continued to paint portraits and self-portraits after 1953. He worked in the garden and the garden became an essential element in his work, as in *In the artist's garden* (cat. 112) and many other works.

In bad weather, Leech painted still lifes and portraits as well as views out of his studio window. One of the views he painted from his studio was *The house opposite* (cat. 109). Here terracotta reds glow against the green of the hedges, and the diamond-leaded panes of Leech's front window form a cross-hatching through which the house is glimpsed. He used this pattern of the panes again in his still life painting *Cast shadows* (cat. 108). Simple bowls sitting on the red-tiled window-sill cast shadows and reflect the light and shade created

Fig. 57 *William John Leech in his studio, Candy Cottage, West Clandon*, photograph

Fig. 57 *William John Leech, his wife May, and Sydney Lough Thompson*, photograph

by the strong sunlight. Leech uses the shadow of the leaded panes to give an overall grid of parallel lines against the sunlight. A flower study which fits into this period and reflects the mullioned panes of Candy Cottage is *Still life with Chinese lanterns* (cat. 110). As an artist he is still pursuing sunlight and reflections, as noted by Dermod O'Brien fifty years earlier in Dublin.[8] The light that pervades

these works is not the raw sun of *Seaweed* (cat. 34) but an even glow from an afternoon sun in Surrey.

When Leech wrote to Sydney Thompson in New Zealand in 1961 to offer his condolences on the death of his wife Ethel, he told him of the subjects he was presently painting at Candy Cottage and of his lifelong striving to capture light on his canvases.[9] "I am painting very simple things – Still lifes, mostly without flowers, so that I only have the changing light to compete with, quite enough and I learn what I can." He also had children to paint, a subject he had begun sixty years previously, with his portraits of *Sylvia* (cats.63, 64, 65) and *Suzanne* (cats. 47 and 48). He bemoaned the lack of water, however: "Also I sometimes paint our little niece Bridget, also Paul. Landscape does not seem to exist here – I like painting water but there is none about: so there we are! Paint in the garden and be thankful that one need not take long walks in search of subjects".

Bridget and Paul were Margaret Wallace's two children, and they became his patient models as the Botterell children and, in turn, grandchildren had been. In his portrait of *Bridget* (private collection) she sits prettily posed and looks out, almost coquettishly, at the onlooker while the summer emphasizes her pale blue dress and suntanned arms. There are hints of *Suzanne* (cat. 47) in this painting, recalling work of forty years earlier. Leech's enjoyment in rendering the demeanour and characteristics of children, especially little girls, is apparent. In *Bridget reading*, a recurring pose in his œuvre (private collection), pattern is introduced into her checked blouse and repeated in the diamond grids of the leaded panes of the cottage window. Behind Bridget, on the tiled studio window-sill, are the objects that form the composition in his painting *Cast shadows* (cat. 108). In his eighties, Leech can still capture the youthfulness and likeness of his sitter while retaining the power of taut pictorial composition.

These were family portrait studies, but in 1965 he accepted his final commission, to paint the por-

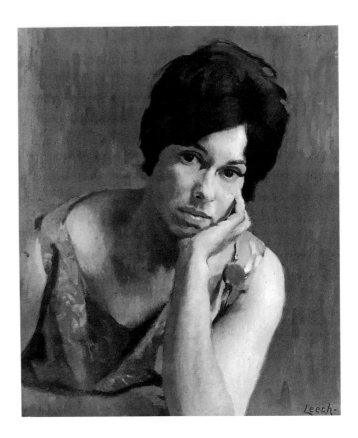

Fig. 59 William John Leech, *Portrait of Chloe Abbott*, oil on canvas, 61 × 51 cm, private collection

trait of Mrs Chloe Abbott, a young bride who had come to live next door (fig. 59). After May's death in July that year he had been unable to paint, and Chloe Abbott's father-in-law commissioned this portrait for £70. It took six months to complete with two or three sittings every week.[10] Granted that Leech was now over eighty and getting slower as a painter, this rate was a pattern well established, even from his younger days. There are consistent stories, among his family, of sittings begun in the winter in heavy clothes which then had to be endured in the heat of the summer, or alternatively, light summer clothes which had to be worn through cold winter days. His brother Cecil's wife Babs had had to endure her heavy velvet green dress through hot summer days when she should have been helping her husband Cecil in their orchards during wartime.[11]

Although he complained to Sydney Thompson, in his letter in 1961, that there was no water or landscape around to paint, Margaret Wallace drove him to painting locations around West Clandon and to the River Wey.[12] *A view on the Wey near Guildford* (London, Pyms Gallery) is one of his small, on-the-spot oil paintings which provides immediate colour notations of the yellowy green of the grass and the pale blue of the water against the dark punts, moored along the river. As was usual, *The Wey* (private collection) is a larger, more composed work, with trees on the far bank casting reflections on to the ducks in the water below, providing a similar subject as London's Regent's Park. However, it was his home and his garden at Candy Cottage, which he lovingly tended up to his death, that provided most of his subject-matter. The genteel world of tea on the lawn is captured in *The tea trolley* (fig. 60), under the dappled shadows of the trees, set with china cup and saucer, and patterned tea-cosy on the teapot, the quintessence of an English summer's day in the garden. As was customary with Leech, it is devoid of people.

The bird bath, which he had moved from his Steele's Studios garden to Candy Cottage (see cat. 77), becomes the subject of his painting *Bird bath and Buddleia*, exhibited at the RHA in 1958, from his address at Candy Cottage. At this time, he wrote to Leo Smith to ask him to collect and keep in his gallery any paintings returned from the RHA to spare Leech the expense of the journey to London from West Clandon.[13] Evidently, however, the market for his work gradually picked up after this for in November 1967 he wrote to tell Leo Smith he had no small works left in his studio, only large works remained. These were more difficult for the Dawson Gallery to sell. He wrote to Leo Smith: "I am always so glad when pictures are sold. I am so sorry I have no small sketches left, only larger pictures left in the Studio now – interesting I think and some very unusual Yes thank-you I am better now and hope gradually to recover my strength." However,

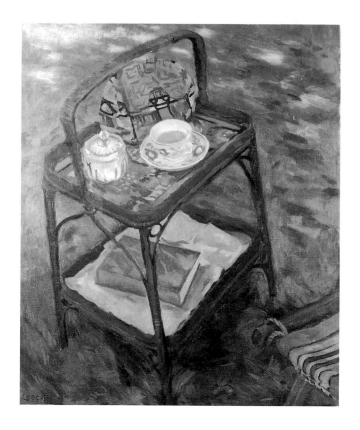

Fig. 60 William John Leech, *The tea-trolley*, oil on canvas, 73.7 × 63.5 cm, private collection

when he wrote a brief note to Leo Smith two weeks later he was not well, and simply stated: "My dear Smith. Thanks for the cheque. Not well at the moment – Heart. Sincerely yours. W.J. Leech."[14]

On 29 November 1967, the Dawson Gallery sold two paintings, *Apples* priced at £250 and *New Forest farm*. Leo Smith sent Leech a cheque for £340 in total, after deduction of commission. *Apples*, which Leech painted in 1966 and exhibited at the RHA in 1967, is a magnificent still life painted with a knowledge of Cézanne's *Apples and oranges, ca.* 1895–1900 (Paris, Musée d'Orsay). In the composition Leech has simplified his still life to focus on a white tablecloth, the folds of which give direction and structure to the rounded shapes of the red apples and fruit-bowl which nestle on top. He was re-examining his work at the end of a long life devoted to painting, and this is expressed in his

letter to Leo Smith in 1967, the year before he died:[15] "I used to paint very quickly, had to, because of my interest in passing effects. But after some years decided that perhaps I ought to go more deeply into things."

The railway line was within a few minutes' walk from Candy Cottage and this made London easily accessible, but Leech took his paintings in a taxi to London each year for transport to Dublin and the RHA. In 1967, he asked Leo Smith if he would kindly collect and store any unsold work from the Academy and keep these paintings in his gallery, to spare Leech these taxi rides. "Do let me know if you would collect any pictures I might send to the R.H.A., you see, it is a 30 mile drive to London from here and I do not want to do that twice, I find it so tiring now. So I would want the pictures to remain in Ireland."[16] In hindsight this was fortunate, in that these paintings remained in Ireland after Leech's death just over a year later. Though Leech continued to send his work, annually, to the RHA, only once did he show his paintings locally and that was as a specially invited guest at the Guildford Art Society.[17]

Neither May nor Leech seemed to miss London. They both enjoyed the peace of the countryside and the security of their own home, and became the happily married couple living quietly in retirement, listening to the radio, with no television. They holidayed with Margaret Wallace and her children on the Isle of Wight and were frequent visitors to her home, and enjoyed the few visitors that came to Candy Cottage. Included among these, on several occasions, was Pat Murphy from Dublin, who was aware of Leech's work, and came to meet him and buy some of his paintings.[18] Meanwhile Leo Smith was trying to persuade Leech to have another exhibition in Dublin since so many years had now elapsed since his show in 1949. Although the early 1950s seems to have been a difficult time for selling Leech's paintings (Leech wrote to Smith on 13 January 1953, "It looks as if the Dublin people have all the Leech's they want at the moment") in the 1960s an exhibi-

Fig. 61 Frances Hodgkins, *The baby*, watercolour, Dublin, Hugh Lane Municipal Gallery of Modern Art

tion of Leech's work seemed timely. Although Leech never returned to Ireland, there is no doubting his affiliation, especially in the later years of his life. In 1965 he wrote to Smith for the name of the curator of the Municipal Gallery, to whom he wished to donate, possibly in the Hugh Lane tradition, the Frances Hodgkins watercolour, *The baby,* which he owned (fig. 61).[19] Leech's thoughts remained very much with Ireland and he even went to the trouble of framing the Hodgkins watercolour.

However, no amount of persuasion could rush Leech into a hasty show. He wrote to Leo Smith expressing his anxieties about this on 2 June 1963. "I am glad that the Exhibition cannot be till next year as one is so slow at my age, and do let us keep the date indefinite as long as possible, working for a date always worries me."

On 10 March 1965 Leech was in good form, writing to Leo Smith, "The Spring is here again to-day with the birds making a most delightful row." In the next few months, however, May's health deteriorated more. Leech attended her with devotion and personal care until she became bedridden and in the end died peacefully of bronchial pneumonia on 10 July 1965, aged eighty-three years. As she had

requested, there was no publicity about her death, no obituary in the paper. Leech was devastated and only wrote to tell Leo Smith about her death on 14 August 1965, "Now I am afraid I have the saddest news to tell you. My dear wife died on the 10th of last month. She had been ill for a very long time, we tried nursing homes and hospitals but they are not what they used to be, and she was so unhappy away from home, that I decided to nurse her myself. Of course towards the end I had to have nurses here. She died peacefully." May's will, of 10 July 1965, bequeathed all of her estate to her husband if he survived her by at least one calendar month, and failing that, everything from her estate was to go to her three children "... my daughter Suzanne Salmond and my sons Guy Percy Dumville Botterell and James Dumville Botterell...."[20]

Leech was a very lonely man from then on. He tried to paint for an hour in his studio every day, mainly working on some self-portraits. His garden remained an important subject-matter, as in *In the artist's garden* (cat. 112). He used this picture as a backdrop to a self-portrait, *The painter with his picture* (cat.113). In his buff overcoat and black round-framed spectacles, Leech gazes out, questioning the viewer, his shining bald head and white moustache reflecting the dignity of old age. His gaze is still enquiring, searching, striving in the pursuit of his craft. He wrote to Leo Smith in January 1966, sadly recognizing that he had failed to become an established, successful painter: "You see not much success really but you cannot be a recluse all your life as I have been and have worldly success. I had an idea when young, that if the work was good enough it would sell in the end. The end is the word. Even with your help, and the help of a few discerning critics, it takes more than a lifetime!" Leech painted a slightly smaller version of this *Self-portrait* (private collection) and gave it to his house-keeper, which she recalled was the last painting he was working on. It would seem, however, that this smaller *Self-portrait* was a preparatory study for the larger, more detailed composition (cat. 111).

During 1967 he wrote often to Leo Smith, usually mentioning his health. Leech was then eighty-seven. In *The Irish Independent* of 11 April 1967 Alan Denson published a tribute to Leech, with accompanying photographs of some of his paintings.[21] When Leech was sent this tribute by Leo Smith he was far from pleased, and in his reply of 17 May 1967 he wrote, "I had asked Denson not to write any more articles regarding self or work, at any rate, while I am still here. I hope you will think that this is right, the letter was therefore a surprise. I had better not say any more. Difficult to understand"[22] Leech maintained his anonymity to the end. However, on 13 July 1968, Alan Denson showed Leech the draft of his monograph *An Irish Artist, W.J. Leech, R.H.A.*, which, according to the author was "gratefully approved".[23]

It was obvious after May's death that Bill had no wish to go on living and his health was slowly deteriorating. Again he wrote to Leo Smith on 9 January 1968, "I have been so ill over Christmas". He made out his will on 19 June 1968 and, less than a month later, early in the morning on 16 July 1968, aged eighty-eight years old, he fell off West Clandon railway bridge. He had dined on Monday evening, 15 July 1968, with his good friends Dr Caleb Wallace and his son Theo without hint of what was to come. This one final thrust of Leech and the inevitable inquest made full newspaper coverage in the *Surrey Advertiser and County Times* of Saturday, 20 July 1968 under the banner headline 'Girl Tells of Death Fall from Bridge'.[24] He was taken to the Royal Surrey County Hospital, where he died after a few hours of "pulmonary oedema and cardiac respiratory failure due to multiple injuries".[25] Both Mrs Wallace and his housekeeper Mrs Mitchell visited him in hospital. He had been conscious on admission and had had "a disquieting conversation" with one of the doctors, Dr Peter Shires. On being asked how the incident had happened, Leech replied: "I sat on the bridge and I just let myself go."

Dr Shires then asked him if it had been an accident and with consideration Leech replied, "I don't think so".[26] Other eye-witnesses saw him sitting on the high parapet before he toppled back on to the line just as a train was slowly pulling out of the station in his direction. A neighbour of his in West Clandon, Arthur Harold Smith, was the first to reach Leech as he lay on his back, between the railway line and the embankment.[27] He was conscious but unable to speak. The morning train out of the station was stopped. An ambulance arrived very shortly afterwards and brought Leech to hospital where he subsequently "lapsed into a fitful sleep" and died a short time later.[28]

Leech painted his own epitaph in *Etude Clandon Station* (cat. 117), the last in the series of railway stations he had painted, in what one might have expected to be an untypical subject-matter for him. In fact he had always been fascinated with the depiction of railway lines and painted them in a variety of different locations. The angle of the telegraph pole in *Railway track and telegraph lines* (cat. 116) in particular recalls the advice he gave Dr Helena Wright in the 1930s: "Begin to understand its construction, it is not a conglomeration of objects, it appears so at first sight, your business is to see them all as one, and draw them as a position of the earth so that your picture will have body and weight. The more you can find, the more will come into your work. To give you an example, last winter I was drawing something that had a lot of perpendiculars and I, the draughtsman, was standing too. The first day, I did nothing but just look, and the thing gradually began to appear more and more magnificent, and slowly I began to understand why. As I stood there, a perpendicular, I seemed to realise as never before that I was one with the earth and all the surrounding things, that I was not really perpendicular, but only so from my point of view. If you produced us all (i.e. the houses, the telegraph poles, other people and myself) our so called perpendicular lines would meet in the centre of the earth. Now I was in a fit state to paint or draw something that could not fail to be interesting because I was conscious of so much. My feet were very firmly planted, like the feet of a circus rider on his horse, like him, I felt at an angle, but an angle that felt so tremendously right, I was able to draw all the other perpendiculars in consequence at their real angles without any hesitation at all, I simply felt them, each had its own place and there was no other place for it. And like the Circus rider I seemed to feel the movement underneath my feet & I was part of it and we all seemed to be swinging round like the spokes of a great wheel, in fact as I draw I was conscious of the revolution of the earth. I seemed to have my back to the direction in which we were going so that all the things I was drawing were following me. Now you see how completely one all the objects I was drawing had become one with the earth and one with myself, and I could not help suggesting the movement too and I had become one with my subject since a line drawn through me would meet all the other 'Perpendicular' lines in my picture. It is amusing to think that some-one else would have drawn all those perpendiculars perpendicular to the tiny bit of ground he was standing on and they would have been paraded to each other and correct from his point of view of the academy. Lord how dull his drawing would have been."[29]

Leech's estate, with the exception of his paintings, went to Mrs Mabel Mitchell, the housekeeper.[30] Leech's intention was that his house would remain intact, with his furniture and those paintings in his house, just as he had left them, and that she would come and live in the house and look after it.[31] Of course this was not to be, the house and furniture were sold off, or given away, and the paintings in the house dispersed. Some of these paintings are recorded in Alan Denson's books on Leech of 1968 and 1969 and in his *Visual Taste: Catalogue of an Author's Art Collection*, compiled in 1971.

Leech gave all the paintings that were left in his studio and in Dublin to Leo Smith, probably in anticipation of the next one-man show he had promised him and which he had suggested could be mounted posthumously in the gallery in Dublin. "I Give Devise and Bequeath unto Leo Smith of The Dawson Gallery, 4 Dawson Street, Dublin, Eire, all those of my pictures and drawings which at the time of my death are in my studio and all those which at the time of my death are in his gallery at 4 Dawson Street aforesaid and all and any other of my pictures and drawings excepting only those which at the time of my death are in my house Candy Cottage aforesaid."[32] There was a report of his funeral in the *Surrey Advertiser and County Times* of Saturday, 27 July 1968.[33] W.J. Leech was cremated, like May, at Woking cemetery but his ashes were scattered as he had requested, so that his paintings would remain his sole monument and epitaph; his life's work.[34] His hope for a posthumous exhibition of his work in fact never did materialize and Leo Smith died suddenly, in 1977, but until his death Leo Smith believed that Leech was "the most neglected of Irish Artists".[35]

1 *My bedroom, Concarneau*

Watercolour on paper
17.8 × 24.8 cm; 7" × 9¾"
Signed lower left, *W.J. Leech*
Private collection

EXHIBITION Dublin, St Columba's College, Arts Weekend, 1984

2 *My bedroom, Concarneau*

Watercolour on paper
19 x 26 cm; 7½" x 10¼"
Signed upper right *W.J. Leech*

VERSO

My bedroom, Concarneau

Private collection

Two of Leech's earliest paintings executed in Brittany, dating to around 1903, are of different views of his bedroom, painted in watercolour. They were possibly painted in the Hôtel de France, Leech's first address in Concarneau. Both water-colours are studies of details of corners of the bedroom and are imbued with the stillness and quietness of Dutch genre painting. They are closer to Chardin, who had brought Dutch *intimisme* into French still-life painting, than to the light of the Impressionists. Leech shows himself as a painter of the quiet life, recording the seemingly unimportant, creating a timeless painting of interesting shapes in subdued colouring. Leech continued to choose the seemingly unimportant, the informal still life – the corner of a room, the view from a window or the pattern created by railway lines or telegraph poles.

The first interior includes the china wash-jug and basin set in a corner of the bedroom against the warm, mellow tones of the wall. Light from the right illuminates the rounded water-jug and wash-basin, while simultaneously bathing in light the white enamel jug placed on the floor underneath. The curved sides of the upturned metal bath echo the rounded shapes of the large wash-basin in front of the curved mirror. Structures of horizontals and verticals in a Whistlerian manner create a calm interior and offer no indication of the future development of Leech's characteristically strong diagonal compositions.

In the second watercolour, a corner of a table, covered in a richly patterned tablecloth, has on top a carefully placed arrangement of an empty bottle of wine and Delft teaware. The shaft of light softly diffuses the pattern of the lamp's shade, the table-top and the background walls into a mellow rich-ness of sepia, ochres and earth tones. Both works are simply accomplished in their use of delicate shadows and brushstrokes which create pattern.

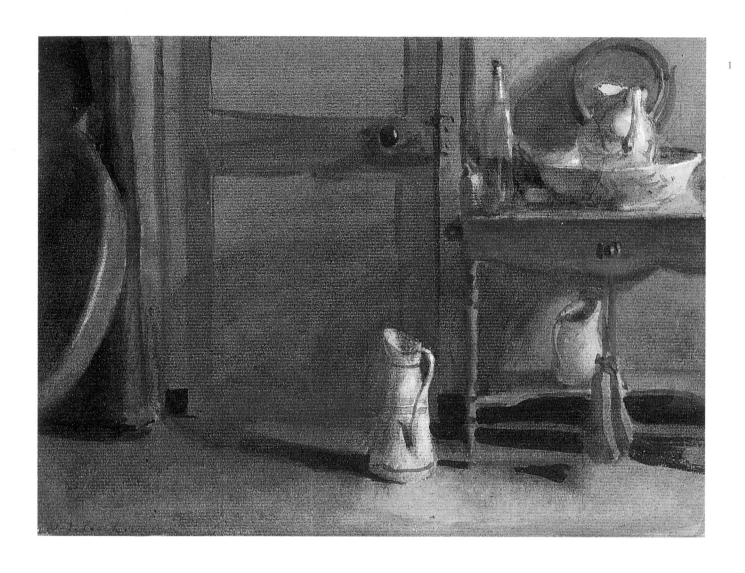

3 *Portrait of a man with a bottle*

Oil on canvas
49.5 × 51 cm; 19½" × 20"
Signed lower right with a monogram, JWK in a circle, and
dated 1904
Private collection

EXHIBITIONS Dublin, Dawson Gallery, 1947 (*Portrait
of an Old Man*, no. 8, £75); London, Pyms Gallery, 1987

LITERATURE *Orpen and the Edwardian Era*, London,
Pyms Gallery, 1987, pp. 42–43; Ferran 1993

Leech, like Hone, O'Conor and several other Irish
artists, dated few paintings, sometimes making it
difficult to establish a chronology. Dated 1904, *A
man with bottle* was executed in the first year of
Leech's arrival in Concarneau. It represents a Breton
peasant posing in the manner of a Dutch
seventeenth-century subject.

4 *Interior of a café*

Oil on canvas
73.7 × 83.8 cm; 29" × 33"
Signed lower right *Leech. 1908*
Private collection

PROVENANCE Purchased RHA 1909 by Hon. Lawrence
Waldron. Subsequently bought by Senator Brennan who left
it to Harry Clarke, who in turn left it to Lennox Robinson.
Purchased from the Dawson Gallery 11.12.1950. By descent
to the present owner

EXHIBITIONS Royal Institute of Oil Painters, 1908 (no.
400, £80); RHA 1909 (no. 81, £63); Salon des Artistes
Français, Paris, 1914 (awarded a Bronze Medal)

LITERATURE Crookshank and the Knight of Glin 1978,
p. 275; Campbell 1980, pp. 328–30; Campbell 1984, p. 260;
Ferran 1992, pp. 12–13; Ferran 1993, pp. 224–225, 227;
Belbeoch 1993, p. 154.

Some suspicion and slight distancing of the peas-
ants from the artist/viewer can be detected in this
work of 1908, which combines the group of peas-
ants and their bar interior into a meticulously fin-
ished studio painting. The old peasant sitting
becapped at the extreme left is the subject in *A man
with a bottle* (cat. 3). Since that is dated 1904, it
seems probable that Leech worked on this paint-
ing for a long time. Here the man sits amicably
drinking a cup of coffee with two of his friends –
one of whom has a small liqueur glass on the table
in front of him. All three look toil-worn with shoul-
ders rounded by work in the fields, with bent backs
and expressively painted boned hands. It is espe-
cially in the face of the standing figure that the
viewer can detect distrust and suspicion.

It is possible that Leech worked from a photo-
graph or a postcard to complete details of the bar
interior, especially in the row of bottles above the
bar, and added the figures from studio poses. The
exaggerated space in the foreground, which directs
the eye to the figures in the middle distance, sug-
gests the angle of a camera lens, and the ques-
tioning gaze of the standing figure captures a
momentary 'off guard' expression. The well stocked
shelves of bottles and china cups which glisten in
the reflected light and shine under the brass lamp
may possibly be those of the Hôtel des Voyageurs,
where Leech stayed from 1907.

Leech conveys the intimacy of this darkened inte-
rior, disturbed by the intrusion of light from the left,
perhaps from a door, just opened. The gentle, with-
drawn figure of a young girl reading, silhouetted
against the lacy curtains of the lighted window,
draws the eye through the bar into the back room,
creating depth with light on dark, in a series of
decreasing rectangles. The painting of the head and
shoulders of a young red-haired woman in the
framed picture on the wall of the café interior indi-
cates the direction Leech's painting style was to take.
Its simplified, bold areas of paint, lightened palette
and strong play of light depart from the more

academic treatment of the room's interior. In Norman Garstin's painting *Estaminet in Belgium, ca.* 1880 (fig. 62), the figures are similarly realized in quick confident brushstrokes, and the bar behind, with its open door, is echoed in Leech's composition.

Interior of a café is a carefully constructed composition which combines drawing from life into a meticulously 'finished' studio painting. Leech painted a much freer study of the same subject (cat. 5). Here he makes use of sunlight and shadows to contrast the lighted areas of the three faces engrossed in conversation in dramatic *chiaroscuro* against the brown shadows which verge into black. To the right, enveloped in shadow, is the figure of a fourth man who waits, leaning on the counter, seeking service, recalling the pose of Degas's *Two harlequins* (fig. 63),

Fig. 62 Norman Garstin, *Estaminet in Belgium*, oil on panel, 21.5 × 26 cm, private collection

Fig. 63 Edgar Degas, *Two harlequins*, pastel, 32 × 24 cm, National Gallery of Ireland

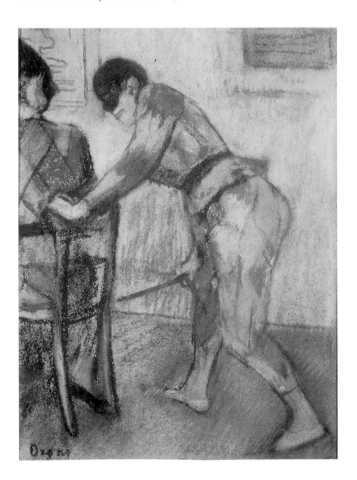

which Leech would have seen in the Loan Exhibition in Dublin in 1899 (see chapter 2).

When Leech exhibited *Interior of a café* at the RHA in Dublin in 1909, the review in *The Irish Times* declared: "His interiors of French cafes are distinguished by a brilliance of execution, a realistic treatment, and a mastery of composition, which makes them singularly attractive." Leech had exhibited another work, *Interior of a kitchen–Brittany* (whereabouts unknown) at the RHA in 1908, showing his interest at that time in the *intimiste* world of darkened interiors. The work failed to sell, however, and Leech exhibited it at the Royal Institute of Painters in Oil that October. It was possibly this work which was exhibited at the Salon des Artistes Français in 1913, for which he was awarded a Bronze Medal. Leech later stated that the Salon work was bought by an American gallery in Philadelphia, but extensive research has failed to trace it. Leech also exhibited an *Interior of a café* in the Sinn Fein-organized exhibition 'Aonach', in Dublin, in December 1909. The review in *Sinn Fein* recognized that "The picture of the Interior of a Café shows him to be a skilled draughtsman, possessing masterly technique"

5 *Interior of a café*

Oil on canvas
45.7 × 54.6 cm; 18" × 21"
Pyms Gallery, London

PROVENANCE By direct descent from the artist to the previous owner (J.W.C. Leech)

EXHIBITIONS Possibly in W.J. Leech exhibition at the Goupil Gallery, London, April–May 1912 (no. 40, £12); the same painting was transported afterwards to another exhibition in Reading.

This smaller *Interior of a Café* relates to *Interior of a barber's shop* (cat. 6) in its fluid brushstrokes and freedom of paint handling; and both works may have been painted in front of the motif, rather than being 'finished' studio work. There is a sense in both of being part of a secret, private scene, and not an intruder, as is conveyed in the *Interior of a café* (cat. 4). The intensity of sunlight which pours into *A café interior* from the street beyond highlights the green of the pool table and the white shirt of the waiter. Grids within grids, rectangle within rectangle, create a sense of space. In this small interior which overlooks the bustling market square, just as in cat. 4, Leech has used a lighted area in the background to draw the eye on through the closed interior.

When Leech went to Concarneau in 1903 he became friendly with Aloysius O'Kelly, and the development of his work reflects this friendship with the older painter. O'Kelly's *The christening party*, 1908 (private collection), which shows a group of peasants at a table in the style of a Dutch seventeenth-century genre painting, was painted in the same year as Leech's *Interior of a café*. The composition and the realism of Leech's painting show the influence of contemporary French painting but the lighted window in the room beyond and the near foreground chair echo elements in O'Kelly's work. From 1903 until 1909, when O'Kelly left for the USA, the influence of both artists on each other can be detected in the harbour, beach and genre paintings executed in Concarneau.

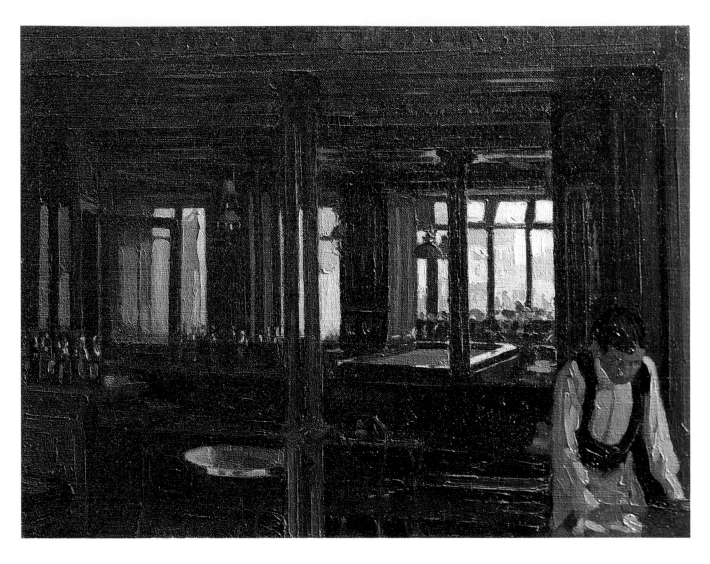

6 Interior of a barber's shop

Oil on canvas
30.5 × 51 cm; 12" × 20⅛"
Signed lower left *Leech*
Crawford Municipal Art Gallery, Cork

PROVENANCE Gibson Bequest, 1927, from the Secretary
of the Dublin Civic Week

EXHIBITIONS NEAC, winter exhibition, 1910 (no. 250);
London, Baillie Gallery, Jan. 1911 (£15)

LITERATURE Campbell 1980, p. 328; Campbell 1984, p.
259; Ferran 1993, p. 228; *Crawford Municipal Art Gallery*,
1991, p. 87

Interior of a barber's shop was most likely painted
in Concarneau in 1909, because when Leech exhi-
bited this work at the New English Art Club in the
winter of 1910, he gave his address as no. 16, rue
Nationale, Concarneau. Leech continues to paint in
dark tones of greens and browns with strong con-
trasts. He repeats the rectilinear structures of the
interior, enclosing one inside another to create a
strong composition in a manner practised by
Whistler in his representations of shopfronts and
houses. Leech's composition and free handling also
invoke the composition and the confidently painted
figures in Garstin's painting *Estaminet in Belgium*,
ca. 1880 (fig. 62, see cat. 4) Garstin's use of brown
and greys in his darkened interiors can be
detected in Leech's work, contrasted against the soft
greys, silvers, subdued greens and pale pinks.
However, Leech's brushstrokes are bolder and the
paint more fluid with greater painterly dexterity.

The foreground mirror reflects the shelf imme-
diately in front, the two windows behind and the
figures silhouetted by dramatic lighting, as in the
background of *Interior of a café* (cat. 5). To the left,
the barber's stooped figure leans over the seated,
balding man he is shaving, his shoulders covered
in a pink towel. The barber is captured in a mir-
ror with another standing figure, which may be the
artist caught capturing the scene, a small deference
to Velázquez's *Las meninas* in the Prado.

7 A caravan at Concarneau

Oil on board
15.6 × 20.6 cm; 6⅛" × 8½"
Signed lower left *Leech*
Inscribed on verso in the artist's hand *No.1 A Caravan
Concarneau*
Denis M. Magee

PROVENANCE Dawson Gallery, Dublin

The caravan which fills the area on the right of the
canvas is reminiscent of Romany gypsy caravans,
which perhaps stopped for the fair in Concarneau.
A figure in Breton peasant clothes stands beyond
the wooden steps leading up to the caravan. Barrels
and containers clutter the area to the right but
details are eliminated as Leech paints the subject
in a bold, simplified manner. A similar picture, *The
market, Concarneau* (fig. 8, p. 19), and *A caravan
at Concarneau* would more than likely have been
painted *en plein air*, and their dimensions suggest
they fitted into a box with slots, in which an artist
would carry his small, wet oil sketches. Whistler
used one of these little *pochade* boxes, and his
small, directly painted panels, when they were first
exhibited, had a long-lasting effect on younger
British artists such as Sickert, Steer and Lavery.

6

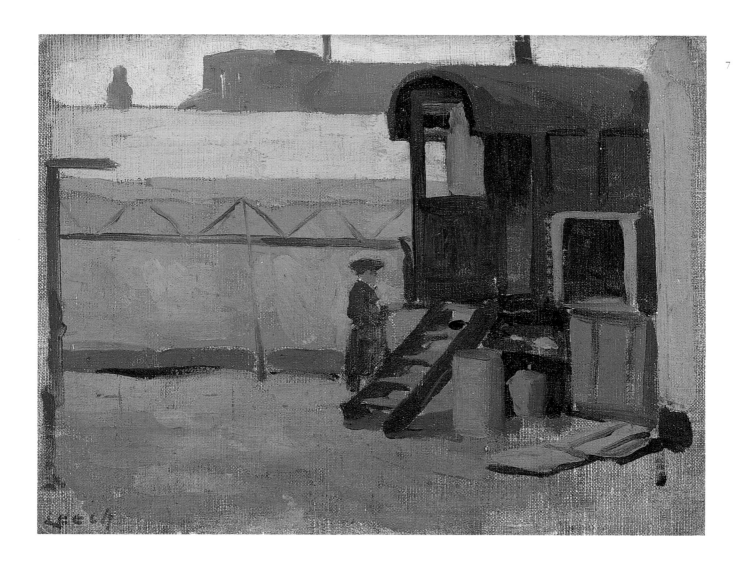

8 *The fair, Concarneau*

Oil on canvas
33 × 46 cm; 13" × 18"
Signed lower right *Leech*
Inscribed on the verso in the artist's hand *The Fair
Concarneau by W.J. Leech*
Private collection

EXHIBITION RHA, 1908 (no. 186, £21.0.0)

Outside the Hôtel des Voyageurs, the large weekly
and smaller daily markets were held. They were
even more colourful then than they are now, still
held in the same area. The women were resplen-
dent in their traditional Breton costumes; the more
elaborate they were the more affluent the wearer.
Contemporary photographs detail the rich pattern
and movement of the bustling scene and capture
the fascination and uniqueness of the subject-mat-
ter for the artist (see fig. 16, p. 30). *The market,
Concarneau* (fig. 7, p. 19) records a similar sub-
ject-matter, except that the lively scene of white-
bonnetted Breton ladies, clustered around a
market stall, is set beneath a high horizon-line. The
figures are simply depicted, the foreground is bro-
ken by the tree's shadows which form as patterns
on the ground. In contrast to the light brushstrokes
of creamy sepias, and barely discernible in the
shadows of the dark interior of the stall, are the
freely painted figures of a woman and child. Leech
uses a traditional composition of strong horizon-
tals and dominant uprights to give a quiet paint-
ing of a gentle scene. Touches of reds, contrasted
against the dark browns of the front of the stalls,
recall Whistler's *The general trader, ca.* 1888
(fig. 78, see cat. 43).

9 *The hat stall, Concarneau*

Oil on canvas
46 × 41 cm; 18⅛" × 16⅛"
Private collection

PROVENANCE Dawson Gallery, Dublin; by descent to
the present owner

10 *The little blue cart*

Oil on canvas
28 × 35 cm; 11" × 13¾"
Private collection
Signed lower left *Leech*

PROVENANCE Dublin, Dawson Gallery; by descent to
the present owner

EXHIBITION RHA, 1925 (no. 84, £15)

The hat stall and *The little blue cart* show Leech's
continued fascination with Breton markets, colour-
ful in the sunlight. Unlike *The market, Concarneau*
(fig. 7, p. 19), which bustles with women shopping,
these two works are devoid of people but glow
with colour under the hot summer sun. The blue
of the cart and the reds in the hat stalls introduce
colour into these views of sections of the market
stalls seen from an elevated angle. Leech uses the
dappled shadows in cream and blue to add sparkle
to the painting and create pattern in the empty fore-
grounds. Small brushstrokes depict the leaves on
the trees, the white of the Breton bonnets and the
edges of the blue cart.

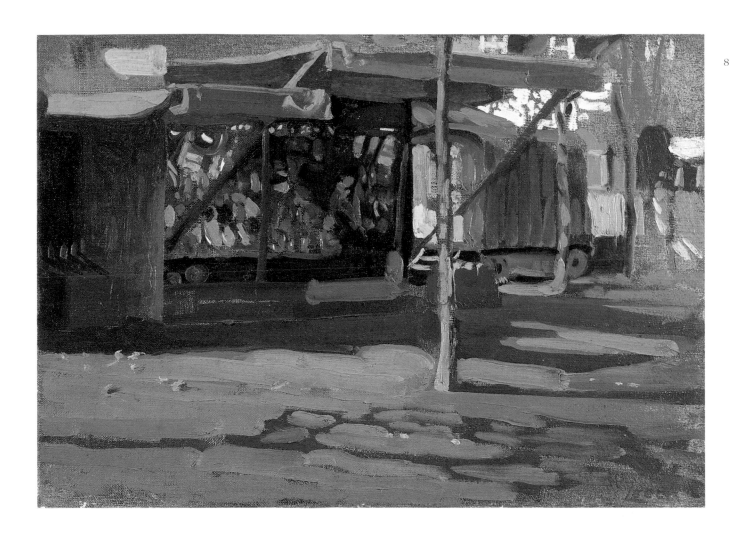

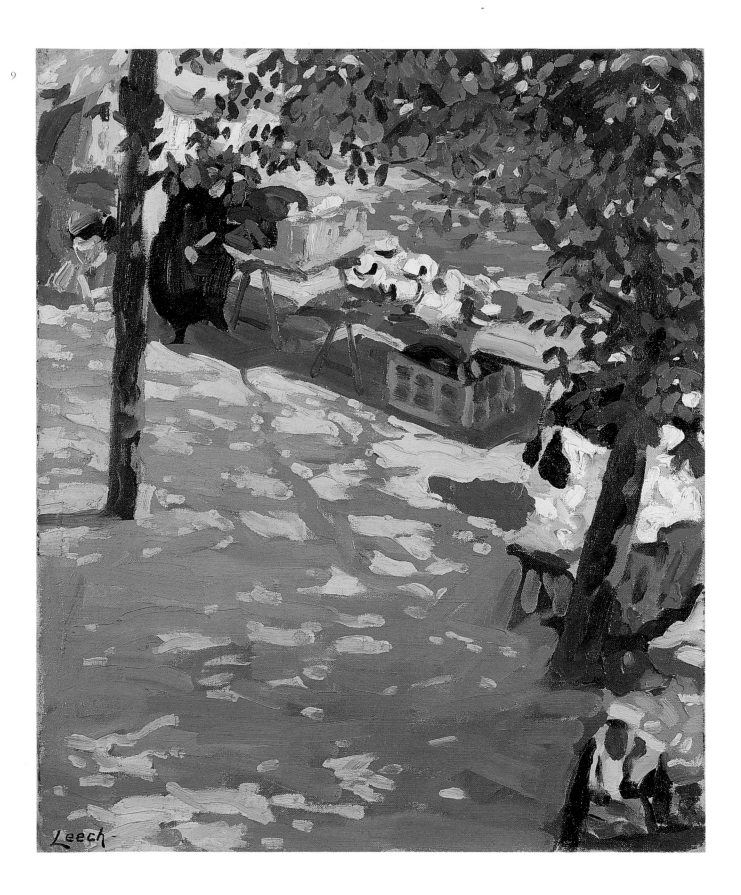

Leech -

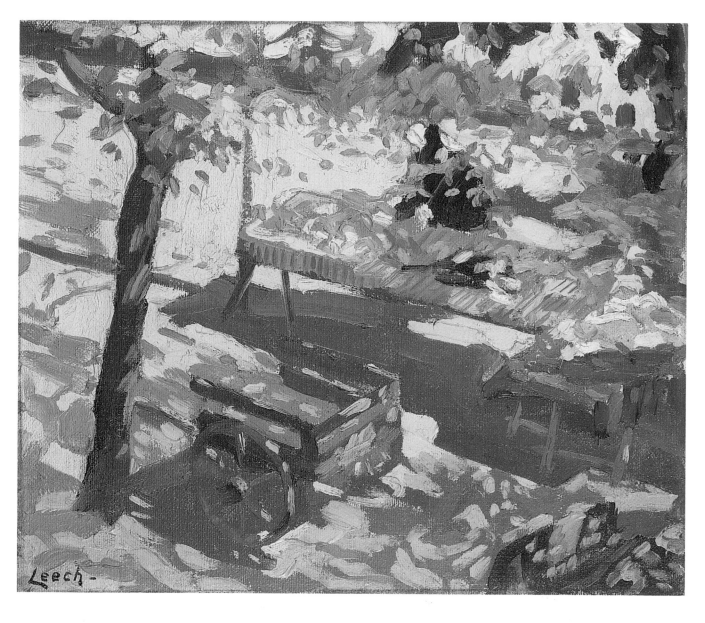

11 *The fish market, Concarneau*

Oil on canvas
45 × 81.3 cm; 17³/₄" × 32"
Signed lower right *Leech*
Private collection

EXHIBITION Dublin, Dawson Gallery, June 1945

A separate building was built for the fish market along the Peneroff basin where the fishing boats landed their catch. Recessed back from the square and raised on a stepped podium, the building enclosed a large airy, open market with individual stalls. Leech paints the lofty building with the white-bonnetted Breton women clustered round examining the newly arrived catch of tuna fish. The white of their bonnets is repeated in the glistening, silvery-white backs of the freshly caught tuna, which strongly contrasts against the browns and dull ochres of the interior. Fishermen in black berets and sweaters wait with the women for the rest of the boats to arrive. The painting may be contrasted with Osborne's *The fish market* (fig. 64), painted about ten years earlier, a work imbued with the knowledge of Impressionist light and colour, which he uses to capture the vivacity of street life; Leech's work retains his early dark, academic approach and the figures merge with the gloom of their static surroundings. However, Osborne's use of a high viewpoint, which truncates the nearest stall and leads the eye into an enclosed background, is similar to that used by Leech in many of his works, for instance *The hat stall* (cat. 9) and *The little blue cart* (cat. 10).

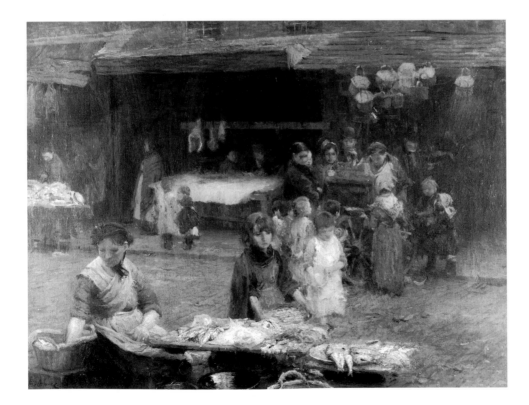

Fig. 64 Walter Osborne, *The fishmarket, Patrick Street*, oil on canvas, 59.7 × 80 cm, Dublin, Hugh Lane Municipal Gallery of Modern Art

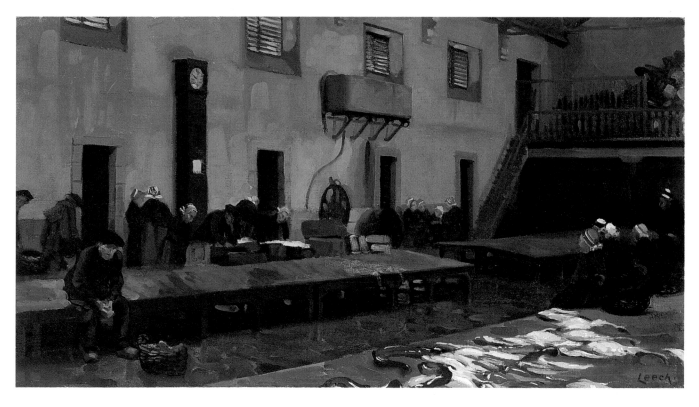

12 Boats at Concarneau

Oil on canvas
38 × 30 cm; 15" × 11¾"
Signed lower left *W.J. Leech*
Private collection

PROVENANCE Cecil Leech, brother of the artist; by descent to present owners

In this early painting by Leech, colour is still sub-
dued, the boats are depicted as dark brown forms
against the tones of grey and blue of the water. The
outline of the town becomes softened and sim-
plified, details are confined to the hull of the boats
with their upright masts. Here the academic qual-
ities and the sombre palette of Leech's Concarneau
friend Hirschfeld are apparent, when looked at in

Fig. 65 Aloysius O'Kelly, *A harbour scene*, oil on canvas,
66 × 45.7 cm, private collection

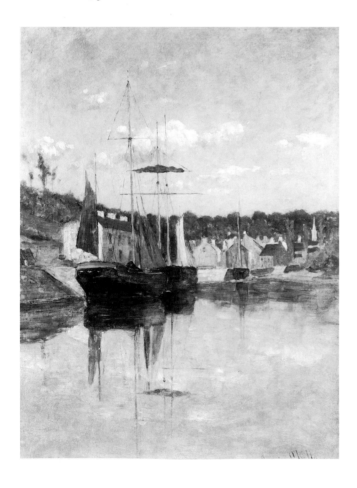

relation to his painting *Sail-boats, evening*
(Concarneau, Collection municipale), and since
both men painted together, this influence is hardly
surprising.[1] However, Leech's composition, with a
tunny boat creating a dynamic diagonal in the
immediate foreground, shows vitality compared to
the conventional structure of Hirschfeld's work. The
composition, indeed, strikingly recalls the line of
boats in Aloysius O'Kelly's *A harbour scene*
(fig. 65), probably a view of the quayside in
Concarneau where he was painting from 1903
onwards.[2] The houses along the waterfront, which
are bathed in atmospheric light, seem similar to the
houses encircling the harbour at Concarneau.
However, Leech's boats create a more dominant
diagonal and lack the light and open airiness of
O'Kelly's work. Leech has eliminated the skyline,
a recurring feature in his work, except in the
composition of *Boats on a Brittany shore, ca.* 1903
(private collection), and *Concarneau in the breeze*
(cat. 17), two landscapes which are unusually dom-
inated by an expanse of sky with scudding clouds.

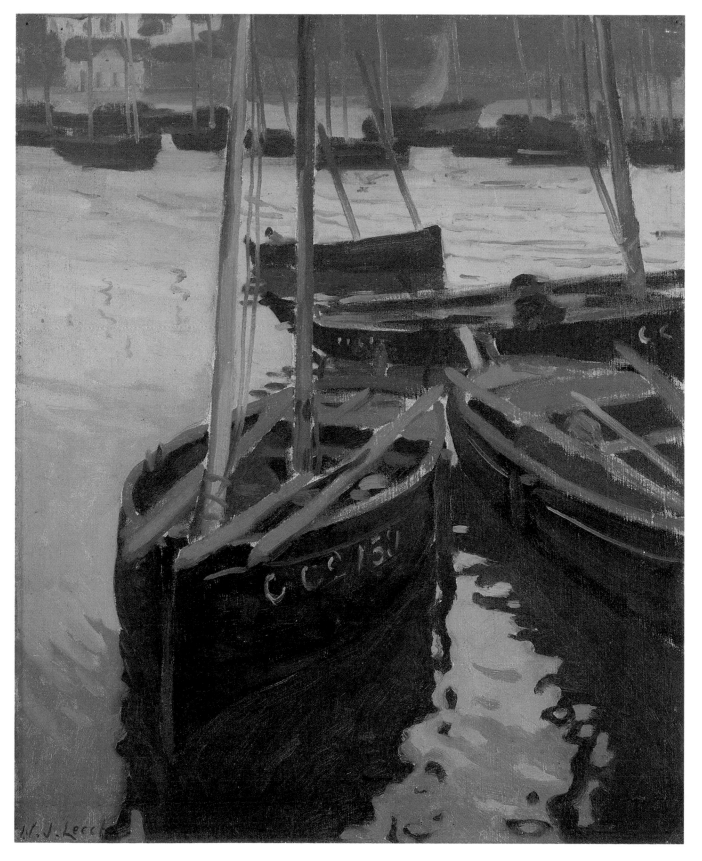

13 A sunny afternoon, Concarneau

Oil on canvas
61 × 116.2 cm; 24" × 45³/₄"
Signed lower right *Leech. 1908*
Private collection

PROVENANCE Bought by Nathaniel Hone from the RHA Exhibition, 1909; collection of the O'Connor family, Dublin; Pyms Gallery, London, where purchased

EXHIBITION RHA 1909 (no. 4, £31. 10s.)

LITERATURE Ferran 1993, p. 228

A sunny afternoon, Concarneau resulted from Leech's continued practice of painting boats, as they sat, moored silently, unmanned in the water. Painting fishing boats moored in the water was a favourite subject-matter with Leech's friends and fellow painters Hirschfeld and Thompson and with the local painters Guillou and Deyrolle, who depicted the harbour at Concarneau as a setting for genre paintings or as a background for portraits, as in Deyrolle's 1901 portrait of Alfred Guillou. Leech and Hirschfeld, on the other hand, preferred to capture harbours empty of people but full of boats. It was common practice to combine *plein air* work with studio practice and contemporary photographs show numerous artists painting *en plein air* in Concarneau, while other photographs show artists working on large-scale naturalistic subjects in their studios.

The sunlit quayside, where women gather to watch and gossip and enjoy the evening light, forms a strong horizontal in a grid of horizontals. The reflection of the houses in the water and the sails of the tuna boats bring colour into Leech's quiet painting of the harbour. Leech has chosen, as was his usual practice, to paint a tranquil scene but the harbour was not always as calm as this. Sydney Thompson recalled how the quayside used to come alive with the arrival of the fishing fleets and wrote

in his memoirs that "sometimes in one day two or three hundred tunny boats would arrive and that meant between fourteen to two thousand fishermen from all parts of the coast, living crowded on the wharf and in the cafés. Men excited by having made a big catch or not having caught anything."

Compared to earlier work such as cat. 12, Leech's palette has lightened with added colour and freer brushstrokes, which introduces colour into the sails, the façades of houses and the quayside. Leech has not yet achieved the sunlight and luminosity which was present in Lavery's *The bridge at Grez*, painted seven years earlier in 1901 (Ulster Museum, Belfast). His painting is more realistic in its depiction and imparts the industry of the fishing village which is absent from Lavery's impressionistic canvas of an idyllic summer's day. Thomas Bodkin in his review of the 1909 RHA in *The Freeman's Journal* praised this painting: "'Sunny Afternoon in Concarneau, Number 4' is charming for its atmospheric clearness, good perspective and other artistic points, which almost make the spectator think he is looking at a real scene instead of a picture". The painting was bought by Nathaniel Hone, Ireland's foremost landscape painter, an important approbation for Leech (see further above, p. 22).

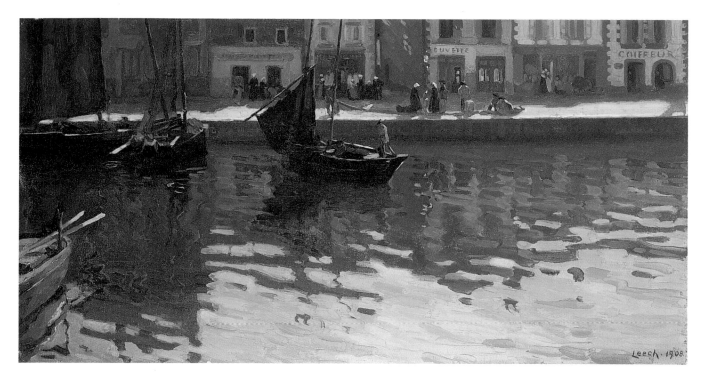

14 *Still evening, Concarneau*

Oil on board
29 × 24 cm; 11⅜" × 9½"
Signed lower right *Leech*
Private collection

PROVENANCE From the artist by direct descent

EXHIBITION London, Baillie Gallery, 1911 (no. 42, *Evening, Concarneau*, 2 gns.)?

This is one of Leech's studies painted in front of the motif using a Whistlerian palette with subdued tonalities. Typically no one stirs on the quayside and the artist alone is capturing the scene in the gathering dusk of the evening. Leech uses the thin trunks of the plane-trees to frame the boats in the harbour, resulting in a gentle landscape. It is through these small, instantaneous works that Leech's style develops.

15 *La France, Brest*

Oil on canvas
53.2 × 63.5 cm; 21" × 25"
Signed lower left *Leech*
William Joll

PROVENANCE James Adam & Sons, Dublin, sold August 1975

EXHIBITIONS London, Baillie Gallery, January 1911 (no. 36, £30); RHA, 1911 (no. 119, £31. 10s. 0d.)

In *La France, Brest*, the title taken from the name on the stern of the boat, Leech has focussed on the shape and colour of the boat moored in harbour. Painted about a year after *A sunny afternoon, Concarneau* (cat. 13), the change in Leech's composition, with the emphasis on pattern and the use of vibrant colour, is marked.

16 *Fishing boats, Concarneau*

Oil on canvas
44.2 × 34.4 cm; 17½" × 13½"
Signed lower left *Leech*
On verso: *No. 59 Fiskerbaade Ved Concarnat*
Private collection

PROVENANCE David Messum, London

EXHIBITION The title on the verso in Danish indicates that the painting was exhibited in Denmark

Leech has painted a small upright section of the long quayside at Concarneau and focusses on the unfurling sails and the activity in the boat as it perhaps arrives or departs. The view from a high vantage point is characteristic of Leech, continuing a Degas influence. The verticality is enhanced by the masts, the sail, the edges of the houses and the elongated shadow of the boat in the water. Distance is created by the lone figure of a woman watching their arrival or departure. The size of this work illustrates Leech's method of working directly on a smaller scale and then combining such works to make a larger studio painting, such as *Sunny afternoon, Concarneau* (cat. 13).

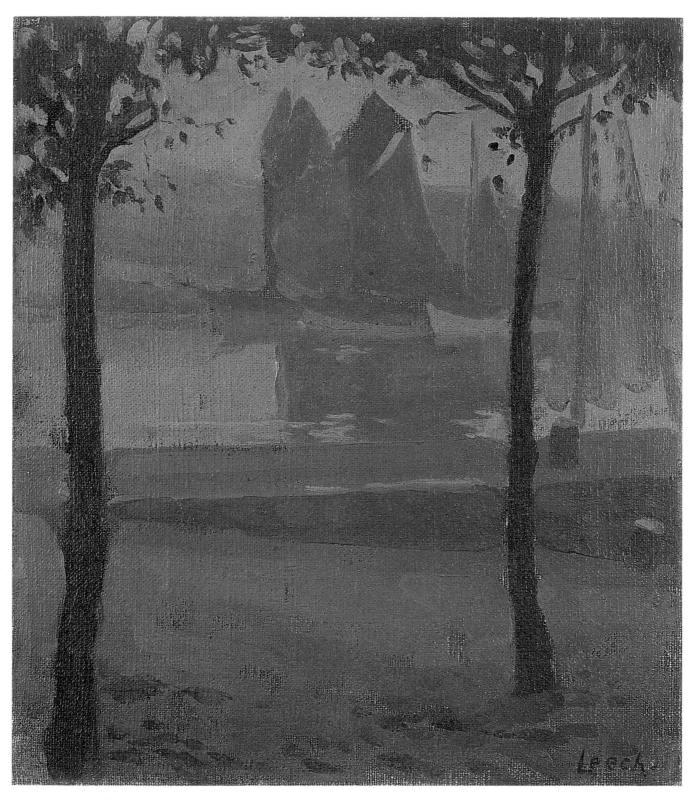

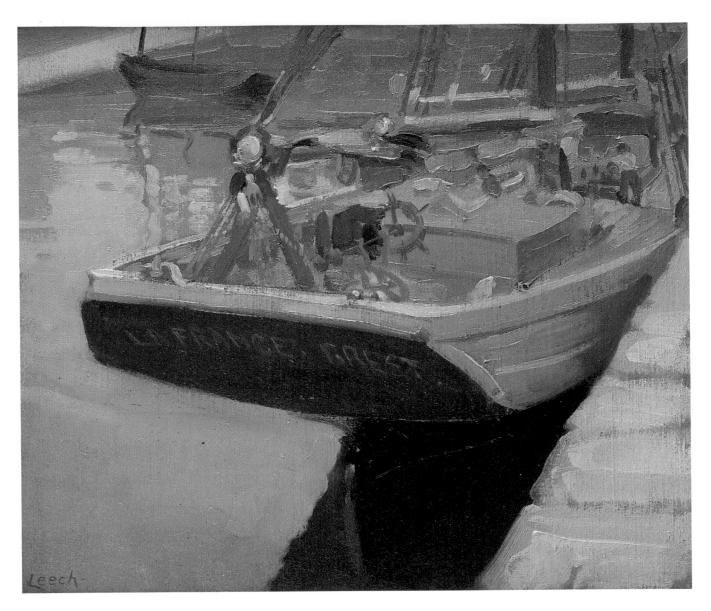

17 Concarneau in the breeze

Oil on canvas
45.5 × 54.5 cm; 18" × 21½"
Signed lower right *Leech*
On verso, title and signature on the stretcher in artist's hand
Private collection, courtesy of Pyms Gallery, London

EXHIBITION London, Baillie Gallery, January 1911

Leech has captured a summer's breeze in the scudding clouds overhead, in the white and orange yacht sails and the white prows of the boats. It is unusual for Leech to create such an expanse of sky with a low horizon-line. His paint handling, his use of colour and his control of the composition demonstrate his confidence in painting a vibrant landscape. Signac painted a similar subject in 1891, *Brise à Concarneau* (Breeze at Concarneau; private collection), depicting a regatta of boats in his pointillist style. Leech has assimilated some of the colour theories of Post-Impressionism but with the paint handling and brio of Lavery or Sargent.

18 Coloured sails, Concarneau

Oil on canvas
43.2 × 34.3 cm; 17" × 13½"
Signed lower left *Leech*
Private collection

PROVENANCE James Adam & Sons, Dublin, sold May 1987

EXHIBITION Dublin, Dawson Gallery, September 1950

Colour erupts in the orange of the sails and is reflected in the blue water with the whites of the boat and the houses. The buildings, on the shore, are simply depicted in fluid brushstrokes with a spontaneity of handling developed from painting *en plein air*. The signature, written simply Leech, which the artist adopted *ca.* 1908, is used here and dates this picture later than *Boats at Concarneau* (cat. 12) which has a cursive W.J. Leech signature.

19 Reflections (Marine subject)

Oil on canvas
45.7 × 54.6 cm; 18" × 21½"
Signed lower right *Leech*
Crawford Municipal Art Gallery, Cork

PROVENANCE Bequeathed by Dr R.I. Best, 1959

LITERATURE *Crawford Municipal Art Gallery,* 1991, p. 87, no. 84

The hulk of a largish trawler dominates the top half of the painting, its masts adding to the reflections in the water below, painted in a manner which suggests the reflections in Monet's *Sail-boats on the Seine, Argenteuil,* 1874 (San Francisco, Fine Arts Museums). The splash of orange along the bow introduces the one band of colour which penetrates the blueness of the water, the metal boat and the blue-green fields in the background. There is an incongruity between the machine-made boat and the gentleness of the landscape and the lushness of the green fields, which could be the fields behind Concarncau. Many of the elements in this work echo forms which Leech will produce in the future when painting the coal and fishing boats moored at Billingsgate docks in the late 1940s.

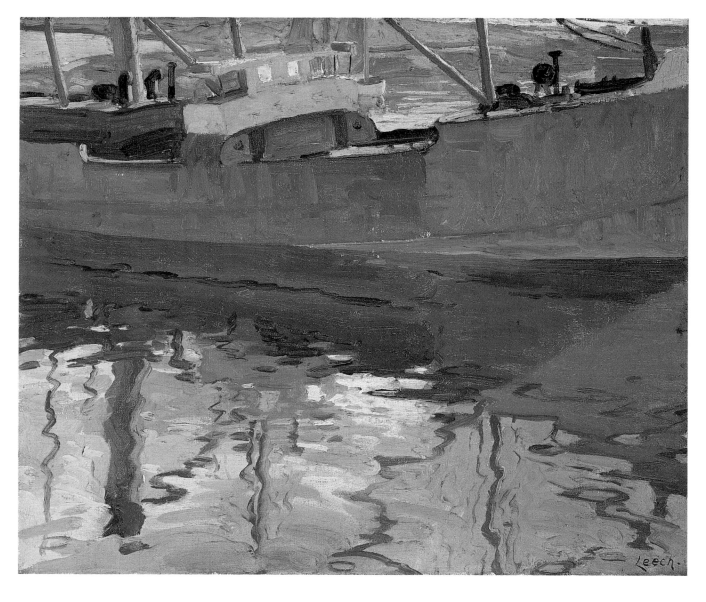

20 *Portrait of Lieutenant C.J.F Leech, R.F.A.*

Oil on canvas
204 × 106 cm; 80" × 24"
Signed and dated 1909
Private collection

PROVENANCE The artist's descendants

EXHIBITIONS RHA, 1909 (no. 17, n. f. s.); London, RA, 1910 (no. 150); London, Baillie Gallery, 1911 (no. 21, n. f. s.); Belfast, Loan Exhibition of Modern Paintings, 1913 (no. 33; lent by W.J. Leech); London, National Portrait Society, 1915 (no. 76)

LITERATURE *The Freeman's Journal*, 31 March 1909, p. 5, col. 5, 'Review of R.H.A. exhibition'

Leech's portrait of his brother Cecil was the first work he had accepted at the Royal Academy in London, from the given address of Concarneau, Finistère. It was one of the two portraits of his brothers, Arthur and Cecil, officers in the British Army, which his father had commissioned from him *ca.* 1908 to launch him as a portrait painter (see p. 40). When Leech first exhibited these portraits at the RHA in 1909, the review in *The Freeman's Journal* declared, "No's 17 and 31, the full size portraits of Artillery Officers, by W.J. Leech, furnish ample proof of the powers already developed by this rising artist". Leech also exhibited both these portraits of army officers at the National Portrait Society, London, in 1915, partly to pay tribute to his brothers who were then fighting in the First World War.

The year after *Interior of a café* (cat. 4), Cecil has been painted in a similar palette with the deep browns of a Dutch seventeenth-century portrait and hints of Degas greens. The dark tones dramatically contrast with the highlighted, young, gentle face of Bill's brother. He stands, leaning on his sword, posing in the dress uniform of an artillery officer, still inexperienced as a soldier on the field of battle. Leech painted no soldiers on active duty, any war scenes or indeed any other commissioned portraits of soldiers, despite living through both World Wars when many of his fellow artists were painting associated subject-matter or, like Orpen, were War Artists. Leech displays his customary sensitive approach to portraiture, showing not any soldier but the brother. Cecil's portrait reveals the sensitivity which was to make him forsake soldiering after the horrors of the First World War and devote his life to apple growing in Devon. Leech has captured this gentle nature in his young face, which, when compared to photographs, shows a striking likeness. This portrait is similar in composition to Orpen's standing *Self-portrait*, 1901 (private collection), but lacks its confident, cocky stance. However, the strong chiaroscuro effect of the artificial lighting, which throws the face and especially the hands into sharp focus, is similar to the effect achieved in Orpen's painting *Grace by candlelight*, painted in the same year.

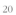 20

21 *Waving things, Concarneau*

Oil on canvas
56 × 82 cm; 22" × 32¼"
Signed lower right *Leech*
The National Gallery of Ireland

PROVENANCE Bequest of Dr R.I. Best, 1959

EXHIBITION London, Baillie Gallery, January 1911 (no. 2, 50 gns.)

LITERATURE Ferran 1992, pp. 14–15

Leech included many views of Concarneau, *The harbour, Concarneau*; *Fishing boats, Concarneau*, and of the town itself, *Old walls, Concarneau*, in his exhibition at the Baillie Gallery in 1911, but *Waving things* at 50 guineas was by far the most expensive painting, indicating how highly Leech regarded it. Leech has captured the soft tonalities of a Whistlerian landscape in his depiction of the old, walled town behind which lies the garden of the convent. However, the high horizon-line and fluid brushstrokes owe more to John Lavery, whom he had met about 1903, than to Whistler, but as yet Leech had not espoused Lavery's colour. The brushstrokes are used in the same free, confident manner as in *Sunny afternoon, Concarneau* (cat. 13)

but here the atmospheric light has softened outlines and simplified form, with little hint of colour. He has "evolved sunshine and reflections", but the influence of Whistler modifies the sunlight which alights on the stone ramparts, reflected in the water. Leech has confidently freed his brushwork to capture empty light-filled spaces and he will soon emerge from this subdued tonality to his use of vibrant colour, as in *A convent garden* (cat. 37) a few years later.

The walls of Concarneau (private collection), a slightly smaller painting, is a similar view of the ramparts of Concarneau, reflected in the blue-toned water of the harbour, empty of any tunny boats.

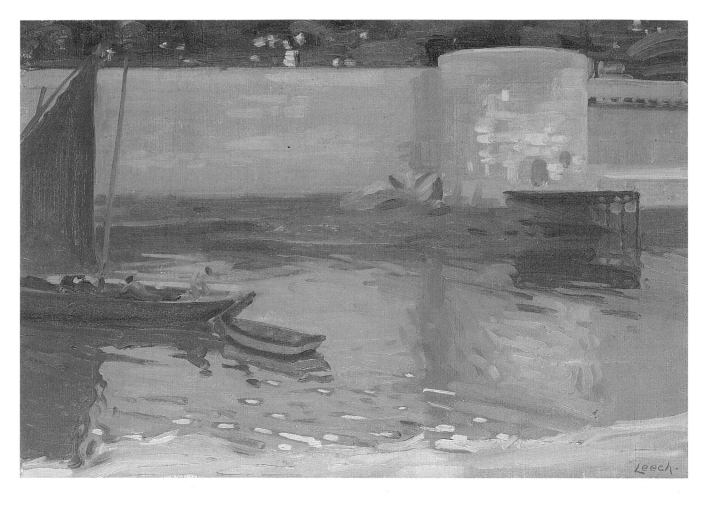

22 'Twas brillig

Oil on canvas
53.3 × 63.5 cm; 21" × 25"
Signed lower right *Leech*
Private collection

EXHIBITIONS RHA, 1910 (no. 39, £84); London, ROI, October 1910 (no. 314, £84); Cork, Crawford Gallery, 'Irish Art 1900–1950', 1975–77

LITERATURE *Irish Art 1900–1950*, exhib. cat., Cork, Crawford Gallery, 1975, pp. 47–48

One of the four paintings Leech exhibited at the Royal Institute of Painters in Oil in 1910 was *'Twas brillig*, which he had shown a few months previously at the RHA. From the price of £84, Leech considered this to be a major work. It was unusual for Leech to give his paintings titles taken from literature, but *ca.* 1910 he also gave the title *The Secret Garden* to his landscape of lilies in a garden (cat. 36), and he frequently gave his landscape paintings imaginative, poetic-sounding titles, such as *Waving things, Concarneau* (cat. 21) or *When things begin to live* (cat. 25). *'Twas brillig* comes from Lewis Carroll's *Through the Looking Glass*, 1872, when Humpty Dumpty says:

'Twas brillig, And the slivey toves

Did gyre and gimble in the wabe ...

A review in *The Leader* in 1910 wrote enthusiastically about this work: "One of the best things I saw was Mr. W.J. Leech's "Twas Brillig' – a strange title which I think is a phrase of Lewis Carroll's. It is an open scene, with a few young girls – children – in the foreground. The intensity of the light beating upon them partially obscures them, while a gale of wind blows back their clothes towards the sandy ground behind. There is a wonderful sense of wind and light in the picture, which is most cleverly handled throughout."

Leech has achieved light, colour and happiness in this Concarneau landscape of a summer's day with two children in the foreground apparently blowing a dandelion clock, while a little girl looks on. In the background children run and play in the sunlit green grass, behind them tuna boats with sails unfurled glide past the high horizon-line of houses along the quayside. The tonality of the boats and the houses reflects the influence of Whistler while the foreground captures the sunlight of the Impressionists with light falling on white dresses and golden hair.

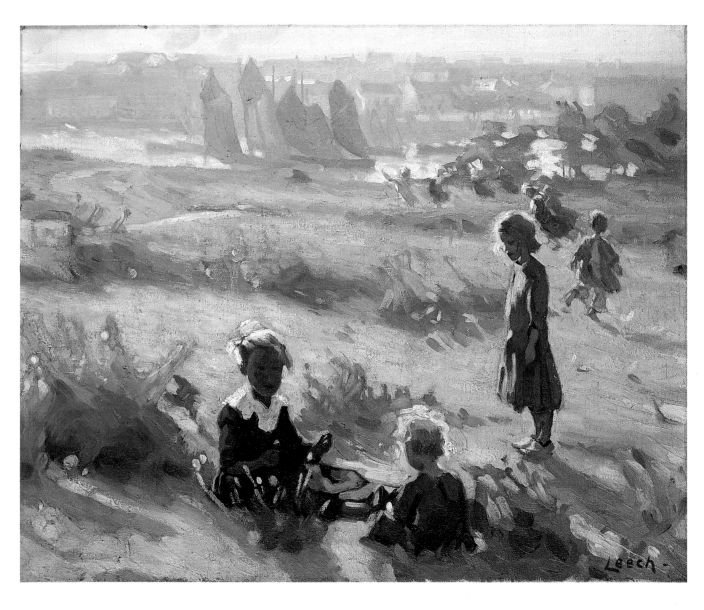

23 Killiney Hill under snow

Oil on canvas
37 × 45 cm; 14½" × 17½"
Private collection

PROVENANCE Dawson Gallery, Dublin; Taylor Galleries, Dublin

EXHIBITION Dublin, Taylor de Vere White, June 1989 (*Vico Road from the Obelisk, Killiney*)

The obelisk dimly emerges like an eastern temple immersed in a snowy plateau set against the soft greys and blues of the misty valley below. Leech uses the mantle of snow which covers the familiar landscape of verdant greens to transform the local topography into close-ranging tones of whites, greys and blues resembling his Swiss scenes of 1911. It may be compared with *Killiney Bay* (private collection), a smaller snowscape possibly painted around the same time, which captures a view of Killiney looking towards the Dublin moun-tains but seen in the unusual silvery light of the morning as it envelopes the sea and the bay beyond in grey-blues. Local colour is introduced in the immediate foreground, freely painted in brush-strokes of deep olive-green and Paynes grey, with submerged hints of light-toned grey. These two landscapes probably pre-date Leech's Swiss land-scapes and it is possible that the restrictions imposed by a limited palette in reproducing snow effects in paint intrigued him as an artist and sug-gested his painting trip to Switzerland in 1911.

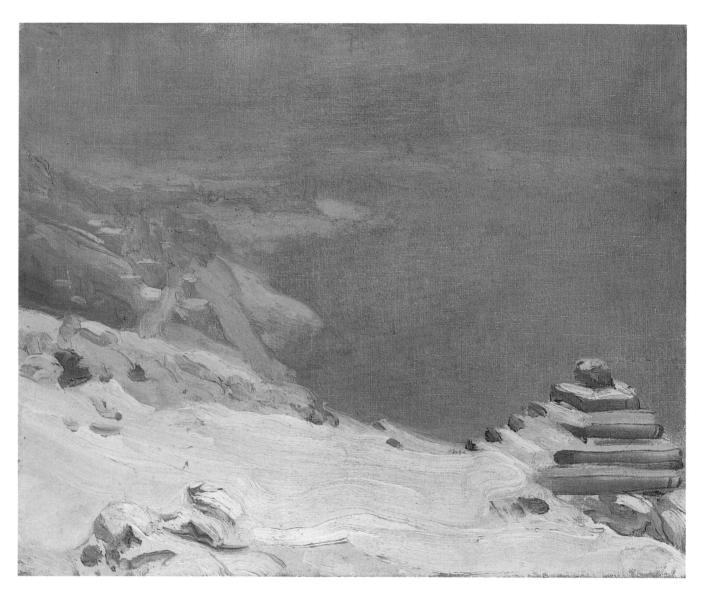

24 *La Paix*

Oil on canvas
55.8 × 66.1 cm; 22" × 26"
Signed lower right *Leech*
Private collection, courtesy of Pyms Gallery

EXHIBITIONS London, Goupil Gallery, 1912 (no. 34, £21); London, Bonhams, 1996

The steep viewpoint looks down from a high vantage point on to a narrow road which leads to the valley and the lake below, possibly Lake Constance where Leech painted in 1911. The soft greys and blues of the town sparkling with occasional lights as it lies below in the valley evoke peace, a suitable title for this painting. Leech draws with fluid brushstrokes the brown and vivid green of the near bank and the silhouettes of fine leaves and branches which jut out from either side.

25 *When things begin to live*

Oil on canvas
65 × 53.5 cm; 25½" × 21"
Signed lower left *Leech*
On verso, label with title
Private collection, courtesy of Pyms Gallery, London

PROVENANCE Purchased from Goupil Gallery exhibition by R. Park Lyle, Bt.; Pyms Gallery, London

EXHIBITIONS London, Goupil Gallery, 1912 (£26.50); London, Pyms Gallery, 1985

LITERATURE *Celtic Splendour*, exhib. cat., London, Pyms Gallery, 1985, illus. p. 57

26 *Glion*

Oil on canvas
60.3 × 50.2 cm; 23¾" × 19¾"
Signed lower left Leech
Pyms Gallery, London

PROVENANCE Purchased from Goupil Gallery exhibition by R. Park Lyle, Bt.; Mrs Sylvia Bride (died 1978)

EXHIBITION Goupil Gallery, 1912 (£21)

LITERATURE Denson 1969, no. 20

When things begin to live (cat. 25) and *Glion* (cat. 26), both bought by R. Park Lyle from Leech's exhibition at the Goupil Gallery in London in 1912, typify the atmospheric landscape paintings which constituted the majority of the work that Leech displayed and which *The Times*'s critic referred to as "vivid illusion by means of that process of elimination which was practised by Whistler". Although these were the only two sales then recorded for Leech, Sir R. Park Lyle (1849–1923), the purchaser, was one of the Lyles of Tate & Lyle. The paintings complemented each other as a harmonious pair. *When things begin to live* captures a view of a Swiss lake in winter and of the hillside houses from a spot further up the steep, snow-covered road. Hints of colour are harmoniously close-toned to avoid any disquiet in the tranquil scene. *Glion* depicts a similar viewpoint of the valley beyond, shrouded in denser mist. These two Swiss paintings demonstrate Leech's confident, fluid paint handling, his ability to capture the essence of the place and to render the ephemeral qualities of light in the close tones of a very light palette.

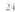

24

139

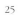

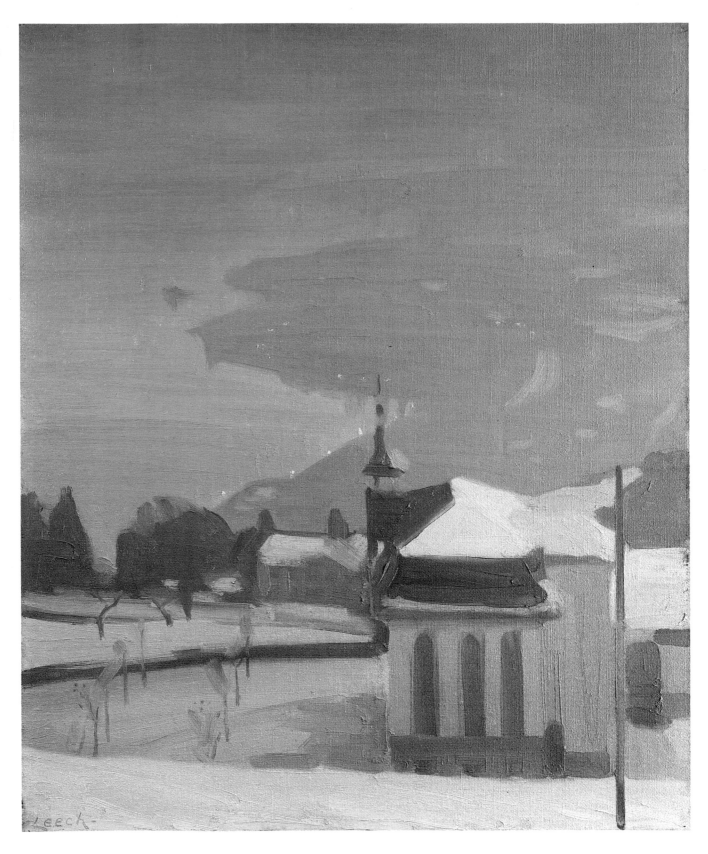

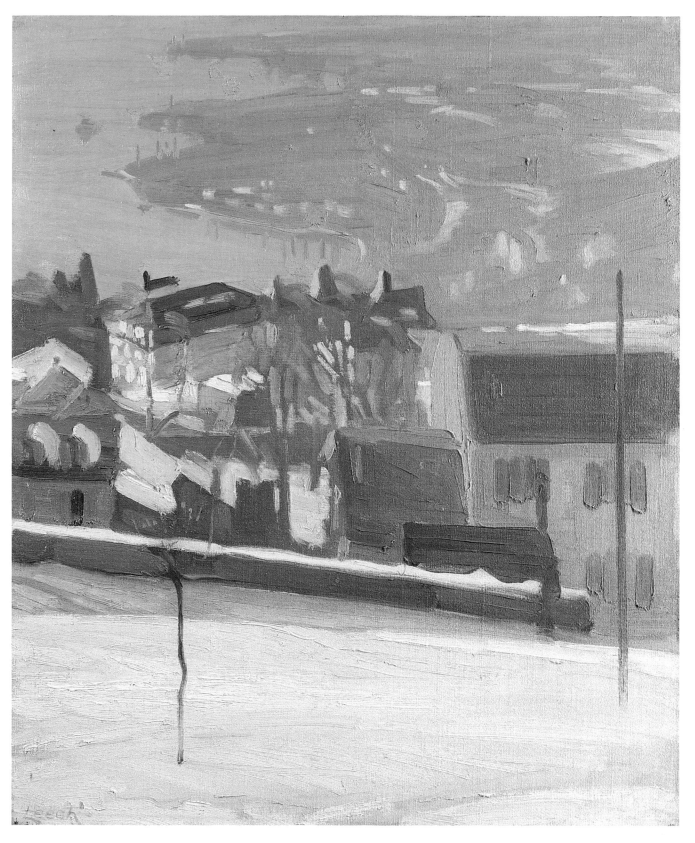

27 Snow scene

Oil on canvas
61 × 50.8 cm; 24" × 20"
Private collection

EXHIBITION London, Goupil Gallery, 1912 (no. 31)?

In this painting, Leech focusses on the light from the morning sun which casts soft, blue shadows and lights up the snow-laden branches of the winter trees. The weight of snow can be sensed lying thickly on the branches, and obstacles on the ground slightly protrude from under the new fall of snow. The depth of the far shadows creates a cave-like effect in the branches. Leech displays remarkable accomplishment as a painter in his representation of the lightness and sparkle of the snow and the blueness of the shadows in this magical, fairytale scene.

28 Trees in the snow

Charcoal and watercolour on paper
51.8 × 35.9 cm; 20⅜" × 14¼"
Signed lower left *Leech*
The National Gallery of Ireland

PROVENANCE Purchased 1968 from Leech's niece

EXHIBITION 'Irish Watercolours, 1675–1925', Dallas,
Museum of Fine Arts, October–November 1976

LITERATURE F. Gillespie, Kim Mai Mooney and Wanda
Ryan, *Fifty Irish Drawings & Watercolours,* Dublin, National
Gallery of Ireland, pl. 43

29 A mountain town or monastery

Watercolour on paper
49.8 × 34.8 cm; 19⅝" × 13¾"
Signed lower left *Leech*
The National Gallery of Ireland

EXHIBITION 'Irish Watercolours, 1675–1925', Dallas,
Museum of Fine Arts, October–November 1976 (no. 73)

30 A snow-covered field

Charcoal and watercolour on paper
51.7 × 35.8 cm; 20⅜" × 14"
The National Gallery of Ireland

EXHIBITION 'Irish Watercolours, 1675–1925', Dallas,
Museum of Fine Arts, October–November 1976

Leech uses charcoal to sketch in the outlines of these Swiss snowscapes before freely painting, in a vertical format, these three watercolours which delicately record the scenes in front of him. Trees recede into the background in the gentle watercolour *Trees in the snow* (cat. 28), while patches of pale sienna introduce colour in the far ground. The fluid painting of the wintery sky hangs heavy over the thin upright trees silhouetted against the white background. *A snow-covered field* (cat. 30) depicts hillsides covered with deep snow but allowing details of a fence and bushes to protrude. The deep shadow of the fence creates a dramatic diagonal which is swept up to the distance with trees etched against the snow, closed in by a snow-covered hill. *A mountain town* or *Monastery* (cat. 29) shows a close affinity to Turner, especially his scenes painted in Switzerland around Bellinzona. Although Turner employed a landscape format, Leech similarly uses a vertical to convey the dominant height of the hill with the town perched on top.

r

Leech.

31 *The bridge at Paris*

Oil on canvas
48.2 × 55.3 cm; 19" × 21¾"
Signed lower right *Leech*
Pyms Gallery, London

PROVENANCE The artist's descendants

EXHIBITION Belfast, Public Art Galley and Museum, 1913 (as *The grey bridge*)?; RHA, 1913 (as *Through a bridge*, no. 308)?; London, Goupil Gallery, April–May 1912 (as *The grey bridge*, no. 10)?; London, Pyms Gallery, 1996

LITERATURE *Truth to Nature*, exhib. cat., London, Pyms Gallery, 1996, pp. 78–79

When Leech went to Paris to paint in 1911, his series of *The bridge at Paris*, of which cat. 31 is one, provided him with a static, solid motif to paint in varying light and from similar viewpoints. Orange is deployed as the underlying colour and shines through in the bridge parapet, in the reflections in the water, and around the edges of the boats in their moorings. This and another view show the same angle of the bridge with boats moored underneath, but one of the works is of a view slightly further back so that the bridge, its railings and people walking past are captured. Each painting combines decorative elements, the parapet of the bridge, the stone façades and the reflected water below. Leech exhibited a painting at the RHA in 1915 entitled *Pont Philippe, Ile St.-Louis, Paris*, which was possibly the smaller oil panel.

Cat. 31 was given by Leech as a wedding present to Jim Botterell and his wife Eileen in 1930, when he told them that he painted it when on honeymoon with Elizabeth in Paris. Although they remembered that the bridge was close to where the couple were staying, the name and location of the bridge were unknown, and the family referred to it simply as *Bridge at Paris*. It has since been identified "as one of the embankment spans of the Pont Louis-Philippe, the only Paris bridge constructed with a block granite core faced with limestone keystones and surmounted by a classical pediment and balustrade." It connects to the old artists' quarter of the Ile St-Louis.

Elizabeth and Bill began to have extended stays in Paris from 1911 to 1913. They were there when Sydney Thompson and his wife Ethel Mabel arrived from New Zealand at the end of August 1911, and found an apartment in a quiet street, rue Denfert-Rochereau, in Montparnasse. Leech gave his address in the Salon catalogue of 1913 as rue Léopold Robert, which was also in Montparnasse. The two friends remained in the same area they had lived in as students, close to Julian's Académie.

There is a suggestion of Monet's bridge studies, particularly *Les Déchargeurs de charbon*, 1875 (private collection), in the composition, the combination of industry and water and the added detail of passers-by on the bridge above. In the dramatic high span of the bridge and in the simplified shapes of stone bridge and hulls of boats, there is an awareness of Japanese woodcuts, which influenced the Impressionists and Whistler. It is possible that cat. 31 was exhibited in the large exhibition of Leech's work at the Goupil Gallery in 1912, which comprised mostly his tonal landscapes, painted in Switzerland and Venice in the winter of 1910–11. Here the palette is broader, heightened in areas with pronounced strokes of paint, yet allowing the texture of the canvas to shine through elsewhere. Beneath the large span of the arch, the ripples of the water capture "sunlight and reflections", created by the sudden burst of sunshine which floods from the far bank, replicated by Leech with touches of Naples yellow and silvery blues. Even in this early work Leech has attained a dryness of texture which is repeated in several works, and throughout his painting career he consistently waxed his paintings to achieve a matt finish, refusing ever to varnish them.

32 *Avenue de l'Observatoire, Paris*

Oil on board
37.9 × 46 cm; 15" × 18"
Signed lower left *Leech*
Crawford Municipal Art Gallery, Cork

PROVENANCE Bequeathed by Dr Lennox Robinson, 1959

Leech concentrates on the line of trees to create a strong converging line along the right-hand side of the painting, and focusses on the contrasts between sunshine and shadows in the trunks of the trees to create directional pattern. The avenue is devoid of people, a customary practice in his work which allows him to concentrate on simplified compositions. As he wrote to Helena Wright in the 1930s, "You must not be in a hurry, and you must not draw or paint everything or anything. You must search till you find some arrangement of lines that speaks to you'." Here he practises his future advice. He has become confident in the handling of various tones of greens and ochres with fluid brushstrokes in the intervening years that possibly separate this *Avenue* from *The bridge* (cat. 31). Leech still visited Paris but for shorter stays when he was on his way to the South of France, to Grasse and Nice. He exhibited a painting entitled *Avenue de l'Observatoire* at the RHA in 1938, no. 136, but its price of £15. 15s. would suggest that this was a smaller panel, painted on the spot, from which Leech possibly painted this work. It is a simply rendered scene in bold areas of simplified colour of a long avenue of tall trees which dramatically lead to a warm-stoned building in the distance. The trunks of the trees are painted in areas of warm browns defined in dark umbers to give solidity and rotundity. Sunlight floods the scene in pools of Naples yellow, merging into browns where the shadows are cast by the trees. The paint handling is free and fluid with brushstrokes blending together to give an overall smooth handling to the dark-green foliage of the trees, the tree trunks and the sandy ground.

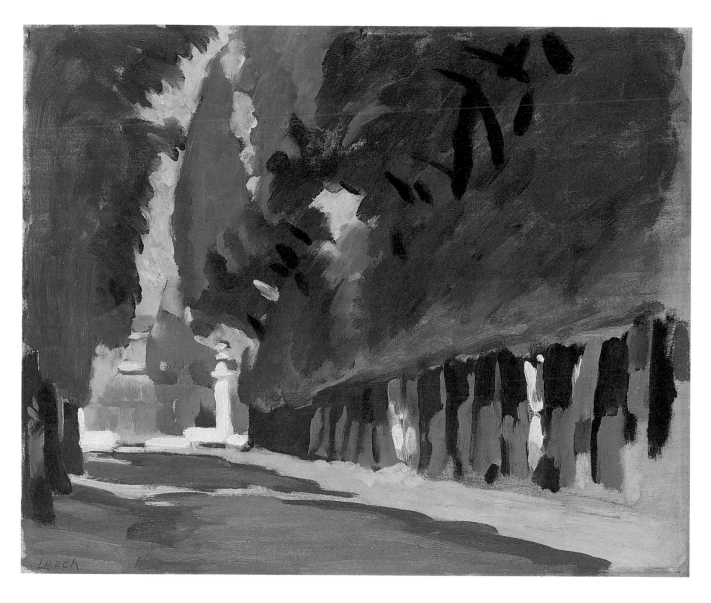

33 *Caves at Concarneau*

Oil on canvas
52 × 84.8 cm; 20½" × 33⅜"
Signed lower right *Leech*
Private collection, courtesy of Pyms Gallery, London

PROVENANCE By direct descent from the artist

EXHIBITION London, Pyms Gallery, 1991

LITERATURE *Life and Landscape*, exhib. cat., London,
Pyms Gallery, 1991, pp. 48-49, illus. p. 49, no. 19;
Impressionism in Britain, p. 152

Caves at Concarneau exemplifies Leech's awareness of Monet's work and his full embrace of Impressionism. The touches of orange, which reappear in *The bridge at Paris* (cat. 31), here reverberate in the rock face of the cave and contrast with the cool blues of the shadows, creating what Kenneth McConkey referred to as "a lunar landscape". The paths, in Naples yellow, lead boldly into the dramatic contrast of dark cave shadows. Bold stark shapes are modelled in bold directional brushstrokes of colour while light breaks the rockface into angular facets. Monet, in works such as *Study of rocks, Creuse*, 1889 (private collection), used pink tones in the foreground to intensify the contrast of orange and cadmium yellow against

blue. Leech uses a similar palette, but his brush has the fluid stroke of later Impressionist paintings and of the Fauves, and the painting lacks the density and small-brush texturing achieved by Monet. The surface tension of Monet's painting emphasizes volume, whereas the rhythmic, flowing brushwork of Leech's painting introduces movement and decoration and recalls the landscapes of Sargent, painted in Palestine. Leech seems to be more interested in the pattern created by the interweaving caves. This interest in design within the painting becomes an increasingly important element in his work, and achieves its maximum effect in his *Aloes* series painted in the South of France in the very early 1920s (see cats. 49–51).

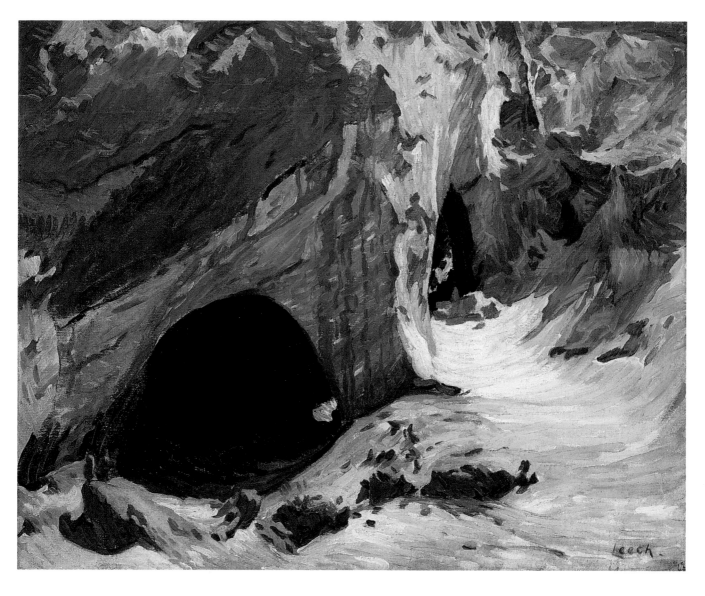

33

153

34 *Seaweed*

Oil on canvas
51 × 61 cm; 20" × 24"
Signed lower left *Leech*
Private collection

PROVENANCE Dawson Gallery, Dublin; Taylor Galleries, London

EXHIBITIONS London, Baillie Gallery, Jan. 1911 (*Rocks and seaweed,* no. 32, £15)? (*Seaweed,* no. 40, appears from the price to have been a watercolour or smaller study); RHA, 1911 (*Rocks and seaweed,* no. 68, £15. 15*s.*)?; London, Whitechapel Art Gallery, 1913 (*Rocks and seaweed,* no. 128)?; RHA, 1945) *Wet seaweed,* lent by Richard McGonigal Esq. S.C., no. 194)?

LITERATURE Campbell 1984, p. 265, col. illus. p. 80

The influence of Roderic O'Conor, whom Leech had met in his early years in Brittany (see p. 37), is apparent in Leech's painting *Seaweed,* especially with regard to O'Conor's technique of rendering his sky areas in blue streaks. There are marked similarities between this painting and O'Conor's

Fig. 66 Roderic O'Conor, *Field of corn, Pont-Aven,* 1892, oil on canvas, 38.1 × 38.1 cm, Belfast, Ulster Museum

landscape of 1892, *Field of corn, Pont-Aven* (fig. 66). All the intensity of colour and textured form is combined in *Seaweed,* and by focussing on the motif Leech is able to concentrate on colour and pattern. Stylistically similar to *A convent garden* but abstracted without the figures, the power of the colour and writhing shapes dominate. Leech showed *Seaweed,* or perhaps it was another in this series titled *Rocks and seaweed,* at an exhibition organized by Hugh Lane and Dermod O'Brien in 1913, at the Whitechapel Art Gallery, London. In 1914, a review of the RHA commented, "*The Octopus* by Mr. Leech is a writhing tree of vivid hues, and an essay in exaggeration, really interesting." This suggests that stylistically *The octopus* (present whereabouts unknown) was similar to *Seaweed.*

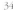

35 Quimperlé – the goose-girl

Oil on canvas
72 x 91 cm; 18¼" × 16¾"
On verso, inscribed on paper on frame *Quimperlé W.L.*
The National Gallery of Ireland

PROVENANCE Allen & Townsend, Dublin; Gorry
Gallery, Dublin; purchased by the National Gallery in 1970

EXHIBITION London, Royal Academy, *Post-
Impressionism*, 1979–80 (no. 319); Dublin, Trinity College,
1979

LITERATURE *Post-Impressionism*, exhib. cat. by
A. Gruetzner, London, Royal Academy, 1979, p. 201; *The
Peasant in French 19th Century Art*, exhib. cat., Dublin,
1980, no. 77; Campbell 1980, pp. 332–33; Campbell 1984,
pp. 79, 262; D. Delouche, *Les Peintres et le paysan Breton*,
URSA, 1988, p. 165; Ferran 1992, p. 15

From the 1880s onwards, Quimperlé had been well accustomed to visiting painters, and Henry Blackburn had specifically recommended the area to British artists. "A painter might well make Quimperlé a centre of operations, for its precincts are little known; the gardens shine with laden fruit-trees and the hills are rich in colour until late in autumn." The gentle landscape of Quimper does not feature much in Leech's work since he preferred to paint water and boats and Concarneau afforded him this opportunity. Still, Quimper would have attracted him, if only to visit the area where Osborne had painted, and Leech and Thompson frequently travelled the short journey in the small train between these two towns. Osborne's *Apple gathering, Quimperlé* (fig. 67) contains in its background a view which, with rooftops and church tower, is similar to the townscape of Quimperlé, and the figures are reminiscent of the goose girl in *Quimperlé – the goose-girl*. There is, however, a greater use of colour in *The goose-girl*, especially in the treatment of the sparkling flowery meadow underfoot.

In Leech's *Summer Brittany* (fig. 68), which could have been painted in Quimper, the figures are loosely modelled, the forms simplified, with less

Fig. 67 Walter Osborne, *Apple gathering, Quimperlé*, oil on canvas, 58 × 46 cm, National Gallery of Ireland

Fig. 68 William John Leech, *Summer Brittany*, oil on canvas, 47 × 53 cm, private collection

detail than in Osborne's *Apple gathering*. *Summer Brittany* is a small-scale work which captures a Breton woman in conversation with a young girl – both subjects are attired in local peasant costume. The bridge wall which fronts a river is more evocative of the tranquil landscape of Quimperlé than the harbour of Concarneau. The handling brings the background of simply shaped houses on the far river-bank close up against the foreground figures, reducing spatial perspective with a flattening of the picture planes. The border of rooftops in the top section of the painting allows no hint of skyline to open up the distant space – a characteristic feature of Leech's compositions. Leech's painting is composed of areas of tonal harmony which recall Whistler and Lavery or a later Osborne, rather than the even light of Lepage, but it does not yet have the bold areas of colour which were to be characteristic of Leech's later paintings. Colour peeps in on the right, as one patch of soft orange in the head-dress of the Breton woman, yet without interruption to the total harmony.

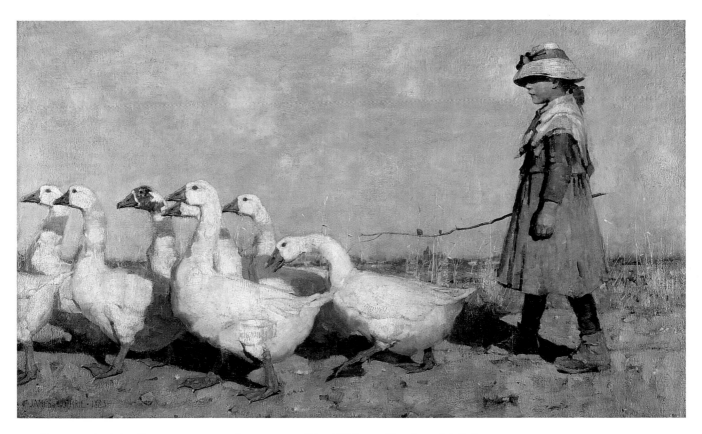

Fig. 69 James Guthrie, *To pastures new*, oil on canvas, 92 × 152.3 cm, Aberdeen Art Gallery

In *The goose-girl*, the full sunshine of a summer's day floods between the narrow-trunked trees forming pools of light on the meadow and through this sunlit patch the flock of geese contentedly waddle. If Leech painted this work, then it was after he had mastered the effects of sunlight and colour in his painting, which he began to achieve between 1910 and 1912. The date of *ca*. 1903 has been suggested for the work, since this was Leech's earliest date in Brittany and the subject-matter would tend to suggest this early date. However, signed works of this period (see cats. 1–3, 12), including *Portrait of a man with a bottle* (cat. 3), dated 1904, show that at that time Leech's palette was dark and tending to monochrome, and his paint handling different from that employed in *The goose-girl*. The date of *ca*. 1910–12, which has also been put forward, is consistent with the development of the use of colour and luminosity in Leech's work but not with

his subject-matter or pictorial qualities. Also untypical of Leech is the delicate, mosaic-like brushwork of *The goose-girl*, built up stroke by stroke, layer by layer; this results in a thick impasto which is susceptible to a fine crazing or craquelure, visible on the canvas. Leech was particular about the craft of his art, worrying about the zinc white used in *Un matin* (cat. 50) and meticulously waxing each canvas six months after completion: it is unlikely he would have used impasto in this way.

Small brush marks have been made with the point of the brush by the painter working close to the canvas – as opposed to Leech's usual fluently drawn brushstrokes. He portrays his own method of painting in his *Self-portrait*, cat. 75. The girl poses in a white sun-bonnet and simple summer dress, not a Breton peasant costume. This bonnet was similar to one bought by Maud Ethel Thompson, Sydney Thompson's wife, when they were staying

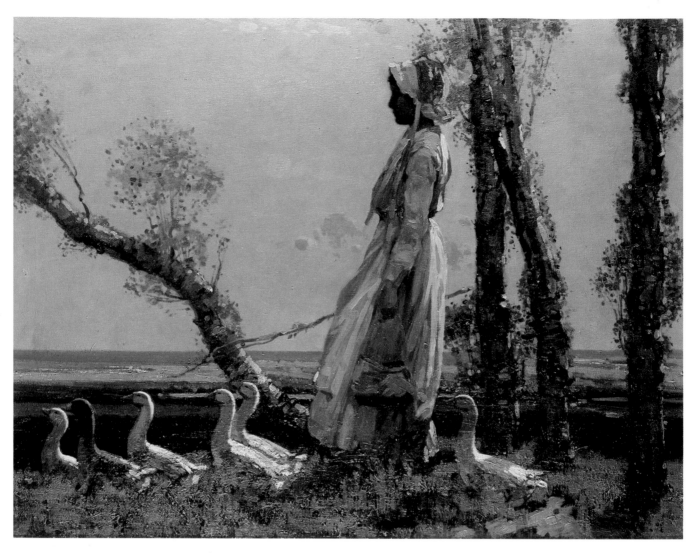

Fig. 70 Stanley Royle, *The lilac bonnet*, 1921, oil on canvas, 71.1 × 91.5 cm, private collection

at Staithes during the summer of 1911 and which she brought back with her to Concarneau, so it could be argued that the painting was painted in France using these clothes. But there is the further problem that *The goose-girl* was painted on a canvas with a Sheffield stamp. Leech used French canvases when in France. Although when in England Leech used English canvases – for instance *La Dame aux irises* (fig. 39) has a Locks Leeds stamp on the back – he never seems to have used a Sheffield canvas on any other occasion. Sometimes he used Winsor & Newton, but mostly he appears

to have stretched his own canvases. The size of *The goose-girl* canvas, 28″ × 36″, is a characteristic Kit-Kat portrait size, which, to the author's knowledge, was used by Leech on only three occasions: one is *The kitchen, 4 Steele's Studios* (cat. 76), one is Leech's portrait of Sydney Thompson (fig. 47), the third is *Painting in a garden* (whereabouts unknown) listed by Bourlet Transport on 30 August, 1950, as one of eighteen works brought from Leech's studio to the Dawson Gallery. Leech painted frequently at Tettenhall Wood outside Wolverhampton when he was staying with his sis-

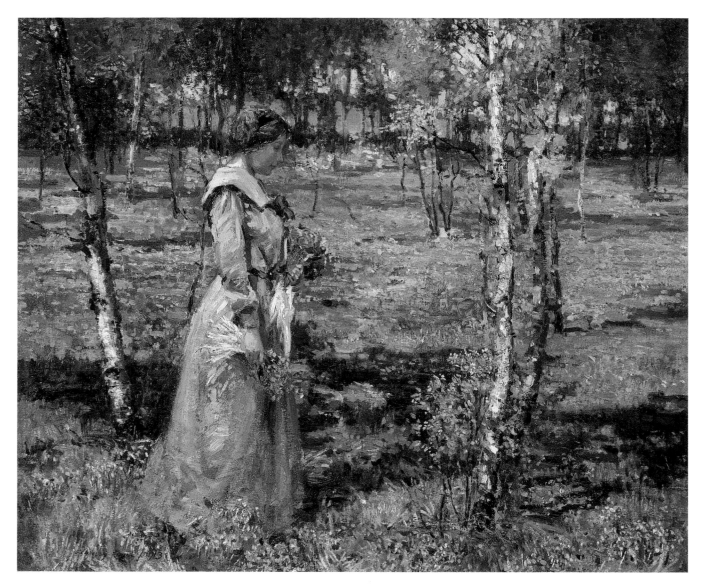

Fig. 71 Stanley Royle, *Spring morning among the bluebells*, 1913, oil on canvas, 63.5 × 76.2 cm, private collection courtesy of Richard Green

ter Kathleen during the 1920s and 1930s and it is possible that he used a Sheffield canvas then, though there is no evidence that Leech went to Sheffield to paint, and the idea is difficult to reconcile with his stylistic development after the First World War. He visited his family throughout England but he usually painted the immediate locale and rarely travelled far in search of a motif.

There is a possibility that *The goose-girl* was in Leech's collection and that it was pinned on the wall of Leech's studio, but was painted by another artist. However, Mrs Eileen Botterell, who knew Elizabeth Leech and identified her as the model in *A convent garden* (cat. 37) and *The sunshade* (cat. 38), had no recollection of seeing this painting in Leech's studio from the period she knew Leech, from the late 1930s until his death in 1968.

A sense of timelessness and peace pervades this painting and this aura is achieved by a classic compositional arrangement of horizontals and verticals

which is not characteristic of Leech. Attention is focused on the foreground action, on the detail of the goose-girl and the geese, a ploy which suggests the influence of Bastien-Lepage or that of his disciple, Clausen, who exhibited at the RHA and was more Leech's contemporary. The pin-holes present on the canvas are consistent with a *plein air* painter, working in a Bastien-Lepage manner, with the canvas pinned tautly to a stretched frame to hold the canvas rigid as the artist applies tiny daubs of paint. Leech is not known to have used this system. The subject itself is untypical, although the New Zealand artist and Leech's friend Frances Hodgkins had painted *A goose-girl* in 1893 – and Camille Pissarro painted a similar subject in the same year. It could be argued that Leech could have seen both works, Pissarro's when it was exhibited in Paris in 1907 and Hodgkins's, since he knew her, but it would seem unlikely that Leech would paint the subject of a goose-girl almost thirty years later than Pissarro and Hodgkins. Although other painters in Brittany were again painting peasant subject-matter, with a new awareness, in the first two decades of the twentieth century, this was not the direction that Leech's work was going. Bastien-Lepage's influence is present in James Guthrie's painting *A hind's daughter*, 1883 (Edinburgh, National Gallery of Scotland), which Guthrie painted after encountering Lepage's work on a trip to Paris. James Guthrie, one of the Glasgow School and a friend of John Lavery, painted *To pastures new* (exhibited 1883; fig. 69) which has resonances in *Quimperlé – the goose-girl*. Guthrie's model, with one arm hanging loosely by her side with the far hand holding a stick, resembles her pose.

When and by whom was *The goose-girl* painted? Dominic Milmo-Penny has put forward the name of Stanley Royle, and compares *The goose-girl* for the model and composition to Royle's *The lilac bonnet* (fig. 70), which he suggests could have been inspired by Guthrie's *To pastures new*. Stanley Royle exhibited *The lilac bonnet* at the Walker Art Gallery

in 1921, the same year in which Leech, who he admired, exhibited *The tinsel scarf* (cat. 40). The difference in style, approach and subject matter in their work at that time is insurmountable. Royle was painting and exhibiting romanticized subject-matter such as *The lilac bonnet* as late as 1925. Although his daughter rejects the suggestion that her father painted *The goose-girl*, she did admit, when she first saw a reproduction, that she was "struck by the similarity to my father's style". Dominic Milmo-Penny suggests *The goose-girl* should possibly be identified with Royle's painting *Among the bluebells*, exhibited at the Walker Art Gallery, Liverpool in 1925. *The goose-girl* is painted not merely on an English canvas but one stamped Hibbert Bros., 117 Norfolk Street, Sheffield. Established in the 1840s, Hibbert Bros. both supplied Stanley Royle's canvases and acted as his agent. When Paul Hibbert of Hibbert Bros. was recently shown a reproduction of *The goose-girl*, he identified it instantly as a Stanley Royle. In other paintings by Royle, for example *Bluebell Wood* (Sheffield, Mappin Art Gallery and City Museum) the bluebell wood setting of *The goose-girl* recurs, as does the stylistic treatment of the trees, and the same farm-house in the background. The colour harmonies are also very similar. Royle's wife Lily Goulding is the model for the single figure in *The lilac bonnet* and in *Spring morning among the bluebells* (fig. 71); she bears a distinct resemblance to the girl in *The goose-girl*, who has a simplified, cut-out appearance, unlike the dramatic poses in most of Leech's work. But, if Royle painted *The goose-girl*, why then did he neither sign it nor date it, while *Spring morning among the bluebells* and *The lilac bonnet* are both signed and dated 1913 and 1921, respectively?

The goose-girl has *Quimperle W.L.* printed on a label on the frame on the back with none of Leech's usual cursive handwriting or other identifiable labels. There is no record of it having been exhibited under Leech's name, although it may have

been exhibited under another title and one painting especially, exhibited as *The lady and the trees* at the RHA in 1917, has, as yet, not been located, though its title arouses curiosity. *The goose-girl* was not listed in the contents of Leech's studio when he died in 1968 nor in any of the Dawson Gallery lists of Leech paintings in stock, nor is it referred to by Denson in any of his books, which includes many of the paintings which remained in Leech's studio on his death, some of which he acquired. However, in 1995, Alan Denson accredited the painting to Leech and recalled that Leech and he had conversations about it in the latter years of Leech's life when it was in his studio at Candy Cottage.

Above all the stylistic argument points to the conclusion that *The goose-girl* was not painted by Leech but was painted by the Sheffield painter Stanley Royle. We may then ask, if this work is by Stanley Royle, why has his work and his name remained in obscurity for so long? *The goose-girl* radiates colour, light and a peacefulness that permeates the room in which it hangs. However, it will be seen that, despite the now traditional attribution to Leech, it has little in common with his work. Setting *The goose-girl* in this large retrospective exhibition of Leech's work allows for further discussion of the evidence and a comparison against Leech's work in all its variety.

36 The Secret Garden

Oil on canvas
109 × 84 cm; 43" × 33"
Signed lower left *Leech*
On verso, signed *Leech* and *W.J. Leech R.H.A.* and inscribed
by the artist *The Secret Garden*; also *19, Porchester Square*
and *The Studio, Hamilton Mews, London, NW8* (the
addresses of two of his London studios); Bourlet transport
label, no. 6847; Daniel Egan label (Brighton)
Private collection

PROVENANCE By direct descent from the artist to the
present owner

EXHIBITION RHA, 1920 (no. 147, £75)

LITERATURE Ferran 1993, p. 228

Leech gave his sunlit lily garden the same title as
a popular, sentimental book written in America in
1909 by the British writer F.E.H. Burnett, author of
Lord Fauntleroy. The tranquil garden of Leech's
painting was most likely a recapturing of the gar-
den which surrounded the hospital and convent of
the Sisters of the Holy Ghost (Les Sœurs du Saint-
Esprit) in Concarneau. It was a secret garden, across
in the old walled town of Concarneau, hidden
behind high stone walls, which overlooked the
bustling harbour. Leech had convalesced in this

hospital and garden in 1904 after suffering from
typhoid fever, from which, like the subject of
Burnett's book, he recovered. About that time he
had painted *A sister of the Holy Spirit* (*Sœur du
Saint-Esprit*; fig. 72), in a work which captures the
tranquillity and meditation of a young nun as she
sits with a book on her lap beside a lighted win-
dow. It is in the style of his earlier academic, brown
paintings of 1903–08. When the painting was exhib-
ited at the RHA in 1913, the reviewer (P.H.G.)
wrote: "*Sœur du Saint Esprit,* which shows a nun

Fig. 72 William John Leech, *A sister
of the Holy Ghost*, oil on canvas,
44.5 × 28 cm, private collection



sitting with folded hands beside a window, captures both interest and affection. Handled broadly but with masterly confidence, this study in browns and off-whites is reminiscent of the Dutch Masters in its suggestion of peace and repose, and is to my mind the gem of the exhibition." However, the painting remained unsold until it was exhibited at Leech's second exhibition at the Dawson Gallery in 1947, priced £38.

The Secret Garden shows a freedom and facility to render colour and light, which strengthened in Leech's work from 1910 onwards, after several years of painterly development in Concarneau. However, the area of reflected light in the background suggests the use of photography. This light area becomes the nuns' gowns in *A convent garden* (cat. 37), and the exact replication of the garden as the backdrop for the figures reinforces this premiss. *The Secret Garden* resembles Walter Osborne's *A cottage garden* (fig. 73), especially in the tall upright lilies concentrated to the right of the canvas. Leech may have seen this work when it was included in the Memorial Exhibition of 1903–04 at the RHA. However, Leech's work of almost thirty years later shows his full absorption of light and colour. Leech's painting of the garden, which was most likely completed before *A convent garden*, remained in France until 1919, when he transported these two paintings, among others, from Paris to London. Though finished in itself *The Secret Garden* may be seen as a preliminary work to achieve an appropriate setting for the ethereal figure of Elizabeth, the object of his desire at that time, in *A convent garden, Brittany* (cat. 37).

Fig 73. Walter Osborne, *The cottage garden*, oil on canvas, 67 × 49 cm, National Gallery of Ireland

37 *A convent garden, Brittany*

Oil on canvas
132 × 106 cm; 52" × 41¾"
Signed lower right *Leech*
The National Gallery of Ireland

PROVENANCE Purchased from the artist by Percy
Botterell, *ca.* 1922; bequeathed to his wife, May Botterell,
who presented it to the National Gallery in 1952

EXHIBITIONS Paris, Salon des Artistes Français, 1913
(as *Les Sœurs du Saint-Esprit*, no. 1082); London, Royal
Academy, 1921 (as *Nun and lilies*); Brussels, Exposition
d'Art Irlandais, 1930 (as *Religieuse et lys*, no. 78, "*prêté par
M. D.* [sic] *Botterell, CBE*")

LITERATURE J.F. Mills, 'Convent Garden, Brittany', *Irish
Times*, 7 May 1969, p. 12, illus.; Durand, *Irish Painters in
Brittany at the Turn of Century*, Carn 1974–75, no. 81, p. 6;
Crookshank and the Knight of Glin 1978, p. 282, illus.;
Campbell 1980, pp. 333-35; Wynne 1983, p. 44, illus.;
Campbell 1984, p. 261; McConkey 1990, pp. 40-43, illus.
p. 43; Campbell 1991, pp. 36–45; Ferran 1992, p. 16; Ferran
1993, p. 228

A convent garden repeats the light, colour and com-
position of *The Secret Garden*, but dramatically
introduces the figure of Elizabeth, Leech's first wife,
into the right foreground. In *Art Forum*, John
Fitzmaurice Mills has described this compositional
emphasis, "Here he uses an entirely unconventional
composition, even to the placing of the most impor-
tant figure well to the right-hand side, almost as
though it were passing out of view. Yet, the whole
succeeds brilliantly by the use of the immediate
foreground."

In this picture glowing with light and colour,
Elizabeth poses as a novice, gazing forward to the
right. With book in hand she moves dream-like,
removed from this world. Walking in prayer behind
her, in the background shadows of the tree-lined
walled garden, are the nuns of the Holy Ghost (Les
Sœurs du Saint-Esprit), the sisters who ran the
hospital and the school in Concarneau. Sister Mary
Benedict Cotter, who belongs to the order of Les
Filles de Saint-Esprit and who lived in the convent
at Concarneau, recognizes the habits of these nuns

as those worn by the sisters of the convent until
1953, when they reverted to the ordinary daily wear
of the local women. Nuns donned these habits
when they became brides of Christ. The day nov-
ices took their final vows, they dressed in traditional
bridal wear, before donning a nun's habit and
devoting their lives to seclusion and prayer. The
garden is still there today but the hospital has
become a rest-home and is no longer run by the
nuns, though their main convent is still in north-
ern Brittany, at St-Brieuc.

A convent garden, Brittany combines on one
canvas the light, colour and decorative pattern of
the Post-Impressionist palette and brushwork, yet
retains elements of an earlier Impressionist work,
Claude Monet's *Women in the garden* of 1867
(Paris, Musée d'Orsay). Monet posed his beloved
Camille several times in the same painting, in beau-
tiful white dresses, which he had specially made
from those featured in fashion magazines. He trans-
ported her, from wife and mother, into an idyllic,
Arcadian Garden of Eden, from which all earthly
worries had been banished. The floating fabric and
voluminous skirts of Camille's dress catch the sun-
light in sparkling areas of an intensity of light and
coloured shadow. Leech poses Elizabeth, dressed
in a traditional Breton wedding dress and starched
lace *coiffe*, as a young contemplative novice in the
secluded world of the convent garden, preparing
to enter a life-long commitment. The heat of the
sunlight is captured in mauves and blues as it per-
meates the flimsiness of Elizabeth's lace gown and
this contrasts with the starched folds of the white
cotton robes of the nuns walking in the back-
ground.

Bright yellows, acid greens and textured forms
as seen also in *Seaweed* (cat. 34) create the writhing
strokes of grass in the garden behind the tall curv-
ing horizontal forms of the lilies. The blue sky and
distant rocky shore of this work have become a
high horizon-line of dark-green shadow against
which the nuns are etched, frieze-like. Behind

Elizabeth, the background is based on *The Secret Garden* (cat. 36), in which there is a similar palette of colours. Dark tones delineate the lily leaves and petal heads in arabesque curves against the white of the novice's dress and the yellow greens of the background grass. Gone is the soft tonality of the Whistler-influenced landscapes *Glion* and *When things begin to live* (cats. 25, 26). The shadow under the trees highlights the upturned face of Elizabeth and throws into focus the lace details of her elaborate *coiffe*. She is in full sunlight as opposed to the nuns whose faces are hidden by the trees. The careful placing, to the right, of the figure, balanced by the tall clump of lilies on the left, suggests that Leech amalgamated several studies into this carefully planned composition.

Fig. 74 Alfred Guillou, *The arrival of the pardon of St Anne at Fouesnant*, 1887, oil on canvas, 281 × 216 cm, Quimper, Musée des Beaux-Arts

Fig. 75 Aloysius O'Kelly, *Corpus Christi procession, Brittany*, oil on canvas, 39.5 × 58.5 cm, Dublin, AIB Art Collection

This is in every respect a Salon work, and it was exhibited by Leech at the Paris Salon in 1913 (entitled *Les Sœurs du Saint-Esprit*). Thereafter, however, it received no attention, mainly because it remained in France until 1919, when Percy Botterell bought it from Leech, and on his death in 1952 it was presented to the National Gallery of Ireland.

Why did Leech choose to paint Elizabeth as a young bride in a convent garden at this time? The couple were planning to marry but Elizabeth had to obtain a divorce from her first husband, Fentress Kerlin, in the United States of America. This would preclude their marriage taking place in a church

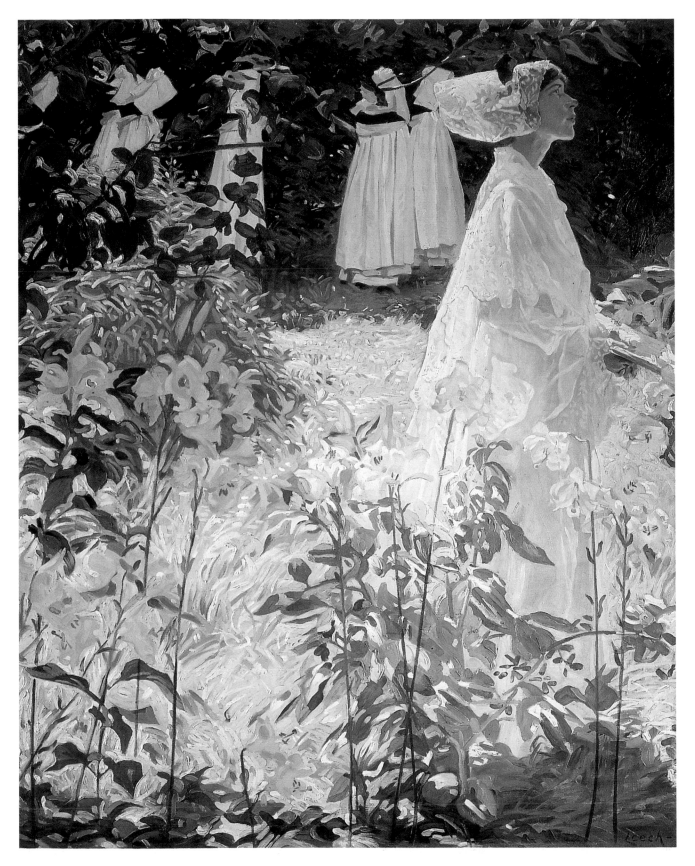

with the usual religious splendour that was accorded to Breton weddings. In fact, their wedding ceremony was simply performed at Fulham Registry Office in 1912 and was other than the traditional white wedding both may have wished for. This painting was probably executed *ca.* 1912, since it was first exhibited at the Paris Salon in 1913, and when May Botterell wrote accompanying her bequest to the National Gallery of Ireland in 1952, she referred to it as "one of the Brittany period (about 1913), figures in sunshine and full of light –".

Leech would probably have known Alfred Guillou's *The arrival of the pardon of St Anne at Fouesnant*, 1887 (fig. 74). Guillou captures the local procession of young virgins, dressed in traditional white wedding gowns, who carry the statue of St Anne across to the shore. In a similar subject-matter, *A Sunday procession (Un Dimanche de procession)*, 1893 (Morlaix, Musée d'art), Guillou has dramatically recorded this highly spectacular, colourful and moving religious procession as it leaves the old town of Concarneau, led by altar boys holding banners and followed by first communicants and the virgins. The red surplices of the altar boys contrast with the dazzling white of the virgins' flowing robes as they wend their way across the bridges into the new town. A similar theme was depicted in Aloysius O'Kelly's painting *Corpus Christi procession, Brittany* (fig. 75). If this work was painted when O'Kelly was in Brittany in the 1880s, it would be almost contemporaneous with Guillou's *Arrival of the pardon*. However, *Corpus Christi procession* is painted in a more impressionistic style, with its broad handling of the brush and accomplished rendering of light; indeed it is closer to Impressionism than Leech's more contrived and decorative work. The broad brushstrokes with which the three maidens leading the procession are painted create 'sensations' of light falling on their white gowns and headdresses. It is more likely that O'Kelly painted this in the first decade of the twentieth century, dur-

ing the time when he was with Leech and Thompson in Concarneau and before he left for the USA. O'Kelly may have been a constant influence on Leech during these formative years.

Hirschfeld, Leech's friend in Concarneau, also painted a processional picture, *The procession of Notre-Dame-des-Flots, ca.* 1899, which portrays the first communicants and virgin brides in their flowing white robes as they lead the procession of altar boys and priest and carry white candles and prayer books under a canopy of banners. Their white bridal dresses are the same as the one worn by Elizabeth in *A convent garden*, with notably the same detailing of the lace along the wide sleeves of the top wrap which softly flows over the long full dress. On their heads are lacy white *coiffes*, which form a band around the head and then extend out in a peaked form at the back. In handling Leech's work resembles the photographic realism of Hirschfeld's brides more than O'Kelly's impressionistic handling of a similar subject.

Orpen, too, painted his mistress Yvonne Aubicq, dressed in a nun's habit, in Paris in 1919, four years after Leech had exhibited *A convent garden*. Orpen's model wears an actual nun's habit and veil with a crucifix hanging round her neck. In spite of this exactness of dress and the realistic style of Orpen's painting and the religious feeling of the pose, the sensuality of Yvonne's eyes confronts the viewer. Orpen enjoyed portraying Yvonne in many guises in his work, as a spy and as a nun, but her sensuality and sexuality is present in every rôle. Leech also paints Elizabeth in many rôles, but although intent on capturing the different facets of her character, he raises her on to a pedestal which distances her from the viewer. We get no closer to knowing her as a person and she remains aloof, an enigma.

The detail with which Leech painted Elizabeth's flowing dress and veil was commented on by Gweltaz Durand, who accurately observed that Leech captured more precisely than Gauguin the

Fig. 76 John Singer Sargent, *Carnation, lily, lily, rose*, 1885–86, oil on canvas, London, Tate Gallery

costumes of the people: "Leech, on the contrary, in 'Convent Garden, Brittany', deals with the young Tregor girl's coiffe and shawl as carefully as he deals with the plants and foliage in the convent garden. In a very impressionistic way, he exploits the light passing through the lace in the same fashion as the light passing through the foliage." The comparison with Gauguin accentuates the different approaches of both artists to Breton subject-matter. There is theatricality in Leech's *A convent garden*. Elizabeth is captured in a spotlight of sunshine, on the stage of life with the nuns as a pattern of dappled light and shade in the background, beneath the avenue of trees. Leech was not interested in realistically capturing a religious scene, but in making a statement of love and devotion to the wife whom he revered at this time. If it symbolizes Elizabeth as a novice finishing her novitiate, there may be a reference to her former failed marriage. It is a love painting caught in frozen movement in the warm sunlight

of a secluded garden. Her gracefulness and ethereal quality echo the virgin figure in James Ensor's *The Virgin as a comforter*, 1892 (Brussels, Collection A. Tavernier), or the figure in Armand Point's *The eternal chimera*, ca. 1893 (London, Piccadilly Gallery). However, both these ethereal females glide along, one holding a lily and the other a book, with eyes downcast, which symbolizes modesty. The subject-matter of *A convent garden* also echoes back to the English Pre-Raphaelites, in particular Charles Allston Collins's painting *Convent thoughts*, 1850–51 (Oxford, Ashmolean Museum). Leech combines the symbolism of the white lilies and a background of nuns in prayerful procession with a young novice, dressed in the pure white of a Breton bride, in a garden of light and joy. By capturing the pattern of sunlight on the main figure and the lilies, Leech breaks the picture plane into flowing pattern, in a manner similar to that used by Sargent in his painting of lilies and children, *Carnation, lily, lily, rose* (fig. 76).

Leech exhibited the painting at the Royal Academy in 1921 under the title *Lilies*, the title he gave *A convent garden* when transporting it from France in 1919. Transport entries for the Royal Academy exhibition record the work as *Nun and lilies* and it was again *Nuns and lilies* when transported to Brussels for the Exposition d'Art Irlandais in 1930 and there exhibited (on loan from Mr Percy Botterell) under the corresponding French title, *Religieuse et lys*. Bought by Percy Botterell after Leech had failed to sell it, and bequeathed to his wife May, on his death in 1952 it was donated by May to the National Gallery of Ireland, and was still entitled *Lilies* when the painting was transported to the National Gallery in 1953. Only subsequently was it renamed by the National Gallery *A convent garden*.

"*Les Sœurs du Saint-Esprit*", which Leech exhibited at the RHA in 1915 priced at only £26. 50s., may have been a study for this work. (By comparison, when Leech exhibited *The Secret Garden* at the RHA in 1920, it was priced at £75.)

38 *The sunshade*

Oil on canvas
81 × 65 cm; 32" × 25½"
Signed lower left *Leech*
The National Gallery of Ireland

PROVENANCE Purchased from the artist *ca.* 1919 by
Percy Botterell, CBE; bequeathed to his wife May Botterell,
who presented the painting to the National Gallery in 1952

EXHIBITION London, NEAC, 1916 (as *Lilacs*, no. 247)?

LITERATURE Campbell, 1991, p. 43; Ferran 1993, p. 229

Elizabeth Leech is again the model in *The sunshade*,
which belongs to the same artistic period as *A con-*

Fig. 77 Sydney Lough Thompson, *Portrait of Mrs Elizabeth
Leech*, oil on canvas, 73 × 60 cm, private collection

vent garden (cat. 37). Leech uses a similar palette
and achieves the same patterned sunlight effects.
Sunlight bursts in strongly from the left of the paint-
ing and highlights the fine bone structure of Eliz-
abeth's face and hands. Leech has taken her out of
the convent garden and painted her in the contem-
porary clothes of a modern woman. The cadmium
yellow of the cardigan, painted in thick impasto to
create texture, vibrates against the viridian green of
the umbrella, which casts green shadows on to the
model's shoulders. These strong yellows and greens
are repeated in the tall lilies in the background with
additional colour introduced in the reds, purples
and lilacs of the hat, which is perhaps why Leech
initially gave it the title *Lilacs*. He had exhibited a
painting entitled *Lilacs* at the RHA as early as 1910
(no. 54, £36. 15*s*.), which could have been a smaller
study. When Leech exhibited a painting called
Lilacs at the NEAC in 1916, a note on the catalogue
describes the subject as a "girl under lilac & yel-
low parasol" and this fits a description of *The sun-
shade*, except perhaps for the colour description of
the "yellow parasol". In 1917, he exhibited a *Lilacs*
at the RHA again for £36. 15*s*. When *The sunshade*
was transported by May Botterell to the National
Gallery in 1952, Bourlet Transport records list it as
The green parasol, which would have been the title
given to it then by Leech. Percy Botterell bought
The sunshade in addition to *A convent garden* (cat.
37) from Leech possibly about 1919, and his wife
May Botterell presented both to the National Gallery
in 1952.

Sydney Thompson also painted Elizabeth (fig. 77)
in similar pose, perhaps contemporaneously, with
echoes of Renoir, confirming that Thompson, unlike
Leech, remained an Impressionist painter without
further investigation of divisionist colour.

39 *Portrait of Elizabeth*

Watercolour on paper
53 × 36.5 cm; 20³/₄" × 14¹/₃"
Signed twice lower left *Leech*
Private collection

PROVENANCE Leech bequest to the Dawson Gallery, 1968

EXHIBITION London, Goupil Gallery Salon, November–December 1911 (*A Portrait*, watercolour, £21)?

LITERATURE Campbell 1991, p.43

Leech displays a masterly control of the watercolour medium in the depiction of Elizabeth, in a work which is reputed to have been painted on their honeymoon in 1912. The gentle tones of soft greys, greens and whites heighten the vulnerable beauty of his wife, captured with her hair loose and tumbling on to her white night-dress and against the white pillows. The freedom expressed in the flowing hair, the subtlety of skin tone, the capturing of white on white and the momentary turn of the head demonstrate Leech's ability to paint in watercolour. Elizabeth has the same innocence as in *A convent garden* (cat. 37), even without the elaborate *coiffe* to hold her abundant hair and the flowing robes of a traditional Breton virgin.

Elizabeth had met both Leech and S.L. Thompson in Concarneau nearly twenty years earlier, and she had been a very important stimulus and support in the development of Leech's art, especially from his late twenties until his late thirties, a crucial decade in his emergence as a painter of light, colour and form. After the break-up of their relationship, the artistic explorations in colour, of decorative compositional arrangements, which were first begun in *The convent garden*, were further developed in his great *Aloes* series of *ca.* 1919. When Elizabeth ceased to be his model, May became the subject of his portraits and a new era began in his painting life as well as his personal life.

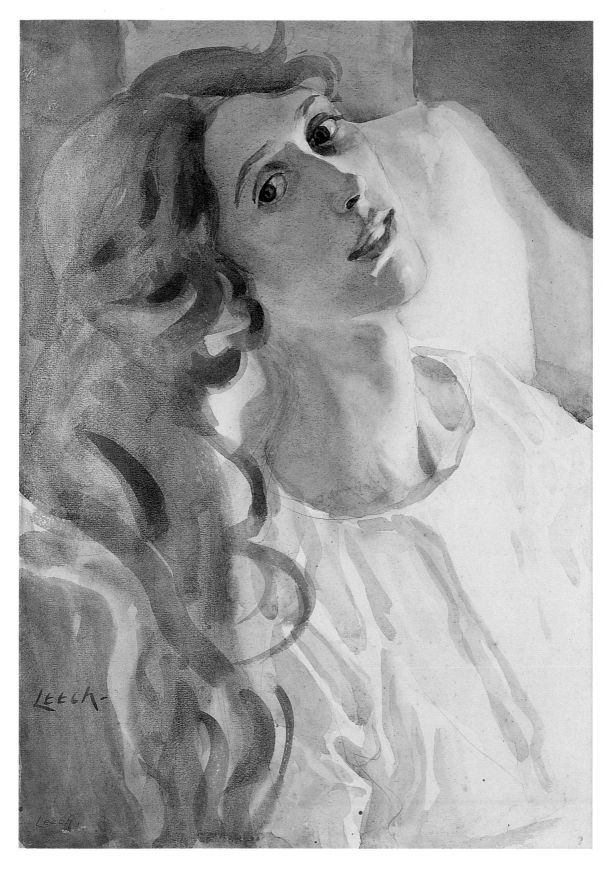

40 *The cigarette*

Oil on canvas
66 × 42 cm; 26" × 16½"
Signed lower left *Leech*
Hugh Lane Municipal Gallery of Modern Art

PROVENANCE Bequest of Dr R.I. Best to the Hugh Lane
Municipal Gallery, Dublin

EXHIBITIONS London, Goupil Gallery, 'Works by
Modern Artists', November-December 1916 (no. 31, £52.
10s.); London, National Portrait Society, 7th Annual
Exhibition, 1918 (no. 13); Dublin, RHA, 1919 (no. 69, £52);
London, Cooling Galleries, June 1927

In this small-scale portrait, the viewer confronts the
full-length portrait of Elizabeth who gazes relent-
lessly out from an interior which encloses the sit-
ter and excludes the viewer. Gone are the light,
colour and texture of *A convent garden, Brittany*
(cat. 37); instead Leech is painting a society por-
trait and displaying all the qualities necessary to
become a fashionable portrait painter. He is able
to capture likenesses with ease and dexterity, and
can place his sitters in their elegant milieu. When
The cigarette was exhibited at the Cooling Galleries
in June 1927, some eleven years after it was first
exhibited in 1916, the review in *The Times* stated:
"The Cigarette', a study of a lady in black, shows
that Mr. Leech is an accomplished draughtsman of
the figure." It is possible that Leech was endeav-
ouring to become established as a portrait painter
after his marriage to Elizabeth. There are similari-
ties in style and composition between this paint-
ing of Elizabeth in black and Lavery's portrait of
his wife Hazel in *The lady in black* (Ulster Museum,
Belfast), which was reproduced in *The Studio* in
December 1908, and of which Leech was possibly
aware. The pose of Elizabeth is echoed in the
seated figure of Lavery's elegant lady, who half
turns to gaze out at the viewer. The theatrical light,
shining from the left, throws Elizabeth's face and
cigarette hand into dramatic *chiaroscuro* against the
black satin of her flowing gown. Leech uses the
folds of the dress to create curving sinuous forms,
which contrast with the white lace of the blouse
and are evocative of his earlier *Black scarf* (fig. 22,
p. 40). He combines the pattern of the chintz seat,
the colour of the oriental rug and the decorative
pot and painting in the background with the arrest-
ing gaze of Elizabeth. Her dominant central posi-
tion is balanced by the diagonal created by her long
legs which leads the eye to the sharply highlighted
areas of the raised hand and gentle face of the sitter.
In the intricate laciness of the white blouse, there
is the hint of a Breton collar, from brighter days,
gone past.

The portrait may have been painted in London
or in Paris in the early part of the War, *ca.* 1915, at
a time when Leech's subject-matter became intro-
spective and studio based, his brushwork studied
and more exacting. The ornate and affluently fur-
nished room which crowds in on viewer and sit-
ter alike could possibly be the sitting-room of his
parents' home at no. 16, Eardley Crescent in Earl's
Court. The vase to the right and its association with
the painting in the background show influences of
Whistler and of Japanese art. He arranges Elizabeth
in a contrived pose, lit by theatrical lighting, which
harks back to the early portraits of his sister
Kathleen, painted *ca.* 1908, and to the influence of
fellow exhibitors at the Society of Portrait Painters,
such as William Rothenstein and John Lavery.

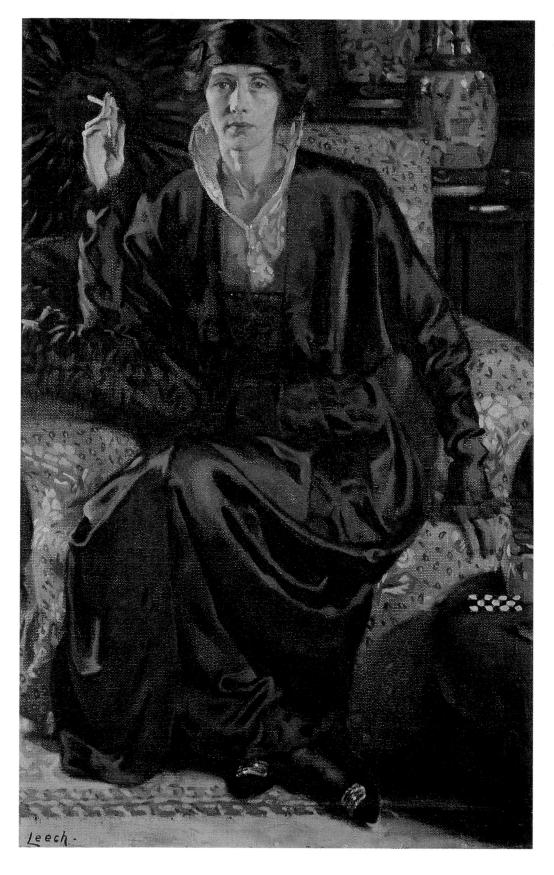

41 *The tinsel scarf (L'Actrice)*

Oil on canvas
60 × 100 cm; 23½" × 39¼"
Signed lower right *Leech*
Hugh Lane Municipal Gallery of Modern Art

PROVENANCE Bequeathed to Leo Smith, Dawson Gallery, Dublin on the artist's death in 1968; purchased by Hugh Lane Municipal Gallery of Modern Art, 1976

EXHIBITIONS RHA, 1917 (*L'Actrice*, no. 161, £75); London, International Society of Sculptors, Painters and Gravers, Autumn Exhibition, 1916 (*L'Actrice*, no. 104); Liverpool, 49th Autumn Exhibition of Modern Art, 1921 (*The actress,* no. 823, £78. 15*s.*); Dublin, The New Irish Salon, Sixth Annual Exhibition, February 1928 (*L'Actrice*); Dublin, Dawson Gallery, 1947 (no. 5, £137.10*s.*); Dublin, Hugh Lane Municipal Gallery, 1994

LITERATURE E.D., *The Studio*, LXXI, 1917, p. 70; C. McGonigal, 'Discovering the Municipal Gallery', *The Irish Times*, 28 November 1980; *Images and Insights*, exhib. cat., Dublin, Hugh Lane Municipal Gallery of Modern Art, 1994, pp. 96-97, col. illus., p. 97

The tinsel scarf (L'Actrice) was probably painted around the beginning of the Great War, *ca.* 1915, when Leech moved between London, Paris and Concarneau with Elizabeth. Leech has posed Elizabeth languidly draped over a couch as she leans across as if listening to unseen company. This dramatically contrived twist of the head affords the artist the opportunity to paint her long graceful neck and beautiful, half profile. Elizabeth replicates the pose of Steer's model in *The muslin dress* (Birkenhead Art Gallery), which he exhibited at the NEAC in 1910, but Leech has focussed on a half-portrait instead of Steer's full-length study, seen from a distance. Leech truncates the couch and his model, and the viewer becomes part of the room, instead of looking on from afar. The transparency of the gold filigree shawl, which now gives the painting its title, is draped across Elizabeth's shoulders towards her outflung left arm which rests on the head of a stuffed leopard. Its bared teeth echo the elegant, long, well cared for nails of a lady of leisure. The symbolism of the leopard and the sitter is only slightly veiled – the beauty of the leopard, its agility, its soft patterned fur which is kitten-like and yet such a deadly foe against its prey may be understood. Leech complained in later life that Elizabeth had been cruel to a kitten he loved. As in many of his portraits, he uses a dramatic side lighting to illuminate Elizabeth's half-turned head and neck. This is a painting of pattern and light but without the strong colours he had been using in *A convent garden* (cat. 37) or *Seaweed* (cat. 34). Colour here is restricted to tones of greens, reminiscent of *Interior of a café* (cats. 4 and 5), but here imbuing this work with an Art Nouveau quality. A review of the RHA exhibition in *The Irish Independent* by P.H.G. (Paddy Glendon) remarked "a certain pre-Raphaelite air about *The Tinsel Scarf,* a picture lovely to look at but with a certain coldness". Behind and above the semi-transparent black and tinsel shawl appears the green satin kimono worn by Elizabeth, indicating her awareness of fashion and the prevalence of Japanese influences at the time. Both *The cigarette* (cat. 40) and *L'Actrice (The tinsel scarf)* were singled out by Hylda Boylan in her review in *The Irish Statesman* of the New Irish Salon in 1928: "*The Cigarette* and *L'Actrice* are arresting. In the latter, which shows a lady seated, with arm outstretched over the back of a lounge, there is a fine bit of workmanship in the wonderful way in which the artist has painted a Japanese shawl over the green dress of the lady, securing an amazing transparency." The dramatic lighting, which throws Elizabeth's face into strong focus, is reminiscent of Lavery's portrait of Hazel, *The silver turban* (The Fine Art Society, London), which was exhibited at the Royal Academy in 1912. Leech was probably aware of the painting, considering his friendship and regard for Lavery's work. During this time when Leech appears to have been sending in work to the Royal Academy, Lavery's influence on Leech's development reached its zenith.

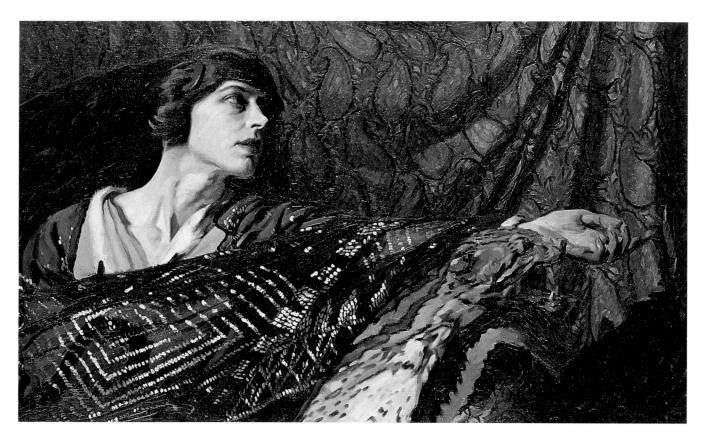

42 The Hell Fire Club

Watercolour and pencil on a postcard
7.5 × 13.5 cm; 3" × 5⅜"
Inscribed with the address of J. Nevin, Esq. At Messrs
Fletcher & Phillipson, Lower Pembroke St., Fitzwilliam
Square, Dublin and a message on the front
John J. O'Connell

PROVENANCE Jorgensen Fine Art Gallery, Dublin

In this postcard with a painting of the Hell Fire Club, perched on the hill above Rathfarnham, Leech has achieved great distance for such a small scale, with the trees in the background etched against the blue of the distant hill. The site was close to where Leech went to school at St Columba's and he would have been familiar with its location and its notoriety among affluent Protestant males in Dublin. Leech painted this possibly from a photograph in London, since he posted it from there in August 1914. The recipient, J. Nevin, was possibly the owner of the large hardware firm Fletcher & Phillipson, to which it was addressed, and he apparently had bought paintings from Leech, judging from the message. It is one of the few remaining items of correspondence sent by Leech to Dublin after his departure in 1910 until 1947, when he began his long correspondence with Leo Smith of the Dawson Gallery.

42

43 *The blue shop, Quimper*

Oil on canvas
61 × 40 cm; 23½" × 15¾"
Signed lower right *Leech*
The Taylor Gallery Ltd, London

PROVENANCE Professor Thomas Bodkin, Birmingham, and hence by descent to the previous owner. Sold Christie's, Belfast, 30 May 1990 (no. 525)

EXHIBITIONS RHA, 1918 (no. 106, £21); London, National Gallery, British Painting since Whistler, March–August 1940 (no. 521) (cancelled); Belfast, Christie's, Fine Irish Paintings and Drawings, 30 May 1990 (no. 525).

LITERATURE *Fine Irish Paintings and Drawings*, Christie's, Belfast, May 1990, pp. 138–39, illus. cover and p. 138.

At present, few of the works which Leech painted in Quimper have surfaced, but *The blue shop, Quimper*, which he exhibited in 1918, epitomizes his use of colour, the play of light on the little blue-fronted shop and his fluid brushwork at this time. Stylistically it is similar to *Rain – Atlantic Hotel, Concarneau* (private collection) which Leech exhibited at the RHA in 1925, but the sunshine in *The blue shop, Quimper* radiates from the canvas. The blue of the shopfront is repeated in the blue suit of the man crossing the street. There is a similarity to the *Pink parasol* (cat. 58) in the figure of the lady passing by. There are elements in the motif and composition which suggest Whistler's shopfronts, such as in *The general trader, ca.* 1888 (fig. 78), and reminiscent of Leech's own *Interior of a café* (cat. 4). However, in the period of a little under ten years, Leech's palette has changed dramatically; gone are the Degas green and the rich browns, now replaced by glowing ochres, pinks and blues with tones of lilac in the shadows.

Fig. 78 James McNeill Whistler, *The general trader*, oil on panel, 12.7 × 22.2 cm, Providence, Rhode Island School of Design, Museum of Art

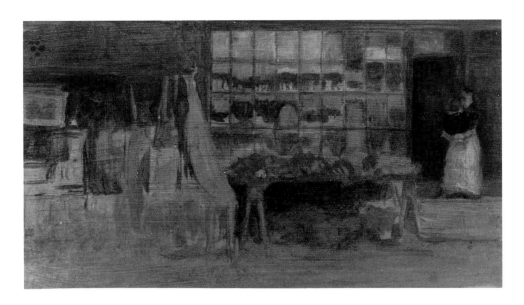

44 *Fields by the sea – Concarneau*

Oil on linen
44.5 × 53 cm; 17½" × 20¾"
Signed lower left *Leech*
Permanent Collection, Limerick City Gallery of Art

PROVENANCE Dr R.I. Best Bequest, 1959

EXHIBITION RHA, 1918 (*Fields by the sea – Concarneau*, no. 311, £21)

Leech has incorporated so much in this smallish work, with the cows nestling near the spindly trees, seeking whatever shade they can find, away from the bright sunshine. The yellows and greens of the meadow which stretches almost to the sea beyond lend distance to the foreground. Leech has painted the twisted form of the bushes in the foreground in decorative forms, which herald his *Aloes* series, begun in Les Martiques, later in the year in which he exhibited this (1918).

45 *Portrait of Mrs May Botterell*

Oil on canvas
120 × 119 cm; 47¼" × 46¾"
Signed lower right *Leech* with an elongated L and 'eech'
inside, in a Chinese manner
Mrs Biddy Stone

EXHIBITIONS Paris, Salon (Société des Artistes
Français), 1922; Brussels, Exposition d'Art Irlandais, 1930 (as
Portrait bleu, no. 76; Bourlet records, 11.9.19, *La Dame en
bleu* unpacked from Pottière, Paris); London, National
Portrait Society, January–March 1921 (*Portrait of Mrs
Botterell,* no. 238)

LITERATURE Denson 1969, fig. 22

This large formal portrait marks the beginning of
a forty-five-year loving relationship between Bill
Leech and May Botterell. May's dramatic pose
against a gold-simulated background, in a rich,
indigo dress, decorated with exotic silver flowers,
invokes comparison with the dramatic, decorative
figure in Whistler's *Harmony in blue and gold; the
Peacock Room,* 1876-77 (Freer Gallery of Art,
Smithsonian Institution, Washington, D.C.). Leech
had displayed a Whistlerian influence in his early
Concarneau paintings, but this portrait has its bias
in Whistler's oriental and exotic period, in his use
of gold and emphasis on decorative pattern. The
Leech signature in an elongated, oriental fashion
reinforces the idea of a Whistlerian influence, fol-
lowing earlier indications of oriental pattern which
surfaced in *The cigarette* (cat. 40) and *The tinsel
scarf* (cat. 41). The dominance of an increased east-
ern direction might have been stimulated by May
Botterell's elegant evening dress which emulates the
interest in oriental culture highly fashionable in that
era. The warmth of colour of the stylized back-
ground, interspersed with deep-green overlays of
patterned areas, adds to the theatricality of the por-
trait. Leech has posed May, sitting with her head
bent coquettishly backwards, rather uncomfortably
– her left hand in an outstretched gesture and her
right hand stretched fully to the right, repeating the
position of Elizabeth's extended hand in *The tinsel
scarf* (cat. 41). The emphasis on the sitter's hands
is a noticeable feature in Leech's portraits and genre
paintings.

Leech has appropriately portrayed the elegant,
rich, cultured wife of an eminent London lawyer
in the portrait exhibited as *Portrait bleu* at the Irish
Art Exhibition in Brussels in May 1930. It was repro-
duced in *The Irish Times* with the caption "The Blue
Portrait". The Brussels exhibition included work by
Osborne, Nathaniel Hone, McAvoy, O'Brien, Orpen
and John Lavery among others. Leech was repre-
sented with five works, including *Religieuse et lys
(A convent garden;* cat. 37), lent by Percy Botterell,
an indication that in 1930 he still supported Leech
as an artist. He also showed a second portrait of
May, *Lady in black* (present whereabouts
unknown), a dramatic painting with Lavery over-
tones, a nude (*Nu;* see cat. 61) and *Cactus* (one of
his *Aloes* series).

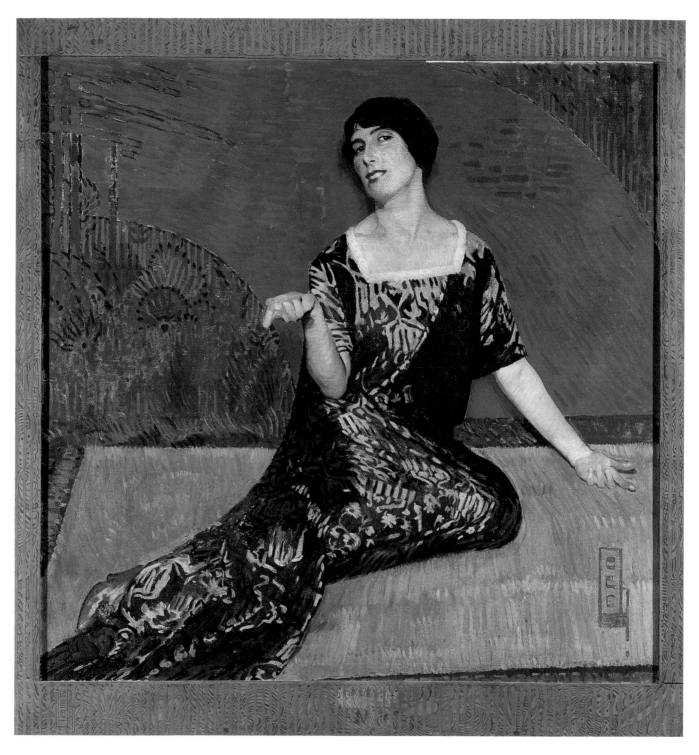

46 *The silver frock*

Watercolour on paper
50.8 × 38.1 cm; 20" × 15"
Signed lower right *Leech*
Private collection

This portrait of May in an evening dress, posed dramatically, continues the formality of *Portrait of Mrs May Botterell* (cat. 45) but with a greater freedom and less theatricality. Leech captures her pose and her likeness with dexterous skill, displaying his command of the watercolour medium in a full-length portrait, the colour of her dress resplendent against the colour of the fabrics behind. The *Portrait of Elizabeth* (cat. 39), in its harmony of white and flesh tones, contrasts with this portrait of May, indicating how Leech's colour harmonies have become more vivid in his portraiture. *Portrait of a lady* (Manchester City Art Gallery) is a further portrait of May in watercolour, her face turned to the side, the red of her open-necked shirt revealing her delicately painted neck and fine-boned face. Leech has simply suggested her features with a few deft brushstrokes, thus displaying his confidence in the handling of watercolour. *Portrait in a garden* (fig. 79) is an arresting portrait, in oils, of May standing bathed in sunlight in a London garden, possibly the back of Steele's Studios which Leech rented from 1926. The orange of her caftan vibrates against a wall in purple and continues the richness of the palette Leech used for these series of portraits in the 1920s.

Fig 79. William John Leech,
Portrait in a garden, oil on canvas,
64.8 × 54.6 cm, private collection

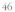

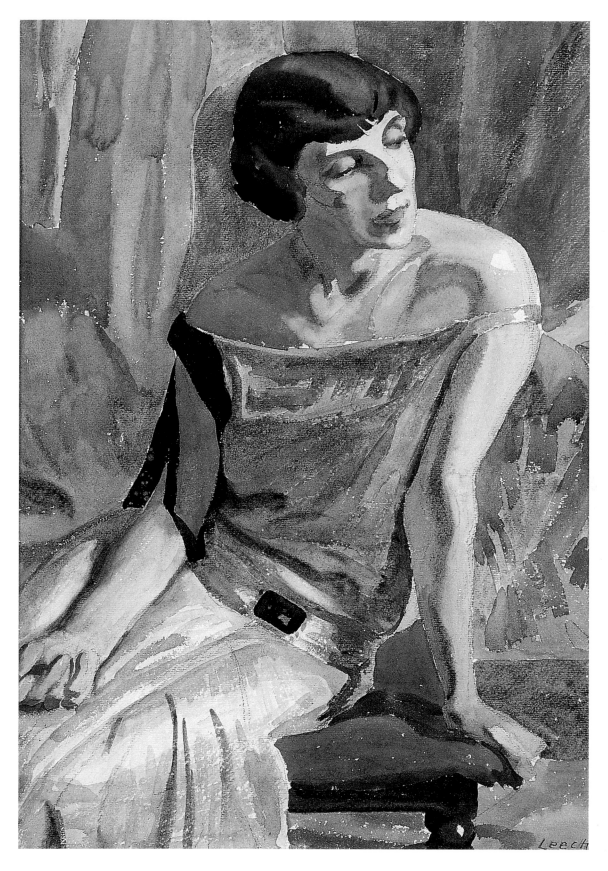

47 *Portrait of Suzanne Botterell*

Oil on canvas
134.6 × 53.3 cm; 53" × 21"
Signed middle right *Leech* with an elongated L and 'eech'
inside, in a Chinese manner
Mrs Biddy Stone

PROVENANCE By direct family descent

EXHIBITION London, National Portrait Society, January–
March 1921 (*Portrait of Suzanne*, no. 294)

In this work painted *ca*. 1920, after completing his portrait of May, Leech captures her daughter Suzanne in an innocent pose, in bare feet and a simple, blue smock dress with a large white collar. Leech paints her vulnerability and childlike, wide-eyed innocence, yet with a questioning look to the viewer, as Augustus John portrayed his son Robin (National Gallery of Wales). However, Leech's paint handling differs from John's in his use of feathered brushstrokes to pattern the pale blues of Suzanne's dress and the shadows on her legs, which contrasts with the paint handling of the background. These striped brushstrokes evoke Roderic O'Conor, but without his Fauve colour. The tonal harmonies and the introduction of a flowering Japanese-style white bush, combined with the oriental-type signature, suggest a Whistler influence, as does the patterned pewter frame. Leech uses a customary device of illuminating the face with light coming in from the right, which highlights Suzanne's gentle face, her upturned nose and shining blond hair. Suzanne, the youngest of the Botterell children, was a lovely little seven-year-old when Leech met her, and a surviving photograph of Suzanne with her mother shows how beautiful mother and daughter were in 1924. At this stage Suzanne was frequently with Leech, and another photograph captures him giving her a piggyback, with May and his brother Cecil, indicating the ease with which Suzanne shared Leech's company. She was to grow into a beautiful young woman whom Leech continued to paint, and she is possibly the subject of *Woman by a window* (cat. 99).

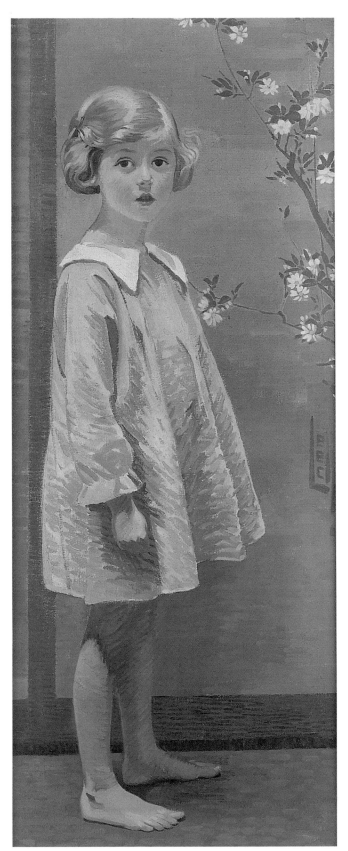

48 Girl in a garden (Sunshine and shadows)

Oil on canvas
60 × 40 cm; 23⅝" × 15¾"
Collection of Patrick and Antoinette Murphy

Leech has painted an uncharacteristically low horizon-line and a large expanse of sky as the little girl poses in the open air, against what appears to be a hay trough with an open landscape behind. This is possibly Suzanne, posing for Leech, now a few years older than when he painted her portrait (cat. 47). Photographs show that with May and Suzanne Leech visited his brother Cecil's small stud farm at Ham Green in Kent in 1924, before Suzanne's long hair was cut. The countryside suggests the rich pastures of Kent with sunlight flooding into the painting, alighting on her blond hair, on the front of her white pinny and on the expanse of the yellowy-green grass of the field. There is a hint of *Alice in Wonderland* and *'Twas brillig* (cat. 22), painted nearly fifteen years previously, but Leech has used a drier, textured style with overpainting and an emphasis on detail in the blond tendrils of hair which fall on her young face. Here, he has focussed on a single figure, set into a landscape, as he did with Elizabeth in *A convent garden* (cat. 37), rather than on a landscape in which children mingle and are absorbed.

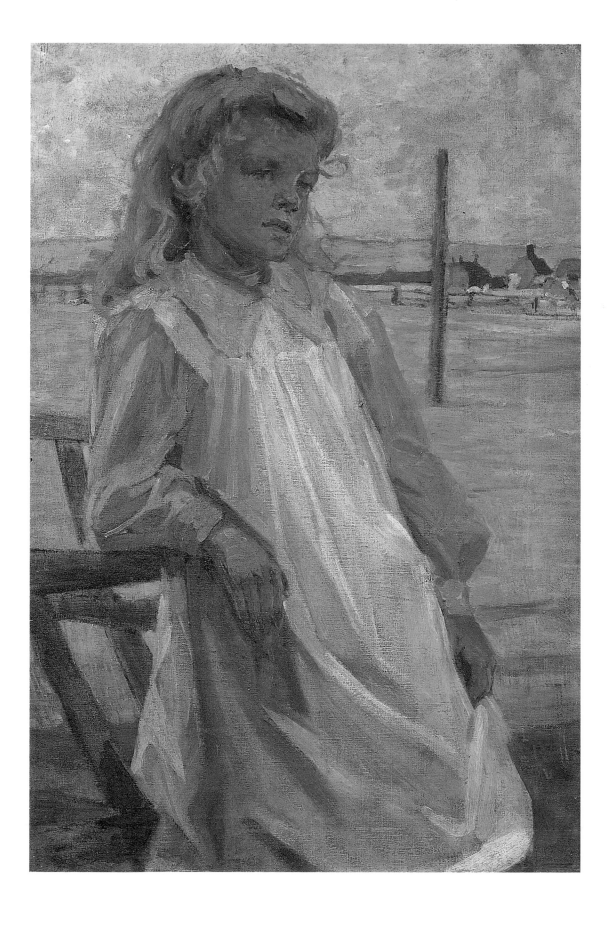

49 *Aloes, Les Martiques*

Oil on canvas
181 × 148.3 cm; 71" × 58"
Collection of Ulster Museum, Belfast

PROVENANCE Artist's studio, 1968; Dawson Gallery, Dublin (Leo Smith); Leo Smith's brother, who sold it to Taylor Galleries, London; purchased by Mr Stafford; resold to the Taylor Galleries; purchased by the Ulster Museum 1984

LITERATURE Denson 1968, p. 24, fig. 11

EXHIBITION Dublin, Dawson Gallery, July-August 1953 (*Aloes, Les Martiques*, no. 9)

Aloes, Les Martiques, the largest painting of Leech's *Aloes* series, and probably one of the earliest, was still unsold at the time of the artist's death in 1968. During the long period it remained in his studio, it became an interesting background for some of his later self-portraits (for example, cat. 111). It is a compelling, memorable painting of colour, light and pattern.

Aloes, South of France (private collection) is a watercolour study of aloes growing on the side of a hill, with the village nestling in the valley below. The spontaneity and fluidity of watercolour allows Leech the freedom to capture the sunlight on the cactus leaves, as their green forms thrust upwards, against the sun-dried grass. Elements of this composition, in the cacti and grass underneath, are incorporated into the oil *Aloes, Les Martiques*. A smaller version less than half the size of cat. 49, entitled *Aloes, Les Martiques*, was exhibited at the Dawson Gallery in Leech's one-person exhibition in 1950, announced in *The Irish Times*: "The Dawson Gallery is also showing paintings by William Leech and his familiar painting of the Aloes at Les Martiques has attractive colouring." This scale suits the imagery better, the aloes relate to the vegetation without the exaggerated, elongated field in between. Compositionally the three works are painted from similarly high viewpoints but Leech has eliminated the village from both *Aloes, Les Martiques* to concentrate on colour and pattern. In the large oil, the clump of aloes seen from above is silhouetted against the sunbaked field beyond. The shapes of the cactus leaves are rendered realistically and provide contrasts in form, texture and colour to the painterly treatment of the background. Broad brushstrokes depict the stiff forms of the succulent leaves as they grow upward and outward forming definite patterns of green, orange and blues in the foreground. The field behind, sloped diagonally, glows in broken brushstrokes of almost iridescent pinks, ultramarines, blues, greens and tones of yellow. Leech is in control of a vibrant Post-Impressionist palette and has found, in the *Aloes* series, an outlet for his greater painterly confidence, revelling beneath the increased light and shimmering heat of the South of France. Strong shadows deflect from under the trees to the top right-hand side of the painting, heightening the strength of the sunlit areas in the middle distance. A haystack's top and a water-trough are outlined by a band of sunlight while, all around, elongated shadows are cast by a few, gnarled olive trees. Along the top of the canvas, the upright composition is contained by a dense border which emphasizes the forms of the aloes in the foreground. The cacti dominate the painting and their taut forms are contrasted with the thin-stroked, finely brushed treatment of the smoother grasses growing underneath. As in *Un matin* (cat. 50), Leech made the frame and possibly Elizabeth painted it in tones of pinks and blues, which have faded greatly with time. There is a passing reference to Gauguin in the entwining pattern around the frame.

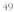
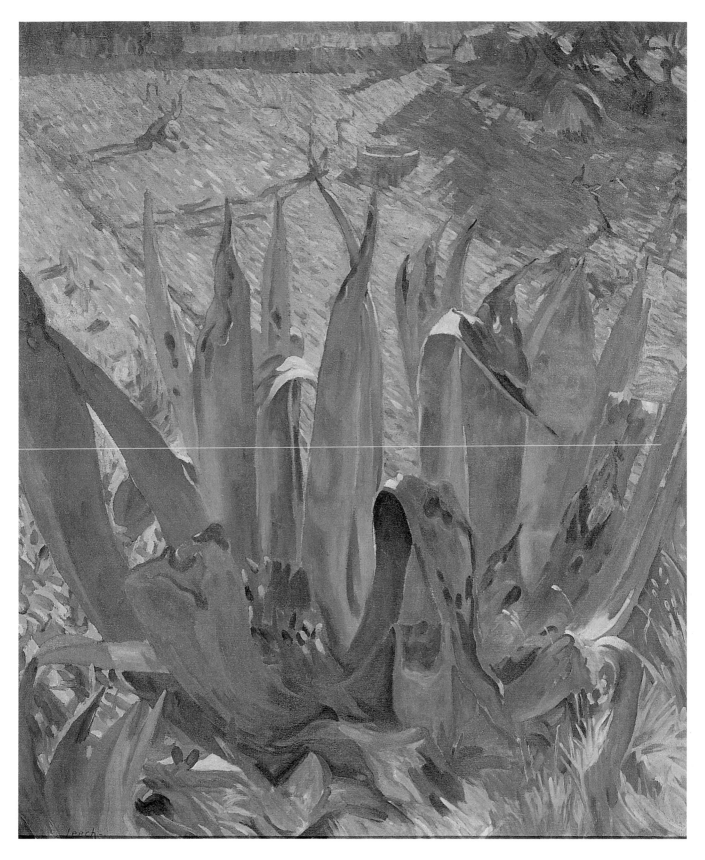

50 *Un matin (Waving things, Concarneau)*

Oil on canvas
114.3 × 127 cm; 45" × 50"
Signed lower left *Leech*, with an elongated L and 'eech' inside, in a Japanese manner
On verso, inscribed *W.J. Leech, 19 Porchester Square, London W2. No v £150*
Hugh Lane Municipal Gallery of Modern Art

PROVENANCE Presented by the artist in remembrance of Sir Hugh Lane who died when the Lusitania sank, 1915.

EXHIBITIONS London, Goupil Gallery Salon, November–December 1919 (no. 149, £200); RHA, 1921 (no. 183, £150)

LITERATURE Campbell 1980, pp. 338–39; Campbell 1984, p. 264, illus.

Un matin, which Leech painted possibly at Grasse near Les Martiques and which is dated by the address on the back 1918–20, combines a confident assimilation of colour and decorative form. It is painted in a landscape format, where the aloes dominate as upright forms, in vivid cobalt blues and viridian green edged with purple and dashes of orange. The paint is applied in short, flat brushstrokes bursting with colour at the top of the canvas, where a high horizon-line is created by lines of trees in shadow and bushes in strong sunlight. This contrasts with the broader treatment of the foreground spiky leaves which are toned down to become pale blues and soft greens with the use of zinc white. The patterned edges of the foreground leaf herald the decorative element – which is fully explored in the later *Aloes near Les Martiques* (cat. 51) and calls to mind the exaggerated, flamboyant flow of natural forms found in Art Nouveau. The signature Leech uses in *Un matin* is the oriental form he used for a short period from 1919 to 1920, for example in *Portrait of May Botterell* (cat. 45), *Portrait of Suzanne* (cat. 47) and *Trees in a garden* (cat. 53). From thereafter Leech favoured an understated signature in grey or black, signed simply "Leech". The hand-decorated frame, possibly made by Leech and decorated by Elizabeth, has also been signed with the same oriental-style signature on the lower left.

Un matin has a truncated landscape format with the cactus leaves springing up from the edge of the canvas. It was possibly painted shortly after *Aloes, Les Martiques* (cat. 49), which was probably one of the first aloe studies. Leech also used zinc white in its execution. This caused him concern in later years, since he was so meticulous about the materials he used. He wrote to Leo Smith in 1966, expressing his anxiety: "That Cactus picture 'Un Matin', I think it was called, used to be very good, unfortunately it was painted with Zinc White, a hopeless colour to use. The sketch for it that you have is painted with Flake White. If I were in Dublin, I would borrow the sketch and repaint the big one." This would seem to indicate that Leech had painted a smaller version of this work, as he had done for *Aloes, Les Martiques*. He possibly was worrying too much about his materials, since the painting has survived well in its present state, whereas it would have been a different painting had Leech touched it up.

When Leech had his exhibition at the Dawson Gallery in 1951, the sketch that he referred to in his letter of 1966 was also mentioned by the critic of *The Irish Times*: "Two versions of 'Aloes, Les Martiques', one of them a sketch for the painting which hangs in the Municipal Gallery, Dublin, are among the most colourful canvases in the show."

Leech must have considered he had achieved a successful realization of this subject-matter, and a culmination of all his painterly endeavours up to that time, when he presented *Un matin* to the Sir Hugh Lane Gallery in Dublin. He had shown it already at the RHA in 1921 for £150, which at the time was a very high price for a Leech painting – almost three times his usual price.

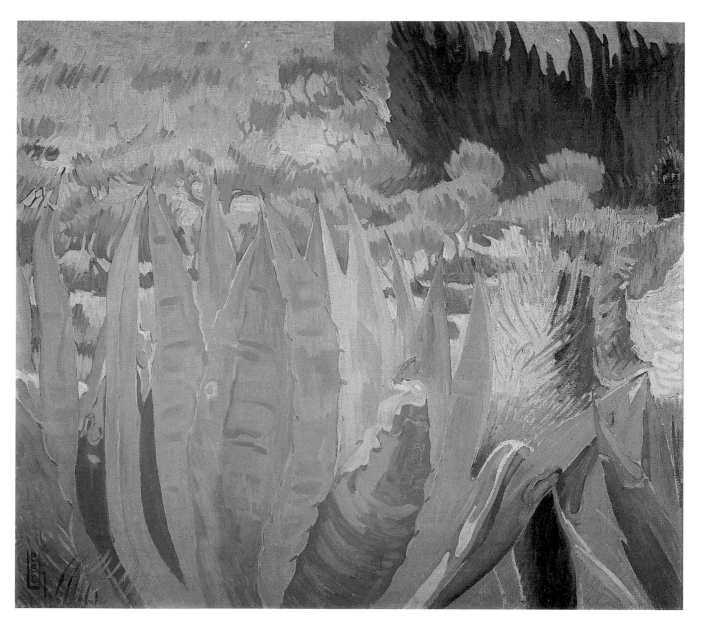

51 Aloes near Les Martiques

Oil on canvas
132 × 95cm; 52" × 37⅜"
Signed lower left *Leech*
On verso, inscribed *William J. Leech, 4 Steele's Studios*
Pyms Gallery, London

PROVENANCE Dawson Gallery; Kathleen Fox; Mrs
Maurice MacGonigal; Dawson Gallery; J. Monaghan; Pyms
Gallery, London

EXHIBITIONS RHA, 1931 (£42); Derby, Autumn Exhibition, October 1932 (*Aloes near Les Martiques*, no. 118, £42);
RHA, 1945 (lent by Kathleen Fox); Dublin, Dawson Gallery,
1945 (£150); RHA, 1969, Memorial Exhibition (lent by Mrs
Maurice MacGonigal)

LITERATURE G.H.G. [Paddy Glendon], *The Irish Times*,
Thursday, 3 May 1951, p. 7; Denson 1969, no. 65, illus.; K.
McConkey, *A Free Spirit*, London 1990, pp. 118–19

In *Aloes near Les Martiques* the thrusting upright
forms in various tones of blues merge into mauves
and purples. The areas of sunlight become almost
like a peacock feather in pattern and decoration,
in white tinged with pinks and mauves. The hot
pinks of the top section of the painting echo the
areas of pink Leech used in *Caves at Concarneau*
(cat. 33). This work is imbued with the same sense
of heat, colour and rhythmic pattern.

The depiction of the blades of grass as spiked
forms re-invokes the ebbing and flowing of the
forms in *Seaweed* (cat. 34). These paintings
demonstrate Leech's awareness of the colour and
textured brushstrokes of Roderic O'Conor, the flamboyant pattern of Gauguin and the structured form
of Cézanne, with echoes of Art Nouveau. He has
assimilated all the varying elements of Post-Impressionism, and the painting of this series of *Aloes* is
for Leech a liberation and a return to the colour
and texture he was using prior to his formal portraits. Shadows become positive forms, adding to
the overall decorative nature of the canvas and distancing the painted image from its original scene.
In forsaking a landscape format, Leech has further
emphasized the decorative elements instead of the
natural forms of his subject-matter.

52 The old orchard

Oil on canvas
53 × 64 cm; 20⅞" × 25¼"
Signed lower right *Leech*, in a Japanese style with an elongated L with 'eech' inside
Private collection

EXHIBITION Dublin, Dawson Gallery, 1951 (*Olive trees*,
£40)?

Leech adopted this oriental style signature for a
short period in 1919 when he met May Botterell and
went to Hammamet, Tunisia, with her, where this
painting may possibly have been painted. Even so,
Leech remained true to his 'exaggerated' style of
his work before the Great War (see cat. 34) to
depict these old trees. This textured style, showing
an influence of Van Gogh and Roderic O'Conor,
seems to last for a short period from *ca.* 1911 to
1917, when Leech reverted to a smooth, fluid style
with softer tones. The gnarled trees, with their
twisted forms reflecting on the colour-flecked
ground, certainly suggest Van Gogh.

53 Trees in a garden

Watercolour
33.4 × 22.9 cm; 13¼" × 9"
Signed lower right *Leech*, with an elongated L and 'eech'
inside the L, in a Japanese manner
Ita and Michael Carroll, Dalkey

Trees in a garden is signed in an oriental manner.
Its vertical shape is heightened by the upright trees,
leaning out to the right. The directness of paint
handling and the tones of blue against white retain
their original freshness. Simple in design and execution, the watercolour concentrates on the foreground of rocks and the upright forms of two trees
against a high horizon of trees edged by a hint of
sky. *Trees in a garden* achieves a suffused light-
effect with soft, blue shadows highlighting the area
of watercolour paper left exposed.

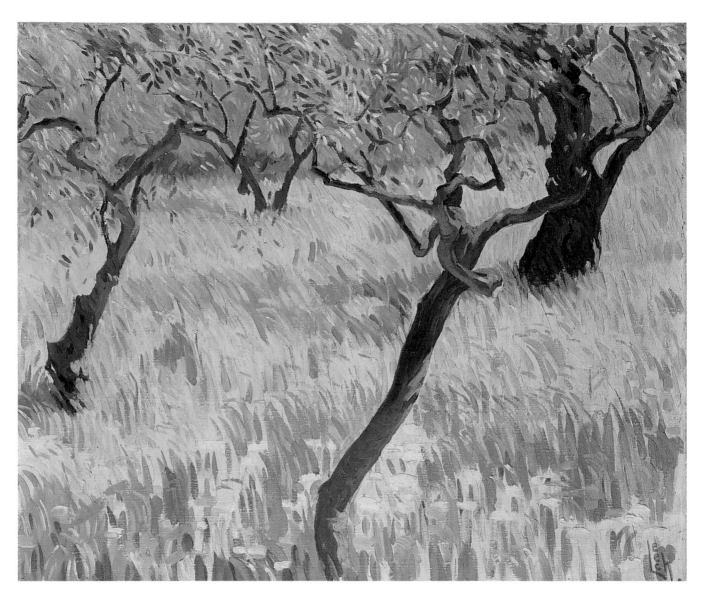

54 Beach scene

Oil on canvas
45.7 × 54.6 cm; 18" × 21½"
Signed lower right *Leech*
Private collection courtesy of Pyms Gallery

PROVENANCE By direct descent from the artist to the previous owner; Pyms Gallery, London

LITERATURE *Modern Pictures and Sculptures*, exhib. cat., London, Bonhams, November 1995, p. 40

Leech continued to paint children on the beaches at Concarneau, Les Martiques and Hammamet in Tunisia, capturing the sunlight on the water and on the children playing on the sand, varying his approach according to his stylistic development at the time. *Beach scene* is possibly one of the earliest of this series, painted in Concarneau, when Leech was strongly influenced by Whistler, as is evident in the close harmonies and the subtle tones of Leech's palette. He also owed a debt to Osborne and Steer at Walberswick (see above, p. 50). He has depicted no sandy shore but instead has allowed the water to fill the canvas, which shines in a silvery sunlight on the waves and harmonizes with the figures paddling at the water's edge. The children's movements are freely and simply drawn and encapsulated in paint.

55 Beach scene

Oil on canvas
60.3 × 72.4 cm; 23¾" × 28½"
Signed lower left *Leech*
Private collection

Leech has created a high horizon-line, with the activity of the children's figures concentrated above or below the shoreline. Attention is mainly focussed on the little group over to the extreme left of the picture, under a parasol. The children, paddling in the sea, are similarly treated to the children in *Beach scene* (cat. 54) but Leech has adopted a pointillist technique to render the foreground sand with its gold shingle as Steer had done in some of his Walberswick pictures. Leech, however, has added the blues of the shadows, creating a lighter, more shimmering effect and as usual adapting other influences to suit his own subject-matter and composition.

56 The sand castle

Oil on canvas
49 × 60 cm; 19¼" × 23⅝"
Signed lower right *Leech*
Private collection

The sand castle continues this series of summer days with children playing on the sand. Leech again fills most of the foreground with a beach, painted in a similar pointillist style of broken colour as in *Beach scene* (cat. 55), with a ribbon of sea at the top. The clothes of the three children, to the left, engrossed in making their sandcastle, merge with the blues of the shadows and the ochres of the sand. The subject is one Steer painted in *Boulogne sands* (fig. 27, p. 50) but here Leech's technique differs from Steer's, though he had been closer in *Plage des Dames* (fig. 35, p. 63).

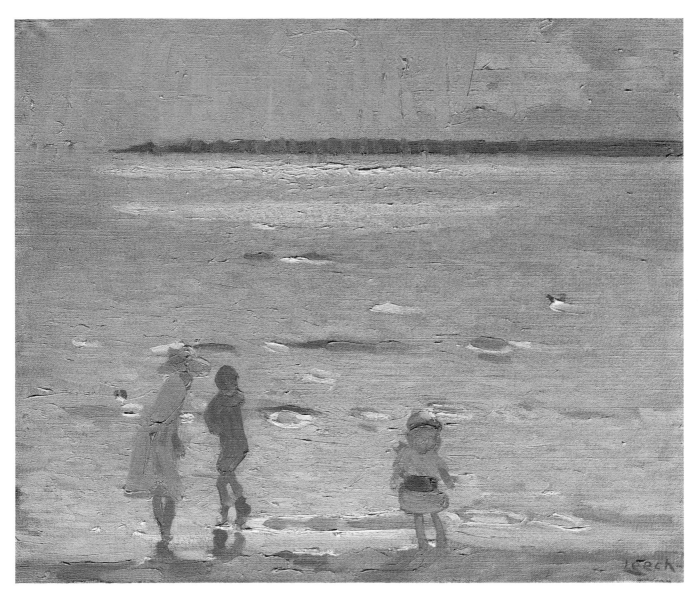

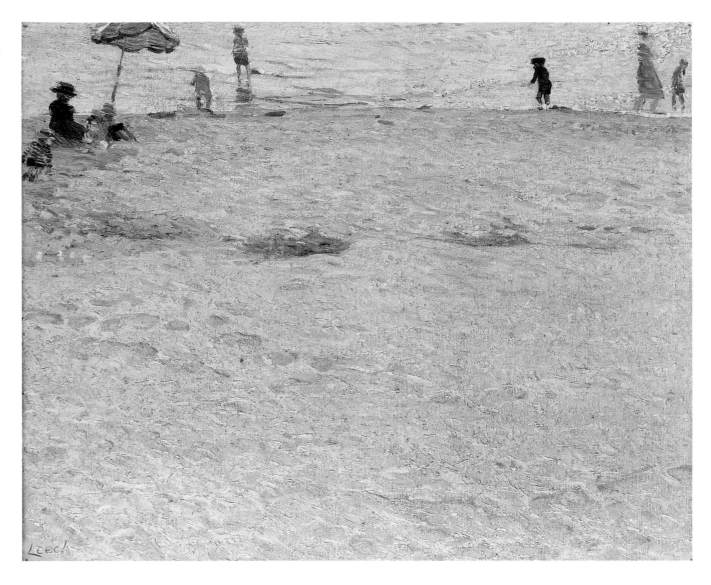

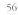

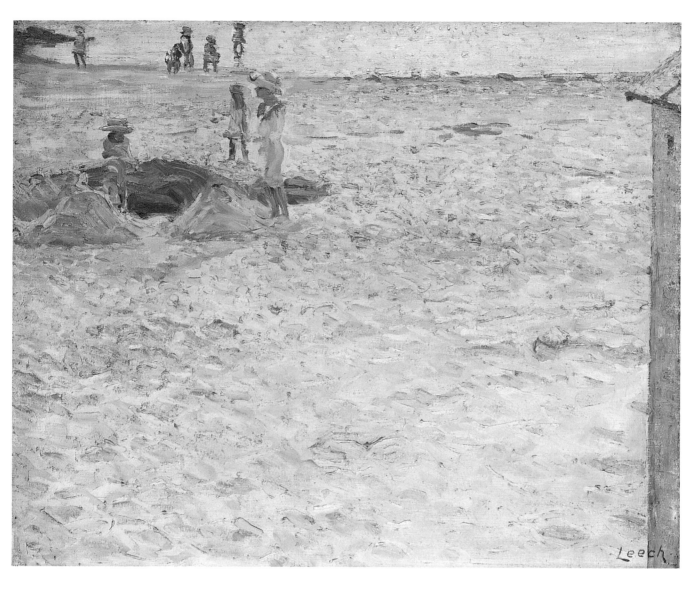

205

57 *Paper parasols*

Oil on canvas
55 × 46.5 cm; 21³/₄" × 18¹/₄"
Signed lower left *Leech*
Private collection

EXHIBITIONS Derby, Autumn Exhibition, 1921 (*Paper parasols*, no. 29, £25); RHA, 1922 (no. 3, £35); Dublin, Dawson Gallery, 1945 (no. 24, £40); Dublin, Gorry Gallery, May 1987

LITERATURE Denson 1969, no. 17; *An exhibition of 18th, 19th and 20th Century Irish Paintings*, exhib. cat., Gorry Gallery, Dublin, May 1987, ill. cover

Paper parasols, ca. 1922, shows a much tighter technique of paint handling and a more decorative approach to the subject-matter of women on a

Fig. 80 *Jim and Guy Botterell with a parasol,* photograph

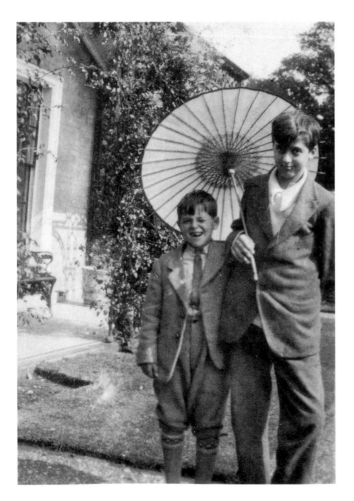

beach with brightly painted parasols than the beach scenes (cats. 54–56). May is again the subject, Leech having combined her lithesome figure in an ankle-length dress with a brightly painted sunlit beach scene, using the studies he had made of her on the beach in Hammamet (see fig. 48, p. 76). There is a Japanese-print effect in *Paper parasols*, which is dominated by the figures of the two women, etched against the flatly painted golden sand, casting grey-mauve shadows. The standing figure with her brightly coloured parasol of vivid blue, splashes of vermilion and Naples yellow is echoed in the second parasol's vividly painted reds and cobalt blues. The background of rocks, in purples and yellow ochres, echoes the dramatic shapes and colours in Leech's landscape *Caves at Concarneau* (cat. 33), which he painted in Brittany about 1912. *Paper parasols* is aglow with colour and sunlight – achieved, primarily, by the dominant use of yellow ochre in the background rocks and Naples yellow in the sand in the foreground. The white of the beach robe of the standing figure recurs in the white dress of the reclining figure. These two women appear to be May in two different poses, one standing, the other figure lying on the sand, under the shade of a parasol. Leech adopts Monet's example in *Women in the garden*, 1866 (Musée d'Orsay, Paris), where Camille is posed in several positions. It is probable that Leech, from several studies of May, composed his painting in his studio, and could possibly have used his painting *Caves at Concarneau* as background to the figures. A photograph (fig. 80) of the Botterell children at this time shows them carrying a large Japanese parasol in the garden at Colne Park, similar to the one May holds in *Paper parasols*.

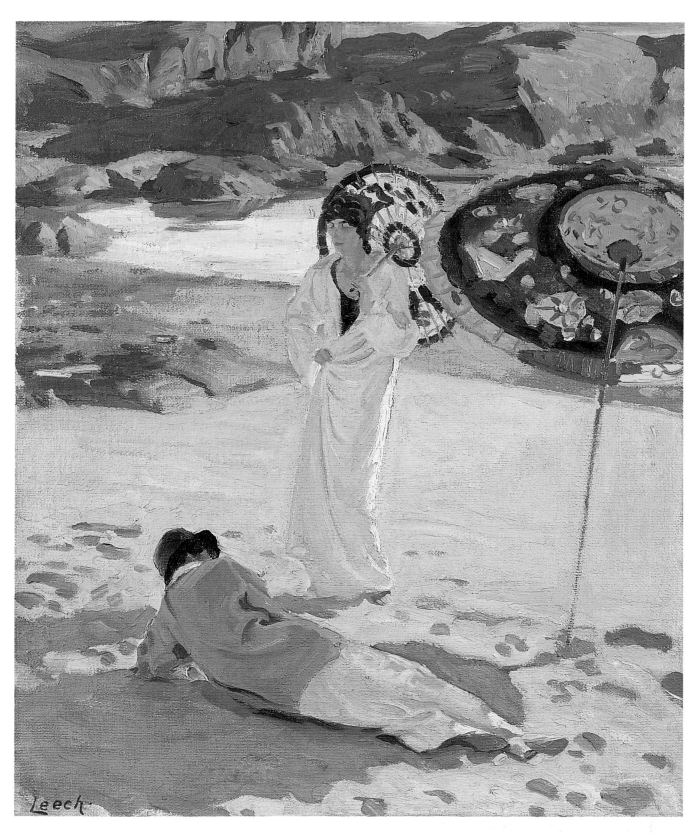

58 Pink parasol

Oil on canvas
41 × 27.5 cm; 16" × 10¾"
Signed lower left *Leech*
Private collection, courtesy of the Gorry Gallery, Dublin

EXHIBITION Dublin, Gorry Gallery, 1988

LITERATURE *An Exhibition of 18th,19th and 20th Century Irish Paintings*, exhib. cat., Gorry Gallery, Dublin, May 1988

Against a low tide, coming in over the sandy beach, the single figure of May is depicted in broad colour masses. The pink parasol encases the walking figure and combines with the blue of her cap, the hints of blue in the shadows of the soft-toned buff sand and the lady's brown dress to portray a harmonious arrangement of tones and form. Brushstrokes are confident and economical in effect. In Leech's watercolour *The opal* (private collection), the figure of May carrying a parasol and holding her skirt as she paddles along the water's edge is similar, indicating how Leech used watercolour as an initial preparatory sketch.

59 May in a red dress

Oil on board
19 × 24.1 cm; 7½" × 9½"
On verso, the French stamp Lechermer Barblitol
A. Paul Jobson

This freely painted study of *May in a red dress* of around 1926 suggests Leech's knowledge of Matisse, in the use of the bright vermilion-red of her dress against the ochre-coloured sheets. The informality of May's pose, reading on top of the bed, exemplifies Leech's new-found freedom in painting the figure, treating the human form and background alike. The size of the work, 24 × 19 cm, fitting into his travelling box (see above, cat. 7), suggests this was executed *in situ*. Leech also executed pencil studies of May, but there were other quick sketches in which she sits, leg raised in her hands, in a casual pose. He captures her grace and her lithe figure with a few pencil marks, making several studies of her on the same page, her youthful figure and short-bobbed hair instantly recognizable. Leech's pencil studies were a means to an end, a preparation for his painting. He frequently drew with charcoal, a medium used in Julian's and which he continued to use with good effect in *Portrait of the Revd Charles Cox* (fig. 46, p. 73). But, with the exception of the drawing for *Haystack and window, evening* (fig. 86, see cat. 105), there are few preparatory sketches of landscape in pencil extant, and none as yet discovered in charcoal. However, there are many spontaneous studies in oils – such as *May in a red dress*. Areas of light and shade are treated in simple blocks of light and dark. Brushstrokes are put down in a confident manner, and create masses of colour and suggested forms which are blended by the eye of the beholder into holistic shapes and background details.

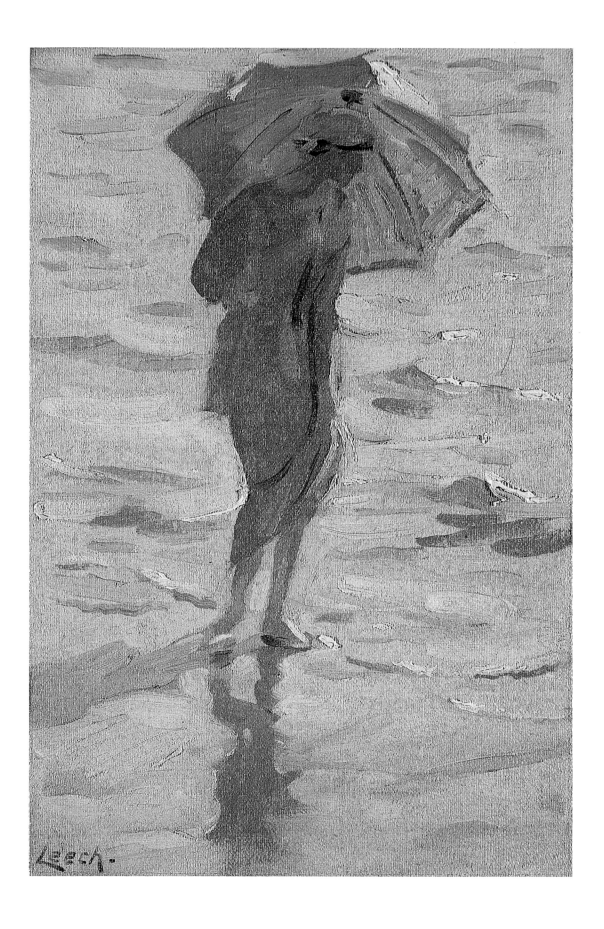

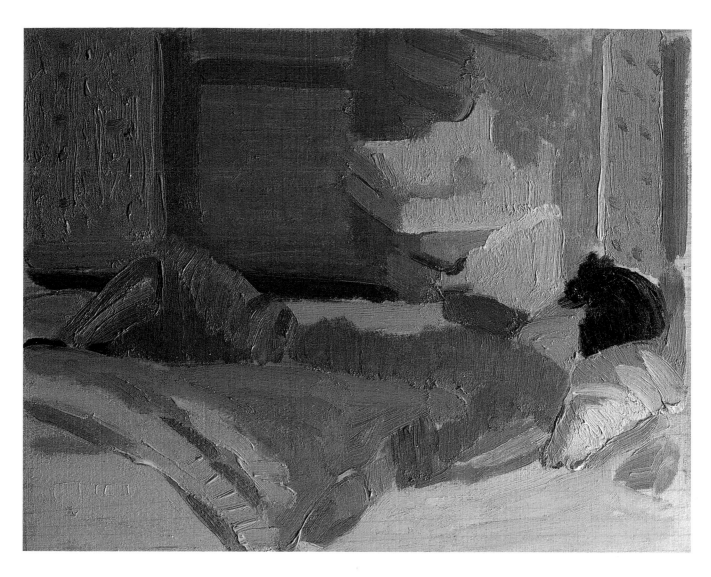

60 Three *pochade* studies

Oil on board
(a) 18.8 × 24.1 cm; 7⅜" × 9½"
(b) 18.7 × 24.1 cm; 7⅜" × 9½"
(c) 24 × 18.1 cm; 9½" × 7⅛"
Pyms Gallery, London

PROVENANCE The artist's studio, Candy Cottage, West Clandon, Surrey

LITERATURE McConkey 1990, p. 19; Denson 1969, no. 28

Four studies, one of a landscape of trees, three presumably of May Botterell, one of her reading a book, and two of her lying on a bed, are freely painted on small panels, about 9½" × 7", which fitted into Leech's surviving *pochade* (see cat. 7) and were found with it in his studio at his death. Recalling the colour and pattern of Matisse, the simply blocked-in colourful backgrounds of deep yellows and reds heighten the nuances of shadow and light in the flesh tones. As with his landscapes, these preparatory studies became the basis for his larger *Nude* (cat. 53).

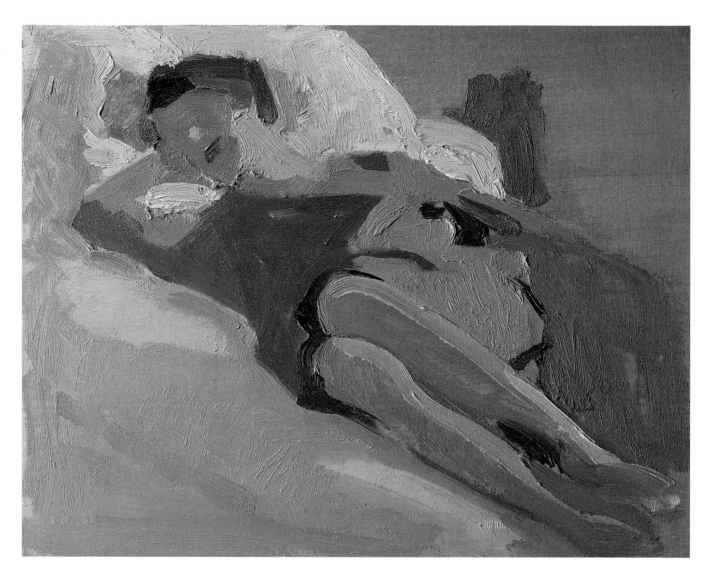

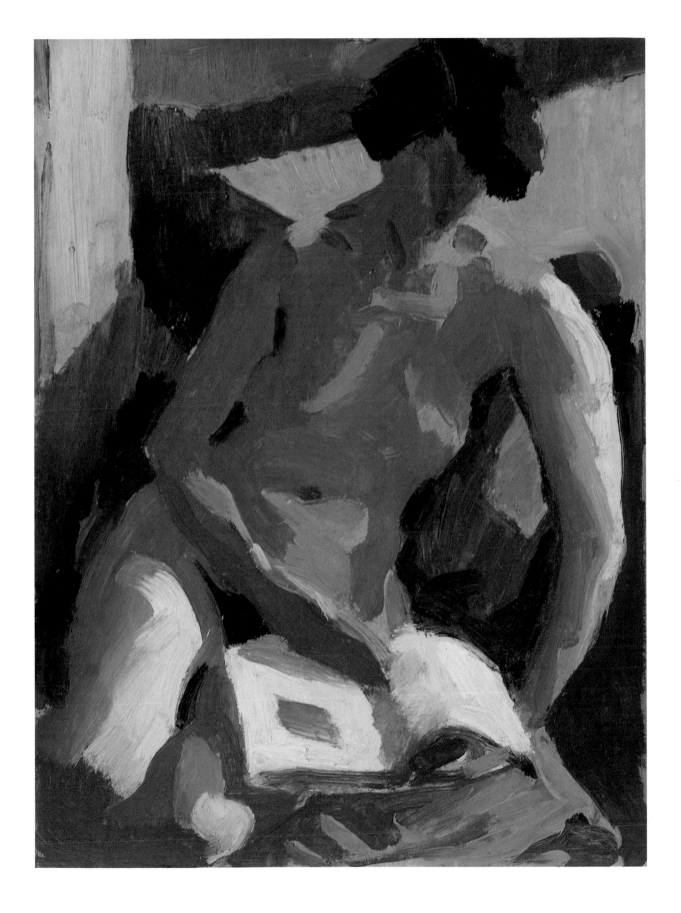

61 *Nude*

Oil on canvas
57 × 78 cm; 22½" × 30¾"
Signed lower left *Leech*
On verso, *W.J. Leech A.R.A No 18*
Collection of Patrick and Antoinette Murphy

PROVENANCE Purchased from the artist, January 1968

EXHIBITIONS Brussels, Exposition d'Art Irlandais, 1930
(*Nu*, no. 77)?; Limerick, Belltable Arts Centre, 1981 (no. 7)

The small studies (cats. 59, 60) exist complete in themselves, but they provided preparation for this large *Nude*. Additionally, a larger pencil study on cartridge (private collection) is a drawing of the same model in a similar pose. The large oil captures the model in a relaxed pose enveloped by light, which illuminates her thighs and breasts and far shoulder, and these areas form a dramatic diagonal which terminates in her unmodelled face and head. Clothes, in red and yellow, thrown over the chair in the background, form a vertical to offset the line of the body. Leech demonstrates skilful draughtsmanship and an ability to paint the softness of skin and the shadows of the flesh tones against the bed's white sheets with a confidence gained since, as a student, he painted his *Male nude* (fig. 14, p. 28). His confidence in using colour is further demonstrated in the hints of lilacs and mauvish greys which are repeated in the shadows of the white pillow behind, indicating an Impressionist influence, acquired from his knowledge of Monet's work. Leech strengthens the curves of the knees, stomach, breasts and arms with deft strokes of Paynes gray. The free handling of the figure, of the bedclothes and of the background shows the fluidity of paint handling acquired through water-colour painting – a technique which he applied, in this instance, to his oil painting.

Leech's earlier experimentation with pointillist methods, in *Beach scene* (cat. 55) for example, and the heavily striped quality of *Seaweed* (cat. 34) have now been subsumed into a confident paint handling which concentrates on masses and ignores detail. Leech merely delineates the nose with two brushstrokes to give facial identity. This work received an amusing review in the *Irish Tatler & Sketch* of 1947: "Though we did not care for his nude, but, as we admit that it has merit, this may be due to crankiness", indicating a narrow viewpoint, not dissimilar to Leech's Aunt Roddice's (see above, p. 39).

When May became Leech's model, a transition occurred in his subject-matter. He became absorbed by an *intimiste* view, painting what could be regarded as the insignificant, but which, to him, then, was of utmost importance, and which with his painter's eye he transformed into interesting motifs. He has now arrived at a style of painting which with paint-laden and decisive brushstrokes gives movement, energy and excitement to all his works irrespective of subject-matter.

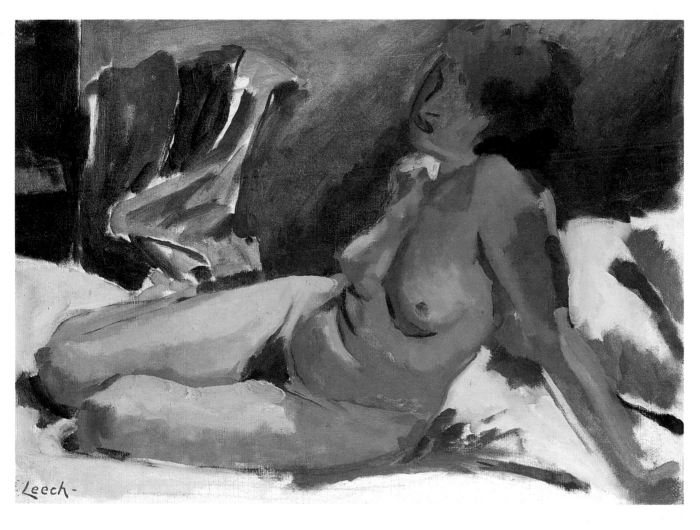

62 *May Botterell*

Bronze
Height 47.5 cm; 18¾"
Signed on base Leech; inscribed *The Studio, Hamilton Mews, London NW8* (Leech's address from 1925 to 1926)
The National Gallery of Ireland

LITERATURE Denson 1968, p. 16, fig. 5; Denson 1971, no. 199

In 1925–26, Leech completed the only three-dimensional work known to exist by his hand. It is a compelling study of May, modelled in clay in his studio at Hamilton Mews. A portrait photograph of May (fig. 81), taken in 1920, just after Leech and she had met, shows a similar aspect of May – except that in the later head May has had her long plaited hair cut into a fashionable bob. This modelled head remained in Leech's studio until his death in 1968. It is included in an interesting study in gouache entitled *May and my bust of May* (fig. 82). In 1990, Dublin Art Foundry cast a limited edition of twelve, and the original plaster head was presented to the National Gallery of Ireland by the Gorry Gallery.

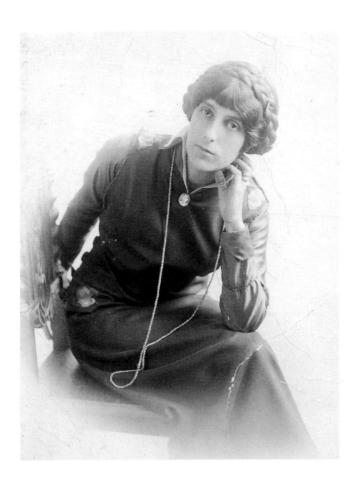

Fig. 81 *Mrs May Botterell*, photograph

Fig. 82 William John Leech, *May and my bust of May*, 56.7 × 38 cm, gouache, private collection

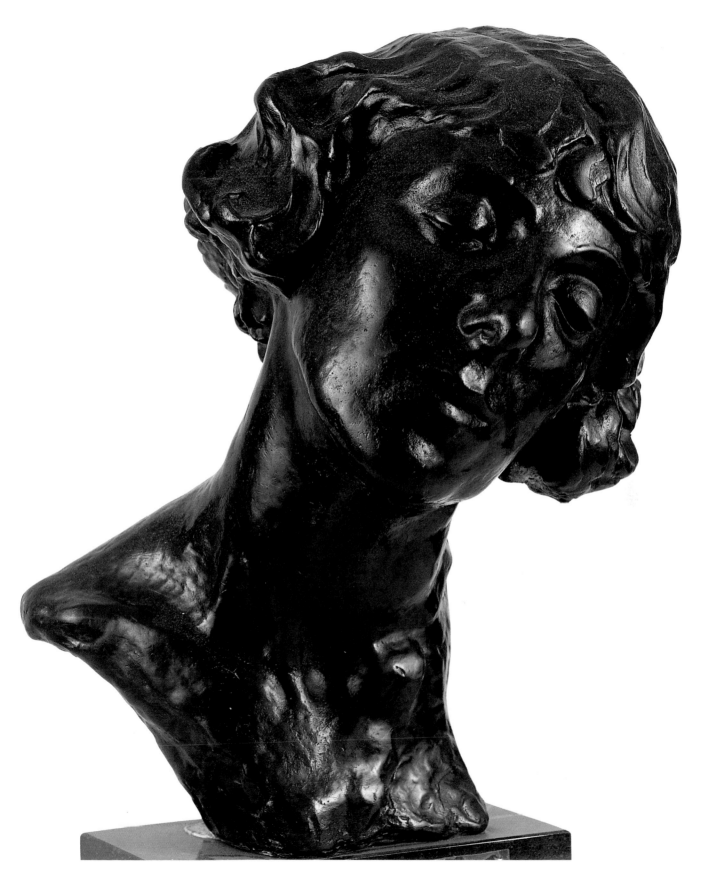

63 *Sylvia Cox*

Watercolour on paper
35.5 × 28 cm ; 14" × 11"
Signed lower left *Leech*, with an elongated L and 'eech'
inside, in a Japanese manner
Private collection

PROVENANCE By direct descent from the artist

All the vulnerability of babyhood is captured in Leech's sensitive watercolour of his little niece Sylvia, who was born in February 1913, the daughter of his sister Kathleen Leech and the Revd John Charles Cox. It was painted at Tettenhall Wood, a year after Leech had married Elizabeth; he was to paint her several times. The gentle tones in *Portrait of Elizabeth* (cat. 39) are repeated in this watercolour of the six-month-old sleeping baby, and the subject-matter is similar to the Frances Hodgkins's watercolour of a baby, painted possibly at the same period, which Leech presented to the Hugh Lane Municipal Gallery in 1965 (fig. 61, p.96).

64 *Sylvia Cox*

Oil on canvas
61 × 50 cm; 24" × 19⅝"
Signed lower right *Leech*, with an elongated L and 'eech'
inside, in a Japanese manner
Private collection

PROVENANCE By direct descent from the artist

After painting *Portrait of Suzanne Botterell* (cat. 47) in 1920, Leech completed this painting of his niece Sylvia in 1921, when she was just eight. Although signed with an oriental-style signature, as in the *Portrait of Suzanne*, the style of painting is completely different. In this work, there is more than a reference to Bonnard in the broad brushstrokes, in the tones of blue and pink of the little girl's dress against a brown and white checkerboard-patterned background. Leech again conveys the innocence and vulnerability of childhood, as in cat. 47, but this is a simpler painting, handled in a much freer style, since Leech was not working to the constraints of a commissioned work.

65 *Sylvia Cox*

Oil on canvas
45.8 × 35.5 cm; 18" × 14"
Signed lower left *Leech*
Private collection

PROVENANCE By direct descent from the artist

Leech's little niece Sylvia and Suzanne Botterell continued to be his willing sitters, and provide lasting evidence of his differing approaches to colour and brushwork as they grow older. About five years after painting Sylvia (cat. 64), Leech in the portrait of Sylvia (cat. 65) layers the paint in a Fauve awareness of complementary colours. The vermilion red of the cushion is juxtaposed against the viridian green of the grass. The background of the sunlit garden is built up, shape upon shape, of light areas against dark. Leech's characteristic composition is evident in the diagonal created by the position of Sylvia's reclining figure in the deck-chair, reading a book. Sylvia, now thirteen years of age, is captured as an emerging adolescent who refused to pose unless she could sit reading.

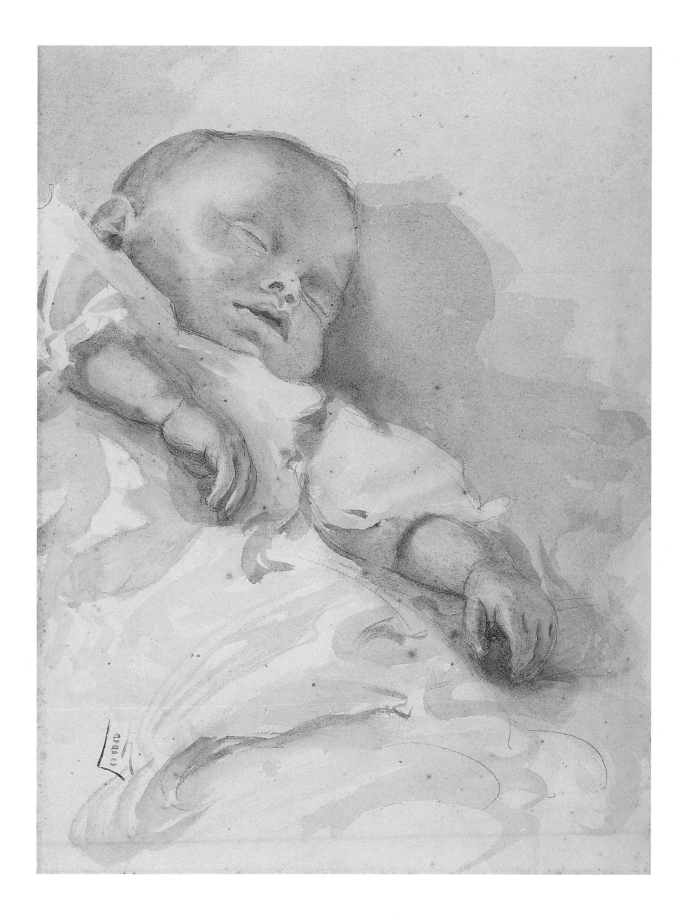

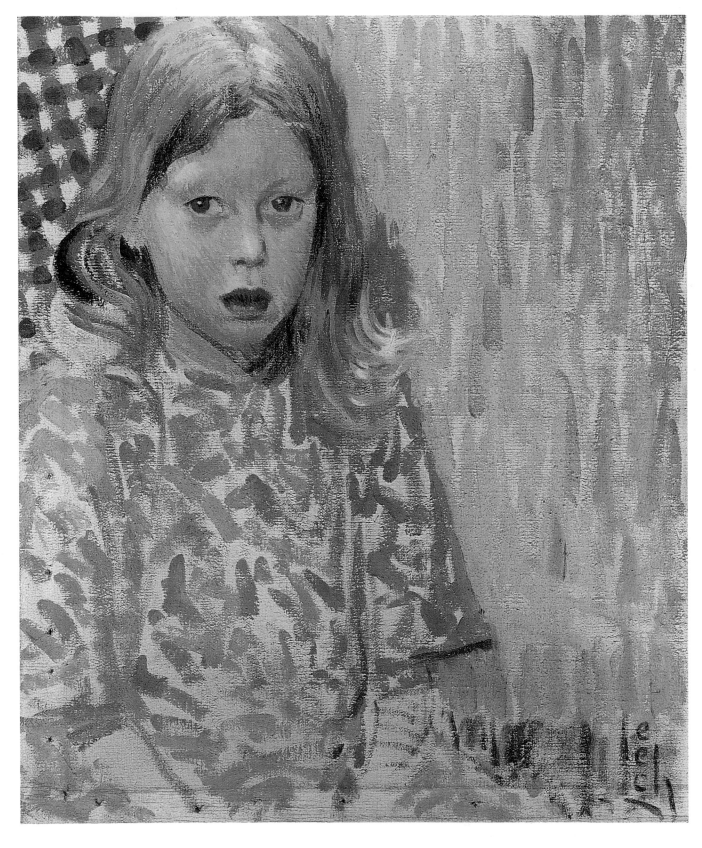

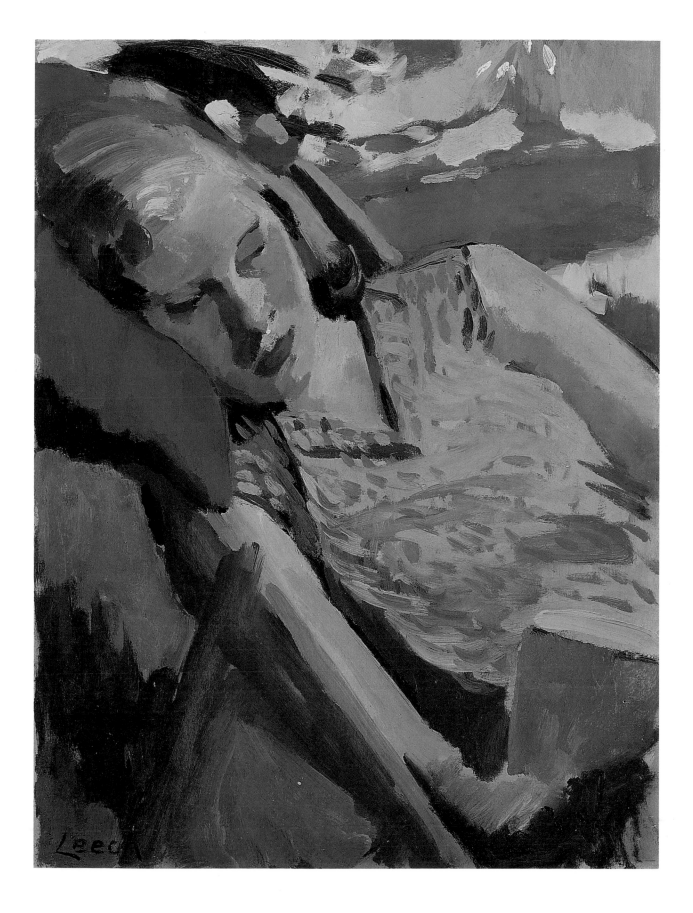

66 *La Cimetière de St-Jeannet*

Oil on canvas
61 × 73.7 cm; 24" × 29"
Signed lower right *Leech*
On verso, in the artist's hand, the title and *W.J. Leech, R.H.A., 20 Abbey Road London N8*. Label of Alfred Stiles & Sons Ltd., London. Fragment of a Goupil Gallery label
Private collection

PROVENANCE Listed in Dawson Gallery stock 1947, £60; bequeathed by Leech to the Dawson Gallery, 1968; the Taylor Gallery, London; purchased by the present owner

EXHIBITIONS RHA, 1928 (no. 29, £73. 10s. 0d.); Derby, Autumn Exhibition, October 1930 (no. 97, £47. 5s. 0d.); London, Royal Academy, 1934 (no. 231)

LITERATURE Denson 1969, no. 38

La Cimetière de St-Jeannet is a restrained painting, dominated by a sombre, dark cypress tree to the left and rows of monumental headstones to the right, but opening out into a valley of patchwork fields and luxuriant hedges. Sunlight picks out a cream farmhouse in the distance, bounces off the white sepulchres to the left and highlights the spring green of the foreground vines. When the work was exhibited at the RHA the reviewer drew attention to its frame: "the frame, while fulfilling its utilitarian purpose of holding and isolating the picture, has, by the skilful use of colour, been made to form a harmonious part of the picture, thus considerably enhancing the value of the whole as a complete work of art." The gentle horizontal forms of the fields and row of trees create a quiet compositional balance. This view across a tranquil valley and beside a peaceful graveyard has changed little even today. A light-filled watercolour, *St-Jeannet near Nice* (private collection), painted in spring greens and yellows, depicts the view from the house down into the valley, with colour creating recession and distance. *La Cimetière de St-Jeannet* epitomizes Leech's observation of the scene in his immediate environment.

67 *Sunflowers*

Watercolour over pencil on white paper
51.1 × 35.6 cm; 20⅛" × 14"
Signed lower left *Leech*
Collection of Ulster Museum, Belfast

PROVENANCE Bequest of Dr R.I. Best through the Friends of the National Collections of Ireland, 1959

68 *Sunflowers*

Oil on canvas
106.7 × 79.4 cm; 42" × 31¼"
Signed lower left *Leech*
Private collection

PROVENANCE Purchased from the artist

EXHIBITIONS RHA, 1925 (no. 94, £85)

LITERATURE J. Crampton Walker, *Irish Life and Landscape*, Dublin (Talbot Press), n. d. [1927], p. 104

The paintings of *Sunflowers* encapsulate the freedom, the assuredness of composition and the sheer *joie de vivre* displayed by Leech in his paintings of the South of France of the 1920s. The two paintings also illustrate his use of watercolour as a preliminary study for a later, larger version in oil, even though the watercolour is an effective painting in its own right. Both paintings are alike in every detail but the oil version has an added shadow on the left-hand side which indicates that the shape creating the shadow on the left is a gate. Light and warm golden and acid-green tones pervade both. These are not the thickly painted expressionistic sunflowers of Van Gogh, but remain closer to the work of Matisse – seen as decorative patterns created by radiant sunlight and shade. The oil version has *Un après-midi d'été* inscribed on the frame, and Leech exhibited a painting with this title at the Salon des Artistes Français in 1914, but a work entitled *Sunflowers* was shown at the RHA in 1925. It is perhaps more likely that Leech reused an existing frame than that he showed the same painting after such a time lapse.

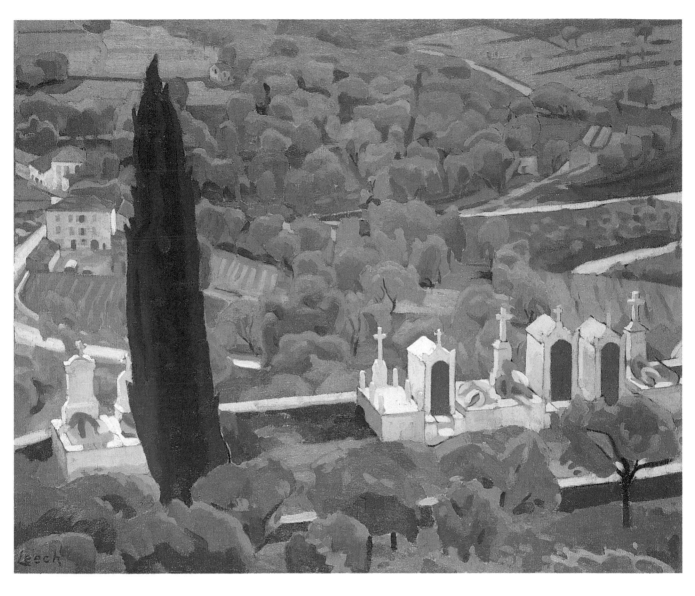

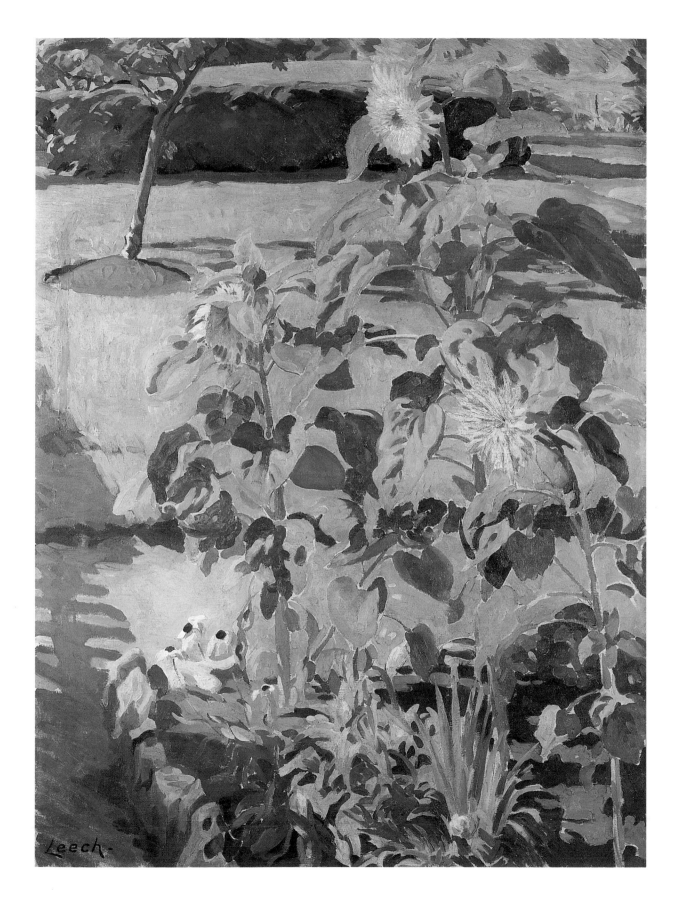

Leech-

69 Red roofs, Nice

Oil on board
44.5 × 37 cm; 17½" × 14½"
Signed lower left *Leech*
Private collection

EXHIBITIONS RHA, 1928 (*Red roofs, Nice*, £21); Bourlet
records, 1.7.1931: collected from the National Gallery, no. 3,
Red roofs, Nice; Dublin, Dawson Gallery, 1945 (no. 17, £23);
Dublin, Dawson Gallery, 1951 (no. 14, £20)

PROVENANCE Dawson Gallery; by descent to the pre-
sent owner

Red roofs, Nice is an unusual subject, but again with
a high viewpoint and painted in a typical style. The
warm, Indian-red tones of the roof-tiles and brick
façades of the houses below can be glimpsed
through the tall, dark cypress trees in the fore-
ground. In the middle distance, bathed in sunlight,
can be seen an elegant terrace of apartment blocks
with traditional red-tiled roofs. In the distance,
painted in Naples yellow, the façade and portico
of a classical building create a dominant diagonal.
Leech painted this work in a convent in Nice – per-
haps from a window which may even have been
the location of his working views of the harbour.

70 The port, Nice

Oil on wood panel
19 × 24.1 cm; 7½" × 9½"
Private collection

PROVENANCE Bourlet records 27.5.1944: Brought in,
no. 24 and no. 27, both same title (*The port, Nice*), dimen-
sions and media; Adams, Dublin, auction, September 1982

EXHIBITIONS Derby, Art Gallery, Autumn Exhibition,
1933 (no. 26, £12. 12s. 0d.)?; RHA, 1935 (no. 110, £5)?

71 The port, Nice

Oil on panel
46 × 37 cm; 18" × 14½"
Signed lower left *Leech*
On verso, inscribed with title on a label on the frame
Private collection

EXHIBITIONS RHA, 1929 (no. 32, £26. 5s.)?; Sotheby's,
London, sale 14 November 1984 (lot 105); London, Pyms
Gallery, 1985 (no. 22)

LITERATURE Denson 1969 (*The harbour, Nice*), no. 16;
Celtic Splendour, exhib. cat., Pyms Gallery, London, 1985, p.
59, no. 22, colour illus.

These two paintings entitled *The port, Nice* differ
markedly from each other stylistically. The small oil
on board (cat. 70) depicts the harbour in a natu-
ralistic fashion and is possibly the earlier work.
Leech has used his *pochade* (see cat. 7) to work
directly *en plein air* and then has further developed
these studies into compositions such as cat. 71. *The
port, Nice* captures a similar subject and angle to
Reflections (Marine subject) (cat. 19) painted about
ten years previously, but the later work in rich tones
of orange against turquoise blues shows an under-
standing of the Fauves, of Derain and of Matisse's
Collioure coastal scenes, even though Leech has
become more a colourist, less Fauve. It builds, too,
on the structure of Cézanne – in particular his L'Es-
taque landscapes. Although cat. 71 is yet another
view of boats in a harbour, Leech has dramatically
changed the angle and the composition of the boats
moored along the quay. He uses a high viewpoint
to depict terracotta rooftops and boats against a
blue-green sea. Colour is absorbed and rendered
with the same tonal harmony achieved in *Glion*
(cat. 26) and *When things begin to live* (cat. 25) but
in a higher key. With the exception of a few tiny
figures at the edge of the quay and on the far bank,
people do not inhabit Leech's dockside scenes.
Rather, he concentrates on the pattern created by
rooftops, shadows and boats. Houses flank the far
bank and contain the composition in a manner rem-
iniscent of the simplified style adopted by Derain
at Collioure in 1905.

72 Near Grasse

Watercolour
35.5 × 45.7 cm; 14" × 18"
Signed lower right *Leech*
Ita and Michael Carroll, Dalkey

Leech used watercolour to paint the landscape of
Grasse, a practice he again adopted when he was
staying in hotels in the South of France. *Near Grasse*
is a freely painted watercolour of an open expanse
of countryside, a landscape which stretches to the
hills and sky beyond and is framed by the trunk
of one tree on the left. There is a feeling of Cézanne
and the countryside of Aix-en-Provence in the
unusually open landscape of distant hills and
expanse of sky and of course the angle of the tree-
trunk with the few leaves indicated at the top.

73 Provençal house, Grasse

Watercolour
35 × 25 cm; 13¾" × 10"
Signed lower right *Leech*
Private collection

Provençal house, Grasse is a freely painted water-
colour, capturing the edge of a white farmhouse
wall against the intensity of the blue sky. Behind
the house looms the dominant dark shape of a
cypress tree. The rocky foreground and middle dis-
tance are built up in horizontal brushstrokes of
blues and tones of greens, and are broken by the
upright forms of the distant cypresses. Leech
demonstrates his ability to capture freely in water-
colour the area's topography and its simple stone
farmhouses etched in the strong sunlight. An occa-
sional drawn line, in Paynes gray, adds vigour and
definition to the form of the farmhouse and to the
surrounding vegetation. By adopting an unusually
high viewpoint in this painting Leech is able to
include a dominating expanse of sky with a wide
vista beneath.

74 Farm near Le Lavandon

Oil on canvas
45.7 × 38.1cm ; 18" × 15"
Signed lower left *Leech*
Private collection

EXHIBITION Dublin, Dawson Gallery, June 1945
(no. 29, £18)

The light and vegetation of the South of France
brought new motifs into Leech's work. The valley
around Grasse and the countryside around Le
Lavandon provided Leech and Thompson with a
new stimulus and source of landscape subject-
matter. In *Farm near Le Lavandon*, Leech captures
the heat of the summer sun in the pinks and blues
of the pattern of vineyards on sloping hills. The
stone barn sits perched to one side of the ploughed
field, saved from visually toppling over by the dia-
gonal bands of colour in the furrows.

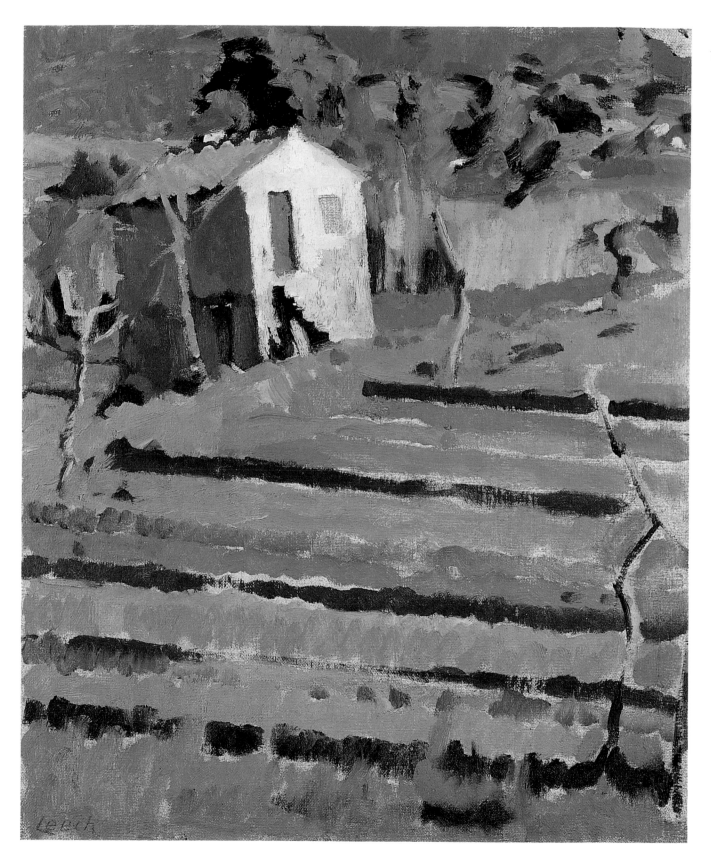

75 Self-portrait (Painting in a garden)

Oil on canvas
109 × 89 cm; 43" × 35"
Signed lower right *Leech*
Private collection

PROVENANCE Dawson Gallery, Dublin

EXHIBITION Dublin, Dawson Gallery, 1951 (no. 15)?

LITERATURE Anonymous, *Irish Tatler*, LX, no. 9, June
1951, p. 21, illus.; Denson 1969, no. 64, illus.

The *Irish Tatler* in June 1951 reviewed Leech's exhibition at the Dawson Gallery and, beside an illustration of the painting, declared Leech's work *Painting in a garden* to be "One of the finest pieces of figure painting Mr. Leech has ever done". This vertical painting, showing Leech leaning backwards with a straw hat and white shirt, is freely painted. His nephew has suggested that it may have been painted from a photograph his father, the Revd John Charles Cox, took in Tettenhall Wood Vicarage garden, when they were clearing a bank. Leech spent a long time staying with his sister Kathleen and her husband, the Revd Cox, at Tettenhall Wood – especially during the 1920s and 1930s.

Painting in a garden is one of a long series of self-portraits that Leech painted from the 1920s until his death in 1968. Judging from his appearance, he was about fifty years old when he painted this one, *ca.* 1930. On the back of this canvas is a second self-portrait with May sitting watching him paint. In fact Leech frequently painted on the backs of canvases, through lack of sales which left him without much money and a surfeit of unbought canvases. For example, *Artist at an easel* was painted on the back of his niece Sylvia's portrait, *Sylvia in a green dress* (private collection), which he completed in 1937. On the back of *Flowers in a vase* (cat. 81) Leech painted another self-portrait, which depicts him standing over his studio table,

framed by his studio window. *Self-Portrait* (Hugh Lane Municipal Gallery) is similar to cat. 75 and depicts Leech standing with arms outstretched towards his canvas, while leaning back over one shoulder to the mirror positioned out of view. It is an *intimiste* view of an artist at work in his studio, wearing his carpet slippers. Again, the pose of the standing figure before his easel is repeated in his self-portrait *Artist at work* (private collection). There is a more strident action in the later pose with Leech's left arm dramatically outstretched towards the canvas as he works concentratedly from his reflection in the mirror in his studio. In the background he captures a study of May as she sits watching him at work. Although unfinished, this is a technically interesting painting with areas of canvas left unpainted in the trouser-leg on the left. He freely sketches in charcoal, laying in the composition and lines of direction, before painting. The stark compositional elements and the use of parallelled diagonals that give energy and movement to the work are revealed in the unfinished areas. Leech repeats the theme of his standing pose in *Self-Portrait in hotel bedroom* (Self-Portrait Collection, Kneafnsey Gallery, Limerick). He could also capture his own likeness in watercolour while losing none of the freshness and spontaneity of the medium.

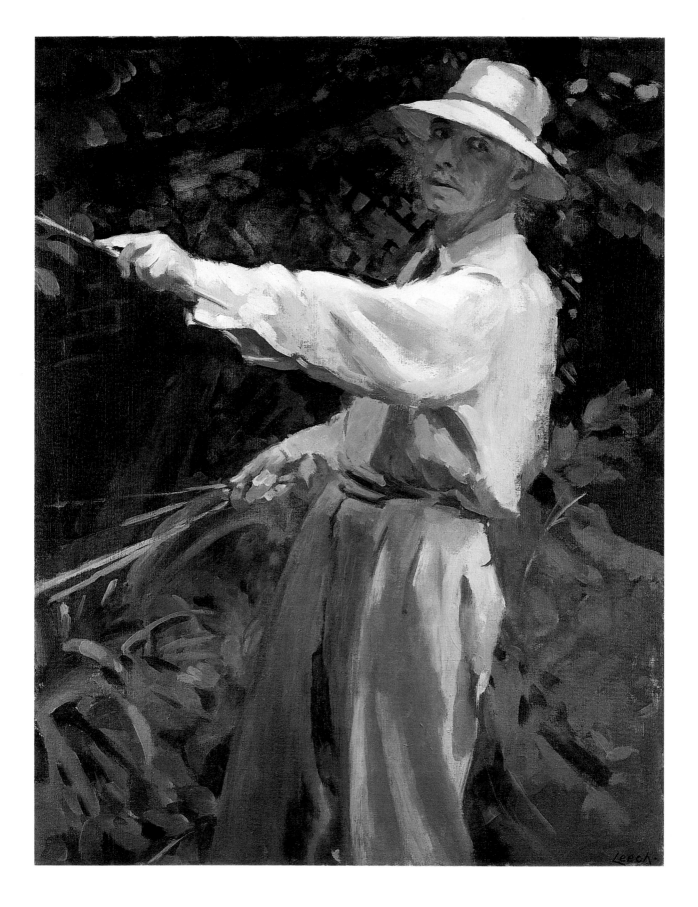

76 The kitchen, 4 Steele's Studios

Oil on canvas
91.5 × 71 cm; 36" × 28"
Signed lower right *Leech*
On verso, inscribed with the artist's name and address
Private collection

PROVENANCE The artist's studio; Dawson Gallery, Dublin; Gorry Gallery, Dublin; Taylor de Vere, Dublin, art auction, 14 December 1993, lot 57

LITERATURE Denson 1968, no. 13; exhib. cat., Gorry Gallery, Dublin, April–May 1986, fig. 26; Taylor de Vere, Dublin, art auction, 14 December 1993, colour illus. cover

The kitchen, 4 Steele's Studios, London depicts the lace-curtained window of his kitchen in Steele's Studios, through which is glimpsed the bird bath, portrayed in cat. 77, in the garden beyond. Framed at the top, above a garden wall, is the row of houses at the back of Steele's Studios. Seen from Leech's usual high viewpoint, the tablecloth, painted in a chequerboard pattern – Bonnard-style – vibrates with light, the green of the apples contrasting with the red. The same cloth is found in the related *Fruit: a still life* (fig. 83, see cat. 79).

Fig. 82 *William John Leech*, photograph

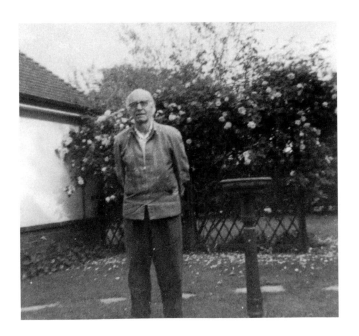

77 The bird bath

Oil on wood
50.5 × 39 cm; 19¾" × 15¼"
Signed lower left *Leech*
Private collection, courtesy of the Gorry Gallery, Dublin

PROVENANCE The artist's studio; Gorry Gallery, Dublin; to present owners

EXHIBITIONS RHA, 1957 (no. 28); Dublin, Gorry Gallery, 1987

LITERATURE Denson 1968, fig. 6; Dublin, Gorry Gallery, exhib. cat., May 1987, colour illus.

His bird bath was painted several times by Leech in different garden locations, in different light. Here the simple motif epitomizes the gentle world Leech created around him, in the midst of London, with impending war. The bird bath was moved to the garden of Candy Cottage in Surrey and is featured in one of the last photographs taken of Leech, in 1966 (fig. 82).

78 Lamplight

Oil on canvas
91.1 × 80.3 cm; 35⅞" × 31⅝"
Signed lower right *Leech*
On verso, inscribed in the artist's hand, the title and the artist's name and his address, *Candy Cottage, West Clandon*
Private collection

PROVENANCE Purchased from the artist in the 1950s

EXHIBITION RHA, 1949 (no. 118, £125)

Lamplight, which was bought directly from the artist in the 1950s for £100, is a carefully arranged interior featuring a simple kitchen-chair, giving focus and direction to a plain kitchen table laid for one person. The checked tablecloth seen in *The kitchen, 4 Steele's Studios* (cat. 76) has been removed and Leech focusses, instead, not on colour but on light and on earth tones.

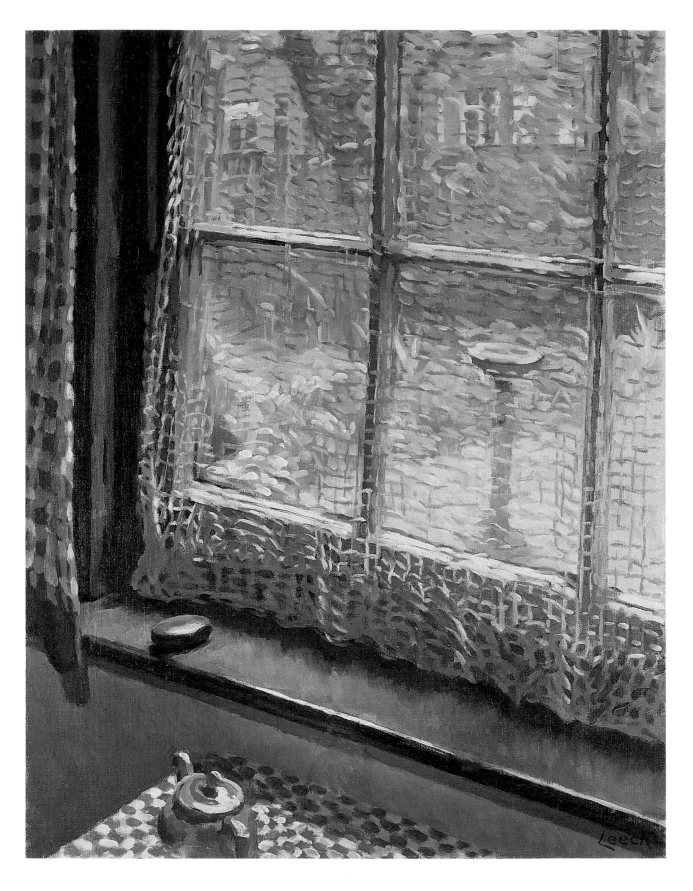

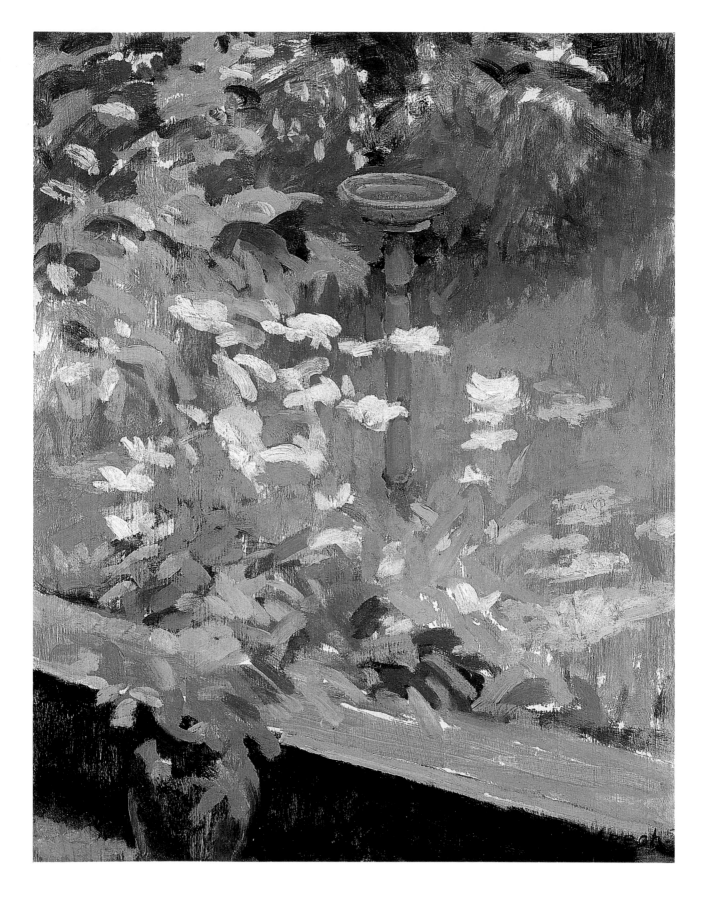

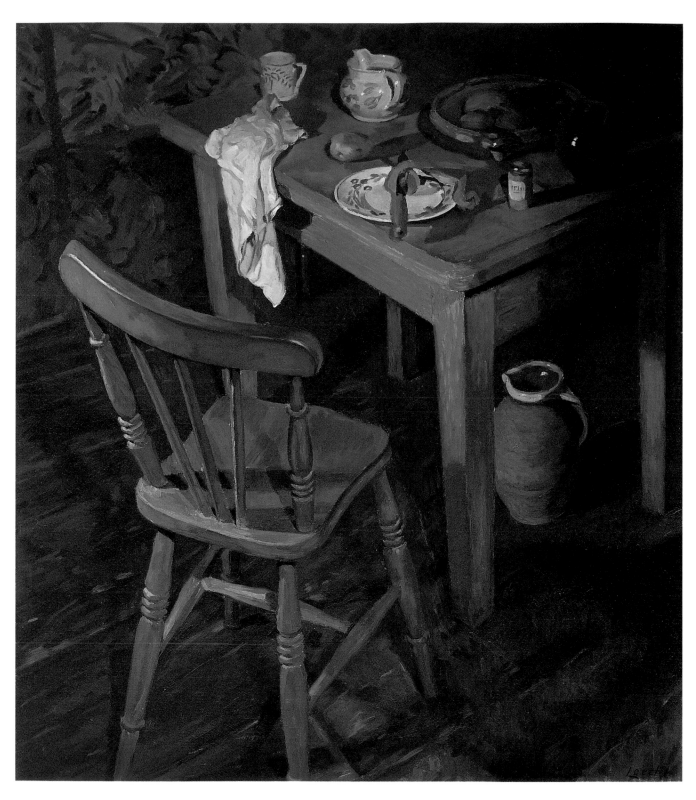

79 Quimper

Oil on canvas
60 × 40 cm; 23⅝" × 15¾"
Signed lower left *Leech*
Private collection

PROVENANCE Adams, Blackrock

This may have been painted in Leech's studio, years after his visits to Quimper, or from a work begun in Quimper years previously, or perhaps the title of this painting could have arisen from one of the objects on the table, the Quimper coffee-mug. Its decoration in blues, yellows and pinks is echoed in the corner of the tablecloth and the jug. Leech uses a high viewpoint and a truncated tabletop to produce a painting that vibrates with colour. All the heat and happiness of a summer's day is captured in the yellow greens of the grass against the white tablecloth with its few carefully arranged objects. The painting recalls Leech's kitchen still lifes at Steele's Studios, such as cats. 76 or 78, or *Fruit: a still life* (fig. 83).

A picture called *Quimper* was chosen by Alan Denson as one of two paintings to represent Leech posthumously at the Royal Academy Summer Exhibition in 1969; it is reproduced in his book of 1969 and is now called *The lace tablecloth* (fig. 84). It may be the painting exhibited at the RHA under that title in 1948.

Fig. 84 William John Leech, *The lace tablecloth*, oil on canvas, 86 × 94 cm, private collection

Fig. 83 William John Leech, *Fruit: a still life*, oil on canvas, 71.5 × 91 cm, private collection

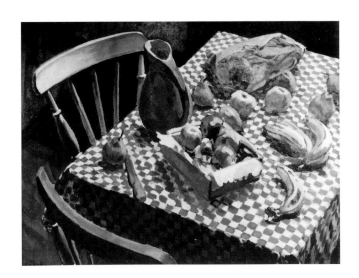

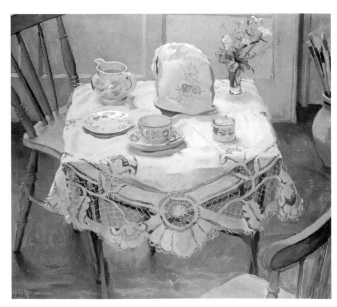

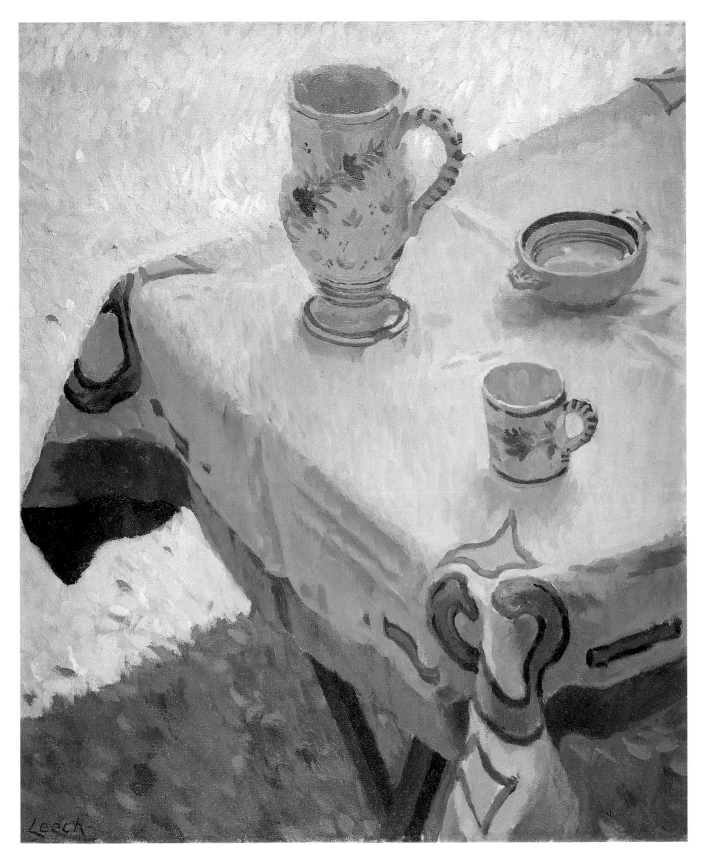

80 *Flowers in a vase*

Oil on canvas
60 × 49 cm; 24" × 20"
Signed lower left *Leech*

VERSO

Self-portrait

Private collection

EXHIBITION RHA, 1930

Leech exhibited this work for the first time at the RHA in 1930. It initiates a new motif in a long series of still lives, painted throughout the 1930s in Steele's Studios. They are as numerous as they are varied. At times he combines different flowers, as in *Stocks and tulips* (private collection), using the contrasting forms and colour of the upright white stocks with the soft pink tulip heads against a background of grey swirling forms. He uses striped brushstrokes in the background of another *Tulips* (private collection), reminiscent of similar brushstrokes employed in his earlier work *Seaweed* (cat. 34). In contrast, *Tulips and sunlight* (private collection) is full of rounded forms, centring on the earthenware vase with its full-budded tulips. The lilac blues of the background highlight the soft green of the leaves and the orangey tones of the tulips.

On the back, Leech has painted a *Self-portrait*, seen from behind and making a taut diagonal against the pattern of the window-frame.

81 *Flowers in a vase – Still life*

Oil on canvas
73.5 × 62 cm; 29" × 24"
Signed *W.J. Leech*, painted as part of the label in the painting
Mrs Hanni Davey

PROVENANCE From the artist as a wedding present in 1937

EXHIBITIONS London, National Portrait Society, 1931 (*Still life in a studio*)

The naturalistically painted mauve tulips, with upright heads and strong leaf-shapes, add colour to the white, grey and black tones of *The Daily Telegraph* and *Vogue Pattern Book* on the pine tabletop. On the tabletop is a label from a painting inscribed with W.J. Leech's name at the top, as if it were printed text within the image. There is just a hint of Georges Braque in the decorative use of lettering and in the label which alludes to collage and *trompe l'œil*. Leech was so particular about the surface quality of his canvases and his materials that he did not experiment with mixed media. He remained a traditional artist, using traditional materials.

This is a typical Leech composition, seen from a high viewpoint, the petal shapes becoming decorative pink and red arabesque forms, not simply pretty flowers in a vase. Hints of the lily heads in *The Secret Garden* (cat. 36) and of *Aloes near Les Martiques* (cat. 51) are embodied in this study. There is also a suggestion of Duncan Grant's *Tulips*, 1911 (Southampton City Art Gallery), in the decorative handling of the tulip motif.

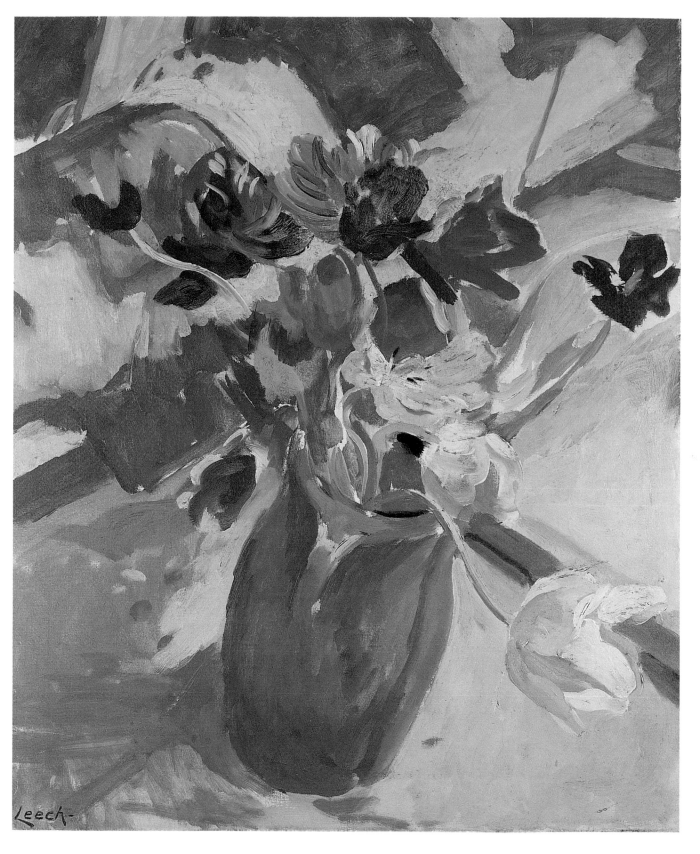

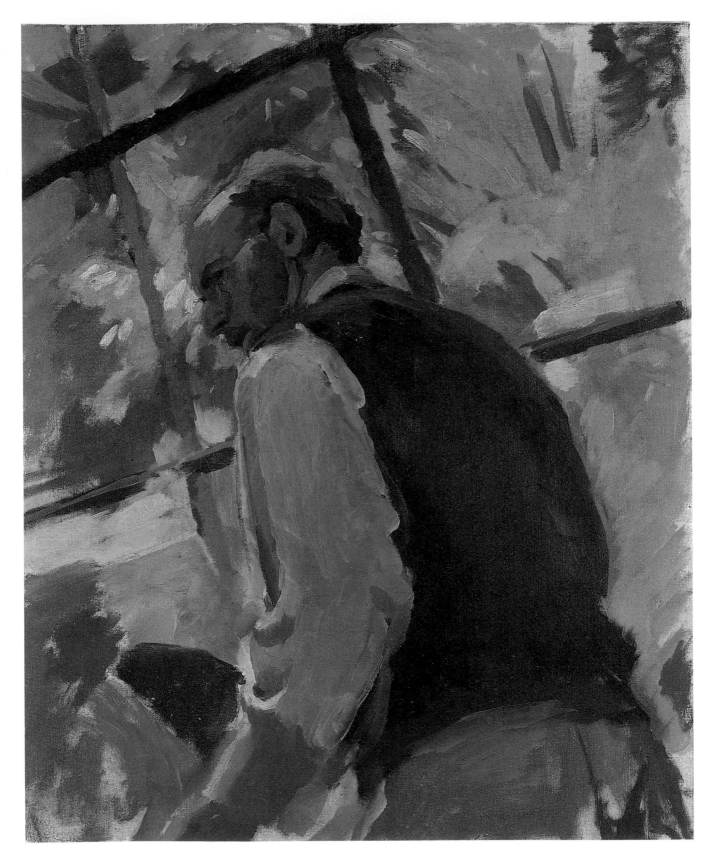

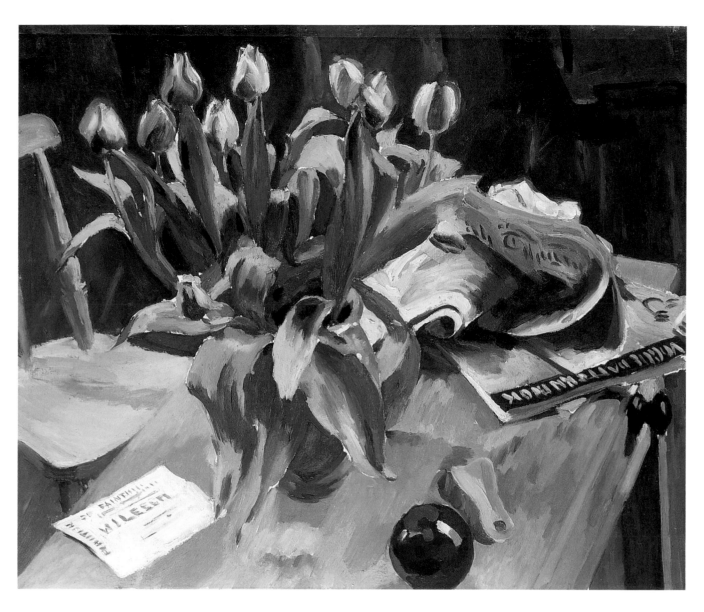

82 Flowers in a mirror

Oil on canvas
96 × 82 cm; 38" × 32¼"

VERSO

French buildings and trees

Collection of George and Maura McClelland

PROVENANCE Dawson Gallery; Dr Eileen McCarville; to
the present owner

EXHIBITIONS RHA, 1932 London, Royal Academy, 1940
(£80); London, RA, 1942 (£80); Dublin, Dawson Gallery,
June 1945 (*Flowers and a mirror*, no. 25, £80); Cork, ROSC,
Irish Art 1943–1973, 1980 (*Flowers of hope*, no. 70); Bourlet
records, 1.3.1932: *Flowers in a mirror* (collected from
Selves); 16.6.1932: Unpacked from RHA; all six unsold.

The colourful, pattern-filled *Flowers in a mirror*
combines Leech's use of mirrors with his love of
painting flowers. In masterly fashion he depicts the
complexity of reflected images, the light on the
orange-red gladioli and on the glass, so that the
viewer has difficulty discerning what is reflection
or not. *Flowers in a mirror* was exhibited for the
same price, £80, in Leech's solo exhibition at the
Dawson Gallery in 1945 as it was at the Royal Acad-
emy in 1942, although Leech had proposed asking
£75 for this painting in Dublin. However, it was still
unsold on his death in 1968 when Leo Smith val-
ued it for death duties.

83 Black slippers

Oil on canvas
76 × 61 cm; 30" × 24"
Signed lower left *Leech*
On verso, inscribed in the artist's hand *W.J. Leech, 4, Steele's
Studios, Haverstock Hill*
Private collection

EXHIBITION RHA, 1930 (no. 1, 25 gns.)

The black slippers are combined with a jug, placed
centrally, brimming with blue and pink summer
flowers. The usual compositional device of the tilted
tabletop tiles gives a directional flow to the

composition. The mirror behind becomes a screen
of patterned colour in which the black slippers and
the vase of flowers are reflected.

Mirrored reflections allowed Leech a freedom to
use form and colour which approaches abstraction.
In *Armchair* (private collection), painted in Steele's
Studios, there features a section of a black armchair
on top of a patterned rug, and in the background
what appears to be a bed glows yellow against a
dark backdrop. The freedom of brushstrokes, the
vivid contrasts of colour and the decision to create
a composition seen from above – with its associated
dramatic lighting – show Leech striving to liberate
his pictorial composition, but he remains rooted in
the process of painting and recording from life in
a representational manner. Leech's exploration into
abstracted form serves to strengthen his Post-
Impressionist painting. His compositions are taut
and dynamic, even though his subject-matter
becomes gentle domestic scenes and objects to
which he is accustomed.

84 Still life (Primulas in a mirror)

Oil on canvas
72 × 59 cm; 28½" × 23¼"
Signed lower left *Leech*
Private collection

Leech uses a mirror to reflect the gardening still life,
which focusses on a carefully painted potted prim-
ula. The soft tones of lilac and purple mould the
flower heads into a correct, botanical study, har-
monizing in colour with perfectly formed and
painted leaves. A gardening glove gives direction
inwards to a carefully constructed composition. This
is a view into an English gardening shed, perfectly
constructed but quietly painted in restrained
colours, lacking the dramatic light and colour of
Flowers in a mirror (cat. 82).

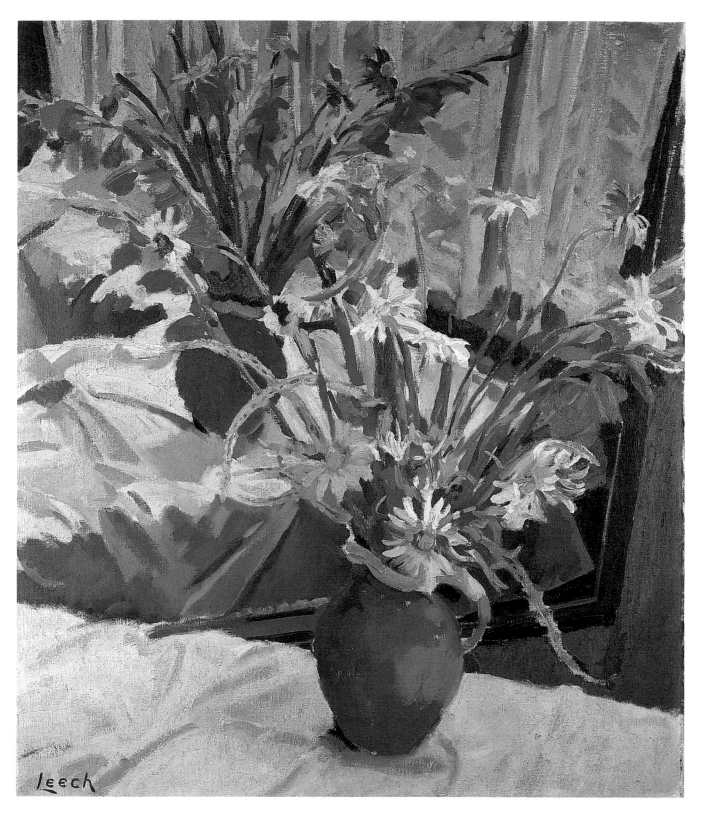

82

83

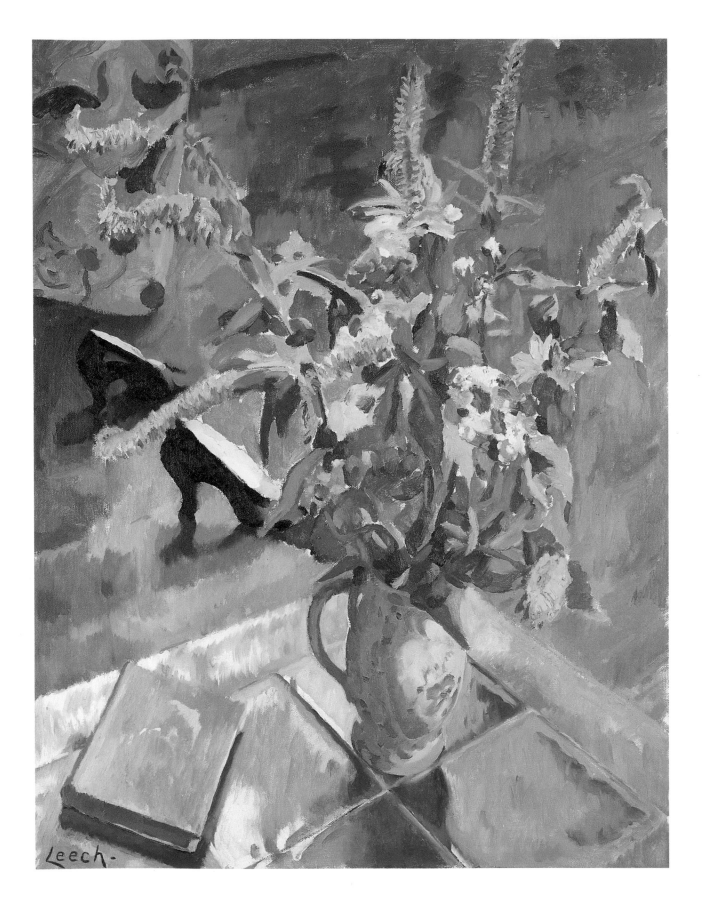

leech.

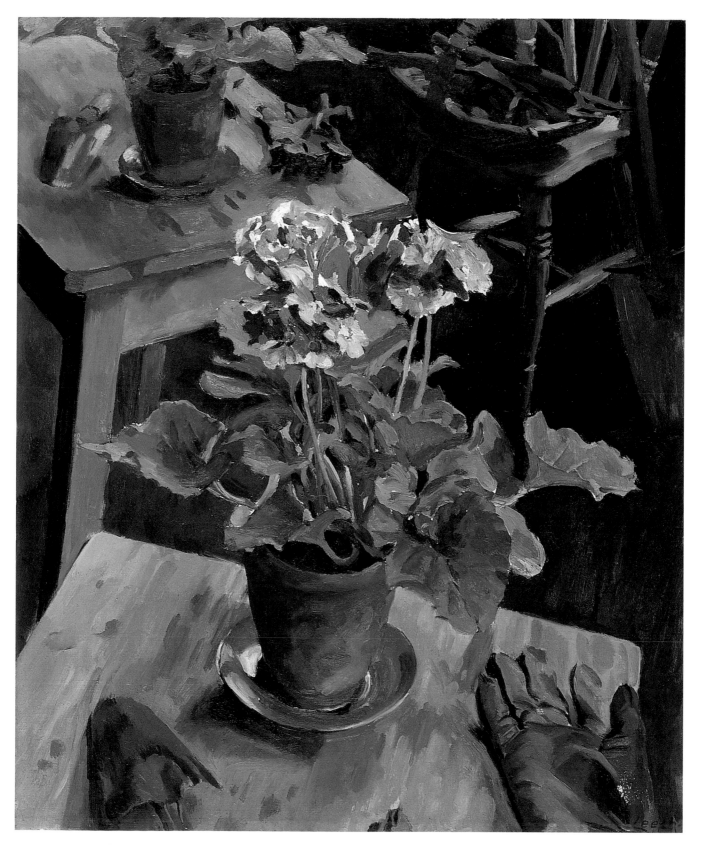

85 *Rutland Square (Parnell Square)*

Oil on canvas
36.8 × 45.8 cm; 14" × 18"
Hugh Lane Municipal Gallery of Modern Art, Dublin

PROVENANCE Bequeathed by Denis Gwynn

86 *Parnell Square*

Oil on canvas
37 × 45.5 cm; 14½" × 18"
Yeats Gallery, Sligo

Three works Leech exhibited at the RHA, Dublin, in 1929, 1934 and 1935 were *Parnell Square*; *The shelter, Parnell Square*, and *7 Parnell Square*. Judging from the prices – £15. 15s., £18. 18s. and £5 – all three may have been watercolours or drawings, and possibly the first studies Leech made of the subject for one or both of the two oil-paintings cat. 85 and cat. 86. In any event, these dates would seem to confirm Denis Gwynn's information, when referring to *Rutland Square* (*Parnell Square)* (cat. 85), that Leech "painted [it] on one of his infrequent visits to Ireland some thirty years ago". Leech may have made the preliminary studies for these works on one visit around 1928, or it is possible that he returned briefly again around 1934. In any case, his visits were – as Denis Gwynn wrote – "infrequent". This may have been a sentimental journey for Leech, to paint the square where he was born, with the shelter to his left. Unfortunately, this house, no. 47, has now been demolished. In *Parnell Square* (cat. 86) he includes the corner of Charlemont House, which housed the Registry of Deeds, where his father Brougham Leech had his office.

Denis Gwynn relates about the Leech paintings in his collection, "I have been happy to own three of his landscapes, one in Paris and one in the South of France, and the third in Dublin, which I have since presented gladly to the Modern Art Gallery at Charlemont House. It was painted on one of his infrequent visits to Ireland some thirty years ago, and it shows the rich red brick of the tall houses in Parnell Square in a sunny Autumn. A view or part of the Charlemont House appears in one corner, and the now demolished nurses' quarters in the foreground. As records of former buildings his paintings have a special interest; particularly this glimpse of Parnell Square, where the national memorial now stands. Incidentally it shows Leech's constant enjoyment of painting concrete walls or buildings The picture of Parnell Square shows other shades and textures in the concrete walls and roof of the nurses' building at the back of the Rotunda Hospital. Only an artist with a vivid sense of colour would choose to paint such an apparently drab subject as concrete." Leech adopts a different view of the square and a different time of day, with changed lighting, in cat. 86. Seen from the side of the garden, the tall Georgian houses are painted red-brick without the glow of the evening winter sun in cat. 85.

87 Regent's Park

Oil on canvas
38 × 46 cm; 15" × 18"
Signed lower right *Leech*
Private collection

88 *The bridge, Regent's Park*

Oil on wood panel
34.9 × 45.1 cm; 13³/₄" × 17³/₄"
Signed lower left *Leech*
Collection of George and Maura McClelland

EXHIBITION RHA, 1958 (*Grey bridge, Regent's Park*, no. 4, £5)

The bridge, Regent's Park is painted in a silvery light with York Bridge, a high horizon-band of subdued umber tones, merging into the soft blue-grey tones of the background. In the foreground, the river reflects the cool grey of a winter sky which mingles with the muddy browns and greens of the still water. All the edges of objects, solid or reflected, are blurred and softened; the top of the bridge is masked by the overhanging grey-green leaves of a weeping willow.

A slightly smaller painting, of the same view, in a similar light, but with slightly freer handling, is *Regent's Park* (cat. 87). In an examination of both paintings it becomes evident that Leech has slightly raised the parapet of the bridge in cat. 88, allowing a larger expanse of water to reflect the grey winter light of the sky, hidden from view. This painting, possibly the later of the two, has more definition in the details of the overhanging tree and in the formation of the bank beyond, with a greater use of drawn dark-green shadows. The reflections in the water, in both, suggest the coldness of a winter's day.

Bourlet transport records of 28 February 1935 list *"The bridge, Regent's Park"* as one of eight pictures taken from Leech's studio to Dublin. *The Bridge, Regent's Park* was exhibited at the RHA in 1935, but the low price of £5 would suggest that this was a drawing. *Reflections, Queen Mary's Gardens* (private collection) continues Leech's theme of parks and reflected water. The tranquillity created by using subdued tones of umbers and soft greens is reinforced by the horizontality of the composition, a horizontality broken only by the verticals of the summer-seat, and the trees reflected in the still, deep water. This is an ornamental, circular pond in the centre of the garden but Leech chooses to eliminate its distinctive shape, concentrating on the shadows and reflections instead. A few figures in soft grey merge with the landscape but Leech painted these park scenes mainly empty of people, which is perhaps the main reason he painted there in the winter time.

87

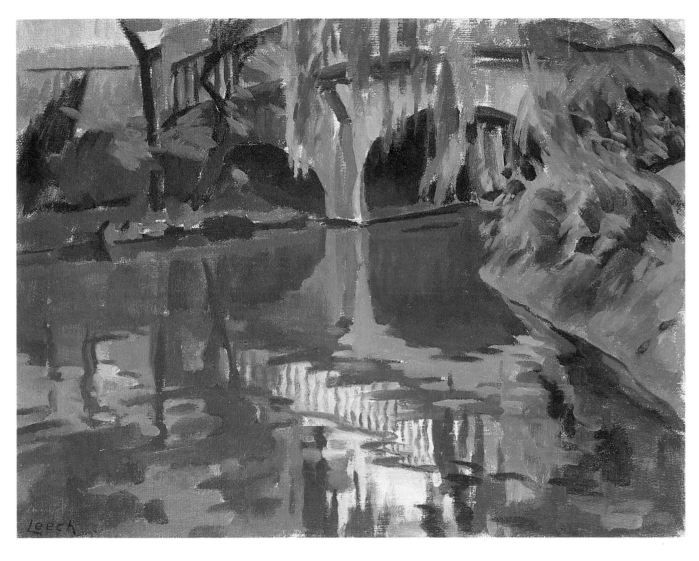

89 *The negress (model)*

Oil on canvas
69 × 64 cm; 27" × 25½"
Private collection

PROVENANCE Artist's studio to Dawson Gallery, Dublin;
to Taylor Galleries, Dublin.

EXHIBITION Dublin, Dawson Gallery, 1947 (no. 25,
£75)

When this work and cat. 90, from the same model, were exhibited at the Dawson Gallery in 1947, Paddy Glendon in *The Irish Independent* "preferred" these two works to Leech's other portraits.

Leech exchanged views with Dr Helena Wright on the complex subject of picture-making and, specifically, on his approach to drawing and painting from the nude. His ideas show the development of his work since his first standing male nude painted in Paris in 1901. In 1936 they were both drawing from the nude. Leech had made intimate, simplified, Fauve-like studies of May that were never exhibited but which culminated in the large reclining *Nude* painted in the early 1930s (cat. 61). He regarded the study of the figure as "the closest search for beauty" and he communicated this to his friend Helena: "I hear that you have been drawing from the nude and hope some day soon to be allowed to see the drawings – when people start drawing from the figure they are serious, have you discovered lots of hidden things? and lovely things, such as that a woman standing seems to grow from the ground in a most perfect way, with a line and balance that no plant ever achieved, I am doing these things with my 'black' model, one of which I may finish to-day, a head, the other two are nudes – not really finished yet. In our search for beauty, I sometimes think, we have a better chance of getting near it, with the figure than in any other way, who knows."

In cat. 89 the model sits clothed, looking pensively to her left, her hands clasped. Leech also painted the head and shoulders of this model in

South American woman (private collection), clothed in a red sweater, leaning with one arm over the back of a chair, while gazing languidly out to the right of the picture. This seems to have been the work which was priced £42 and shown at the RHA in 1937.

90 *The refugee*

Oil on canvas
86.5 × 68.5 cm; 34" × 27"
Signed lower right *Leech*
Private collection

EXHIBITION RHA, 1947 (*Nude*, no. 13, £150); Dublin,
Dawson Gallery, 1947

LITERATURE Denson 1968, no. 28 (*Female nude study*)

The refugee sits with her head in her right hand and her left hand leaning over her knees; the yellow artificial light shines on her hand, her upturned face and knees. Leech simplifies the background to focus attention on the model's softly toned brown skin. He included this painting in a small group he sent to Leo Smith of the Dawson Gallery in 1947, and he wrote a covering letter: "I could send more, but these are all very good and would make a most interesting show. I would like to send you that nude of the Black woman, it is so well painted. It ought to be in the Nat. Gallery instead of the 'blownup watercolour'. I wonder could an exchange be made?" Leech is referring to his *A convent garden, Brittany* (cat. 37), which is an indication of how he regarded the change in his painting style and subject-matter. He also wanted to have *Un matin* (cat. 50) back to repaint it, because of the deterioration of the zinc white. Artists are not always the best judges of their own work, frequently regarding their latest work as their best.

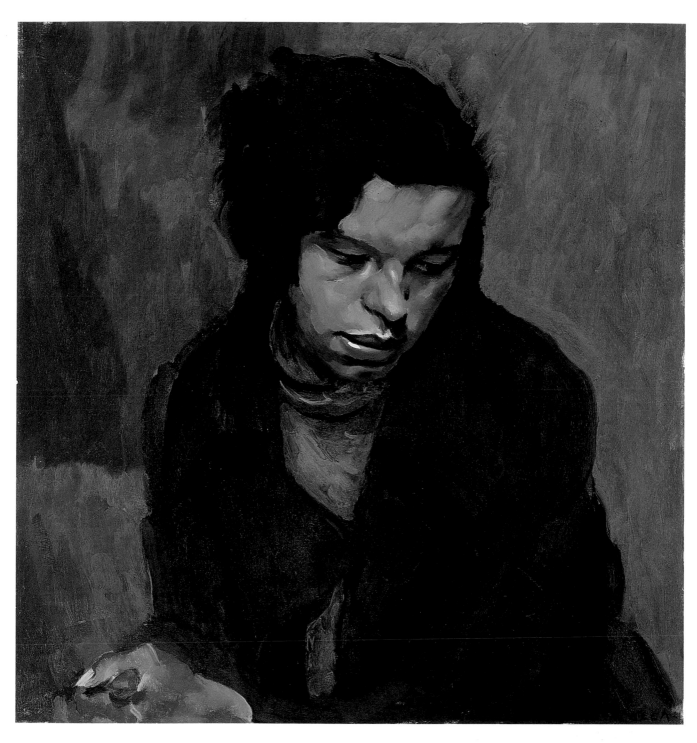

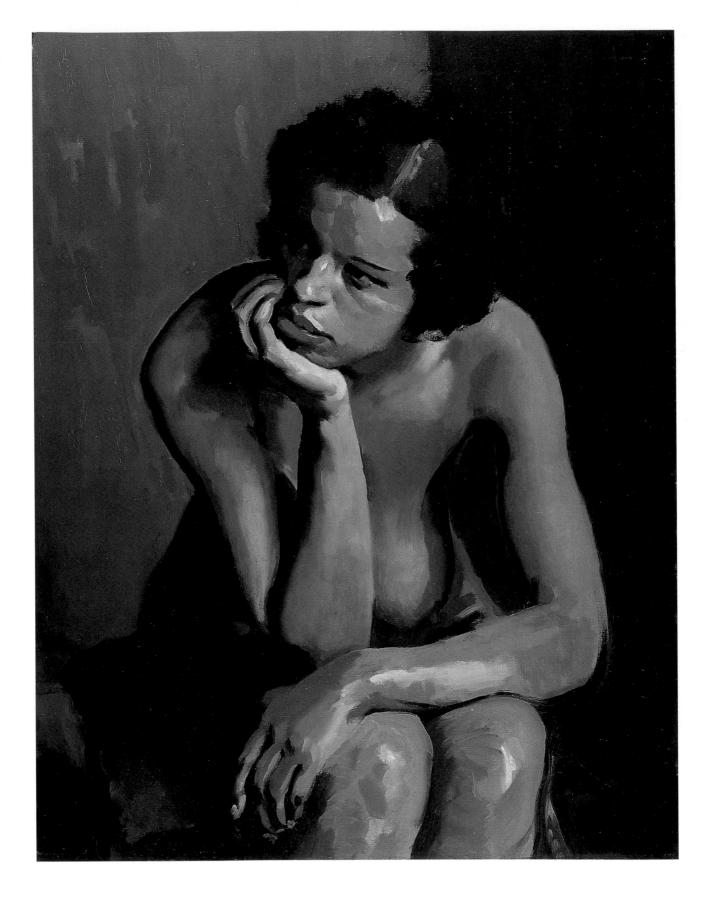

91 *Portrait of Mrs Huxley Roller*

Oil on canvas
63 × 53 cm; 25" × 21"
Signed lower right *Leech*
Ita and Michael Carroll, Dalkey

PROVENANCE Purchased Taylor Gallery, Dublin, 1984,
£2500

EXHIBITIONS RHA, 1937 (no. 45, £42); Bourlet records,
30.8.1950: brought in, oil on canvas, 26" × 22"

Among May Botterell's close friends and neighbours
at Abbey Road was Mrs Huxley Roller, whose por-
traits (cats. 91 and 92) Leech painted in 1937. She
was the aunt of Aldous Huxley, who had published
Brave New World in 1932. She herself was a cap-
able artist, working mainly in pastels, and showed
her paintings at the Royal Academy. In this portrait
Leech captures her as she sits beside the window
with her head in her hand, looking meditatively out
to the left of the picture. The full light from the win-
dow falls on her head and hand and her coat. The
soft skin-tones harmonize with the earth-tones of
her coat, the orange shades of her blouse and the
blue and purple of the radiator.

92 *Courage*

Oil on canvas
61 × 51 cm; 24" × 20"
On verso, Bourlet label F 3190 & 1795
The picture has been waxed. It has a French canvas with
stamp, Toiles et Coloeurs, Extra Fines, Lucien Lefebvre
Foinet, Paris, 19, Rue Vaven & Rue Brea
Private collection

Here Leech has painted a more vivid portrait of Mrs
Huxley Roller that of cat. 91, with auburn-toned hair
adorned with a green laurel wreath, echoing the
green of her cardigan. Leech entitled this painting
Courage but Mrs Huxley Roller was not happy with
the painting, because she thought it made her look
like a gypsy. The portraits Leech painted of his
friends have the informality and free painting
approach of Augustus John in *Miss Iris Tree* (Dublin,
Hugh Lane Municipal Gallery of Modern Art). Gone
are the formal portraits, instead friends are painted
in the glow of artificial light.

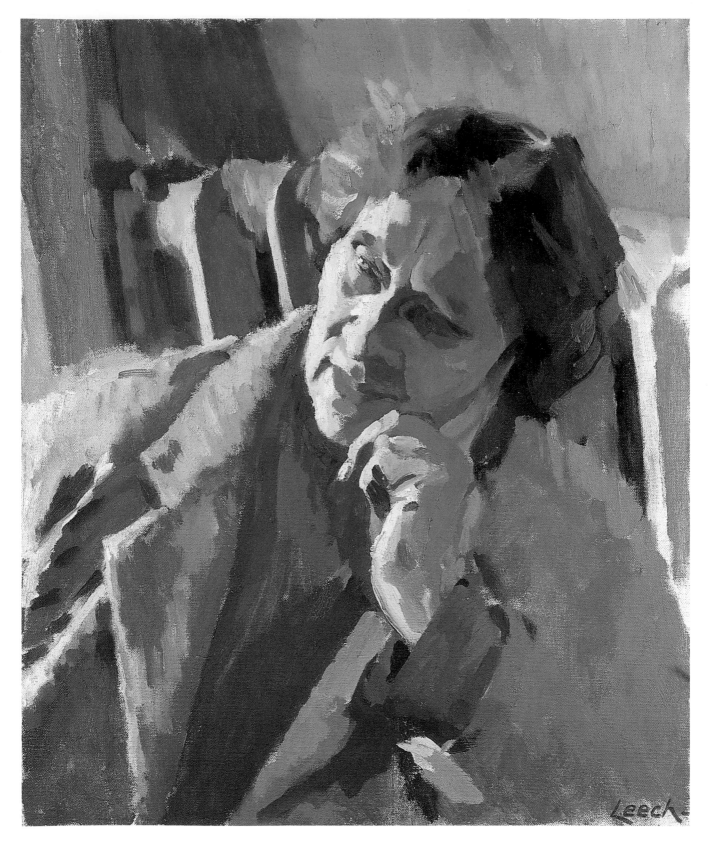

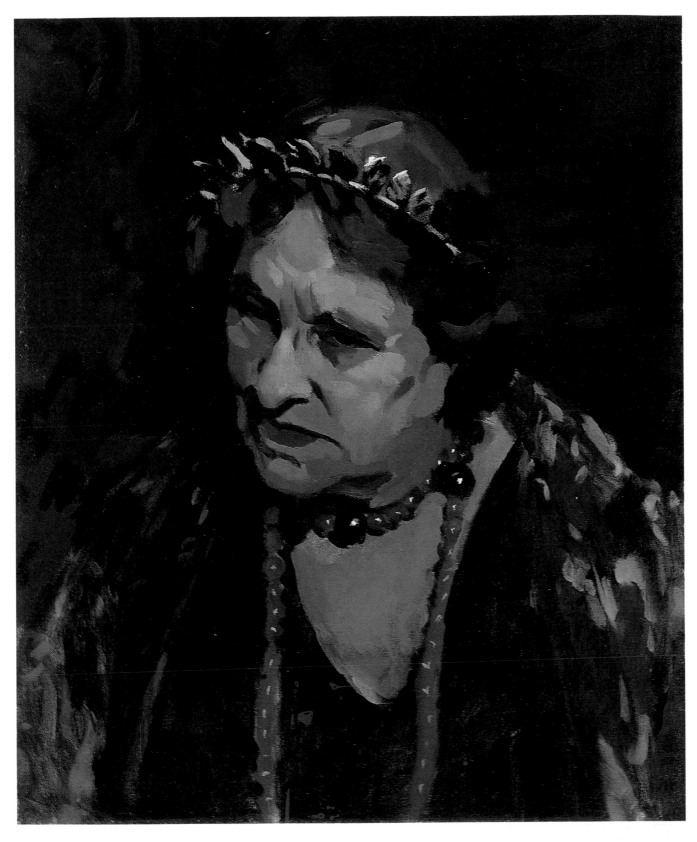

93 Portrait of Hanni Davey

Oil on canvas
66 × 81.3 cm; 26" × 32"
Signed lower left *Leech*
On verso, waxed Bourlet label A 33293. Old frame with labels: *No. 1 Johanna, Steele's Studios* and *1. Woman Sewing. No1 York Bridge Regents Park, 20 Abbey Road*

VERSO

Picture of Leech's South American model (see cats. 89 and 90) which has been painted out, except for the head

Private collection

Leech had painted a portrait of Hector Davey, a civil servant who worked for the Board of Works, in 1934, before he met and married Hanni, who had come to London from Switzerland. It is a serious study of a preoccupied young man, sitting with his

Fig. 85 William John Leech, *Portrait of Jan Thompson*, oil on canvas, 73 × 61.3 cm, private collection

hands gently clasped in front of him. Leech's paint handling is free and fluid in the highlights of the sensitive face, long nose and high forehead and the whiteness of the collar. When Hector and Hanni married in 1937, Leech painted her portrait in the flat at no. 20, Abbey Road. He later gave it to her in the late 1950s or early 1960s. She sits wearing a brightly striped dress, the material bought in Galerie Lafayette and the dress made by her aunt. It is a gentle portrait of a pretty young woman full of radiant happiness, and it exudes the cosiness and privacy of the world of May and Bill and their simple lifestyle which they shared with a few close friends. She is painted by electric light which falls on her neck and her folded hands, which gently hold the knitting she has been working on. The portrait took six months to complete, with three sittings each week. The couple remained close friends of Bill and May through the War, and in 1946, after an unusually dark, cloudy, cold summer, during which Leech "had to paint indoors all the time", Bill and May went to house-sit for the Daveys when they were away in Switzerland for three weeks. "Billy got two pictures painted from the windows" in their house near Hampton Court.

The portrait of Hector Davey has a similar palette and is painted in a similar light as Leech's portrait of his friend Sydney Thompson (fig. 47, p. 74). This was probably painted in December 1933, when Thompson, his wife Ethel, daughters Annette and Mary and son Jan arrived in London *en route* to New Zealand. After Christmas, when the Thompson family departed, their son Jan remained in England to complete his education. He stayed in England all his life and became a constant friend of Bill and May. The following March, 1934, Leech also painted a portrait of Jan (fig. 85) who was then in his early twenties. Leech exhibited the portraits of Jan and of Sidney at the RHA in 1936, priced £42 and £78.15*s*. respectively.

94 Darning

Oil on canvas
73 × 60 cm; 28¾" × 23½"
Signed lower left *Leech*
National Gallery of Ireland

PROVENANCE Dr R.I. Best Bequest, 1959

EXHIBITIONS Derby, Autumn Exhibition, 1933 (no. 88, £36. 15s.)?; RHA, 1946 (no. 49, £73. 10s.)?; Dublin, Dawson Gallery, 1951 (*Mending*, no. 30, £40)?

Life in no. 20, Abbey Road was quiet: May sat and knitted or sewed, while Leech painted, and they had become a typically settled couple who were devoted to each other. The intimacy of this life becomes evident in Leech's painting, and his subject-matter becomes more immediate and specific to his surroundings. Leech embarked upon a series of paintings of May reading and sewing. Titles like *Sewing*, *Darning* and *Mending* depict May sewing either in Abbey Road or in Steele's Studios, differentiated by the style of the window and the glimpse of the garden outside. It was usual for May, after Leech had rented no. 4, Steele's Studios in 1928, to come and clean or cook and spend her day there occupied with simple domestic chores, although she had been long accustomed to having her own serving staff and a rich social life. Usually May is viewed from behind, her right hand captured in the characteristic position of someone holding a sewing-needle. The debt to Degas is obvious in the focus on the sitter's back seen from an elevated angle. The light changes in these gentle genre paintings from the warm sunshine of midday to cooler tones of blue and green of an evening light. The paintings depict May gradually ageing as light dapples the surface of the side of her head. The first of these studies of May, *Darning* (cat. 94), was probably exhibited at the Autumn Exhibition in Derby in 1933 and *Sewing* (whereabouts uncertain) was exhibited at the RHA in 1935.

95 Portrait study

Oil on canvas
81.3 × 66 cm; 32" × 26"
Signed lower left *Leech*
On verso, waxed Bourlet label 1926
Private collection

EXHIBITION RHA, 1949 (*Sewing*, no. 49, £73. 10s.)

Portrait study belongs to the series of May sewing and depicts her sitting engrossed as she delicately sews beside the light of a window. Painted in Abbey Road in the late 1940s, this is a gentle study of May when she was in her sixties. The daisies thrusting in at the bottom of the painting – beside her hands which hold her sewing – take up the mauve tones used throughout the picture. These daisies Leech develops into a separate flower study on a window-sill, *Daisies* (private collection), as he did with *Chrysanthemums* (cat. 97) from the small inclusion in *Through this window* (fig. 56).

96 Au cinquième

Oil on canvas
75 × 60 cm; 29½" × 23½"
Signed lower right *Leech*
National Gallery of Ireland

PROVENANCE Dawson Gallery, Dublin; purchased 1969

EXHIBITION RHA, 1948 (*Reading by the Window*, no. 148, £135)?

Au cinquième (On the fifth [floor]) is a gentle study of May Botterell, reading beside the window inside no. 20, Abbey Road. Leech painted her frequently, in a series of paintings, as she sat reading at the window. The final painting, entitled *May Leech on the fifth floor*, Leech exhibited at the RHA in 1964 to commemorate her death earlier that year and to pay public tribute to her, and for the first time to give her married name in the title of a work. He was very pleased with his work, and he wrote to Leo Smith expressing his disappointment at not having received any critical mention.

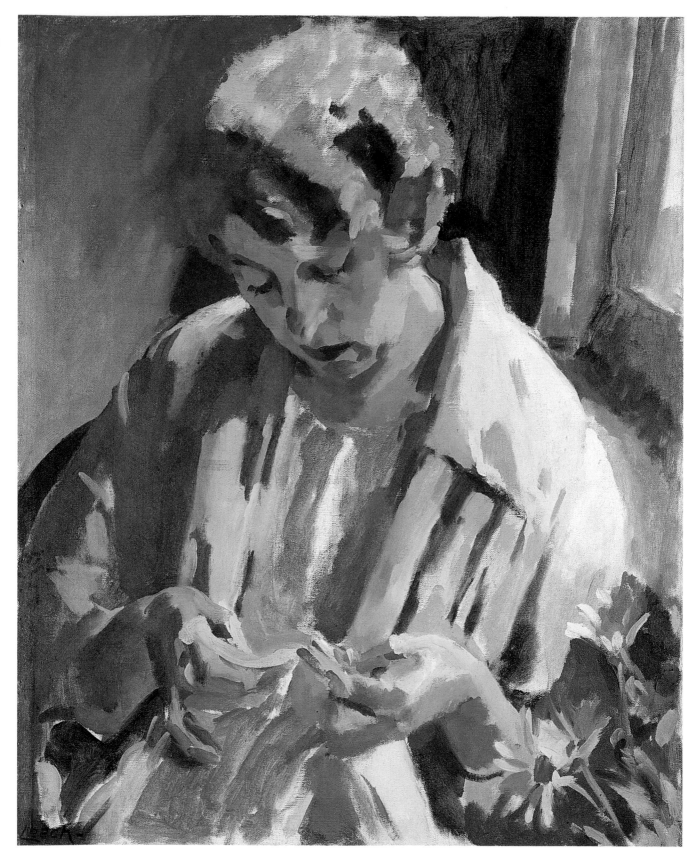

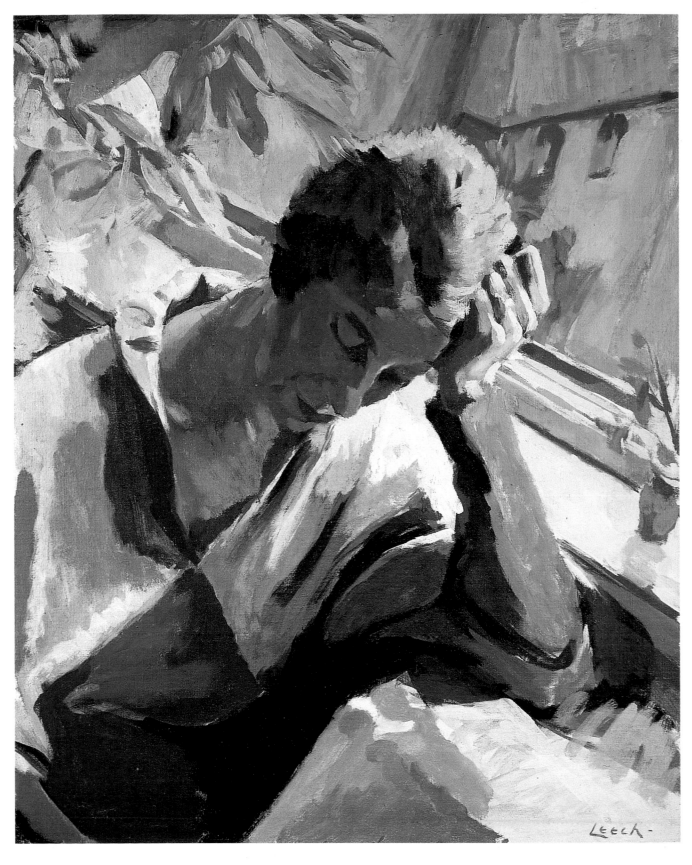

97 Chrysanthemums

Oil on canvas
56 × 45.5 cm; 22" × 18"
Signed lower left *Leech*
AIB Art Collection

PROVENANCE Dawson Gallery, Dublin; Carol Mullan; purchased from Carol Mullan, September 1982

LITERATURE *The Allied Irish Bank Collection*, 1986, p. 27

The vase of flowers to one side of *Through this window* (fig. 56, p. 88) becomes the focus of *Chrysanthemums* (cat. 97). Leech has rendered a harmonious painting in mauves and pinks from a simple window-sill arrangement, beyond which the bare trees are glimpsed in the early morning light. Leech captures the beauty of the chrysanthemum heads, losing none of their botanical properties, yet softening edges against reflections in the pane. Leech's characteristic diagonal in the window-sill, seen from a high viewpoint, is checked by the truncated bowl with two eggs, chosen for their rounded white forms.

98 Window early morning

Oil on canvas
61 × 51 cm; 24" × 20"
Signed lower left *Leech*
Private collection

PROVENANCE Adams, Dublin

EXHIBITION Dublin, Dawson Gallery, May–June 1947 (no. 17, £57. 10s.)

The dramatic diagonal of the window-sill focusses attention on the sill and its bowl of flowers bathing in the white light of the early morning. The garden outside, painted in partial shade, is captured through the glass of the closed window. The first flicker of the sun's rays begins to seep through the panes and change the eerie light of the moon to the early dawn light. The window appears again to be that of no. 20, Abbey Road, and we can only surmise that Leech suffered from insomnia, like May Botterell, or that he intentionally got up to capture the light, as he had done frequently in his youth in Concarneau.

99 Woman by a window

Oil on canvas
66 × 53 cm; 26" × 20"
Signed lower right *Leech*
Maire and Maurice Foley

PROVENANCE Taylor de Vere, Dublin, sale, 10 August 1989

Leech had continued to paint Suzanne Botterell from her first portrait in *ca.* 1920 (cat. 47) and continued to sketch her, as in the pencil sketch (Collection Kelly's Hotel, Rosslare) made when she was about twenty, with fine aquiline features, blue eyes and blond hair. *Woman by a window* is apparently a painting of Suzanne in her late twenties or early thirties. The charcoal drawing for the oil realistically captures the bored pose of this young woman. Leech repeats the method he employed in painting the Revd Charles Cox, by making an initial drawing in charcoal (fig. 46, p. 73) before proceeding to a much more detailed portrait in oils. In the drawing, a few deft strokes indicate the pattern of Suzanne's dress and the curl of her short hair. The final work is more dramatic in its composition, with what appears to be a window-sill in Abbey Road bathed in strong light and forming a diagonal at the top of the painting. Except for the edge of green and the red highlights in Suzanne's hair, the colours are subdued and the portrait study does not do justice to this lovely young woman, but by then her relationship with Leech had become strained.

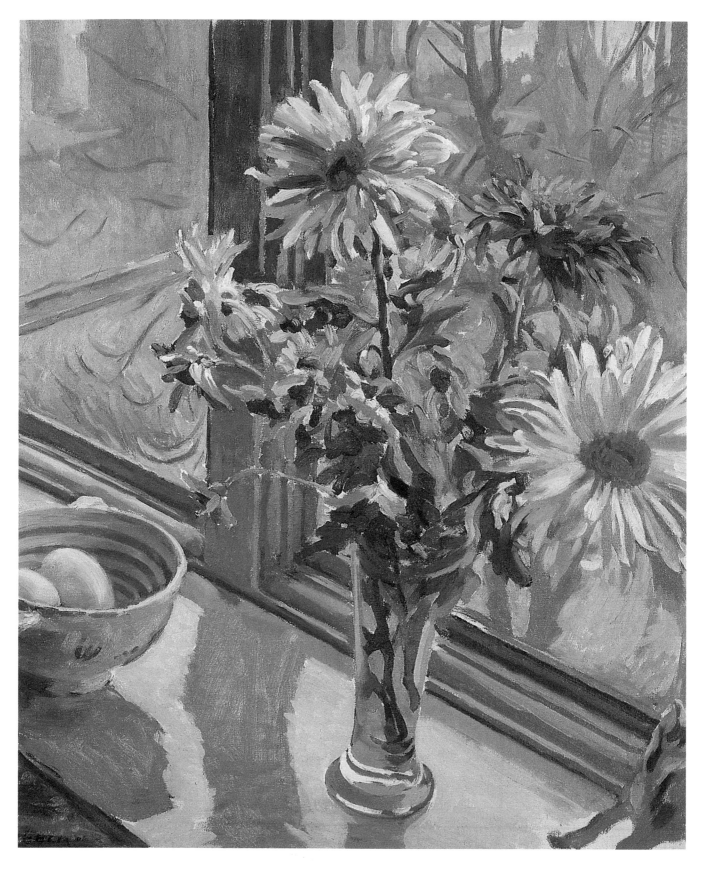

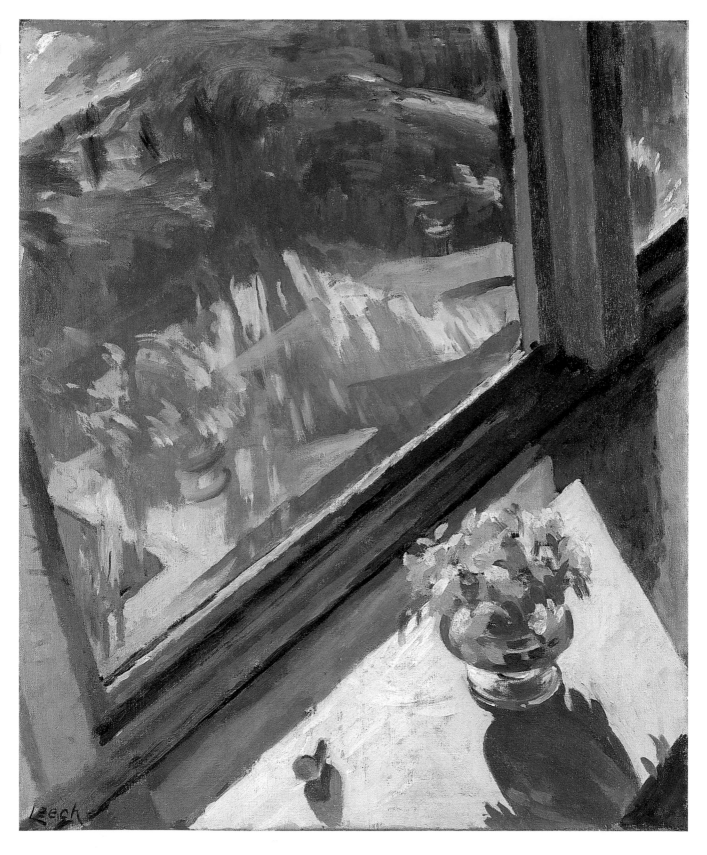

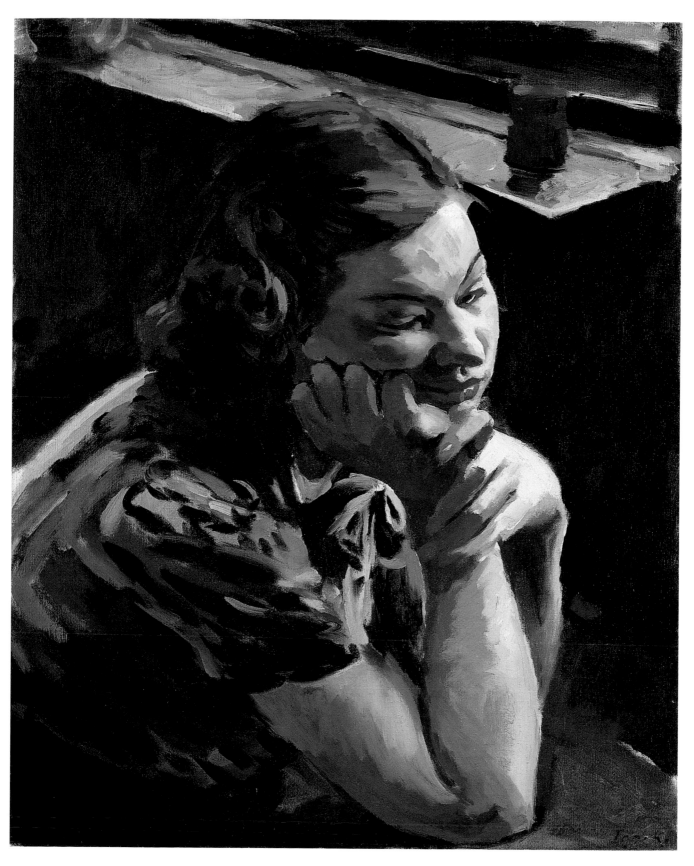

100 London Bridge and Southwark Cathedral

Oil on canvas
43.2 × 35.5 cm; 17" × 14"
Signed lower right *Leech*
On verso, inscribed *William J. Leech. R.H.A.*
Private collection

EXHIBITION Dublin, Dawson Gallery, March 1947

Leech exhibited five paintings of the Thames around Billingsgate at the 1939 RHA exhibition, but, judging from the prices, these were watercolour studies. A larger oil, *London Bridge and Southwark Cathedral* (private collection), in muted umbers and viridian blues, is a freely painted study composition. This is probably the first painting in the series and, as in the case of the *Aloes*, Leech begins with a closely observed study from nature before he gradually abstracts elements from the subject-matter. In *London Bridge and Southwark Cathedral* (cat. 100) the curve of the dock forms a lead-in to the expanse of cold water beyond which small wooden boats are moored at the harbour. The pier's wooden uprights offset the dominant horizontal of the bridge beyond. The swell of the icy water is captured in strong brushstrokes in tones of blue. These works are evocative of Monet's views of Westminster, seen in muted tones and captured in an atmospheric light.

The Billingsgate series also included *London Bridge* (private collection) which is painted in the silvery light of morning, and in which the arches of the bridge focus interest on the quayside where boats and ships are waiting to be unloaded. *London Bridge from Billingsgate* (private collection) is a vertical composition with the hoist-rigging of the docks in the foreground and London Bridge forming a high horizon-line in the background. The tones of colour range from umbers through to grey blues. *Billingsgate harbour* (private collection) was bought directly from Leech at Steele's Studios for £10; this work emphasizes a viewpoint where the

rigging, creating a vertical to the left, leaves the dockside exposed and allows a view of a boat coming in to dock. The subdued red of the hull of the ship is the only colour introduced among all the tonality of greys. *Billingsgate shipping – autumn* (private collection) focusses on a ship in harbour, with a tugboat alongside. It is viewed from below and the waves in the foreground appear to lap over the edge of the painting. The simplified form of the ship's hull and the sparse details are reminiscent of Derain's harbour-scenes or, subsequently, Leech's own paintings of *The port, Nice* (cat. 71) but without the bright colours of the South of France.

101 St Paul's – 1945

Oil on canvas
45 × 37 cm; 18" × 14½"
Signed lower right *Leech*
The Corporation of Drogheda

PROVENANCE Dr R.I. Best Bequest, 1959

EXHIBITION RHA, 1946 (no. 12, £31. 10s.)

St Paul's is painted in tones of grey and blue and shows the dome of the church dominant against the winter sky. In the foreground, Leech has painted the ruins and rubble of bombed buildings in a painterly manner, with none of the horror and devastation conveyed by such as Paul Nash, who was appointed a War Artist in both World Wars, though there is a similarity of paint handling and in the use of soft harmonies in both artists' work.

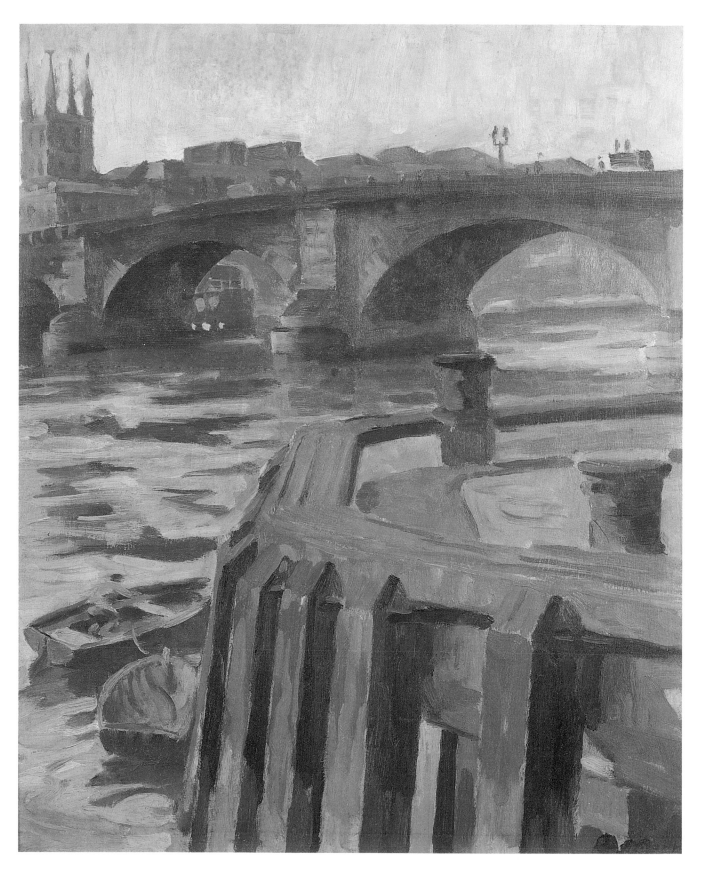

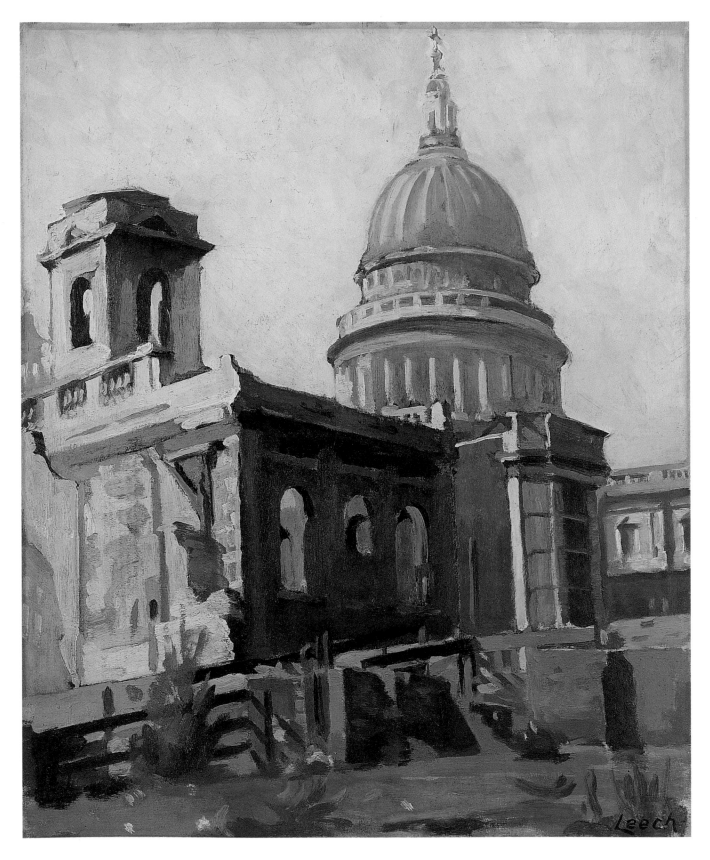

102 *The Lady Chapel, Christchurch Priory*

Oil on canvas
49.5 × 59.7 cm; 19½" × 23½"
Signed lower left *Leech*

VERSO

The Lady Chapel, Christchurch Priory

Private collection

PROVENANCE Dawson Gallery; to present owners

EXHIBITION RHA, 1949 (no. 131, £85, *The Lady Chapel*); Dublin, Dawson Gallery, 1950 (no. 10); Bourlet records: Brought in 1950. W.J. Leech. R.H.A. 20 Abbey Road, London NW8. Dublin, 262. 'The Convent Wall, Christchurch'. Oil on Panel 35.5cm × 25.4cm.

103 *The Norman colonnade, Christchurch Priory*

Oil on canvas
51 × 61 cm; 20" × 24"
Signed lower right *Leech*
Private collection

PROVENANCE Dawson Gallery, Dublin

EXHIBITION RHA, 1949 (no. 184, £85)

LITERATURE Denson 1969

These two paintings are probably *The Lady Chapel, Christchurch Priory* (cat. 102) and *The Norman colonnade, Christchurch Priory* (cat. 103) which Leech exhibited at the RHA in 1949. The latter is a sunlit study of headstones in a peaceful graveyard. They stand in front of the solid Romanesque priory whose pattern of columns and arches is repeated along the façade. *The Lady Chapel, Christchurch Priory* is an 'interior' of the church which glows in the reflected light from the stained glass. A dramatic diagonal is formed by the church seats, and emphasized by the bright shaft of light which floods in from the right lightening the altar and floor of the church.

Churches and cemeteries fascinated Leech as subject-matter for painting. He had painted *La Cimetière de St-Jeannet* (cat. 66) *ca.* 1927 and he had painted *The Church, Thorton Le Dale, Yorkshire* (private collection) during the War, in 1944. Since he now was unable to go to France each year to paint because of the War, increasing age and a shortage of money, the South of England must do him as a substitute. "There is quite a lot of sunshine here, it must be one of the sunniest places in England, and there are boats & water, though the boats are really yachts." Not only did he paint the priory church but he also painted the River Stour at Christchurch, as it flowed down to the sea at Harwich from the Gog Magog Hills.

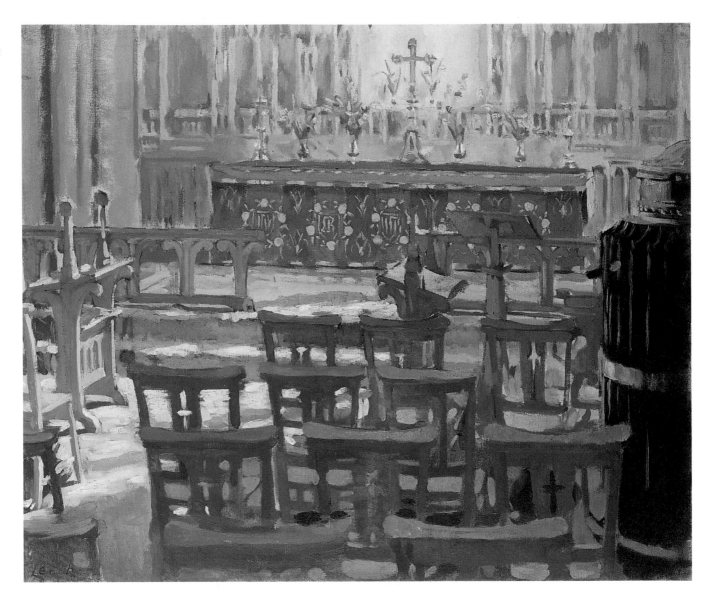

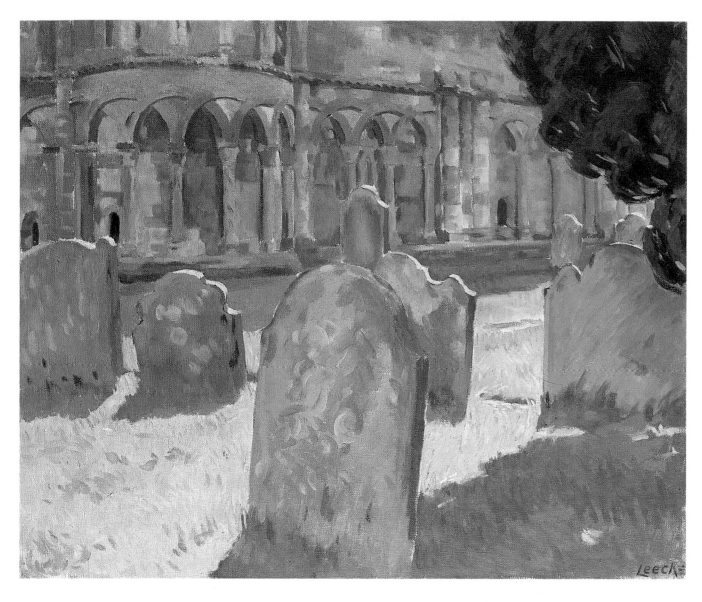

104 *The studio garden*

Oil on canvas
78 × 67.5 cm; 31" × 26"
Signed lower left *Leech*
AIB Art Collection

PROVENANCE Artist's studio; Dawson Gallery, Dublin;
Taylor Galleries, Dublin

EXHIBITION RHA, 1964 (no. 88, £95)

LITERATURE Denson 1968, no. 9; *The Allied Irish Bank
Collection*, 1986

Studio garden is aglow with sunlight falling on the grass and on the white shirts on the washing-line held by a thin tree-trunk. The white studio built beside the house is in the right-hand corner of the picture while, beyond, a neighbour's house can be seen through the distant trees. In this work nothing is diminished by Leech's advanced years. The study for *Studio garden* (private collection) is a very freely painted view of a clothes-line dancing as white and coloured shapes against the abstracted forms of foliage behind. When painting at Burley, nearly fifteen years earlier, Leech had not allowed washing to be hung out, lest it spoil his motif. Here the clothes on the line become a focus of pattern and shadows – Leech's world is complete: his shirts and pyjamas on the line assert his presence and the studio to the left his life's dedication. Leech in his eighties captures as much light and colour in these works painted in his Surrey garden as he did in Concarneau forty years earlier. The bright pinks have now gone but the intensity of the chrome yellow remains. The sheer happiness and tranquillity of these burst from the canvas. *Studio door* (private collection) depicts the flagged stepping-stones winding through the yellow-green grass to the open studio door. The configuration of the striped deck-chair and its wooden support recurs in the grid pattern of the trelliswork at the studio door, and in the shaded area to the deck-chair's right. As in his painting *Cast shadows* (cat. 108), Leech has used dark shadows as an important element in the composition.

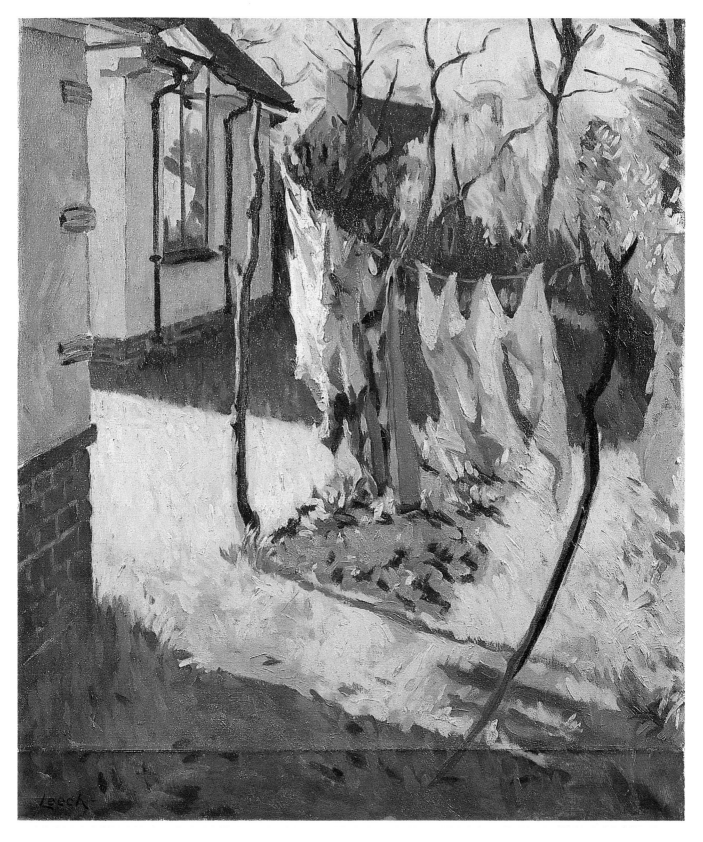

105 *Haystack and window, evening*

Oil on canvas
61 × 51 cm; 24" × 20½"
Signed lower right *Leech*
Private collection, courtesy of the Gorry Gallery, Dublin

PROVENANCE Dawson Gallery; Gorry Gallery, Dublin

EXHIBITIONS Dublin, Oireachtas exhibition, 1945
(*Fuinneog tige feirme* [Farmhouse window]); Dublin, RHA,
1948 (no. 68, £95); Dawson Gallery, 1953 (no. 8); Dublin,
Gorry Gallery, 1–4 May 1987

LITERATURE Dublin, Gorry Gallery, exhib. cat., 1–14
May 1987, ill. no. 4, colour

Haystack and window, evening is a view out of a
window on to a farmyard scene with chickens
pecking down below beside a golden haystack in
the background. The blue tinted lace curtains at the
window frame, the warmth of the scene below and

Fig. 86 William John Leech, *Haystack and window*, pencil
on paper, 66 × 53.5 cm, private collection

the diagonal of the window-bar accentuate distance
and give a dramatic compositional emphasis to the
immediate foreground. There exists an interesting
preparatory drawing of the same scene (fig. 86),
which shows Leech's careful approach to the plan-
ning of composition; little attention is given to shad-
ing areas of mass but the surface is seen as areas
of pattern held in a well organized framework.

106 *A cottage window*

Watercolour on paper
35.6 × 25.4 cm; 14" × 10"
Signed lower right *Leech*

VERSO
A cottage window

Private collection

A cottage window combines the verticality and
solidity of the window frame with the flimsiness
and pattern of the blue and white gingham curtains.
This provides a frame to carry the eye out into the
gentle landscape of fields and farmyard fencing and
epitomizes Leech's habit of painting views through
windows at this period. Leech exhibited *A cottage
window* at the Dawson Gallery exhibition, July–
August 1953. It was an oil, 30″ × 26″, nearly twice
the size of this watercolour, demonstrating how he
used this medium to provide him with information
for larger oils but at the same time producing
accomplished works which can stand alone.

107 *Woman in a garden*

Oil on canvas
23 × 18 cm; 9" × 7"
Signed lower left *Leech*
Ita and Michael Carroll, Dalkey

Leech

leech

108 Cast shadows

Oil on canvas
55.9 × 45.7 cm; 22" × 18"
Signed lower right *Leech*
Private collection

PROVENANCE Direct descent from the artist

EXHIBITION RHA, 1963 (no. 74, £65)

LITERATURE Denson 1969, no. 41, *The Kitchen*

109 The house opposite

Oil on canvas
60 × 51 cm; 23½" × 20"
Private collection

EXHIBITION RHA, 1964 (no. 3, £70)

LITERATURE Denson 1969, no. 56, *The House Opposite*

The house opposite was painted from Leech's studio at Candy Cottage; the same pattern of the panes in the window recurs in the still lifes *Cast shadows* (cat. 108) and *Still life* with Chinese lanterns (cat. 110).

110 Still life with Chinese lanterns

Oil on canvas
60 × 50.8 cm; 23½" × 20"
Signed lower right *Leech*
Private collection

PROVENANCE Bought from the artist

Still life with Chinese lanterns glows with light and colour, combining the orange shapes of the Chinese leaves with the diagonals of the studio background. The cloth recalls the tablecloth in *Quimper* (cat. 79), where there was a similar play of colours – yellows, blues and greens.

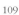

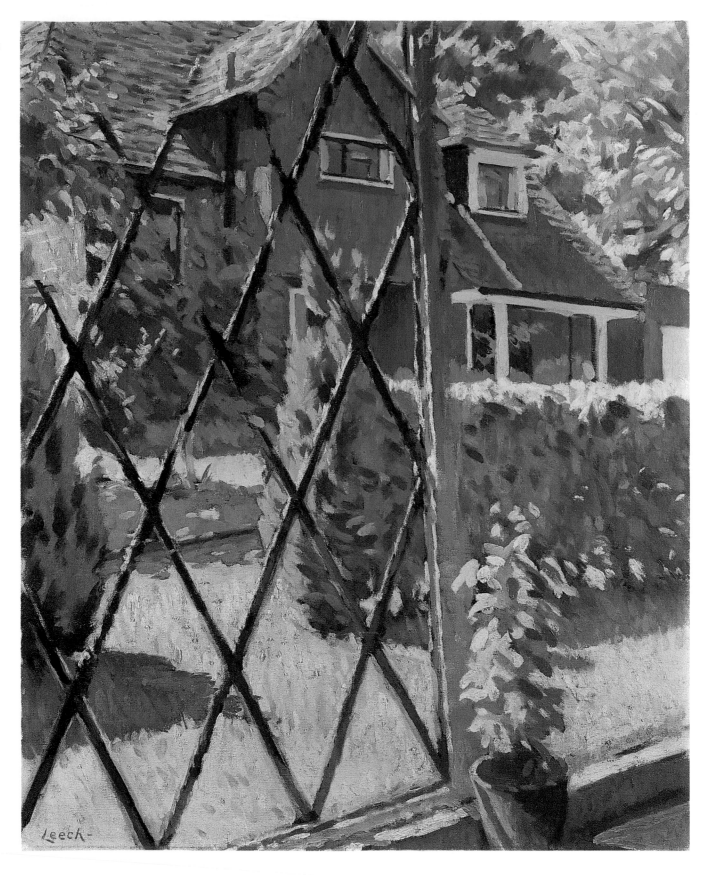

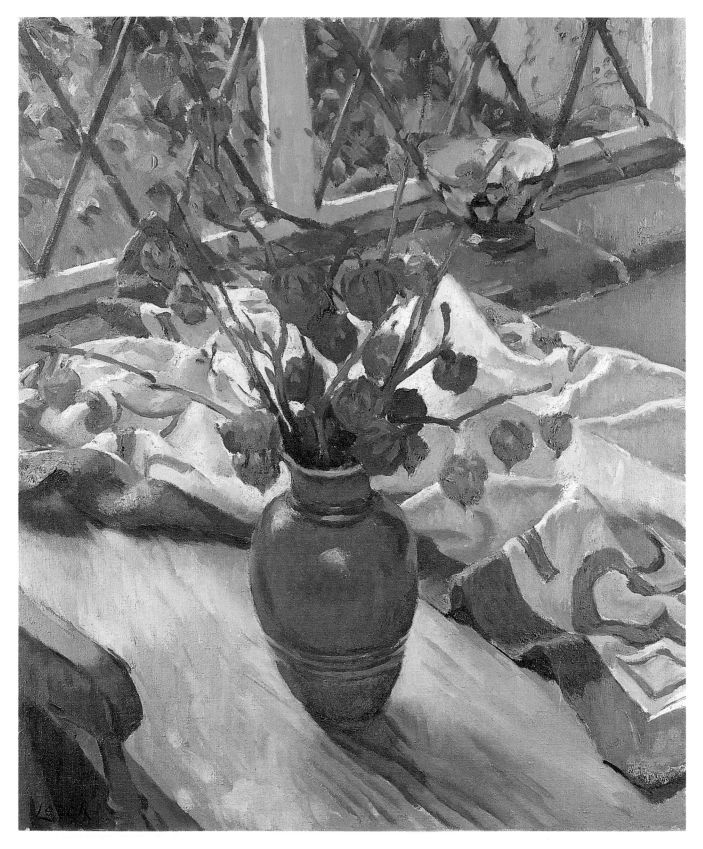

111 Self-portrait

Oil on canvas
64 × 56 cm; 25½" × 22"
Signed lower right *Leech*
National Gallery of Ireland

PROVENANCE Purchased Dawson Gallery, 1969

EXHIBITION RHA, 1967 (*Self-Portrait*, no. 130, £250)?

LITERATURE Denson 1968, no. 29, *Self-Portrait, ca.*
1965–66.

There are two *Self-portrait*s which Leech painted
in his seventies, self-consciously wearing his black
hat to cover his bald head. They are overladen with
introspection, as he gazes searchingly out of the
canvas. In one the corner of his studio, in red brick,
juxtaposed to the right, creates a discordant back-
ground. In the second portrait (cat. 111) – a later
work painted in the 1960s – Leech is seated, wear-
ing his raincoat, in front of one of the *Aloes* series
(see cats. 49–51). Light falls in from the left of the
painting, illuminating Leech's right shoulder and the
side of his face. A smaller study of this work, which
Leech gave to his housekeeper (see cat. 114), seems
to have been the last painting he was working on
before his death.

112 In the artist's garden

Oil on canvas
96.5 × 83.8 cm; 38" × 33"
Signed lower left *Leech*
On verso, inscribed *W.J. Leech R.H.A. Candy Cottage, West
Clandon, Surrey*
Private collection

EXHIBITION Dublin, RHA (*Studio garden*, no. 88, £95)

LITERATURE Denson 1969, no. 85, *The Wheelbarrow,
ca.* 1967.

Leech has painted his gardening equipment,
arranged on the lawn: the wheelbarrow to the fore
creating a strong diagonal that carries through to
the blue and red grass cutter in the background;
the handle of a spade projecting from the left,
strengthening the dynamics of the composition. The
green of the grass against the touches of red in the
handle and wheel of the lawnmower has the res-
onance of colour contrasts used in *Sylvia* (cat. 64)
and a faint echo of Matisse. Leech has painted the
effect of the dappled sunlight, which pervades this
private world, in downward feathery strokes.

113 The painter with his picture

Oil on canvas
84 × 64 cm; 33" × 24"
Signed lower right *Leech*
On verso *W.J. Leech, R.H.A., Candy Cottage W.J. Leech. Self-
portrait*
Private collection

PROVENANCE Artists's studio; Dawson Gallery; Taylor
Gallery

LITERATURE Denson 1969, no. 86, *The painter with his
picture,* 1967–68

In this *Self-portrait* Leech uses *In the artist's garden*
(cat. 112) as background, reversed, as the image
in a mirror.

114 *The housekeeper*

Oil on canvas
81.3 × 61 cm; 32" × 24"
Signed lower right *Leech*
Private collection

During the 1950s May's health caused the Leech couple concern and she had to spend long periods resting because of her heart condition. They took on a housekeeper, Mrs Mabel Mitchell, the widow of a railwayman, who lived quite near in a railway cottage beside the station at Effingham Junction. The accessibility of the railway track both to her home and to Candy Cottage made travelling easy and she kept house for them for six or seven years, going daily to Candy Cottage, with the exception of Sundays. Seen from a high vantage point, she poses sitting in a floral overall, shining a copper kettle, a harmony of creams and turquoises. She is highlighted by the sunlight coming in through the window, and the pattern of her overall, in blues and pinks, recalls the dress of *Sylvia* (cat. 64); both have more than a passing reference to Bonnard, who Leech professed to admire. The tabletop, bathed in light, diverges diagonally to the background, in a customary Leech composition, adhering to his appreciation of Degas's compositions.

115 Railway embankment

Oil on canvas
60.2 × 73.2 cm; 23³/₄" × 28³/₄"
Signed lower left *Leech*
Collection of the Ulster Museum, Belfast

PROVENANCE Donated by Mr and Mrs Z. Lewinter-Frankl, 1954

EXHIBITION RHA, 1938 (no. 72, £47. 5s.)?

116 Railway track and telegraph lines

Oil on canvas
82 × 63.5 cm; 32" × 25"
Signed lower right *Leech*
Private collection

PROVENANCE Purchased from the artist *ca.* 1945; by direct descent to the present owner

117 Etude Clandon Station

Oil on canvas
37.5 × 44.5 cm; 14³/₄" × 17¹/₂"
Signed lower right *Leech*
Private collecion

PROVENANCE Purchased from the artist; by descent to present owner

EXHIBITIONS RHA, 1959 (no. 78, £42); possibly Christie's, Castletown House sale, *Important Irish Pictures, Drawings and Watercolours*, 29 May 1980, lot 133 (*Clandon station*, 21" × 25¹/₄" (53.3 × 64.2 cm))

In *Etude Clandon Station* Leech has elongated the view up the track, towards the railway bridge, the emphasis on the light-splattered platform invoking Concarneau market places and quayside, but now with a mellow light and mature brushstrokes. He painted a related *Clandon Station* (private collection), possibly a later work, with a slightly greater finish and balanced composition. The gentleness of *Etude Clandon Station* is apparent in comparison with the harder edges of *The railway embankment* (cat. 115), showing railway track with the accentuated horizontality of the telegraph poles and the fence running alongside. Leech finds here the pattern and light common to his other subjects, but with the track providing an additional instant dramatic diagonal. People or animals are again absent from this work, allowing him to concentrate on the forms presented. A reviewer of his solo exhibition in 1951 referred to "being struck by the exquisite beauty of a picture which showed a railway cutting and the lush green of the adjoining fields under summer sunshine". The vertical format of *Railway track and telegraph lines* (cat. 116) focusses on the dramatically leaning telegraph pole with telegraph wires which lead into the distance and are balanced by the twin track of the rail below.

When visiting with the Cox family outside Wolverhampton, he rendered in watercolour the bridge *Compton and Tettenhall railway bridge* (private collection), which is full of vibrant colour, belying its utilitarian structure. When he visited Burley, in the New Forest, Leech painted *The Ringwood Line* (private collection) in which the parallel lines of the railway track swing from the right over to the left, before curving out of sight in the middle distance. When this work was exhibited at the Dawson Gallery in 1951, the reviewer in *The Irish Times* wrote: "He has even managed to make an attractive picture from a section of railway line, bordered with rubbish and lined with telegraph poles."

Author's Acknowledgements

It is fitting that the National Gallery of Ireland should present the first retrospective exhibition of W.J. Leech's works. Nearly fifty years have passed since Leo Smith exhibited thirty-five of Leech's paintings at the Dawson Gallery in 1951. A subsequently planned exhibition of Leech's paintings never materialized since Leech died tragically and suddenly on 16 July 1968. He bequeathed the entire contents of his studio to Leo Smith to enable the Dawson Gallery to exhibit his work posthumously. This bequest ensured that Leech's unsold work returned to Dublin, the city of his birth. His major works are included in the collections of the Hugh Lane Municipal Gallery of Modern Art and the National Gallery of Ireland. The scale of the exhibition is planned to enhance these known, loved and admired works and to place them in context with works which have not been publicly exhibited for many years. I am grateful to the Director of the National Gallery of Ireland, Raymond Keaveney, for inviting me to select this Leech exhibition, and to write the accompanying catalogue. I am especially grateful to Fionnuala Croke (Curator, Exhibitions) and her assistant Susan O'Connor for their enthusiasm and efficiency in organizing all aspects of the exhibition. I should also like to thank Paul Holberton and Rita Winter for their invaluable help in editing my text.

My locating and selecting Leech paintings has resulted from years of painstaking research and I should like to express my thanks to all those owners who have generously agreed to lend their paintings to this exhibition. I am especially indebted to those owners who expressed willingness to lend, but whose works are not included in the exhibition because of space constraints. However, their paintings and the information they supplied informed my text. I should also like to thank the Allied Irish Bank; Drogheda Corporation; the Crawford Art Gallery, Cork; the Butler Gallery, Kilkenny; the Hugh Lane Municipal Gallery of Modern Art, Dublin; Limerick City Art Gallery; Sligo Library and the Ulster Museum, Belfast.

Since Leech was a recluse for most of his life and wrote infrequent letters and no memoirs, few records remained with the disintegration of his studio after his death. I am, therefore, indebted to the Botterell family and to the Leech family for their support and enthusiasm for my research. Two individuals in particular, now sadly deceased, Mrs Eileen Botterell and Mrs Ellen Mabel Leech, gave me the benefit of their in depth knowledge and unstinting assistance; their families continue to assist. To Leech's nephew, Mr Cecil Cox, and Leech's niece, Mrs Sylvia Kenchington, and their families, I am also indebted. In the initial days of my research, Mrs Margaret Wallace and Mr Theo Wallace gave me generous assistance by providing unique family information.

I mention the New Zealand painter Sydney Lough Thompson frequently because, for almost seventy years, he was a close friend of the artist. This friendship and their painting trips together were well chronicled in an unpublished manuscript written by Thompson's wife, Maud Ethel, in 1952. I am very grateful to Annette Thompson and her niece, Annette, for providing me with a copy of this manuscript and for giving me the letters written by Leech to Thompson, and by May Botterell to Maud Ethel Thompson. My gratitude is also due to the Wright family, who provided me with the correspondence between their mother, Dr Barbara Wright, and the artist from the 1930s until Leech's death.

Throughout my research I have had constant support from James and Thérèse Gorry of the Gorry Gallery, Sir Robert Goff of the Cynthia O'Connor Gallery, Mary and Alan Hobart of Pyms Gallery, London, John and Pat Taylor of the Taylor Gallery, John de Vere White, Pat and Antoinette Murphy, George and Maura

McClelland, James O'Halloran of Adams Fine Art, Ib and Sonia Jorgensen of Jorgensen Fine Art, David Britten of the Frederick Gallery and Catherine Buget of the Pont-Aven Museum. Amongst the other individuals to whom I am grateful are Michael Carroll, Ciarán MacGonigal, Julie King and Anne Reihill. Helpful assistance was given by the staff of the National Library of Ireland, the Library and Department of Manuscripts in Trinity College, Dublin, the Central Library, Belfast, and my colleagues in the Ulster Museum.

In England, the staff of the British Library, the Royal Academy, the Tate Gallery archives, the Victoria and Albert Museum Library, the Museum of Fine Art, Boston, Quincy Public Library and St Louis, Missouri, Public Library gave me helpful assistance. I also wish to thank the staff in the library of the Walker Art Gallery, Liverpool, the Manchester City Art Gallery and Derby City Council, Museum and Art Gallery. I am especially grateful to Monsieur Yvon Le Floch, Galerie Gloux, to Mlle Annette Thompson, Concarneau, Brittany, to the Robert McDougall Art Gallery, Christchurch, New Zealand, and Auckland City Art Gallery, to the staff of the History of Art Department of Trinity College, Dublin, to my supervisors, former and present, Professor Anne Crookshank and Dr Philip McEvansonaya, for support and guidance. Finally, I should like to thank my husband, Brian, and my children, Emer and Oisín, for their tolerance, support and encouragement over the years spent on this research. My text has been informed by earlier books and articles written by Alan Denson on Leech and by Dr Julian Campbell's informative catalogue, *The Irish Impressionists*. Although the current exhibition is extensive, one hundred and seventeen works is a limited number. Nevertheless, my selection charts Leech's life through different locations, various motifs and diverse stylistic approaches which, hopefully, will provide a wider knowledge and greater understanding of this important Irish painter.

<div align="right">DENISE FERRAN</div>

Bibliography to the Catalogue

The Allied Irish Bank Collection, exhib. cat. by F. Ruane, Dublin, Douglas Hyde Gallery, 1986

Belbeoch, H., *Les Peintres de Concarneau*, France (Editions Palatines) 1993

Campbell, J., 'Irish Artists in France and Belgium 1850–1914', PhD diss., University of Dublin 1980

Campbell, J., *The Irish Impressionists: Irish Artists in France and Belgium 1850–1914*, exhib. cat., Dublin, National Gallery of Ireland, 1984

Campbell, J., *Nathaniel Hone the Younger*, exhib. cat., Dublin, National Gallery of Ireland, 1991

The Crawford Municipal Art Gallery (Illustrated Summary Catalogue of), by P. Murray, Cork 1992

Crookshank, A., and the Knight of Glin, *The Painters of Ireland, c1660–1920*, London (Barrie & Jenkins) 1978

Denson, A., *An Irish Artist: W.J. Leech R.H.A. (1881–1968)*, Kendal 1968

Denson, A., *W.J. Leech R.H.A., II: His Life Work*, Kendal 1969

Denson, A., *Visual Taste: Catalogue of an Author's Art Collection*, Kendal 1971

Ferran, D., *Leech: William Leech 1881–1968*, Dublin (Town House Dublin in association with the National Gallery of Ireland) 1992

Ferran, D., 'W.J. Leech's Brittany', *Irish Arts Review*, 1993, pp. 224–32

Gillespie, F., K.M. Mooney and W. Ryan, *Fifty Irish Drawings & Watercolours*, exhib. cat., Dublin, National Gallery of Ireland, 1986

Impressionism in Britain, exhib. cat. by K. McConkey, London, Barbican Art Gallery, 1995

McConkey, K., *A Free Spirit: Irish Art, 1860–1960*, London (Antique Collectors Club) 1990

Orpen and the Edwardian Era, exhib. cat., London, Pyms Gallery, 1987

Notes

Chapter One

1. See also Burke's *Landed Gentry of Ireland*, 1912 edn. only, pp. 391–92, under heading 'Leech of Clooncora'. For information on H.B. Leech (1843–1921), see *Who was Who*, XI, 1916–28.

2. *Register of Graduates of Dublin University*, I (1591–1868), Berkeley Library, Trinity College, Dublin. Details recorded are: Leech Henry Brougham. Sch. 1862. BA Hiem 1865. Entered T.C.D. 1862 as Junior Freshman. Additional information from Mr Cecil Cox, England.

3. This was the address of the Registry of Deeds until 1929, and an inscription carved in the stone over the side door is still legible.

4. *The Times*, 14 June 1886.

5. H.B. Leech, *The Continuity of the Irish Revolutionary Movement*, London and Dublin 1887.

6. Information contained in letters, exchanged in 1969, between Denis Gwynn and James White, the then Director of the National Gallery of Ireland (NGI Archives). D. Gwynn had bought it, after Leech's death in 1968, from Leo Smith of the Dawson Gallery for £50, the price accepted by Leech for the commission. Together with two of O'Brien's other grandchildren, Mrs Moorhead and Mrs Wiltshire, he presented the work to the National Gallery in 1970 as William Smith O'Brien's grandson.

7. R.B. McDowell and D.A. Webb, *Trinity College Dublin 1592–1952: An Academic History*, Cambridge (CUP) 1982.

8. W.J. Leech was known as 'Bill' to his close family and relatives. Information from his nephew, Mr Cecil Cox. He was known as 'Sir William' or 'Billy' to Sydney Thompson, evidence from letters in the collection of the author. His second wife, May Botterell, called him 'Billy', as did their close friend Dr Helena Wright, evidence from letters in the collection of the author. The Dublin painter Margaret Clarke called him 'Willie', conversation with her son David Clarke, Dublin, February 1996.

9. In conversation with Mrs 'Babs' Leech, Cecil Leech's widow, interview, Devon, England, 1988.

10. A. Denson, *W.J. Leech R.H.A. (1881–1968)*, II: *His Life Work, A Catalogue (Part 1)*, Kendal 1969, ill. in b. & w. no. 70.

11. *Thom's Dublin Street Directory*, 1907, pp. 1714–15 (National Library of Ireland, Kildare Street, Dublin).

12. *Ibid.*

13. B. Arnold, *Orpen: Mirror to an Age*, London 1981, pp. 19–21.

14. 'Cooling Galleries', *The Times*, 15 June 1927, p. 10.

15. *The Irish Times*, advertisement for Bennett & Sons, auction to be held at Yew Park, Clontarf, on 6 August 1908, p. 3. A. Bennett, Sales Index Vendors, Brougham Leech Auction held, 19 August 1908, Dublin, Card Index, Library, National Gallery of Ireland.

16. P. Wyse Jackson and N. Falkiner, *A Portrait of St. Columba's College, 1843–1993*, Dublin (Old Columban Society) 1993, p. 5.

17. For further information, *Ibid.* and G.K. White, *History of St. Columba's College, 1843–1974*, Dublin 1981. See also *Register, College of St. Columba, 1843–1993*, Dublin (Old Columban Society) 1993.

18. *The Columban*, October–November 1893, p. 1, Library of St Columba's College, Rathfarnham, Dublin.

19. *Ibid.*, May 1894, p. 2.

20. *Register of Graduates of Dublin University*, I and XI, *cit.* note 2.

21. *Register: College of St. Columba, 1843–1953*. Arthur, the eldest, went to St Columba's College, Rathfarnham, Dublin, until 1895 when he enrolled at Trinity College, Dublin. *Register of Graduates of Dublin University*, IV, *cit.* note 2. He graduated with a BA in 1899 and then proceeded to study law and obtained an LLB in 1903 and an LLD in 1904. However, he never practised law but joined the Royal Horse Artillery and became a career soldier. It is suggested that he fought in the Boer War between 1899 and 1902 but this information is difficult to justify considering the intensity of his academic career between 1895, when he first registered as a student at Trinity College, and 1904, when he was awarded an LLD. He used these qualifications effectively in his army career and this is recognized in *The Columban*: "Lieutenant A.G. Leech (1892), Royal Artillery, is one of the few army officers who hold the Degree of L.L.D. In a recent number of the Journal of the Royal Artillery he has been combining his military and legal knowledge in an article on 'The Jurisprudence of the Air'. In his opinion, nations will in future have control over a limited space of '*territorial air*', just as there is a three-mile territorial limit at sea, and you will be able to prevent belligerent airships from engaging in hostile operations while flying over neutral territory." *The Columban*, March 1911, p. 2.

22. 'University and other Honors gained in 1899–1900', *The Columban*, July 1900.

23. *Ibid.* After studying at St Columba's he went to Trinity College in 1897 where he graduated with a BA in 1901, subsequent to which he began studying medicine and

graduated in 1906 with a BAO, a BCH and MB qualifications. These were followed in 1907 with an MD.

Dr and Mrs Gibson-Black were the next-door neighbours of the Leech's in Clontarf (their home is now a hospital) and Harry married their daughter Augusta. After their marriage, Harry and his wife Augusta went to live in England and Harry practised as a doctor in Hatton Psychiatric Hospital. Here he remained until he retired in 1924 and began raising horses in Saxmunden, Kent, with his brother Arthur.

Additional personal information about Henry 'Harry' Leech gained from his nephew Mr Cecil Cox, interview, England, 1988.

24. In conversation with Mrs 'Babs' Leech, Cecil Leech's widow, interview, Devon, England, 1988.

25. *The Columban*, April 1909, p. 2.

26. This model boat was remote controlled and Leech used to race it on the lake in Regent's Park.

27. Information from Kathleen Leech's son, Mr Cecil Cox. Kathleen, W.J. Leech's only sister, married the Revd Charles Cox in 1912. He had graduated from the University of Dublin with a BA in 1909 and acquired an MA in 1913. (*Register of Graduates of Dublin University*, IV, *cit.* note 2.) As a student he played cricket for the university.

28. *The Columban*, December 1906, p. 3.

29. *Ibid.*, April 1909, p. 2.

30. A. Denson, 'W.J. Leech, R.H.A.: A Great Irish Artist, 1881–1968', *Capuchin Annual*, 1974, p. 122.

31. *Ibid.*, p. 122.

32. 'Studio Talk – Dublin', *The Studio*, October 1906–January 1907, p. 166. Leech may have rented a room in no. 7, St Stephen's Green, Dublin, since he gave this address on the back of *Interior of a café* 2 (cat. 6), although his name is not listed in *Thom's Directory* among the many other tenants. Osborne previously had a studio there and so did Jack Yeats, later on. Dermod O'Brien had "helped [Leech] to carry round some of his work to the studio" from perhaps the Metropolitan School indicating that Leech had a studio in town.

33. *The Irish Times*, 6 August 1908, p. 3, advertisement for Bennett's Auction listed furniture and contents of the house and the yard, including the horse and trap. The house has now been demolished and a block of flats built on the site.

34. *Thom's Dublin Street Directory* (1877 *et seq.*) and addresses for Leech at the RHA for 1909–10.

35. Denson, *op. cit.* note 30, p. 122.

In a codicil to the last will and testament of Henry Brougham Leech, 1 March 1921, Somerset House, The Strand, London, Brougham Leech still remembered his dead son and had kept his medal. "I leave to my third son William J Leech the gold medal awarded in 1906 to the dear boy who had gone before."

36. A tribute to Mr H. Brougham Leech, in the collection of his grandson, Mr Cecil Cox, "Like most of his generation he was a pronounced Unionist."

37. This included Dr Caleb Wallace who became Leech's doctor in West Clandon for the last ten years of his life, until 1968.

38. See Chapter 6 for further information.

39. As a result of financial ruin, caused by a disastrous investment in the film industry, H.B. Leech ended his own life. The shock of her husband's death resulted in his wife's collapse and subsequent death a few months later, in hospital in Wolverhampton. Information from Mrs 'Babs' Leech, interview, Devon, England, 1989.

40. See Chapter 7.

Chapter Two

1. Denson, *op. cit.* chap. 1 note 30, p. 119.

2. Yew Park, Clontarf, Important Sale, *The Irish Times*, 8 August 1908, p. 12. Lists painters including Cuyp and Hobbema.

3. Metropolitan School of Art, 1899–1900, *Index Register*, library of the National College of Art, Thomas Street, Dublin. Leech's address is recorded as Yew Park, Clontarf. Other students who were registered then are Lilian Davidson, seventeen years, Beatrice Elvery, seventeen years, and Estella Solomons, seventeen years.

4. J. Turpin, 'The Royal Hibernian Academy Schools and State Art Educational Policy from 1826 to National Independence', in *Martello, Royal Hibernian Academy of Arts*, special issue, edd. Geraldine Walsh and Eric Patton, Dublin 1991, p. 27. See also J. Turpin, *A School of Art in Dublin since the Eighteenth Century, a History of the National College of Art and Design*, Dublin (Gill and Macmillan) 1995.

Arnold, *op. cit.* chap. 1 note 13, pp. 29–32.

N.G. Bowe, *The Art of Beatrice Elvery, Lady Glenavy (1883–1970)*, (*Irish Arts Review Yearbook 1995* XI), Dublin 1994, p. 170.

5. J. Turpin, 'The Royal Dublin Society and its School of Art, 1849–1877', and 'The South Kensington System and the Metropolitan School of Art, 1877–1900', *Dublin Historical Record*, XXXVI, nos. 1 and 2, December 1982 and March 1983.

 Arnold, *op. cit.* chap. 1 note 13, pp. 26–28.

 N.G. Bowe, 'Women and the Arts and Crafts Revival in Ireland, c.1886–1930', *Irish Women Artists from the Eighteenth Century to the Present Day*, exhib. cat., Dublin, National Gallery of Ireland and Douglas Hyde Gallery, 1987, pp. 22–23.

 J. Sheehy, 'The Training and Professional Life of Irish Women Artists before the Twentieth Century', *ibid.*, pp. 7–11.

6. A. Crookshank and the Knight of Glin, *The Painters of Ireland c1660–1920*, London 1978, pp. 261–66. J. Turpin, 'The RHA Schools 1826–1906', *Irish Arts Review*, 1991–92, p. 206.

7. James Brenan, Address of the Headmaster of the Metropolitan School of Art in 1901, reporting on the previous year 1900, *Annual Distribution of Prizes, 1884–1915*, Royal Dublin Society Library, Dublin.

8. *The Irish Impressionists: Irish Artists in France and Belgium, 1850–1914*, exhib. cat. by J. Campbell, Dublin, National Gallery of Ireland, 1984, p. 269.

 Bowe, *op. cit.* note 4, p. 170.

 Sarah Purser's Papers, National Library of Ireland, Letters from John Hughes, January 1901. Hughes wrote to Sarah Purser telling her that Beatrice Elvery was modelling for another student. Leech was a student at the Academy School then. "... Miss Herbert is doing relief portrait of Miss Elvery. Come to the <u>school</u> some day and look at her sitting La Belle [*sic*] creatura; her neck all bare and such a neck! and the figure that <u>must</u> be attached thereto – Che bellezza! the Metropolitan School of Art, Kildare St., Dublin."

 K. McConkey, *A Free Spirit: Irish Art 1860–1960*, London 1990, Orpen's portrait of Beatrice Elvery is illustrated in colour, fig. 42, p. 55.

9. Bowe, *op. cit.* note 4, p. 171.

10. *Ibid.*

11. Arnold, *op. cit.* chap. 1 note 13, p. 24.

12. Bowe, *op. cit.* note 4, p. 170.

13. *Index Register, Metropolitan School of Art, Session 1899–1900*, in the library of the National College of Art and Design, Dublin.

14. Arnold, *op. cit.* chap. 1 note 13, p. 28.

15. *Thom's Dublin Street Directory*, 1907, p. 1875.

16. Information from St Columba's College, Rathfarnham, and from Mr Cecil Cox, Leech's nephew, England, interview 25 February 1988.

 Information from Mrs Cecil Leech, daughter-in-law, Devon, interview 28 April 1988 and 20 August 1991.

17. Records of the Metropolitan School of Art, National Library, Dublin. Science & Art Department of the committee of Council on Education Distribution of prizes, "on the 10th January 1900, at Metropolitan School of Art, Dublin by Her Excellency Countess Cadogan accompanied by Miss Farquharson of Invercauld and attended by Lord Plunkett". G.T. Plunkett was the director and Mr James Brenan RHA was the headmaster.

18. Arnold, *op. cit.* chap. 1 note 13, p. 29.

19. Letter, W.J. Leech to Leo Smith (Director of the Dawson Gallery, Dublin, and the artist's agent from the 1940s), 15 February 1967. James Brenan came from Cork School of Art as headmaster to the Metropolitan School of Art, until his retirement in 1904.

20. Arnold, *op. cit.* chap. 1 note 13, p. 32.

 Report, 1897, of the headmaster of the Metropolitan School of Art, James Brenan, which details Orpen's achievements.

21. *Ibid.*, p. 35.

22. For further information on Arthur and Harry Leech, see Chapter 1.

23. Crookshank and the Knight of Glin, *op. cit.* note 6, appendix 2.

24. Denson, *op. cit.* chap. 1 note 30, p. 119.

25. *Walter Osborne*, exhib. cat. by J. Sheehy, Dublin, National Gallery of Ireland, 1983, pp. 12 and 178 note 5.

 The Irish Impressionists, cit. note 8, p. 131 note 22 ("Osborne's name does not seem to be included in the Registers of the Metropolitan").

26. J. Turpin, 'The Royal Hibernian Academy Schools and State Art Educational Policy from 1826 to National Independence', in *Martello, Royal Hibernian Academy of Arts*, special issue, edd. Geraldine Walsh and Eric Patton, Dublin 1991, p. 26. See Turpin, *op. cit.* note 6, pp. 198–209.

27. Turpin, *op. cit.* note 4.

28. *Ibid.*, p. 25.

29. Letter from W.J. Leech to Leo Smith, dated 16 February 1967, private collection, Ireland.

30. Denson, *op. cit.* chap. 1 note 30, p. 119.

31. *Cork Examiner*, Friday, 19 July 1968, p. 10.

 Denis Gwynn was mistaken in believing that Leech went to the Slade in London.

32. R. Johnston, 'Roderic O'Conor, 1860–1940', PhD diss., Dublin, Trinity College, 1989, I, p. 45 (unpublished thesis).

 Verlat stressed to his students to "paint vigorously so that drawing and painting were fully integrated from the outset".

Walter Osborne, cit. note 25, p. 43.

33. *Ibid.*, pp. 47, 64, 66, 96.

34. *Ibid.*, p. 133.

35. *Ibid.*, pp. 50, 107, ill. in b. & w. See Ferran, 'W.J. Leech's Brittany', *Irish Arts Review*, 1993, pp. 224–32.

36. *Walter Osborne, cit.* note 25, ill. b. & w., p. 76.

 See Chapter 6, for further discussion of these paintings.

37. *Walter Osborne, cit.* note 25, pp. 129 and 149.

38. Arnold, *op. cit.* chap. 1 note 13, pp. 124–27.

39. W.J. Leech, letter to Leo Smith, dated 23 February 1967, private collection, Ireland.

40. *Walter Osborne, cit.* note 25, p. 164. On the committee was Walter Armstrong, Director of the National Gallery, who Leech knew, as well as his brother Cecil, a drama critic, whose portrait he painted.

41. Both these works were in the collection of Edward Martyn, the playwright who bequeathed them to the National Gallery of Ireland on his death in 1923. National Gallery of Ireland, *Illustrated Summary Catalogue of Drawings, Watercolours and Miniatures*, Dublin 1983, p. 87.

42. National Gallery of Ireland, *Illustrated Summary Catalogue of Paintings*, Dublin 1981, ill. no. 852, in b. & w., p. 111.

43. D. Gwynn, *Cork Examiner*, 19 July 1968, p. 10.

44. S.B. Kennedy, *Irish Art and Modernism, 1880–1950*, Institute of Irish Studies at the Queen's University of Belfast 1991, p. 6.

45. W.J. Leech's letter to Leo Smith, dated 16 February 1967, private collection, Ireland.

46. *The Irish Impressionists, cit.* note 8, p. 88.

47. Crookshank and the Knight of Glin, *op. cit.* note 6, p. 261.

48. *Walter Osborne, cit.* note 25, p. 97.

49. *Ibid.*, p. 27.

50. *Ibid.*, p. 26.

51. 'Old Columban News', *The Columban*, April 1929, p. 3.

 Nathaniel Hone the Younger, exhib. cat. by J. Campbell, Dublin, National Gallery of Ireland, 1991, p. 24.

52. *Ibid.*, p. 25.

53. *Ibid.*, pp. 14–15.

54. Leech's use of *ébauche* (rough shape or outline) is evident in his unfinished self-portraits, for example cat. 55 (verso) in which Leech is standing painting, and May is seated, watching him work.

55. *Nathaniel Hone the Younger, cit.* note 51, pp. 31–34.

56. Kennedy, *op. cit.* note 44, pp. 6–7.

57. *Nathaniel Hone the Younger, cit.* note 51, p. 59.

58. Unsigned review of Royal Hibernian Academy, Monday, 6 March 1911, p. 6. Thomas Bodkin, Hone's biographer, wrote reviews of art exhibitions at this time, many of them unsigned. There is, however, no confirmation of this review having been written by Bodkin in A. Denson's *Thomas Bodkin: A Bio-biographical Survey of his Family*, Dublin 1966.

59. See Chapter 6 for further analysis of these Post-Impressionist influences on Leech.

60. "I remember another picture of mine bought from the Academy by old Nathaniel Hone of the Quay at Concarneau, a long picture ... about the first picture I sold." Letter from W.J. Leech to Leo Smith, dated 2 November 1950, private collection, Ireland. See List of Works Exhibited in the possession of the author. See Ferran, *op. cit.* note 35, p. 228.

61. See *Whistler*, exhib. cat. by R. Dorment and M.F. MacDonald, London, Tate Gallery, 1994 for information.

62. *Ibid.*, p. 309.

63. *Ibid.*, p. 317.

64. *Nathaniel Hone the Younger, cit.* note 51, p. 11.

65. *The Irish Impressionists, cit.* note 8, pp. 56–62.

 See E. Morris and A. McKay, 'British Art Students in Paris 1814–1890', *Apollo*, February 1992, p. 78.

66. *The Irish Impressionists, cit.* note 8, p. 64.

67. C. Holland, 'Student Life in the Quartier Latin, Paris', *The Studio*, XXVII, no. 115, October 1902, p. 33.

68. *The Irish Impressionists, cit.* note 8, pp. 94–95.

69. *Ibid.*, pp. 94–95. Lennox Robinson (1886–1958), manager of the Abbey Theatre, playwright and director and biographer of *Dermod O'Brien, Palette and Plough*, Dublin 1948.

70. H. Barbara Weinberg, *The Lure of Paris: Nineteenth-Century American Painters and their French Teachers*, New York 1991, pp. 221–22.

71. *Ibid.*

72. See L.M. Fink, *American Art at the Nineteenth-Century Paris Salons*, Berkeley CA 1990, p. 133.
 See Morris and McKay, *op. cit.* note 65, p. 81.
 See Weinberg, *op. cit.* note 70, pp. 76–79 and 222.

73. Mary Lago (ed.), *William Rothenstein: Men and Memories 1872–1938*, Columbia 1978, pp. 40–41.

74. This friendship, which began in 1901, lasted until S.L. Thompson's death at Concarneau in Brittany in 1973. See *Sydney Lough Thompson: At Home and Abroad*, exhib. cat. by J. King, Christchurch (New Zealand), Robert McDougall Art Gallery, 1990, for further information.

75. Maud Ethel Thompson's eighty-four-page unpublished biography on S.L. Thompson, from his birth in Canterbury, New Zealand, in 1877, up until 1958: details provided from S.L. Thompson's letters and records and his wife's diaries; frequent mention of Leech and details as to his whereabouts throughout. Thompson married Maud Ethel Coe in Canterbury, New Zealand, in 1911. She died in 1961 in New Zealand. The manuscript was begun in 1952. See *Sydney Lough Thompson*, *cit.* note 74, pp. 40 and 104. Copy in the collection of D. Ferran. I am grateful to Mlle Annette Thompson in France and her niece Annette, in England, for making this manuscript available to me.

76. *Sydney Lough Thompson*, *cit.* note 74, p. 24.

77. Fink, *op. cit.* note 72, p. 113.
 See Weinberg, *op. cit.* note 70, p. 218.

78. Fink, *op. cit.* note 72, p. 133.

79. The register of the Académie Julian, on microfilm in the Archives de France, Paris. See Campbell, *Irish Arts Review Yearbook 1995*, II, Dublin 1994, p. 163.

80. K. McConkey, *Sir John Lavery*, Edinburgh 1993, p. 19.

81. Fink, *op. cit.* note 72, p. 125.

82. *Ibid.*, pp. 116–20.

83. Weinberg, *op. cit.* note 70, p. 258.

84. Crookshank and the Knight of Glin, *op. cit.* note 6, p. 261.
 Walter Osborne, *cit.* note 25, p. 24.

85. Weinberg, *op. cit.* note 70, p. 223.

86. *The Irish Impressionists*, *cit.* note 8, p. 65.

87. Leech, letter to Helena Wright, undated, *ca.* 1935, from no. 4, Steele's Studios, London N.W.3. "... Get a drawing board, good size, charcoal (not pencil) and good sized sheets of paper tinted or not, tinted would be less trying to the eyes. Then start to draw landscapes instead of painting it"
 Quoted in full in J. Campbell, *Irish Artists in France and Belgium, 1850–1914*, PhD diss., Dublin, Trinity College, 1980, p. 340, and in Campbell, J., 'The Convent Garden', in *Art is my Life: Tribute to James White*, ed. B. Kennedy, Dublin (NGI) 1991, pp. 36–45.

88. *Sydney Lough Thompson*, *cit.* note 74, p. 26.

89. See Campbell, 'Art Students and Lady Travellers, Irish Women Artists in France, 1870–1930', *Irish Women Artists*, *op. cit.* note 5, p. 18.
 See also *The Irish Impressionists*, *cit.* note 8, p. 17.

90. Weinberg, *op. cit.* note 70, p. 223.

91. *Sydney Lough Thompson*, *cit.* note 74, pp. 26–27.

92. W.J. Leech, letter to Leo Smith, dated 16 February 1967.

93. *Ibid.*

94. *The Irish Impressionists*, *cit.* note 8, p. 94 and p. 133 note 5.

95. Sydney Lough Thompson, *cit.* note 74, p. 25.

96. W.J. Leech, letter to Leo Smith, dated 16 February 1967.

97. Thompson, unpublished manuscript, *op. cit.* note 75, p. 2.

98. *The Irish Impressionists*, *cit.* note 8, ill. p. 111. See also Denson, *op. cit.* chap. 1 note 10, ill. 14, and *Sydney Lough Thompson*, *cit.* note 74, ill. in b. & w., p. 24. Original negative coll. D. Ferran.

99. W.J. Leech's letter to Leo Smith, 16 February 1967, private collection, Ireland.

100. C.R.W. Nevinson, *Paint and Prejudice*, London 1937, p. 34. See Chapter 8, on Steele's Studios, where Nevinson and Leech were next-door neighbours.

101. Sir John Lavery, *The Life of a Painter*, Cassell & Co. Ltd. 1940, p. 52. Quoted in *The Irish Impressionists*, *cit.* note 8, p. 65.

102. *Ibid.*, p. 51. When George Moore went to the Académie Julian in 1873, he had an allowance of £500 per year.
 Ibid., pp. 56–57. Sarah Purser went to Julian's in 1878–79 on £30, given to her by her brothers.
 Sydney Lough Thompson, *cit.* note 74, p. 21. Thompson was given £500 when he left New Zealand for Europe in 1900.
 E.H. McCormick, *The Expatriate: A Study of Frances Hodgkins*, Wellington (New Zealand) 1954, p. 69. According to the New Zealand artist Frances Hodgkins, it was possible to live then on £1 per week.

103. *The Irish Impressionists*, *cit.* note 8, p. 17.

104. Weinberg, *op. cit.* note 70, p. 223.

105. Letter from W.J. Leech to Leo Smith, dated 2 November 1950, private collection, Ireland. See Denson, *op. cit.* chap. 1 note 10, ill. in b. & w., no. 15.

106. Arnold, *op. cit.* chap. 1 note 13, p. 54, ill. in b. & w. p. 55.

107. C.R.W. Nevinson, *op. cit.* note 100, p. 15.

108. J. Benington, *Roderic O'Conor*, Dublin 1992, p. 91.

109. See McConkey, *op. cit.* note 80, pp. 20–21 for a description of how Lavery was in the practice "of faking backgrounds to his costume studies and making them into pictures which were bought by some dealer in Glasgow".

110. Leech, letter to Leo Smith, 16 February 1967.

111. *Sydney Lough Thompson*, *cit.* note 74, p. 25.

112. D.S. MacColl, *The Life, Work and Setting of Philip Wilson Steer*, London (Faber & Faber) 1945, p. 22. Wilson Steer wrote about the 'Concours' at the Académie Julian in 1900.
 See also *The Irish Impressionists*, *cit.* note 8, referring to the competitions at the Académie Julian on p. 18. See *Walter Osborne*, *cit.* note 25, p. 18. The 'Concours' was a competitive examination in composition and in drawing the figure. When Osborne was studying in Antwerp, "The highlight of the year was the Concours, in the summer, when the students competed in painting from life."

113. McConkey, *op. cit.* note 80, pp. 21–25.

114. Leech, letter to Leo Smith, 16 February 1967.

115. Sylvia Kenchington, Leech's niece, Scotland, 22 August 1988.

116. Information from P.J. Murphy, Dublin, 1985, who visited Leech in his studio at Candy Cottage.

117. Johnston, *op. cit.* note 32, I, p. 294. See Benington, *op. cit.* note 108, pp. 92–93.

118. *Sydney Lough Thompson*, *cit.* note 74, p. 47.

119. Thompson, unpublished manuscript, *op. cit.* note 75, p. 2.

120. *Sydney Lough Thompson*, *cit.* note 74, p. 27.

121. J. Rewald, *The History of Impressionism*, 4th rev. edn., New York 1973, p. 570. "Indeed when Caillebotte died in 1893, leaving his collection of sixty-five paintings to the nation, the Government received his gift with the greatest embarrassment, protest from politicans, academicians, and critics, equalling and surpassing even the insults heaped upon the painters at the occasion of their first group exhibitions. Several official artists threatened to resign from the Ecole des Beaux-Arts and Gérôme summed up the position of the Institute with the words: 'I do not know these gentlemen, and of this bequest I know only the title Does it not contain paintings by M. Monet, by M. Pissarro and others? For the Government to accept such filth, there would have to be great moral slackening' '

122. *The Irish Impressionists*, *cit.* note 8, p. 18.

123. Thompson, *op. cit.* note 75, p. 2.

124. Weinberg, *op. cit.* note 70, p. 223.

125. Cecil J. Webb, an English artist who exhibited at the London Salon from 1908 to 1909, from an address in Somerset. See J. Johnson and A. Greutzner, *Dictionary of British Art*, V: *British Artists 1880–1940*, England (Antique Collectors Club) 1990. Mrs Thompson's manuscript records that Webb was in Paris with Leech in 1911, when Thompson returned from New Zealand.

126. Leech, letter to Leo Smith, 16 February 1967.

127. *The Irish Impressionists*, *cit.* note 8, p. 56. See J. Campbell, 'Aloysius O'Kelly in Brittany', *Irish Arts Review*, 1995, pp. 81–84. See M. Cappock, 'Aloysius O'Kelly and the Illustrated London News', *Irish Arts Review*, 1995, pp. 85–90.

128. Thompson, *op. cit.* note 75, p. 3.

129. H. Potterton, 'Aloysius O'Kelly in America', *Irish Arts Review*, XII, 1995, p. 92.

130. *Sydney Lough Thompson*, *cit.* note 74, p. 34.

Chapter Three

1. Paul Gauguin, letter to Mette, 19 August 1885, in M. Malingue, *Lettres de Paul Gauguin à sa femme et à ses amis*, France 1946, p. 6.

2. *The Irish Impressionists*, *cit.* chap. 2 note 8, pp. 26, 72 and 61. See also Gweltaz Durand, 'Irish Painters in Brittany at the Turn of the Century', *CARN*, Winter 1974–75, no. 81, pp. 5–6.
 See also McConkey, *op. cit.* chap. 2 note 80, p. 90.

3. Thompson, *op. cit.* chap. 2 note 75, p. 2. An old English doctor invited S. L. Thompson to accompany him to Grez-sur-Loing for the summer, at the end of which he went to Concarneau.

4. *Post-Impressionism: Cross-Currents in European Painting*, exhib. cat., edd. J. House and M.A. Stevens, London, Royal Academy of Arts, 1979–80 for details of Salon exhibits at the turn of the century, including A. Guillou, pp. 85–86.

5. D. Delouche, *Les Peintres et le paysan Breton*, Baille 1988, p. xi.

6. Henry Blackburn, *Breton Folk: An Artistic Tour in Brittany*, London 1880, p. 3.

7. Michael Jacobs, *The Good and Simple Life: Artist Colonies in Europe and America*, Oxford (Phaidon) 1985, p. 42.

8. D. Delouche, *La Route des peintres en Cornouaille, 1850–1950*, Groupement Touristique de Cornouaille, France 1990, p. 2. (Cornouaille was the ancient name for the region, which was renamed Finistère.)

9. M.T. Cloitre-Quere, 'The Words and Colours of Brittany: 1850–1950', *ibid.*, p. 6. See also Jacobs, *op. cit.* note 7, p. 45. 'Despite improved transport in the second half of the nineteenth century, the journey from Paris to Pont-Aven was a relatively long one. The overnight train from Paris arrived in Quimper at about noon the following day. The traveller had to finish his journey in a mail coach drawn by four horses, which in 1890 did not leave Quimper until 6.24 in the evening . . . and eventually, about two hours later and after descending the very steep Touliffo hill, would arrive at the main square of Pont-Aven.'
 See also Jacobs, *op. cit.* note 7, p. 48. 'The mail coach from Quimper to Pont-Aven deposited travellers at the north-east corner of the central square, just outside the Hôtel des Voyageurs.'

10. Jacobs, *op. cit.* note 7, p. 42.

11. Delouche, *op. cit.* note 8, p. 4.

12. Armand Seguin, *Une vie de Boheme: Lettres du peintre Armand Seguin à Roderic O'Conor, 1895–1903*, edd. Catherine Puget and Caroline Boyle-Turner, intro. by Denys Sutton, Pont-Aven 1989, p. 10.

13. Jacobs, *op. cit.* note 7, p. 86.
 H. Belbeoch, *Les Peintres de Concarneau*, Quimper (Editions Palatines) 1993, pp. 17–18.

14. Armand Seguin, *op. cit.* note 12, p. 291.

15. Thompson, *op. cit.* chap. 2 note 75, p. 3.

16. *Sydney Lough Thompson, cit.* chap. 2 note 74, p. 32.

17. *Ibid.*, p. 32.

18. *Ibid.*, p. 32.

19. *Ibid.*, p. 31.

20. Leech, letter to Leo Smith, 16 February 1967, private collection, Ireland.

21. 'Studio Talk – Dublin', *The Studio*, XXXIX, November 1906, p. 166. Belbeoch, *op. cit.* note 13, p. 236 gives 1909 as the year Leech left Concarneau. Catalogue of the Royal Academy, Summer Exhibition, London 1910 gives Leech's address as Concarneau.
 See also Denson, *op. cit.* chap. 1 note 30, p. 122. See Chronology. In the Registre d'Immatriculation, Leech is registered as staying at the Hôtel des Voyageurs, owned by Monsieur Joyeau, dated 13 March 1915. Leech had an 'Autorisation de residence'. Catalogues of the RHA also list paintings, with Concarneau titles, up to 1925. Denson, *op. cit.* chap. 1 note 10, p. 112. Denson states that Leech visited Concarneau between 1925 and 1933. Thompson, *op. cit.* chap. 2 note 75, records that the Thompson family were living off and on in Concarneau from 1912 to 1923 and from 1926 to 1933, and that Leech visited them there.

22. Thompson, *op. cit.* chap. 2 note 75, p. 14. Leech's address for the Société des Artistes Français in 1913 was no. 3, rue Léopold-Robert, Paris.

23. G. Durand, *op. cit.* note 2, p. 6.

24. Jacobs, *op. cit.* note 7, p. 65.

25. *Ibid.*

26. McCormick, *op. cit.* chap. 2 note 102, p. 68.

27. Belbeoch, *op. cit.* note 13, p. 19.
 'Il (Thaddeus) s'installera à l'hôtel des Voyageurs, l'été 1881 et obtiendra même du maire de Concarneau l'usage d'une chapelle dans la Ville-Close pour lui servir d'atelier! Thaddeus était accompagné de Edward Simmons. . . .'

28. Jacobs, *op. cit.* note 7, p. 65.

29. Thompson, *op. cit.* chap. 2 note 75, pp. 2–3.

30. Catalogues of the RHA give Leech's address in 1905 as Concarneau, Finistère; in 1906 as Hôtel de France and in 1908 as Hôtel des Voyageurs.

31. Belbeoch, *op. cit.* note 13, pp. 13–14.

32. Thompson, *op. cit.* chap. 2 note 75, p. 3.

33. List of Works Exhibited in the possession of the author, no. 209, £30.

34. *Landscapes of France: Impressionism and its Rivals*, exhib. cat. by J. House, London, Hayward Gallery, 1995, p. 144.

35. *Sydney Lough Thompson, cit.* chap. 2 note 74, p. 43.

36. McConkey, *op. cit.* chap. 2 note 80, p. 90.

37. Thompson, *op. cit.* chap. 2 note 75, p. 4.

38. Walter Shaw Sparrow, *John Lavery and his Work*, London (Kegan, Paul, Trench, Trubner & Co Ltd.) 1911, p. 33. See also McConkey, *op. cit.* chap. 2 note 80, pp. 21–22; and A. Greutzner, 'Two Reactions to French Painting in Britain', in *Post-Impressionism, cit.* note 4, p. 178.

39. *The Irish Impressionists, cit.* chap. 2 note 8, p. 59.

40. McConkey, *op. cit.* chap. 2 note 80, p. 90.

41. *Ibid.*, pp. 67–82. See also *Sir John Lavery R.A., 1856–1941*, exhib. cat. by K. McConkey, the Ulster Museum and the Fine Art Society, Belfast and London, 1984, pp. 47–51.
 See also *Sydney Lough Thompson, cit.* chap. 2 note 74, p. 31, Thompson "recalled meeting the Glasgow impressionist, John Lavery, and the marine painter Julius Olsson".
 Thompson, *op. cit.* chap. 2 note 75, pp. 3–4, records that Thompson met Alfred Guillou, Théophile Deyrolle, Hirschfeld and Delobbe that summer, and later Legout-Gerard, the English painter Bulfield, Granchi-Taylor, Recknagel, Florance, the Irish man O'Kelly, the Americans Alexander Harrison and Charles Fromuth, and the Austrian painter Emmy Leuze Hirschfeld. "Already staying at the hotel [Hotel de France] is a rich American couple, M. and Mme. Haushalst from Rochester They rent a studio in Gloaguen's house, next door to Alexander Harrison's studio, and they board at the hotel. They spoil the young painters W.J. Leech and Sydney."

42. *Sydney Lough Thompson, cit.* chap. 2 note 74, p. 66, note 4. Thompson, *op. cit.* chap. 2 note 75, p. 14, records meetings with Kite and Barnes, W.J. Leech in 1911, the American Meynard, the Irish painter Katherine MacCausland, Owen Merton, Frances Hodgkins and Cora Wilding, after Thompson's return to Paris from New Zealand in 1911.

43. McConkey, *op. cit.* chap. 2 note 80, pp. 90–91.

44. Thompson, *op. cit.* chap. 2 note 75, p. 3. "Ces jeunes peintres ont beaucoup subi l'influence de la peinture tonale de Whistler. . . ."

45. *Sydney Lough Thompson, cit.* chap. 2 note 74, p. 34.

46. Thompson, *op. cit.* chap. 2 note 75, p. 5.

47. *Sir John Lavery R.A., cit.* note 41, p. 50.

48. *Ibid.*, p. 51.

49. *Sir John Lavery, cit.* note 41, p. 51. "He had first encountered his bride to be in 1904 on a trip to Brittany." Lavery details this information in *The Life of a Painter*, London (Cassell) 1940. Since Leech left few records, we cannot, as yet, date accurately Leech's meeting with Saurin Elizabeth Lane, but from the Registre d'Immatriculation dated 1915 (Appendix 13(c), in the Archives Department of L'Hôtel de Ville, Concarneau), we can deduce that it was around 1903, the same year Leech arrived in Concarneau. Elizabeth is registered as a painter. After their marriage in 1912, Elizabeth became the subject of his most important works at this period.

50. Leech married Elizabeth Kerlin, née Lane, on 5 June 1912, at Fulham Register Office. She was born on 10 January 1879, at St. Louis, Missouri (Appendix 13(c)). When she married Leech she was thirty-three years old and the divorced wife of Fentress Gordon Kerlin. Both parties gave their address as no. 55, Castletown Road, West Kensington, which was the London address of Leech's parents at that time.

51. Belbeoch, *op. cit.* note 13, p. 56.

52. Thompson, *op. cit.* chap. 2 note 75, p. 14.

53. *Irish Renascence*, exhib. cat. by A. and M. Hobart, London, Pyms Gallery, 1986, p. 42.

54. Belbeoch, *op. cit.* note 13, pp. 162–63.

55. Portrait of Madame Leuze Hirschfeld, Coll. Municipale, Hôtel de Ville, Concarneau.
 Concarneau de pas en pages, Ville de Concarneau 1987, ill. colour, fig. 41, p. 209. See also photographs of her on pp. 215 and 237.
 Delouche, *op. cit.* note 8, ill. in colour, p. 69.

56. *Sydney Lough Thompson, cit.* chap. 2 note 74, p. 50.

57. *Concarneau de pas en pages, cit.* note 55, p. xi (ill. 33).

58. Belbeoch, *op. cit.* note 13, p. 162.

59. *Ibid.*, p. 15.

60. *Ibid.*, p. 16, ill. in colour pp. 60–61.

61. Ferran, *op. cit.* chap. 2 note 35, p. 225.

62. Belbeoch, *op. cit.* note 13, p. 59.

63. *Sydney Lough Thompson, cit.* chap. 2 note 74, p. 111.

64. *Ibid.*, p. 110.

65. *The Irish Impressionists, cit.* chap. 2 note 8, p. 85.

66. *Sydney Lough Thompson, cit.* chap. 2 note 74, p. 47.

67. McCormick, *op. cit.* chap. 2 note 102, p. 32.

68. Thompson, *op. cit.* chap. 2 note 75, p. 14, referring to 1911, "Il y a a Paris, a cette epoque, des jeunes peintres de la Nouvelle Zelande: Owen Merton est masseur a l'Academie de Tudor Hart bien suivie par les etudiants americains, Frances Hodgkins qui a aussi son academie, fait des aquarelles interessantes et personnelles."

69. Leech, letter from Candy Cottage, West Clandon, to Eithne Waldron, Curator, Hugh Lane Municipal Gallery, Dublin, 27 February 1966.

70. Leech's letter to Leo Smith, 18 March 1967 (private collection, Ireland) lists where he had exhibited his paintings, including the sale of *Interior of a café* from the Paris Salon of 1914 to a gallery in Philadelphia. Extensive searches have failed to locate this painting in Philadelphia but the search is still continuing through the National Museum of American Art in Washington.

71. List of Works Exhibited in the possession of the author.

72. *Interior of a café* is not mentioned in the review in *The Times*, 20 April 1912, p. 4, col. 1.

73. Bourlet Records, Fulham Road, London. I am grateful to Mr Kevin Delaney for his giving me access to past records of the Bourlet firm.

74. Review of the Royal Hibernian Academy, *Freeman's Journal*, 31 March 1909, p. 5.

75. The Aonach Art Exhibition "which is representative of the modern school of Irish painting" (*Sinn Fein*, 18 December 1909, p. 3) was organized by the Sinn Fein Movement in 1909, as part of the much larger Aonach exhibition of Irish-made products.

76. Review of the Aonach exhibition, *Sinn Fein*, 18 December 1909, p. 3, col. 6. Leech's participation in the exhibitions at the Leinster Lecture Hall (1906–10) is discussed at length in Chapter 4.

77. This review, signed S.A.W. (possibly Samuel Wadell), was included in *Sinn Fein*, 16 October 1909, p. 1.

78. *Sydney Lough Thompson*, *cit.* chap. 2 note 74, pp. 31 and 111.

79. *Ibid.*, p. 111.

80. *The Irish Impressionists*, *cit.* chap. 2 note 8, ill. in b. & w., p. 180.

81. Benington, *op. cit.* chap. 2 note 108, p. 179 note 17.
M. Laclotte, *The Musée d'Orsay*, Paris 1986, Carolus-Duran: *La Dame au Gant*, 1869, ill. in colour, p. 74. See also *The Irish Impressionists*, *cit.* chap. 2 note 8, p. 141.

82. Benington, *op. cit.* chap. 2 note 108, p. 51.

83. Kennedy, *op. cit.* chap. 2 note 44, p. 9.

84. *Sir John Lavery*, *cit.* note 41, p. 54.

85. *Post-Impressionism*, *cit.* note 4, p. 216.

Chapter Four

1. Riccardo Leech was Brougham Leech's sister, a school teacher, who lived in Dublin. Dorothy Day and Roddice Day were friends of Kathleen Leech. They lived at no. 1, Clyde Road, Ballsbridge, and they also went to the RHA exhibitions and commented on the works on display.

2. List of Works Exhibited in the possession of the author.

3. List of Works Exhibited in the possession of the author. Background information about the sitter has, as yet, not been unearthed.

4. Crookshank and the Knight of Glin, *op. cit.* chap. 2 note 6, p. 266.

5. Arnold, *op. cit.* chap. 1 note 13, appendix B.

6. Denis Gwynn, obituary on Leech, 'A Great Artist', *The Cork Examiner*, Friday, 19 July 1968, p. 10, col. 5. See also *Walter Osborne*, *cit.* chap. 2 note 25, ill. p. 259.

7. Brougham Leech paid his son William £50 for each portrait. In 1914, Arthur, as a major in the Royal Horse Artillery, acted as the official interpreter between the French and the British. He was awarded the Cœur du Guerre and the DSO. He fought in the third battle of Ypres and was second in command of the French army at Salonika. He was gassed and returned to his sister Kathleen's home at Tettenhall Wood to recuperate.

8. [Thomas Bodkin], *Freeman's Journal*, Wednesday, 31 March 1909, p. 55. RHA Catalogue 1909 lists nos. 17 and 31 as *Portrait of Lieut. A.G. Leech, Royal Horse Artillery* and *Portrait of Lieut. C.J.F. Leech, Royal Field Artillery*.

9. D. O'Brien, letter to Mabel, his wife, from Kildare Street Club, 21 January 1910. Letters in a private collection, Dublin, and being collated and researched by Mrs Anne Stewart, Ulster Museum, Belfast.

10. Information from Mrs Cecil Leech (Babs), Leech's sister-in-law, England, 28 April 1988, whose help was greatly appreciated before her death in January 1992.

11. *Sydney Lough Thompson*, *cit.* chap. 2 note 74, p. 34.

12. Information from Sylvia Kenchington, regarding the date of the portrait of her mother, Kathleen Cox (Leech's sister Kathleen), Scotland, 22 August 1988.

13. Unsigned review, perhaps Thomas Bodkin, *The Irish Times*, 26 August 1907, p. 6, col. 4.

14. A. Denson, *Visual Taste: Catalogue of an Author's Art Collection*, Kendal 1971, ill. b. & w., fig. 32.

15. The fluid paint handling with areas of bare canvas around the eyes and the confident depiction of the white blouse set off with a brooch suggest 1911, when Leech painted cat. 38.

16. *Walter Osborne*, *cit.* chap. 2 note 25, p. 138.

17. Leech, letter to Leo Smith, Dawson Gallery, 22 August 1951.

18. Information from Mrs E.M. Leech, England, 28 April 1988.

19. *Ibid.*

20. List of Works Exhibited in the possession of the author.

21. *Walter Osborne*, *cit.* chap. 2 note 25, p. 125.

22. M.E. Thompson's unpublished records, Private collection, France. Paintings with Irish motifs, selected from the list of paintings exhibited by S.L. Thompson in New Zealand, in 1905: 19. *Thatched cottage*; 20. *Ross Castle, Killarney, 1904*; 26. *Midie Lake, Killarney*; 37. *Cliffs, Killiney Hill*; 47. *Killarney*; 81. *Dublin Bay*; 86. *Killarney, rainy day*.

23. Robert Elliott's review, *The Nationist*, 1, no. 27, 22 March 1906, p. 372.

24. 'Studio Talk – Dublin', *The Studio*, XXXIX, November 1906, p. 166.

25. *Sydney Lough Thompson*, *cit.* chap. 2 note 74, p. 38. Thompson's painting *Au pardon* was bought by the Canterbury Society of Arts for £31. 10, when "twenty, or even ten guineas, was regarded as a good price for a painting by a local artist".

26. *The Studio*, XXXIX, November 1906, p. 166.

27. *Catalogue of Munster–Connacht Exhibition*, Limerick 1906, in National Library, Dublin.

28. "These are a people living at Pont L'Abbé in Brittany, who [speak] a language akin to Welsh and wear a distinctive costume."

29. Imaal [F. Sheehy Skeffington], 'Imaal's' review, *The Leader*, XIV, 16 March 1907, at pp. 56–57, name taken from Glen of Imaal, County Wicklow.

30. *Ibid.*

31. Information from Mlle Annette Thompson, Brittany, 30 August 1991.

32. Catalogue of the Irish International Exhibition, National Library of Ireland, Dublin, Leech exhibited five paintings, see List of Works Exhibited.

33. List of Works Exhibited in the possession of the author.

34. Leo Smith, letter to the Ulster Museum, Belfast, providing information on Leech, from Dawson Gallery records, undated but *ca.* 1971.

35. See List of Works Exhibited for details of the RHA exhibitions. See also Chapter 3, note 70. There may be two versions of this painting or it could be that there is only one painting *Interior of a café* which won the bronze medal and which is in a private collection in Dublin; List of Works Exhibited in the possession of the author.

36. Review of the Royal Hibernian Academy Exhibition in *The Irish Times*, 1 March 1909, p. 5.

37. Review of the Royal Hibernian Academy Exhibition in *The Irish Times*, Monday, 4 March 1912, p. 5.

38. Ed. A. Denson, *Printed Writings by G.W. Russell (A.E.): A Bibliography and Iconography*, Evanston IL (Northwestern University Press) 1961, pp. 220–23. T. Bodkin, *The Irish Times*, 10 October 1910, p. 5, 'Exhibition of Pictures' lists Mr George Russell, Miss Frances Baker, Miss Beatrice Elvery, Mr Percy F. Gethin and Mr W.J. Leech.

39. Ed. A. Denson, *Thomas Bodkin: A Bio-biographical Survey with a Bibliographical Survey of his Family*, Dublin 1966, p. 21.

40. 'Pictures at the Leinster Lecture Hall', *The Irish Times*, Monday, 26 August 1907, col. 4, p. 6.

41. Denson, *op. cit.* note 39, pp. 114 and 72. *British Painting since Whistler*, exhib. cat., London, National Gallery, March–August 1940, no. 521. *The blue shop, Quimper* was not in the catalogue among the original 355 works listed. However, owing to the extensive daylight bombing of London it was decided to postpone the exhibition in early September, and with the bombing of the National Gallery itself on 12 and 17 October, the exhibition was cancelled indefinitely. These pictures, of which *The blue door, Quimper* is one, were to form part of this extended exhibition, but despite many of the works arriving in London and indeed private view invitations being printed, they were never exhibited. (*Fine Irish Paintings and Drawings*, exhib. cat., Belfast, Christie's, 30 May 1990, pp. 138–39, ill. colour.)

42. Thomas Bodkin?, 'Pictures at the Leinster Lecture Hall', *The Irish Times*, 26 August 1907, p. 6.

43. Seumas Ó'Congaile, 'A Picture Parley', *Sinn Fein*, 31 August 1907, p. 3.

44. Bodkin?, *op. cit.* note 42, p. 6.

45. Ó'Congaile, *op. cit.* note 43, p. 3.

46. Bodkin?, *op. cit.* note 42, p. 6.

47. Ó'Congaile, *op. cit.* note 43, p. 3.

48. Bodkin?, *op. cit.* note 42, p. 6.

49. Imaal, *The Leader*, XIV, 16 March 1907, col. 1, p. 57.

50. Ó'Congaile, *op. cit.* note 43, p. 3.

51. Bodkin?, *op. cit.* note 42, p. 6.

52. [Thomas Bodkin], review of exhibition at Leinster Lecture Hall, *The Irish Times*, 24 August 1908, p. 9.

53. *Ibid.*, p. 9.

54. W.J. Leech, letter to Leo Smith, 2 November 1950. Private collection, Ireland.

55. Unsigned review in *The Irish Times*, Monday, 11 October 1909, p. 9.

56. Bodkin?, *op. cit.* note 42, p. 6.

57. Denson, *op. cit.* note 38, p. 220.

58. Kennedy, *Irish Art and Modernism*, *op. cit.* chap. 2 note 44, p. 115.

59. Denson, *op. cit.* note 38, p. 223.

60. Thomas MacDonagh, review of the 'Young Irish Artists', *The Leader*, 1 May 1909, p. 253.

61. *Ibid.*, p. 253.

62. *Ibid.*, p. 253.

63. Review of 'The Young Irish Artists', *Sinn Fein*, 20 April 1907, p. 3.

64. *Ibid.*, p. 3.

65. *Ibid.* Review of the Aonach Art Exhibition, *Sinn Fein*, 18 December 1909, p. 3.

66. Aonach Art Exhibition, *Sinn Fein*, 18 December 1909, p. 3.

67. *Ibid.*, p. 3.

68. *The Irish Impressionists, cit.* chap. 2 note 8, p. 112. Dr Helena Wright gave a date as *ca.* 1914, "Leech returned to Ireland to enlist in the army, but that he only stayed in it a few days'. See also Denis Gwynn, *Cork Examiner*, Friday, 19 July 1968, p. 10, "on one of his infrequent visits to Ireland some thirty years ago".

69. Leech, letter to Leo Smith, 11 March 1967.

70. *Whistler, cit.* chap. 2 note 61, p. 29.

71. Aonach Art Exhibition, *Sinn Fein*, 18 December 1909, p. 3.

72. Seumas O'Congaile, 'The Young Irish Artists', *Sinn Fein*, 20 April 1907, p. 3.

73. *Irish Art*, exhib. cat., prefatory notice by H.P. Lane, London, Guildhall Art Gallery, May 1904, p. x.

74. McConkey, *op. cit.* chap. 2 note 8, p. 45.

75. B. Fallon, *Irish Art 1830–1990*, Belfast (Appletree Press) 1994, pp. 17–21.

76. Hugh Lane's letter to Sarah Purser, 13 May 1903, Sarah Purser Papers, National Library of Ireland. Hugh Lane wrote, telling Sarah Purser that Osborne's death 'has been a great shock to me, as he was one of our few genius's and I hoped for still greater things from his brush'. As a footnote he added, 'Isn't it <u>splendid</u> of Hone to give his best work?' (Hone presented *Evening, Malahide Sands* to Hugh Lane, to form a collection of Modern Irish paintings; now in the Hugh Lane Municipal Gallery of Modern Art.)

77. Arnold, *op. cit.* chap. 1 note 13, p. 292.

78. Thompson, *op. cit.* chap. 2 note 75.

79. D. O'Brien, letter to his wife Mabel, from Kildare Street Club, 15 April 1909, telling his wife that he 'Spent a couple of hours with Leech ... I think that if you are going to have such a houseful towards the end of May that I shall go to Kerry with Leech.'
 Ibid., 18 April 1909, recording that he would 'like to have Leech down', that is, to stay at the O'Brien family house, Ardagh, Cahirmoyle, County Limerick.

80. Information from Ciaran MacGonigal, Dublin 1985.

81. Letter from Dermod O'Brien from no. 24, Roland Gardens, London (a family house), to his wife Mabel, 2 May 1909.

82. Letter from Dermod O'Brien, from the Kildare Street Club, to his wife Mabel, 14 April 1909.

83. *Post-Impressionism, cit.* chap. 3 note 4, p. 295.

84. Letter from Dermod O'Brien, no. 24, Roland Gardens, London, to his wife Mabel, 2 May 1909.

85. *Impressionism in Britain*, exhib. cat. by K. McConkey, London, Barbican Art Gallery, 1995, p. 70.

86. Dermod O'Brien, letter to Mabel, 2 May 1909.

87. Bruce Laughton, *Philip Wilson Steer*, Oxford 1971, pp. 147–148.

88. *Ibid.*, p. 144.

89. Arnold, *op. cit.* chap. 1 note 13, pp. 227–236. See *Impressionism in Britain, cit.* note 85, pp. 10–13.

90. Denson, *op. cit.* note 39, p. 75. [Thomas Bodkin], *The Irish Times*, 30 November 1912, p. 7. Laughton, *op. cit.* note 87, pp. 101 and 148.

91. *Ibid.*, p. 143.

92. Arnold, *op. cit.* chap. 1 note 13, p. 288. William Rothenstein was a fellow student of Dermod O'Brien at the Académie Julian from 1891 until 1893 when O'Brien moved to London from France.

Chapter Five

1. See Chapter 6 for details of Elizabeth Kerlin as the model in *The sunshade* and *The convent garden*.

2. Leech used his parents' address, which in 1912 was no. 55, Castletown Road, West Kensington, London. Their previous London address from 1910 had been no. 45, Westbourne Park Road, Blackheath, near Greenwich Park, SE London. During the War they lived first at no. 16, Eardley Crescent, Earls Court (in 1914), and then at no. 39, Gunterstone Road, West Kensington (in 1915) before moving finally to no. 19, Porchester Square.

3. See Chapter 6 for details on Leech's meeting with Elizabeth.

4. Denis Gwynn, 'Now and Then: A Great Artist', *Cork Examiner*, 19 July 1968, p. 10.
 In reference to Leech's painting of Parnell Square, he wrote that "It was painted on one of his infrequent visits to Ireland some 30 years ago and it shows the rich red brick of the tall houses in Parnell Square in a sunny autumn." If this painting was the one exhibited at the RHA in 1928, then Denis Gwynn's approximation is underestimated by some ten years and Leech probably painted it on a trip to Dublin, in the late 1920s.

5. Leech, letter to Leo Smith, 14 August 1965. See Chapter 9 for details about May Botterell, Leech's second wife, who suffered from heart trouble in the last few years of her life.

6. F. Spalding, *British Art since 1900*, New York (Thames & Hudson) 1986, p. 37.

7. *Ibid.*, pp. 20–21.

8. *Sydney Lough Thompson, cit.* chap. 2 note 74, p. 100, records that he exhibited a painting entitled 'Shy'. See also Thompson, *op. cit.* chap. 2 note 75, p. 5: "il expose à la 'Royal Academy' de Londres, une étude d'une Bretonne".

9. Dermod O'Brien, letter to Mabel O'Brien, 14 April 1909, mentioning Leech's rejection from the RA in 1909.

10. *Post-Impressionism, cit.* chap. 3 note 4, pp. 184–85.

11. For information on Leech paintings exhibited at the RA, see List of Works Exhibited.

12. McConkey, *op. cit.* chap. 2 note 87, p. 54.

13. List of Works Exhibited in the possession of the author.

14. See Chapter 6.

15. Review in *The Times*, 'The Royal Academy: Distinguished Painters Rejected', 3 May 1921, p. 6: "1000 fewer works are hung this year".

16. *The Times*, 3 May 1921, p. 6.

17. *The Times*, 14 May 1921, p. 12. A.E. [George Russell], *The Studio*, LXXXI, January–June 1921, p. 187, wrote: "R.A. of 1921 has been a great improvement on its predecessors" Although "... nearly 200 of rejected works though it yielded no surprises – justified, to a considerable extent that some exhibitors, other than Members and Associates, had two and sometimes three works placed" suggesting that the "space available ... was not quite fairly allocated".

18. *The Times*, 5 May 1921, p. 13.

19. *Ibid.*, 9 May 1921, p. 13.

20. Gabriel Mourey (conservateur des Palais Nationaux, Paris). 'Review of R.A.', *The Studio*, LXXXI, January–June 1921, p. 22. 'Royal Academy Exhibitors, 1905–1970', *A Dictionary of Artists and their Work in the Summer Exhibition of the Royal Academy of Arts*, V.

21. List of Works Exhibited in the possession of the author.

22. List of Works Exhibited in the possession of the author.

23. See Chapter 6 for further information on *Lilies (A convent garden)*.

24. Leech might have expected a mention in A.E. [George Russell], *The Studio*, LXXXI, January–June 1921, p. 187, but, although they had exhibited together at the Leinster Lecture Hall, George Russell (A.E.) – editor of *The Irish Statesman* – in his frequent reviews of the RHA, seemed to have ignored Leech but enthused about Yeats. Perhaps the reason for this lay in Leech's lack of Irish subject-matter, and perhaps George Russell (A.E.) gives us an indication of this in *The Irish Statesman*, 'Pictures of Life in the West of Ireland', 24 September 1927, pp. 103–04: "This is one of the best exhibitions of recent years in Ireland. And it is Irish life interpreted by an artist with imagination We are never in doubt about Jack Yeats' country."

25. Information from Eileen Botterell, England, 18 May 1985. Leech and May Botterell were staying with them, summer 1940, and she accompanied Leech to the Royal Academy on that occasion.

26. Leech adhered to this promise. These two paintings, *The lake* and *Lace tablecloth*, were exhibited by Alan Denson, who owned *Lace tablecloth*, given to him by Leech. Information in Denson, *op. cit.* chap. 2 note 14, ill. no. 16, b. & w., description p. 43. See List of Works Exhibited.

27. *Impressionism in Britain, cit.* chap. 4 note 85, p. 32: "the Royal Institute of Oil Painters opened in 1884, an offshoot from the Royal Institute of Painters in Watercolours. Again ... attracted younger, less experienced exhibitors."

28. Royal Institute of Oil Painters, Catalogue of 25th Exhibition, 1907, Library of the V. & A., London. See List of Works Exhibited for details of *Malahide*.

29. *Impressionism in Britain, cit.* chap. 4 note 85, p. 32, for information on the appearance of many new exhibiting venues, including the NEAC. 'Studio-Talk', *The Studio*, LII, February–May 1911, pp. 56–58, refers to "The Sketch Society which held its second exhibition in January at the Royal Institute Galleries. It may still be called a quite new society. Messrs. Oswald Mosley, Douglas Fox-Pitt, Frank Gillett, W.J. Leech, Isaac Cooke, F. Whitehead, seemed to us to bear away the honours this time." Fox-Pitt, Gillett, Cooke and Whitehead were in the main landscape painters and older than Leech.

30. Information on the cover of the *Catalogue of Paintings by W.J. Leech, R.H.A., R.O.I. and William Wildman, January, 1911, The Baillie Gallery, 13, Bruton Street, Bond Street, W.* Library of the V. & A., London.

31. Simon Watney, *English Post-Impressionism*, London 1980, p. 39.

32. *Post-Impressionism, cit.* chap. 3 note 4, pp. 293 and 295.

33. For information about Monet's influence on Conder, see *Impressionism in Britain, cit.* chap. 4 note 85, pp. 63–65. For information about the Baillie Gallery exhibition, see *Post-Impressionism, cit.* chap. 3 note 4, pp. 293 and 295.

34. *Ibid.*, p. 295.

35. *Post-Impressionism, cit.* chap. 3 note 4, p. 9.

36. Johnson and Greutzner, *op. cit.* chap. 2 note 125, p. 546. William Ainsworth Wildman, figure and landscape painter and etcher, lived in London and exhibited at similar venues to Leech.

37. Anonymous, 'Other Galleries', *The Times*, 10 January 1911, p. 11.

38. M.M.B., 'Studio-Talk', *The Studio*, LII, February–May 1911, p. 143. See List of Works Exhibited for the list of paintings submitted.

39. "Painted oil on wood, My mother as a young woman aged 16. The picture is signed and dated 1907 Title the Black Scarf – I would guess it was painted at Yew Park Dublin – the family home. The picture has a crack in the wood across the middle." Letter, Leech's niece, Mrs Sylvia Kenchington, Scotland, the subject of *Sylvia* (cats. 56, 57 and 58), to the author, 7 September 1986.

40. D. Ferran, *Leech: William Leech 1881-1968*, Town House Dublin in association with the NGI 1992, plate 2, p. 15.

41. B. Laughton, *Philip Wilson Steer*, London 1971, p. 148. *Post-Impressionism*, *cit.* chap. 3 note 4, p. 297. Dermod O'Brien, letter from no. 24, Roland Gardens, London, to Mabel O'Brien, 2 May 1909. Private collection.

42. For background to the Goupil Gallery, see Anna Greutzner Robins, 'The London Impressionists at the Goupil Gallery', *Impressionism in Britain*, exhib. cat., London, Barbican Gallery, pp. 87–96. For exhibitions at the Goupil Gallery, 1910–12, see *Post-Impressionism*, *cit.* chap. 3 note 4, p. 297. See also exhibition catalogues Library of V. & A., London.

43. See List of Works Exhibited for list of paintings in the Leech Exhibition at the Goupil Gallery, April–May 1912. William Marchant & Co., the Goupil Gallery, *W.J. Leech, RHA*, April & May 1912, Library of V. & A., London.

44. *The Goupil Gallery Salon*, Nov/ Dec, 1911, 6th of a series inaugurated in 1906 by Messrs. William Marchant & Co. Library of the Tate Gallery, London. See 'Studio Talk: The Goupil Gallery Salon', *The Studio*, LIV, 1911, p. 219, for a review of the exhibition which mentions "Mr. W.J. Leech's *The White Bridge, Venice*, and *A Circle, Venice*" and "Mr. William Nicholson and Mr. Augustus John are to be seen this year in full force."

45. *'Twas brillig* was first exhibited at the RHA in 1910, see List of Works Exhibited.

46. J.B. Bullen, *Post-Impressionists in England*, London and USA 1988, p. 494. In the Chronology of Post-Impressionist Exhibitions, Wolmark is included at the Goupil, April 1912, but Leech is omitted. The Leech that is included in this chronology is John Leech, the English artist.

47. Leech, letter to Leo Smith, Dublin, 18 March 1967.
 The original firm of Goupil was founded in Paris in 1827 by M. Adolphe Goupil in partnership with M. Rittner. Exactly when the London House was opened is not on record but it was in existence in the early 1860s in premises at no. 17, Southampton Street, Strand, now pulled down, and the gallery space moved to no. 23, Bedford Street, then nos. 116 and 117, New Bond Street and no. 5, Regent Street. In 1901 the London business was ceded to Mr Marchant, who had been connected with the establishment since 1886, and his firm of William Marchant & Co. continued its activities until the end of 1926, after which it functioned as the Goupil Gallery and began with a show of Stanley Spencer's work which included the *Resurrection* now in the Tate Gallery.

48. William Rothenstein (1872–1945), a pupil of Legros at the Slade School, became principal of the Royal College of Art, 1920–35. His painting *The doll's house*, 1899 (Tate Gallery, London), conveys his interest in figure composition and the use of Whistlerian tonal values. He was an important exhibitor at the National Portrait Society and the NEAC, with Steer, Bevan, Fry and Sickert, and a close friend of Dermod O'Brien.

49. Written notes on the catalogue of the Leech Exhibition at the Goupil Gallery, London, April–May 1912. Library of the Tate Gallery, London.

50. "... his pictures are quite empty ..." and "... a hit and miss method ...", *The Times*, 20 April 1912, p. 4.

51. List of Works Exhibited in the possession of the author (41 paintings).

52. Leech, letter to Leo Smith, 2 November 1950.

53. Goupil Gallery Review, *The Times*, 20 April 1912, p. 4.

54. Johnson and Greutzner, *op. cit.* chap. 2 note 125, p. 556.

55. 'Cooling Galleries', *The Times*, 15 June 1927.

56. *Through Switzerland with Turner*, exhib. cat. by Ian Warrell, London, Tate Gallery, 1993, p. 153.

57. See Kennedy, *op. cit.* chap. 2 note 44, p. 215. Leech would possibly have been familiar with this Monet painting, through the Lane Exhibition in Dublin, 1905.

58. *Whistler*, *cit.* chap. 2 note 61, p. 85.

59. See *Sir John Lavery, R.A.*, *cit.* chap. 3 note 41, pp. 70–71, ill. b. & w. See also McConkey, *op. cit.* chap. 2 note 80, p. 103.

60. Information from Mr Cecil Cox, England, 1988, regarding *Les Rochers de Naye*: "It was a wedding present which hung over the fireplace in Tettenhall Wood. The Rev. Cox tried to clean it, snow went yellow." See Denson, *op. cit.* chap. 1, note 10, no. 21, entitled *Les Manchen*.

61. Denson, *op. cit.* chap. 1 note 30, p. 122.

62. Information from Mrs Hanni Davey, England, 4 May 1988.

63. *Post-Impressionism*, *cit.* chap. 3 note 4, p. 297.

64. Watney, *op. cit.* note 31, p. 22.

65. *Impressionism in Britain*, *cit.* chap. 4 note 85, ill. in colour, p. 27.

66. *Ibid.*, pp. 46–47.

67. Watney, *op. cit.* note 31, p. 22. See also Watney's 'The New English Art Club and the Slade', *ibid.*, pp. 17–26 for history of the development of the NEAC.

68. H.B.B., 'Studio-Talk', *The Studio*, XLIX, February–May 1910, p. 26.

69. E.D., 'Dublin – RHA', *The Studio*, LXVIII, June–September 1916, p. 55.

70. A. Denson, *An Irish Artist W.J. Leech RHA (1881–1968)*, Kendal 1968, p. 30.

71. *The Irish Impressionists*, *op. cit.* chap. 2 note 8, ill. b. & w., p. 163.

72. *The New English Art Club*, Summer, 1916, exhib. cat., p. 35. Library of the Tate Gallery, London. *The sunshade* was listed in Bourlet Records as *The green parasol*, in 1952, for delivery to the National Gallery of Ireland.

73. Retrospective Exhibition of NEAC, *Evening Post*, January 1925.

74. *Ibid.*

75. *Loan Exhibition of Modern Paintings*, exhib. cat., Belfast, Public Art Gallery and Museum, March–April 1913, nos. 1, 33 and 80.

76. Catalogue of the Summer Exhibition at the Whitechapel Gallery, 21 May 1913. Library at the V. & A., London.

77. List of Works Exhibited in the possession of the author.

78. *The Irish Times*, 5 March 1913, p. 9.

79. Mrs Eileen Botterell, letter from England to author, undated but *ca.* 20 June 1988, stating that "Bill had no London shows after 1919, he & May were very discreet I think by arrangement with Percy...." He did have a further exhibition at the Cooling Gallery, London, 1927, which received a favourable review in *The Times*, declaring that Leech "is an artist who deserves to be better known in London". It was possibly this review which determined Leech to become even more discreet and not exhibit in London again. See Chapter 7 for further discussion of the Cooling Gallery Exhibition in 1927.

Chapter Six

1. Dermod O'Brien, letter from Cahirmoyle, County Limerick, to his wife Mabel, 2 February 1910. Leech was staying with O'Brien at Cahirmoyle and painting in a studio in his house.

2. This detached house, which overlooked Plage des Dames, was the former home of the mayor of Concarneau, Mayor Thierry. Information from Mlle A. Thompson, Concarneau, August 1991. Hirschfeld and his wife, Emma, also a painter, lived in Concarneau but later built their house with two studios on the rue des Sables-Blanc, the beach beyond Plage des Dames.

3. This was one of the paintings Leech exchanged with Thompson and it indicates the brighter fauve palette Leech was using to paint the beach in front of the house he rented with Elizabeth.

4. Leech, letter to Leo Smith, 9 September 1965.

5. Leech, letter to Leo Smith, Dawson Gallery, Dublin, 22 August 1951.

6. *Walter Osborne*, *cit.* chap. 2 note 25, no. 77, ill. b. & w., p. 134.

7. *Sydney Lough Thompson*, *cit.* chap. 2 note 74, p. 47.

8. In Registre d'Immatriculation, no. 16, dated 3 April 1915, Saurin Elizabeth Leech is recorded as an *"artiste peintre"* who first arrived in that area twelve years previously. Archives Department, Hôtel de Ville, Concarneau, Brittany.
 Kerlin, Saurin Elizabeth (Mrs), Littleton, Mass., is registered at the School of the Museum of Fine Arts in Boston from 1906 to 1909, receiving No. 1 in Concours (head) Antique Class, March 1907. Passed in Anatomy, March 1907, Antique promoted to Life, June 1907: received diploma, 27 May 1909. No. 523, Register of Pupils, Archives of the School of the Museum of Fine Arts, Boston.

9. The obituary for Mrs Saurin E. Leech recorded that "She studied art at the Boston Museum of Fine Art completing a three year course in one year. She won a scholarship to study abroad" Quincy Patriot Ledger, 28 June 1951, p. 12.
 The Register of Pupils – School of the Museum of Fine Arts – records that she won the Gardner Scholarship for 1908–09, awarded April 1908, which may be the scholarship referred to.

10. *Sydney Lough Thompson*, *cit.* chap. 2 note 74, pp. 46–47.

11. *Ibid.*, pp. 46–52.

12. McCormick, *op. cit.* chap. 2 note 102, pp. 140–41.

13. *Sydney Lough Thompson*, *cit.* chap. 2 note 74, p. 46.

14. *Post-Impressionism*, *cit.* chap. 3 note 4, p. 141.

Chapter Seven

1. Johnson and Greutzner, *op. cit.* chap. 2 note 125, p. 306, lists Mrs W.J. Leech as having exhibited three paintings at the RHA in 1914. No trace of this could be found in catalogues of the RHA, National Library, Dublin.

2. *Ibid.*, Mrs W.J. Leech's address was given as no. 16, Eardley Crescent, Earls Court, London. See Chronology.

3. Registre d'Immatriculation, no. 16, dated 3 April 1915, and signed by Saurin Elizabeth Leech.

4. Thompson, *op. cit.* chap. 2 note 75, p. 19. Leech came to paint with Thompson in Les Martiques, and Henry La Thangue and his wife were there as well. Thompson had known Henry La Thangue at least since December 1915, when the Thompson family wintered at Bormes Les Mimosa, where la Thangue had already had a house for some years.

5. *Ibid.*, p. 19.

6. Leech, letter to Sydney Thompson, "So I decided to remain free to do my own job and to help in other ways in my spare time. Of course if I was a younger man I would have to put this case before a tribunal but the importance of the arts is recognized to a greater extent here than was the case during the last war, though I personally was quite well treated even then."

7. G. Howell, *'In Vogue': Six Decades of Fashion*, Condé Nast Publications Ltd, 1975, p. 3.

8. Spalding, *op. cit.* chap. 5 note 6, pp. 11–12.

9. *The Studio*, LXX, February–May 1917, p. 288.

10. *Ibid.*, LXXI, June–September 1917, p. 70.

11. Letter, Sylvia Kenchington to the author, 27 January 1987. "I am sure it was done for my grandmother's drawing rooms as I vividly remember her lilac & purple silk cushions."

12. *Ibid.*

13. Howell, *op. cit.* note 7 p. 1.

14. James Bourlet (Fine Art Packers), n. 18, Nassau Street, London W, unpublished handwritten ledgers in their office in Fulham Road, London, 11 September 1919. Unpacked from Pottière, Paris, *Lilies*, *La Dame en bleu*, *Les Enfants et les ombres*, *La Dame aux [Irises]*, *(Untitled) Lady with red cap*, *The lady of the garden*, *La Femme (Canvas)* 32" x 43", *The secret garden* 44" x 35".

15. Information from Mrs Eileen Botterell, 18 May 1985. "Elizabeth Leech came to London after the war but Leech had met May by then – Percy Botterell bought her a cottage and provided her with an allowance of £500 per annum." The will of Percy Botterell, 6 December 1948, bequeaths "To Elizabeth Leech the sum of one thousand five hundred pounds." Elizabeth had died the year before Percy Botterell's death in 1952, and her daughter, Mrs Fentress Park, replied from Quincy, Massachusetts.

16. James Bourlet (Fine Art Packers), *op. cit.* note 14, 8 October 1920.

17. C. McGonigal, 'A Long Life Painting', *The Irish Times*, 10 April 1981, p. 10, "and up to his death the Academy were responsible for having his works for Annual Exhibitions sent to Dublin at their expense. At the time of his election, [to Academician in 1910] Members of the Academy could send ten works to an annual exhibition, so that from his point of view he was able to obtain a fairly wide audience for his painting."

18. Mr Cecil Cox, letter to the author, 14 March 1988: "Uncle Cecil did not get back from Germany & Holland until Feb 1919 " and it was Cecil Leech who had met the Botterell family in The Hague at the end of the War, when he was released after four years in a prisoner-of-war camp in Germany. Mrs Sylvia Kenchington, letter to the author, 27 January 1987.
 May, with her two younger children, Guy and Suzanne, had accompanied her husband to Holland; Jim had remained at school in Winchester. In The Hague, at the end of the War, May Botterell had organized a relief centre for released prisoners, providing clothes, money and information to aid prisoners on their return home. Cecil, a major in the Royal Artillery, worked with her to repatriate the soldiers in his regiment. Percy Botterell was awarded a CBE for his services in The Hague.

19. List of Works Exhibited in the possession of the author.

20. *Sir John Lavery, R.A.*, *cit.* chap. 3 note 41, ill. b. & w., pp. 102–03.

21. Married in 1905, they never divorced to avoid any scandal. On his death in 1952, Percy Botterell bequeathed to his wife May, who was an executor of the will, all the contents of his house "and effects of every kind belonging to me", "the sum of three thousand pounds to be paid to her immediately …", "and to pay the said income [from nine-twelfths of a trust fund] to my wife during her life …".

22. Contemporary photographs show Jim Botterell at Clayesmore School, Winchester, 1924, where he excelled at athletics and played a saxophone in the school band.

23. See Chronology, which gives the studio addresses for Leech.

24. I am grateful to Jim Botterell for his assistance and information until his death in 1988.

25. Percy Botterell, the eldest son in a family of two, had a privileged background. His father was an eminent lawyer and president of the Law Society.

26. Mr Cecil Cox, letter to the author, 14 August 1985. Unfortunately Professor Leech had invested his entire life's savings in a film company which soon afterwards went bankrupt, causing him financial ruin. His son Cecil cleared up all outstanding debts.
 This distress precipitated Brougham Leech's tragic death on 2 March 1921. Information from Mrs Ellen Mabel Leech (widow of Cecil Leech), 20 August 1991.

27. Brougham Leech's original will was dated 11 June 1918, with a codicil added on 1 March 1921. The next day Brougham Leech shot himself. This codicil, written to take account of his financial situation, left half of the residue of his estate to Kathleen and Bill, giving them a quarter each. The remaining half was to be divided between his three other sons, Arthur, Harry and Cecil. Wills & Probates, Somerset House, London.

28. Mrs Sylvia Kenchington, letter to the author, 27 January 1987: "the studio then was in St. John's Wood & I remember a little green door …". See Chronology for details of Leech's studio addresses.

29. The trust fund outlined in the will of 11 June 1918 was to provide an "income and dividends to my son William during his life and after his decease shall pay such income and dividends to his wife Elizabeth during her life". Will of Henry Brougham Leech, Wills & Probates, Somerset House, London.

30. Mrs Sylvia Kenchington, letter to the author, 7 September 1986: "I so remember him going off on one of my parent's bicycles – to paint in the countryside all day …. I also remember how my brother & I used to delight in his tales of Paris – his adventures in the parts of Paris when he was poor."

31. Leech, a message written on the back of a photograph of himself sitting in his studio, to his niece, Sylvia Kenchington, undated but *ca.* 1960. Collection, the author.

32. Mrs Sylvia Kenchington, letter to the author, 6 June 1986, "William John was a frequent visitor at Tettenhall Wood and stayed several months."

33. *Ibid.*, "leaving a picture as his rent as it were". Mrs Sylvia Kenchington, letter to the author, 27 January 1987: "… for Uncle Bill was very hard up". Mr Cecil Cox, letter to the author, 14 August 1985, "Uncle Bill after the first world war was extremely hard up, so he came and stayed with us for months at a time. I surmise that he gave these pictures after each long stay. He also stayed with Uncle Harry and Uncle Cecil."

34. Mr Cecil Cox, letter to the author, 28 January 1986.

35. Information from Mrs Margaret Wallace, daughter of the Revd Tom Pearson, 30 April 1985. Information from Mrs Eileen Botterell, 18 May 1985. May Botterell, née Pearson, was the daughter of Isaac Pearson, the director of Sunlight, which was later amalgamated into Lever Bros. She was fourth in a family of seven or eight children. Her brother, the Revd Tom Pearson, was slightly older than May and studied at Trinity College, Oxford, where he met Percy Botterell. The Pearsons lived in Hull, where they built Pearson Park for the workers in the factory. Isaac Pearson left the business to his eldest son; John and May had a yearly allowance of £600 from her father's estate. May was cultured, rich and musical.

36. Information from Mrs Eileen Botterell, England, 18 May 1985.

37. *Ibid.*, Leech was depressed and unable to paint at the end of the War, until Percy Botterell commissioned portraits of his family, and May Botterell sat for him.

38. Mrs Eileen Botterell, letter to the author, undated but *ca.* 20 June 1988: "Bill had no London show after 1919 [in fact his last was 1927] he & May were very discreet I think by arrangement with Percy giving May complete freedom of movement hence their yearly trips to France – Percy dreaded a divorce."

39. Review in *The Times*, 15 June 1927, p. 10.

40. See List of Works Exhibited for the list of exhibits. This Appendix outlines how extensively Leech did exhibit, but without a London venue he remained unknown in England. Because he never came to Ireland he was known only to a few in his own country. He suffered because of this dilemma.

41. J. Campbell, 'Irish Artists in France and Belgium', unpublished Ph.D. Thesis, Trinity College Dublin, p. 327 and note 14 of the thesis. Leo Smith was of the opinion that Leech would not return to Ireland after 1919 because of his relationship with May Botterell and his separation with Elizabeth.

42. Information from Mr Jim Botterell, England, 18 May 1985. They stayed in the Hôtel Commercial in Grasse after 1926. Information from Dr Beric Wright, England, 20 August 1991. From the early 1930s until the War, May Botterell and Leech spent three months with the Wright family at the Robins Hotel, La Verrarie, outside Cassis.

43. List of Works Exhibited in the possession of the author.

44. Information from Mr Jim Botterell, 18 May 1985, that Leech knew John; he certainly would have known his work.

45. Johnson and Greutzner, *op. cit.* chap. 2 note 125, p. 10. The Chenil Gallery, near Chelsea Town Hall, was run by John Knewstub but financed mainly by William Orpen. *Larousse Dictionary of Painters*, London 1990, p. 192. John exhibited "about 50 Provencal Studies". T.W. Earp, 'The Recent Work of Augustus John', *The Studio*, XCVII, January–June 1929, pp. 231–38, referred to the fact that he had returned to the area where he had painted his early landscapes, "the scene of most of these landscapes is the neighbourhood of the town of Martiques".

46. McConkey, *op. cit.* chap. 2 note 8, p. 118.

47. List of Works Exhibited in the possession of the author.

48. Thompson, *op. cit.* chap. 2 note 75, p. 22, writing about the winter of 1919–20 when Thompson went painting to Hammamet, Tunisia, and Leech arrived to paint with him. "Some friends from England, W.J. Leech and Mrs. Botterell come to the hotel [situated on the beach] for several weeks. W.J. Leech paints a fine portrait of Miss Marion Clough and the sittings were in a room in the Thompson's house."

49. McConkey, *op. cit.* chap. 2 note 80, detailing Lavery's years painting at Tangiers, pp. 92–99.

50. A photograph of Jim and Guy Botterell, taken at Cone Park, Essex, in 1923–24, captures them carrying a large painted parasol, similar to the one May is holding in *Paper parasols*.

51. 'Cooling Galleries', *The Times*, 15 June 1927, p. 10.

52. See List of Works Exhibited. Information from Mrs Mabel Leech about this painting, which hung in her house until Leech borrowed it for an exhibition.

53. 'Cooling Galleries', *cit.* note 56, p. 10.

54. Thompson, *op. cit.* chap. 2 note 75, p. 26.

55. Y.O. [George Russell, A.E.], 17 April 1926, p. 148. George Russell edited the weekly journal *The Irish Statesman*.

56. Thompson, *op. cit.* chap. 2 note 75, p. 39.

57. Information from Dr Beric Wright, England, 20 August 1991.

58. McCormick, *op. cit.* chap. 2 note 102, p. 97.

59. Leech, letter to Leo Smith, 26 December 1950.

60. This is apparent in a comparison of Paul Nash's *Pillar and avenue*, 1943 (Tate Gallery, London) with Leech's *Steps to the cours, Grasse* (fig. 50).

Chapter Eight

1. RHA, Catalogues, National Library of Ireland, Dublin, record Leech's Steele's Studios address from 1928 to 1941, the year his studio was blitzed. *Kelly's Street Directory*, Westminster Library, London, records Leech at no. 4, Steele's Studios from 1938 to 1948.

2. Johnson and Greutzner, *op. cit.* chap. 2 note 125, p. 18. Mrs Emily Aitken, whose husband was an architect, exhibited at the Royal Academy, the Royal Institute of Oil Painters and the Society of Women Artists during the years 1933–39. *British Artists, 1880–1940*, London 1990, p. 18. At the United Artists' Exhibition at the Royal Academy, 5 January–9 March, Emily Aitken exhibited *Cold sunlight*, no. 192, and *Dahlias and michaelmas*, no. 336. Her address is given as no. 3, Steele's Studios; Exhibition Catalogues, Royal Academy, Burlington House, London.

3. Edmond Xavier Kapp was born in London in 1890 and subleased no. 2, Steele's Studios to Miss Batterbury in 1926. Kapp was a painter, draughtsman and lithographer. He had studied art in London, Paris and Rome. He served in the First World War and was an Official War Artist from 1940 to 1941. Kapp lived in France from 1946 to 1960. In London, he exhibited at the Chenil Gallery, the Cooling Gallery, the Goupil Gallery and the Leicester Gallery. Leech also exhibited at the Leicester, at least on one occasion, with two pictures in an exhibition of Irish Painters; catalogue not seen. in 1946.
 E. Kapp exhibited a portrait, *The Revd H.N. Asman, M.A., B.D.* (1939) at the United Artists' Exhibition, Royal Academy, and his address was no. 2, Steele's Studios. Exhibition Catalogues, Royal Academy, Burlington House, London.
 Leech sublet his studio for a period to a sculptor, Kate Parbury, presumably to earn some money. By 1955–56 Eton College decided to sell the freeholds of the studios but Leech had already sold his lease shortly beforehand.

4. Information from Mrs Edmond Kapp, no. 2, Steele's Studios, 31 March 1985.
 May drove an old Austin Seven, which she put away for the War and then brought out again, information from Mr Adrian Wright, England, 1991.

5. Information from Nevinson's nephew, Mr C. Haskins. Select Managements Ltd. London N3 3LH. *Kelly's Street Directory*; Westminster Library, London. Nevinson also exhibited at the United Artists' Exhibition. His address was no. 1, Steele's Studios in the Exhibition Catalogue, Royal Academy, Burlington House, London.

6. Information from Leech's nephew, Mr Cecil Cox, England, to whom I am very grateful for his unstinting assistance during 1985 to 1986.

7. *British Artists*, cit. chap. 2 note 125, p. 374. See also Christopher Richard Wynne Nevinson, *Paint and Prejudice*, London 1937.

8. *Ibid.* and Spalding, *op. cit.* chap. 5 note 6, pp. 49–59. W. Gaunt, *English Painting*, London 1988, p. 225.

9. Leech, letter to Leo Smith, 21 July 1951.

10. Leech, letter to Sylvia Kenchington, née Cox, 24 December 1966.

11. Leech, letter to Leo Smith, 21 July 1951.

12. May Botterell, letter to Mrs M.E. Thompson, Christchurch, New Zealand, postmarked 30.12.1945. "Billy thinks it rather deplorable that anyone who did do such good work & is really capable, should lend himself to such exhibitionism."

13 Leech, letter to Leo Smith, 28 May 1949. "The idea is to sell my studio as soon as I can."

14. RHA Exhibition Catalogues, National Library, Dublin.

15. Eileen Botterell, letter from Burley to the author, undated but late 1985.

16. Leech, letter from Candy Cottage to S.L. Thompson, Christchurch, New Zealand, 9 September 1991.

17. Leech, footnote to a letter from no. 4, Steele's Studios, to Dr Helena Wright, *ca.* 1936. See Campbell, *op. cit.* chap. 2 note 87.

18. Nadia Benois, 'How to look at Flower Paintings', *The Studio*, CXIII, January–June 1937, pp. 257–63.

19. *Sydney Lough Thompson*, cit. chap. 2 note 74, cat. no. 20, p. 115.
 Thompson, *op. cit.* chap. 2 note 75, p. 48. In 1938, Thompson was staying at the hotel in Pont-Croix, where there were three studios. He was in one; Lionel Floch and Monsieur de Lassence were in the other two. Lionel Floch had brought a young woman from Paris, Josepha, originally from Martinique, to pose as their model, and Thompson made several paintings of her.

20. Maxwell Armfield, 'The British Gleann', *The Studio*, January–June 1938, pp. 312–17.

21. *Impressionism in Britain*, exhib. cat. by K. McConkey, London, Barbican Art Gallery, 1995.

22. Records of the Pont-Aven art school, run by William Scott and his wife Mary, May 1939. These records are held at Le Musée, Pont-Aven, Finistère, France. *William Scott*, exhib. cat. by Ronald Alley and T.P. Flanagan, Belfast, Arts Council of Northern Ireland, 1986, p. 10, refers to their "summer painting school … the Pont-Aven School of Painting, to teach painting and drawing to summer visitors and a few private students from England".

23. Leech, letter from no. 20, Abbey Road, to S.L. Thompson, Christchurch, New Zealand, 10 December 1952.

24. Leech, letter to Leo Smith, 13 January 1953.

25. Information from Mrs Chloe Abbott.

26. Leech, letter from no. 104, Windermere Road, Reading, to S.L. Thompson, Christchurch, New Zealand, 4 February 1942.

27. Cecil Leech returned from Germany and Holland in February 1919 and soon afterwards resumed civilian life and bought a small farm and orchard at Ham Green in Kent. Cecil Leech, Bill Leech, May Botterell and Suzanne Botterell were photographed at Ham Green Farm in 1924.

28. Letter, Cecil Cox to the author, "Uncle Arthur went to Saxmunden in the early 1920's … and left in the mid 30's when he went to share a house with Uncle Harry when he retired from Hatton Hospital … it was really not a farm, but he had some fields for his horses.

29. Information from Dr Beric Wright, 20 August 1991. Leech and May Botterell went to the South of France together; the Wrights for three weeks. Dr Helena Wright flew down and her husband Dr Peter Wright drove down with the children. They stayed in Robins Hotel. La Verrerie, near Cassis, where Leech taught Helena Wright to paint. Letter, May Botterell to Helena Wright, leaving her one of Leech's *Aloes near Les Martiques* "because it has so much of the magic and 'untouchedness' of the winter mornings in the South that you used to love at La Verrerie –", 23 July 1943.

30. Letter, Leech, from Steele's Studios, to Dr Helena Wright, *ca.* 1935.

31. Dr Helena Wright bought Brudenell House, near Aylesbury, in 1962, for £6500. She shared it at weekends with Bruce McFarlane, a history don at Oxford. During the week she lived with her husband Dr Peter Wright in London at Randolf Crescent.

32. B. Evans, *Freedom to Choose: The Life & Work of Dr. Helena Wright, Pioneer of Contraception*, London 1984, p. 195. Leech painted few horses but this may have been painted in the New Forest when he stayed at Burley, from 1947 onwards. *A New Forest farm*, which Leech exhibited at the RHA in 1958, for £105, has a horse grazing in the distance.

33. F. MacCarthy, *Eric Gill*, London 1989, p. 260. Evans, *op. cit.* note 32, p. 150.

34. Eric Gill became a close friend of Helena Wright, meeting her through his friend and patron Oliver (Tom) Hill. Hill was one of Helena Wright's lovers and Gill met her frequently when he painted the frieze in the sitting-room of the country house of the architect Tom Hill. Evans, *op. cit.* note 32, p. 155. Gill corresponded with Duncan Grant and Laura Knight, and was a friend of Stanley Spencer. *Ibid.*, p. 105. Gill exhibited at the Goupil Gallery.

35. Information from Mrs Margaret Wallace, her niece, England, 29 April 1985. "May wanted to be different … the influence of the Bloomsbury group and she found in Billy a Bohemian outlet."

36. Leech, letter to Helena Wright, 4 March 1938, private collection, England.

See Ed. Gillian Naylor, *Bloomsbury*, Great Britain (Pyramid Books) 1990, p. 20.

37. *Ibid.*, pp. 228–29 and 322.

38. *Ibid.*, p. 22.

39. Evans, *op. cit.* note 32, p. 191.

40. Thompson, *op. cit.* chap. 2 note 75, p. 44. Mrs Sawtell, from Christchurch, New Zealand, visited Leech at Steele's Studios in 1935, where she admired the *Portrait of S.L. Thompson*. She described it as "painted by electric light", information she was probably given by Leech. Information kindly supplied to me by Neil Roberts, curator, Robert McDougall Art Gallery, Christchurch, New Zealand, 4 March 1992.

41. *Ibid.*, p. 49.

42. Leech, letter to S.L. Thompson, New Zealand, 4 February 1942.

43. *Ibid.*

44. Letter, May Botterell, to Mrs M.E.Thompson, Boxing Day, 1945.

45. *Ibid.*, 14 October 1946.

46. Leech, letter to S.L. Thompson, New Zealand, 4 February 1942.

47. List of Works Exhibited in the possession of the author.

48. *United Artists*, exhib. cat., London, Royal Academy, 1940, in Royal Academy Library.

49. Information from Mrs Eileen Botterell, England, April 1985.

50. *Ibid.*

51. List of Works Exhibited in the possession of the author.

52. *2nd United Artists*, exhib. cat., Royal Academy, London 1943, Library Royal Academy.

53. Leech, letter to S.L. Thompson, New Zealand, 5 May 1948.

54. *Ibid.*

55. *Ibid.*

56. May Botterell, letter to Mrs M.E. Thompson, 14 October 1946.

57. *Ibid.*, undated but postmarked 30 December 1945.

58. *Ibid.*, 2 November 1947.

59. Leech, letter to Theo Wallace in the 1960s with a reproduction of Botticelli's *Pietà*, from Alte Pinakothek, Munich..

60. List of Works Exhibited in the possession of the author.

61. *The Irish Times*, 30 May 1947, p. 5. P.H.G. [Paddy Glendon], 'Artist reveals Vivid Descriptive Powers', *The Irish Independent*, 21 May 1947, p. 2. Review of the exhibition, referring to Leech as "an artist of stature".

62. Leech, letter to Leo Smith, 9 May 1947.

63. *Ibid.*, 28 May 1949.

64. *Ibid.*, undated, 1951.

65. List of Works Exhibited in the possession of the author; Bourlet, London, records are not complete.

66. *Ibid.*

67. Leech, letter to Leo Smith, 16 October 1950.

68. Leech, letter to Leo Smith, 11 February 1953.

69. Leech, letter to Leo smith, 16 February 1967.

70. List of Works Exhibited in the possession of the author.

71. Leech, letter to Leo Smith, 17 May 1967.

Chapter Nine

1. Leech, letter to Leo Smith, Dawson Gallery, Dublin, 4 July 1953.

2. Their work became similar in compositional qualities so much so that Denson, *op. cit.* chap. 1 note 10, attributed no. 52, a watercolour entitled *Queen Mary's Gardens*, to Leech when it was in fact painted by Dr Lucy Piggott.

3. Information from Mrs Margaret Wallace, May Botterell's niece, England, 1985.

4. The same bird bath was in the small garden opposite no. 4, Steele's Studios. It moved with the couple to Candy Cottage and was featured in many of Leech's paintings, including *The kitchen, 4 Steele's Studios, London*.

5. Mrs Sylvia Kenchington provided me with letters from her uncle, W.J. Leech, and a photograph taken of him in his studio in Candy Cottage. He wrote to her at Christmas 1966, after May's death, and he was mainly concerned with the exhibition he was endeavouring to prepare for the Dawson Gallery: "its a job making out the lists, and difficult to take much interest when there is no-one to share it with". On the day May died, Leech's niece and her husband called by to visit, and when Bill opened the door he told them very quietly that May had died that morning. He gave them a sherry and they stayed with him a while. He was a very sad old man.

6. Information from Mrs Mabel Mitchell, Leech's former housekeeper, England, 1985. Deceased 1989.

7. Information from Mrs Margaret Wallace, England, 1985.

8. Dermod O'Brien, letter from Cahirmoyle, Ardagh, County Limerick, to his wife Mabel O'Brien, 2 February 1910. Leech must have been painting with O'Brien in Cahirmoyle.

9. Leech, letter from Candy Cottage to S.L. Thompson, Christchurch, New Zealand, offering consolation on learning of the death of his wife Maud, Ethel Thompson, and narrating the subject-matter he was painting, 9 September 1961.

10. Information from Mrs Chloe Abbott, England, 1988–93, who lived next door to Leech at Candy Cottage. She had tea two or three times a week with Leech, after May's death.

11. Information from Mrs Ethel Maud (Babs) Leech, England, 1988 until her death in 1991. I am grateful to her and her daughter Kathleen for their unstinting information and generosity.

12. Information from Mrs Margaret Wallace, England, 1985. I am grateful to her for her help and that of her children, Bridget and Paul.

13. Leech, letter from Candy Cottage to Leo Smith, 14 April 1956.

14. *Ibid.*, 28 November 1967.

15. *Ibid.*, 16 February 1967.

16. *Ibid.*, 21 July 1951.

17. Leech exhibited the *River Wey* and *West Clandon Railway Station*. (Catalogue not seen.) Information from Mrs Doris Cowley, a painter and lifelong member of the Guildford Art Society, who lived in Tree Tops, Dedswell Drive, West Clandon, behind Candy Cottage. She spoke with pride about Leech as an artist and stressed the fact that both Mr and Mrs Leech lived quietly in retirement at West Clandon.

18. One of these paintings bought by Pat Murphy was *Nude* (cat. 53). I am grateful to Mr Pat Murphy for his help, especially in making available to me copies of extracts from the correspondence between Mr Leo Smith and W.J. Leech (1945 until 1968).

19. One of these paintings was his own work *Un matin*, which he presented in memory of Hugh Lane; the other work must be the Frances Hodgkins' *Baby*. He is referring to Eithne Waldron, curator of the Municipal Gallery of Modern Art. From this comment, it is obvious that Leech communicated with others in Dublin than Leo Smith. He did correspond with Dermod O'Brien until O'Brien's death in 1945. He also corresponded with Dr Denis Gwynn, who told him about Dermod O'Brien's illness in 1945.

20. Wills & Probates, Somerset House, London. W.J. Leech and Leonard Walter Loryman were the executors of May Botterell's will, and one of the witnesses was Mrs Mabel Mitchell, the housekeeper. The net value of May's estate was £6566. 9s. 0d.

21. A. Denson, 'An Outstanding Irish Artist', *The Irish Independent*, 11 April 1967, p. 10. The article reproduced four paintings, *Aloes* (cat. 59), *Portrait of Gillian Botterell*, *Lamplight* (cat. 79), *The kitchen, 4 Steele's Studios, London* (cat. 77) and a photograph of W.J. Leech taken in 1966.

22. Leech, letter to Leo Smith, 17 May 1967. Leech, the recluse, felt vulnerable after May's death in 1965 because May had always managed his affairs and was adept at protecting him from any intrusion of their privacy. He felt pressurized by any publicity and Alan Denson's impending book caused him great anxiety in the last year of his life, a fear he expressed to Leo Smith and to Pat Murphy. He wanted nothing published while he was alive and he reiterated this to Leo Smith in his letter of 17 May 1967.

23. Denson, *op. cit.* chap. 5 note 70, p. 14, and Denson's Letters to the Editor, *The Irish Times*, 25 June 1969, p. 6.

24. Anonymous, 'Girl Tells of Death Fall from Bridge', *Surrey Advertiser and County Times*, 20 July 1968, p. 5. A long article covering all the evidence given at the inquest on Leech's sudden death. At the end of the detailed account of his fall there is a long résumé of his Distinguished Career possibly provided by A. Denson, who gave evidence at the inquest.

25. 'Girl Tells of Death Fall from Bridge', *cit.* note 24.

26. Medical report given at the inquest and reported in the *Surrey Advertiser and County Times*, *cit.* note 24.

27. 'Girl Tells of Death Fall from Bridge', *cit.* note 24. Information from Mr Arthur Harold Smith, at his home in West Clandon in 1985. He recalls Leech's fall very vividly and is certain that Leech intended to kill himself since the bridge is too high to sit on casually and an effort had to be made for an eighty-year-old man to climb on to it.

28. *Ibid.*

29. Leech, letter from no. 4, Steele's Studios, to Dr Helena Wright, *ca.* 1936. See Campbell, *op. cit.* chap. 8 note 17.

30. The Last Will and Testament of William John Leech, dated 19 June 1968. Somerset House. London. He was to die less than a month later, on 15 July 1968.

31. Information from Mrs Margaret Wallace, England, 1985.

32. Leo Smith's list of paintings in the house for death duty purposes on 5 September 1968 as follows:
 Drawing Room.
 1. Portrait of Mrs. Leech £50.
 2. Bird Bath £20.
 3. French Window £50.
 4. " (Grey Light) £40.
 Bedroom 1.
 5. Suzanne £5.
 6. Self Portrait £30.
 7. Suzanne as a child £40.
 8. Portrait of May Leech £60.
 9. Bridget Reading £60.
 Bedroom 2.
 10. The Lace Tablecloth £60.
 11. Bridget (Blue Dress) £70.
 12. Studio Door £30.
 13. The Bird Bath £30.
 14. Self Portrait £30.
 15. Self portrait £30.

33. *Surrey Advertiser and County Times*, 27 July 1968, p. 4. This covered Leech's funeral at St John's Crematorium, Woking, on Friday, 19 July. It also listed those present which included Mr Jim Botterell and Mr C.H.B. Cox, Mrs Kenchington, Mr Theodore Wallace, Mrs Loryman, Mrs Mitchell-Innes, Mrs Procter, Miss Procter, Mr Alan Denson, Mrs William Abbott and Mrs Mitchell. Mrs Salmond (stepdaughter), Mrs Margaret Wallace and Dr C.P. Wallace were unable to attend.

34. Denson, *op. cit.* chap. 1 note 10, p. 108.

35. Pat Murphy, *The Irish Times*, 5 August 1977, p. 5.

Catalogue

Cat. 4
 The Irish Times, 1 March 1909; 'The Spirit of the Aonach', *Sinn Fein*, 18 December 1909, p. 3

Cat. 12
 Arthur had acted as the official interpreter between the French and the British in 1914, and was awarded the Cœur du Guerre and DSO. Cecil fought in the Battle of Le Catto in August 1914 and was captured by the Germans.
 See B. Arnold, *Orpen*, London 1981, p. 95, colour illus. p. 96.

Cat. 13

Sydney Lough Thompson, At Home and Abroad, exhib. cat. by J. King, Christchurch (NZ), Robert MacDougall Art Gallery, 1990.

[Thomas Bodkin], 'Royal Hibernian Academy', The Freeman's Journal, 31 March 1909, p. 5.

Cat. 20

[Thomas Bodkin], 'Royal Hibernian Academy', The Freeman's Journal, 31 March 1909, p. 5.

Cat. 22

The Leader, 12 March 1910, p. 87.

Cat. 26

The Times, 20 April 1912, p. 4.

Cat. 31

Truth to Nature, exhib. cat. London, Pyms Gallery, 1996, p. 78.

Cat. 32

J. Campbell, 'The Convent Garden', in ed. B. Kennedy, Art is My Life: A Tribute to James White, Dublin, National Gallery of Ireland, 1991, pp. 44-45.

Cat. 33

Impressionism in Britain, exhib. cat. by K. McConkey, London, Barbican Art Gallery, 1995.

Cat. 35

Henry Blackburn, Breton Folk, London 1880, pp. 140-41. Denis Delouch, Les Peintres et le paysan Breton, Baille 1988, p. 165. Walter Osborne, exhib. cat. by J. Sheehy, Dublin, National Gallery of Ireland, 1983, cat. 7, p. 54. Post-Impressionism, exh. cat., edd. J. House and M.A. Stevens, London, Royal Academy of Art, 1979-80, pp. 156, 279 etc; also J. Campbell, 'The French Peasant in 19th-Century Irish Art', in exh. cat. ed. J. Thompson, The Peasant in French 19th-Century Art, Dublin, Douglas Hyde Gallery, 1980, cat. 77, p. 188. The Irish Impressionists, exh. cat. by J. Campbell, Dublin, National Gallery of Ireland, 1984, p. 262. See Chapter 7 for information from Leech in a letter to Leo Smith. Curatorial information from the Musée des Beaux-Arts, Quimper, confirms that this is not a Breton subject.
For the bonnet: Annette Horniblow, granddaughter of S.L. Thompson, in a letter to the author.
Bourlet Transport Company records.
For the canvas: see The British Portrait 1660-1960, exhib. cat., 1991, pp. 113-15.
The information that her mother, Mrs Margaret Wallace, saw the painting in Leech's studio in Candy Cottage is from Mrs Bridget Stevens, to the National Gallery of Ireland, August 1996. The information quoted from Mrs Eileen Botterell, 1985, was confirmed by her daughter on 28 August 1996.
For Bastien-Lepage and his influence on the British see W.S. Feldman in Jules Bastien-Lepage, exhib. cat. Verdun, Les Musées de la Meuse, 1984, p. 116. For George Clausen see Sir George Clausen, RA, exhib. cat., Bradford, Bradford and Tyne and Wear Museums, 1980, pp. 107-08.
Dominic Milmo-Penny, Milmo-Penny Fine Art Dublin, has provided me with the extensive research he has collated on the work of Stanley Royal. I am very grateful to him for his assistance and information. Further, Jean Copleston, daughter of Stanley Royle, letter to the author of 6 May 1996.
Copy of Leo Smith's valuation for Death Duty in the possession of the author.
Denson 1968, 1969, 1971 (see Bibliography to the catalogue); Alan Denson, letter to The Independent, 'The real thing?', April 1995.

Cat. 36

Paddy Glendon (P.H.G.), 'R.H.A. Review', The Irish Times, 3 March 1913, p. 7.

Cat. 37

John Fitzmaurice Mills, 'Art Forum', The Irish Times, 7 May 1969, p. 12. May Botterell, letter to MacGreevy, Director of the National Gallery of Ireland, 6 September 1952. G. Durand, 'Irish Painters in Brittany at the Turn of the Century', CARN, no. 81, winter 1974-75, p. 6.

Cat. 38

NEAC Winter Exhibition, catalogue, in the library of the Tate Gallery, London.

Cat. 40

The Times, 15 June 1927, p. 10.

Cat. 41

B. Laughton, Philip Wilson Steer, Oxford 1971, cat. 438, fig. 145. Information on the kitten from Mrs Mitchell, Leech's former housekeeper in Clandon, 1985. [Paddy Glendon], 'Artist Reveals Vivid Descriptive Powers', The Irish Independent, 21 May 1947. Hylda Boylan, 'Review of the Irish Salon', The Irish Statesman, 11 February 1928, p. 520.

Cat. 45

'The Blue Portrait', The Irish Times, 11 March 1930. Exposition d'art irlandais, exhibition catalogue, Brussels, Musée d'art ancien, May-June 1930, no. 75.

Cat. 49

Leo Smith's inventory of Leech's paintings in his studio at Candy Cottage, 5 September 1968, copy in the possession of the author. An Ireland Imagined, exhib. cat., London, Pyms Gallery, 1993, pp. 38-39, no. 24. The Irish Times, 24 July 1953, p. 5.

Cat. 50

Letter from Leech to Leo Smith, 18 January 1966. See also Chapter 7 and notes.

Cat. 58

Denson 1969 (see Bibliography to the catalogue), no. 17, illus.

Cat. 61

The Irish Tatler, LX, no. p, June 1951, p. 21, illus.

Cat. 66

Hylda Boylan, 'The Royal Hibernian Academy', The Irish Statesman, X, 10 March-1 September 1928, p. 92.

Cat. 75

The Irish Tatler & Sketch, May 1947, p. 13. Information from Cecil Cox, Leech's nephew.

Cat. 86

Denis Gwynn, 'Now and Then', Cork Examiner, 19 July 1968, p. 10.

Cat. 89

Letter from Leech at no. 4, Steele's Studios to Helena Wright, ca. 1935.

Cat. 90

Letter from Leech to Leo Smith at the Dawson Gallery, Dublin, 18 December 1966.

Cat. 103

Letter from Leech to S.L. Thompson, Christchurch (NZ), 5 May 1948.

Cat. 115

'Fashion and Gossip', Dublin Evening Mail, 4 May 1951, p. 3. 'G.H.G. Exhibition of Paintings', The Irish Times, 3 May 1951, p. 7.

Addenda

Cat. 3

Literature: Ferran 1993, p. 224, illus. p. 226

Cat. 4

Exhibitions: The Irish Impressionists: Irish Artists in France and Belgium, 1850–1914, Dublin, National Gallery of Ireland, and Belfast, Ulster Museum, 1984, no. 116

Cat. 6

Exhibitions: The Irish Impressionists: Irish Artists in France and Belgium, 1850–1914, Dublin, National Gallery of Ireland, and Belfast, Ulster Museum, 1984, no. 117

Cat. 29

Provenance: Purchased from Mr Alan Denson (on behalf of the artist's niece), 1968
Exhibitions: The Irish Impressionists: Irish Artists in France and Belgium, 1850–1914, Dublin, National Gallery of Ireland, and Belfast, Ulster Museum, 1984, no. 120; Irish Watercolours and Drawings, Dublin, National Gallery of Ireland, 1991, no. 46; Irish Watercolours and Drawings from the National Gallery of Ireland, Boston College Museum of Art, 1993, no. 46
Literature: B.P. Kennedy in Irish Watercolours and Drawings, exhib. cat., Dublin, National Gallery of Ireland, 1991, pp. 106–07

Cat. 30

Provenance: Purchased from Mr Alan Denson (on behalf of the artist's niece), 1968
Exhibitions: Watercolours and Drawings from the National Gallery of Ireland, Boston College Museum of Art, 1993, no. 45; Watercolours and Drawings from the National Gallery of Ireland, Boston College Museum of Art, 1993, no. 46
Literature: B.P. Kennedy in Irish Watercolours and Drawings, exhib. cat., Dublin, National Gallery of Ireland, 1991, pp. 104–05

Cat. 34

Exhibition: The Irish Impressionists: Irish Artists in France and Belgium, 1850–1914, Dublin, National Gallery of Ireland, and Belfast, Ulster Museum, 1984

Cat. 35

Exhibitions: The Peasant in French 19th Century Art, Dublin, Douglas Hyde Gallery, 1980, no. 77; The Irish Impressionists: Irish Artists in France and Belgium, 1850–1914, Dublin, National Gallery of Ireland, and Belfast, Ulster Museum, 1984, no. 119
Literature: McConkey 1990, pp. 115, 118

Cat. 37

Exhibition: The Irish Impressionists: Irish Artists in France and Belgium, 1850–1914, Dublin, National Gallery of Ireland, and Belfast, Ulster Museum, 1984, no. 118

Cat. 104

Literature: The Allied Irish Bank Collection, 1986, p. 28

Chronology

1893 Leech becomes a student at St Columba's College, Rathfarnham, and wins prizes for English, French, drawing and painting.

1897 Leech departs for Switzerland, to study French.

1899 Leech enrols at the Metropolitan School of Art in Dublin. James Brenan is headmaster.

1900 Transfers to the Royal Hibernian Schools where Nathaniel Hone is Professor of Painting and Walter Osborne his teacher.

1901 Registers as a student at the Académie Julian in Paris; teachers are William Bouguereau and Gabriel Ferrier. He studies in the studio of Jean Paul Laurens and Henri Boyer.

1902 Wins £5 Taylor Prize for *A mother*. Judges: Walter Osborne, S. Catterson Smith and Sir Walter Armstrong.

1903 £5 Taylor Prize for *Sisters* and £10 for *A portrait study*. Judges: Viscount Powerscourt, Sir Walter Armstrong and S. Catterson Smith.

1903 Leaves Paris with C.J. Webb, for Concarneau, Brittany, to join his New Zealand friends S.L. Thompson and Charles Bickerton.

1904 £10 Taylor Prize for *A study of a boy*. Judges: Viscount Powerscourt, Sir Walter Armstrong and S. Catterson Smith.

1904 Both Thompson and Leech contract typhoid, and are hospitalized in Quimper and Concarneau; both return to Ireland to recuperate. Painted around Dublin, in Connemara and Killarney.

1905 £50 Taylor Prize for *A lesson on the violin*. Judges: Nathaniel Hone, Sir Walter Armstrong and James Brenan.

1906 £50 Taylor Prize for *The toilet*. Judges: Nathaniel Hone, Sir Walter Armstrong and Nassau Blaire Browne.

1906 Returns to his parents' home at Yew Park, Clontarf, Dublin. His brother Frederick dies suddenly of peritonitis, 8 December 1906, aged twenty-one.

1907 Elected Associate of the Royal Hibernian Academy, proposed by Dermod O'Brien.

1908 August: auction at Yew Park, Clontarf. Leech family move to no. 6, Victoria Villas, Morehampton Road, Dublin.

1909 London with Dermod O'Brien, end of April–early May; visits Wilson Steer's studio and Steer's exhibition at the Goupil Gallery.

1909 Leech family move to 'Wilmar', Dartry Road, Dublin.

1910 Elected full member of the Royal Hibernian Academy. Leech family leave Dublin to live at Blackheath, SE London, and then no. 45, Westbourne Park, London.

1911 Leech family address: no. 55, Castletown Road, West Kensington, London W.

1911–12 Winter in Paris with Elizabeth Kerlin.

1912 5 June: marriage to Saurin Elizabeth Kerlin (née Lane) at Fulham Registry Office.

1913 Paris, Salon des Artistes Français; no. 1082, *Les Sœurs du St. Esprit* (*A convent garden*).

1914 Exhibited no. 1225, *Un après-midi d'été*, and no. 1226, *Le Café des Artistes, Concarneau*, at Salon; awarded a bronze medal for *Le Café des Artistes, Concarneau*.

1914 Leech family address: no. 16, Eardley Crescent, Earls Court, London SW.

1915 Leech family address: no. 39, Gunterstone Road, West Kensington.

1915 13 March: Leech in Concarneau; 3 April: Elizabeth Leech joins him in Concarneau.

1917–18 Winter painting in Les Martiques with Thompson and Henry La Thangue.

1918 Leech received his 'call-up' papers for enlisting in the British Army.

1918 Leech family address: no. 19, Porchester Square, London.

1919 Leech meets May Botterell, which begins a life-long relationship. Break-up of his marriage.

1919–20 Winter painting, Hammamet, Tunisia with May Botterell.

1919 Rented The Studio, Hamilton Mews, London NW8, until 1928. May Botterell rents no. 24, Hamilton Terrace.

1920 Exhibited *Portrait of Mrs Botterell* at the Salon des Artistes Français.

1921 2 March: the sudden death of Brougham Leech at Porchester Square, London. Death of Mrs Leech in hospital in Wolverhampton that October.

1921 Elizabeth Leech returns to the USA.

1921–26 Leech rents a house at St-Jeannet in the South of France.

1923 Leech and Thompson painting together at Grasse.

1928 Leech rents no. 4, Steele's Studios, London, until 1948.

1938 May Botterell rents no. 20, Abbey Road, London NW8.

1940 Submitted work to the RA from The Dilly, Upper Beeding, Sussex, the address of Jim and Eileen Botterell.

1941 No. 4, Steele's Studios damaged in the Blitz.

1942 Bill Leech and May Botterell rent no. 104, Windermere Road, Reading.

1943 No. 4, Steele's Studios, damaged for the second time in the London blitz.

1945 June: solo exhibition at the Dawson Gallery, Dublin (thirty-five paintings).

1947 May/June: solo exhibition at the Dawson Gallery, Dublin (twenty-five paintings).

1951 May: solo exhibition at the Dawson Gallery, Dublin (thirty-five paintings).

1951 26 June: death of Elizabeth Leech, Quincy, Mass., USA, aged seventy-two years.

1952 Death of Percy Botterell. Highcroft, Burley.

1953 20 April: marriage to May Botterell at Marylebone Registry Office. July/August: exhibited six paintings at the Dawson Gallery with Frances Kelly and Evie Hone.

1958 Bought 'Candy Cottage', Felix Drive, West Clandon, Surrey.

1963 10 July: death of May Leech, aged eighty-three years.

1968 16 July: death of Bill Leech in Guildford Hospital, Surrey, aged eighty-eight years. His remains were cremated at Brookwood, Woking, on Friday, 19 July, and his ashes scattered there.

Index